The
Golden
Century
of
Venetian
Painting

This exhibition was made possible by a grant from BankAmerica Foundation and by an indemnity from the Federal Council on the Arts and Humanities.

The Golden Century of Venetian Painting

Terisio Pignatti

Catalog in collaboration
with
Kenneth Donahue

Los Angeles County
Museum of Art

Distributed by
George Braziller, Inc.

Library of Congress Cataloging
in Publication Data

Pignatti, Terisio, 1920–
The Golden Century of Venetian
Painting.

Catalog for an exhibition at the
Los Angeles County Museum of Art,
October 30, 1979–January 27, 1980.
 Bibliography: p.
 1. Painting, Italian–Italy–Venice–
 Exhibitions. 2. Painting, Renais-
 sance–Italy–Venice–Exhibitions.
 I. Donahue, Kenneth. II. Los Angeles
 Co., Calif. Museum of Art, Los
 Angeles. III. Title.
ND621.V5P49 1979b 759.5'31
79-17412
ISBN 0-8076-0935-8
ISBN 0-87587-088-0

Cover:
Titian *Self Portrait* detail,
catalog number 22.

Published by the
Los Angeles County Museum of Art
5905 Wilshire Boulevard
Los Angeles, California 90036

Copyright © 1979 by
Museum Associates of the
Los Angeles County Museum of Art

Hardcover edition distributed by
George Braziller, Inc.
One Park Avenue
New York, New York 10016

Designed in Los Angeles by
Ken Parkhurst & Associates

Composed in Garamond types by
R S Typographics, Los Angeles

Printed in an edition of 2,500
hardcover and 52,500 softcover
on Lustro Offset Enamel Dull paper
by Graphic Press, Los Angeles

First printing

Contents

Lenders to the Exhibition

Austria	Vienna	Kunsthistorisches Museum, Gemäldegalerie	United States	Boston	Museum of Fine Arts
				Cleveland	The Cleveland Museum of Art
Canada	Ottawa	National Gallery of Canada		Detroit	Detroit Institute of Arts
				Fort Worth	Kimbell Art Museum
France	Besançon	Musée des Beaux-Arts		Greenville	Dr. and Mrs. Bob Jones
	Paris	Musée du Louvre		Hartford	Wadsworth Atheneum
		Private Collection		Houston	Sarah Campbell Blaffer Foundation
				Kansas City	Nelson Gallery-Atkins Museum
West Germany	Berlin	Staatliche Museen Preussischer Kulturbesitz, Gemäldegalerie		Los Angeles	The Armand Hammer Collection
					Los Angeles County Museum of Art
	Braunschweig	Herzog Anton Ulrich-Museum			Norton Simon Inc Foundation
				Malibu	The J. Paul Getty Museum
Italy	Bassano del Grappa	Museo Civico		New York City	M. Knoedler & Co.
	Belluno	Church of San Pietro			Suida Manning Collection
	Feltre	Museo Civico			The Metropolitan Museum of Art
	Naples	Galleria Nazionale, Capodimonte			Private Collections
	Parma	Pinacoteca Nazionale		Norfolk	Chrysler Museum
	Rome	Galleria Nazionale, Palazzo Barberini		Omaha	Joslyn Art Museum
				Raleigh	North Carolina Museum of Art
	Venice	Church of the Carmini		San Diego	San Diego Museum of Art
		Church of San Bartolomeo al Rialto		San Francisco	The Fine Arts Museums of San Francisco
		Church of San Giovanni Elemosinario			
		Gallerie dell'Accademia		Washington, D.C.	National Gallery of Art
		Museo Civico Correr			
	Verona	Justo Giusti Del Giardino Collection			
Spain	Madrid	Museo del Prado			
Switzerland	Lugano	Thyssen-Bornemisza Collection			

Preface

Eighty-five years ago, Bernard Berenson wrote: "Among the Italian schools of painting the Venetian has for the majority of art-loving people, the strongest and most enduring attraction." During the intervening decades, American museums have validated his statement by acquiring an extraordinary number of Venetian paintings, especially those of the great masters of the late fifteenth and sixteenth centuries. Yet, curiously, this is the first comprehensive exhibition of Venetian Renaissance painting in this country. When, over the years, I spoke with specialists in Venetian painting or colleagues in Italian museums about such an exhibition, I consistently received the reply, "It can't possibly be done; the paintings cannot be borrowed." I was, therefore, unexpectedly delighted some five years ago when Terisio Pignatti responded to the same query with spontaneous optimism and an immediate agreement to be guest curator of the exhibition. Professor Pignatti could speak with assurance based on his extraordinary qualifications: an encyclopedic knowledge of Venetian painting and many years of agreeable association with potential lenders as successively the Deputy Director, Director, and Director Emeritus of the City Museums of Venice, as Professor of Art History at the Universities of Padua and Venice, and as the author of monographs on Tiepolo (1951), Lotto (1953), Carpaccio (1953, 1958), Canaletto (1958), Jacopo de' Barbari (1963), Paolo Veronese (1965), Pietro Longhi (1968), and Giovanni Bellini (1969), and the catalogue raisonné of Paolo Veronese (1976).

As it is assembled, the exhibition is quite close in concept to that proposed by Professor Pignatti in our earliest discussions: not a routine survey, but a selection of paintings that offers the viewer an insight into the artistic personalities and forces that determined the evolution of Venetian painting from Giovanni Bellini's stay in Padua to the death of Tintoretto. Presented as a succession of individual artists, the exhibition nonetheless reveals the sequence of artistic and intellectual crises and resolutions that make the history of sixteenth-century Venetian painting an intensely dramatic one: the impact of Florentine and Paduan Early Renaissance art and thought; the development of the oil medium and of new techniques that permitted highly individual means of expression; the continuous invasion of artistic forms and concepts, first of Dürer, Leonardo, Raphael, and Michelangelo, then of the Mannerists of Florence, Rome, and Parma; the adaptation of these influences by artists who at the same time steadfastly maintained the Venetian belief in the beauty and perfection of nature as perceived by the senses, and who persisted in basing their artistic theory and their work on color and light in the face of jibes from even such a respected master as Michelangelo; the unfolding of Venetian humanism; and the emergence of an intensely personal and emotional spirituality in the wake of the Catholic Reformation. Paintings were especially sought in three categories: world-renowned masterpieces by the most celebrated artists, those that hold a unique place in the history of Venetian art, and works of importance that are little known or had been lost to scholars for a considerable period of time. Some works, of course, fit into two or three of the above categories. Through the bountiful cooperation of museum officials and collectors there are in the exhibition a larger number of well-known masterpieces than we dreamed possible when the exhibition was first discussed. Works of special historical interest include the earliest known Venetian Renaissance portrait, the *Joerg Fugger* of Giovanni Bellini; the avant-garde *Drunkenness of Noah* by the aged Bellini; the *Dead Christ Supported by an Angel* left incomplete by Giorgione and finished by Titian; the most discussed enigma of the period, *The Appeal* attributed to Palma Vecchio, made as an homage or a spoof; the single most renowned work of Cariani and of Leandro Bassano; and *Christ Healing the Blind,* one of the relatively few paintings by El Greco from his period of training in Italy. Obvious examples of unknown or lost paintings are the Tintoretto

Paradise, never before exhibited, and the Veronese *Portrait of a Venetian General in Armor,* for which scholars have searched for more than two decades.

It was also our hope in the planning stage that each major artist would be represented by paintings exemplifying his stylistic development throughout his career. While this has been achieved ideally for Tintoretto and to a lesser degree for Veronese, it could not be realized for everyone. It did remain, however, as one of the guiding principles of selection. Giorgione and Carpaccio are least well represented, not only because their works are always difficult to borrow but also because we lost one of Giorgione's few extant masterpieces through a change in government in its country of ownership and two large narrative Carpaccios through the sudden death of the lender.

The exhibition also affords the viewer the opportunity to follow step-by-step the greatest revolution in painting technique of the past millennium. It began in the 1470s when Giovanni Bellini, at first sporadically and later regularly, replaced traditional tempera emulsion with the oil medium developed by Jan Van Eyck in Flanders as the vehicle for his pigments. He employed it, however, much like tempera, using as support a wood panel covered with polished white gesso on which he drew the outlines of the composition precisely and filled them in, area by area, with local color. He modeled forms by almost imperceptibly graduating lighter to darker tones (values) of the same hue. The white ground gave luminosity to the transparent layers of paint. Giorgione is credited with the three great technical innovations of the first decade of the sixteenth century: 1) the discovery of the proper proportions of lead and walnut or linseed oil and the required temperature to prepare a boiled oil infused with wax that would yield a darker, richer, more viscous paint, 2) the use of colored ground, and 3) much to Vasari's horror, painting without preliminary drawing. Sixteenth-century writers regarded the resultant softening of outlines, the blending of colors, and the unification of figures and setting in light and atmosphere as the beginning of modern Venetian painting. By the early sixteenth century the Venetians had adopted canvas rather than wood panel or plastered wall as their preferred support, even for large mural paintings. Its texture gave an irregularity to the surface that encouraged freer, faster painting application and an overall tonality. It was Titian who fully exploited the new materials and methods for effects of nature and for expression. Over a colored ground, usually dark red, brown, or gray, he brushed in his images in color and tone, at times using the ground as part of the composition. When this was dry, he finished the painting with glazes (transparent layers of paint) and scumbles (opaque layers of paint thinly or irregularly applied to modify color below). Instead of the bright, clear colors of Giovanni Bellini, the painting was now dominated by half-tones with deepened shadows and sparkling highlights. Instead of luminosity emanating from the white ground, it was produced by the jewel-like quality of glazes against the darker ground and opaque white highlighting. Figures, setting, and landscape melt together in a complete pictorial unity. Tintoretto used a greater proportion of wax in his medium for a more matte surface and speedier completion. He worked with great rapidity, sketching in his figures on a thinly covered canvas and applying glazes in such a fluid manner that they often overran their boundaries. The fifty-six paintings in the exhibition illustrate how manifold were the variations of the *colorito veneziano.*

The contributors to this exhibition are as numerous as the participants in Gentile Bellini's Corpus Christi procession in St. Mark's Square and just as diverse. They are acknowledged here in associated groups without any implication that those near the end are of less importance than those farther ahead.

Without financial support from a number of sources the exhibition, with its higher than average cost of insurance, transportation, and couriers, would have remained an attractive but unrealizable project. We should like, therefore, to express our gratitude first to the Bank of America for sponsoring the exhibition, and personally to A. W. Clausen, President, and C. J. Medberry, Chairman of the Board, as well as to Kyhl Smeby, Senior Vice President, and C. J. Bocchieri, Executive Director of the Bank-America Foundation, who have been our liaison in the implementation of the grant; to the Federal Council on the Arts and Humanities for providing indemnification in lieu of insurance for the European loans; to the Ahmanson Foundation for enabling us to reproduce all the paintings in color in the catalog; to the Kress Foundation for providing travel funds and personally to Mary Davis for her help on many aspects of the exhibition; and to the Supervisors of Los Angeles County and the Trustees of the Los Angeles

County Museum of Art for providing the basic budget and the network of support activities essential to the show. The Trustees unanimously endorsed the exhibition when it was first proposed and, along with the President, Camilla Frost, have unwaiveringly favored its consummation. Richard Sherwood, President of the Board when the exhibition was approved, devoted considerable time and effort to help secure seemingly impossible loans as did Franklin Murphy, Chairman at that time, who also obtained critical funding.

A wide range of public officials gave their personal time and the authority of their offices to securing loans that required governmental approval. We should like to recognize here their indispensable contribution and to extend our deepest gratitude. They are listed by the country they represent rather than by rank.

For Italy, Paolo Pansa Cedronio, Ambassador of Italy to the United States; Sergio Romano, Director General of Cultural Relations with Foreign Countries in the Ministry of Foreign Affairs; Guglielmo Triches, Director General of Fine Arts in the Ministry of Cultural Properties; Licisco Magagnato and Cesare Brandi, the former and present president of the Consiglio Superiore of the Ministry of Cultural Properties along with the members of the Council; the regional Superintendents of Artistic Properties: Dante Bernini, Rome, Renzo Chiarelli, Veneto, Eugenio Riccomini, Emilia, Francesco Valcanover, Venice; Cardinal Marco Cè, Patriarch of Venice, and Maffeo Ducoli, Bishop of Belluno and Feltre; Amadeo Cerchione, Italian Consul General in Los Angeles, and Vittorio Farinelli, former Consul General here, in whose house the first discussion of the exhibition with Professor Pignatti took place. For Spain, Evelio Verdera y Tuells, Director General, Artistic Patrimony, Archives and Museums, Ministry of Culture. For the United States, Richard Gardner, Ambassador to Italy; Wells Stabler, Ambassador to Spain; Richard Arndt, Cultural Affairs Officer in Rome; Frances Coughlin, Cultural Affairs Officer in Madrid; and Peter Solmssen, Advisor on the Arts to the International Communication Agency, who in his typical unassuming manner provided us the means of overcoming some of our most difficult obstacles.

We would like to cite personally those with whom loans were arranged since in so many instances they have exerted themselves far beyond professional responsibility or friendship's claim in providing or securing those loans against opposing precedent and occasionally active resistance. Tracy Atkinson, Hartford; Laura Bentivoglio, Feltre; Henning Bock, Berlin (West); Monsignor Gino Bortolan, Venice; J. Carter Brown, Washington, D.C.; Richard F. Brown, Fort Worth; Raffaello Causa, Naples; Walter P. Chrysler, Jr., Norfolk; Ralph T. Coe, Kansas City; Denis Coutagne, Besançon; Frederick J. Cummings, Detroit; Moussa M. Domit, Raleigh; Jan Fontein, Boston; Umberto Franzoi, Venice; Burton B. Fredericksen, Malibu; Henry Gardiner, San Diego; Elizabeth Gardner, New York City; Stephen Garrett, Malibu; Conte Justo Giusti Del Giardino, Verona; Armand Hammer, Los Angeles; Terrell Hillebrand, Houston; Dr. and Mrs. Bob Jones, Greenville; Frederike Klauner, Vienna; Rudiger Klessmann, Braunschweig; Michel Laclotte, Paris; Sherman E. Lee, Cleveland; Giuseppina Magnanimi, Rome; Mr. and Mrs. Robert Manning, Forest Hills, New York; Peter Marlow, Hartford; Charles Parkhurst, Washington, D.C.; José Manuel Pita Andrade, Madrid; John Pope-Hennessy, New York City; Monsignor Ottorino Pieroban, Belluno; Fernando Rigon, Bassano del Grappa; Giandomenico Romanelli, Venice; Pierre Rosenberg, Paris; Lucia Fornari Schianchi, Parma; Frederick Schmid, Omaha; Norton Simon, Pasadena; Hsio-Yen Shih, Ottawa; Françoise Soulier-François, Besançon; Jack Tanzer, New York City; Baron H. Thyssen-Bornemisza, Lugano; Francesco Valcanover, Venice; John Walsh, Jr., Boston; Ian M. White, San Francisco.

In the preparation of the exhibition and catalog, the standard bearer was, of course, Terisio Pignatti and close to him Francesco Valcanover, Superintendent of Artistic Properties of Venice, who from the outset unstintingly shared his counsel and time. Alla T. Hall had a dual role; as special coordinator for this exhibition she maintained liaison with lenders and assembled appropriate documentation, and as research specialist she insured the scholarly utility of the catalog by painstakingly verifying each entry in the "Collections, Exhibitions, and Literature" section and supplementing it whenever possible; Jeanne D'Andrea both supervised and personally participated in the planning, editing, design, and production of the catalog and collaborated in the design and installation of the exhibition. Stephen West edited the manuscripts and adapted them to design requirements. Patricia Nauert arranged transportation and insurance and provided the

manifold registrar services and documentation that too often go unrecognized. Myrna Smoot conducted negotiations and maintained liaison with the Federal Council for the Arts and Humanities; Emily Nilson devotedly kept abreast of the evolving text; Elena V. de Olivera made valuable editorial suggestions and Betty Foster volunteered her services as skilled proofreader. Philippa Calnan, Public Information Officer, Eleanor Hartman and her library staff, as well as members of the Administrative and Operations staffs have made contributions too numerous to be listed but for which we are nonetheless grateful.

We should also like to extend our appreciation to Cristina Pesaro for her bibliographic research in Venice; to Murtha Bacca for having made the original translation of Professor Pignatti's manuscript; to Esther de Vecsey for collecting photographs and documents during the planning stage of the exhibition; to David Rosand for his translation of Palma Giovane's report on Titian's technique; to Marco Grassi for his advocacy of the Museum on this and a number of other occasions; and to Carlo Speroni who, as the Los Angeles Aretino, reviewed my correspondence with Italian officials to insure that its phraseology was diplomatic and effective. To all the above and to the many who are not named we express our gratitude for their help in bringing to Los Angeles the painting of the Golden Century that gave to Venetian life the grandeur of legend and to myth and sacred history the sensuous reality of Venetian life.

Kenneth Donahue

Director Emeritus
Los Angeles County
Museum of Art

The Venetianness of Venetian Painting

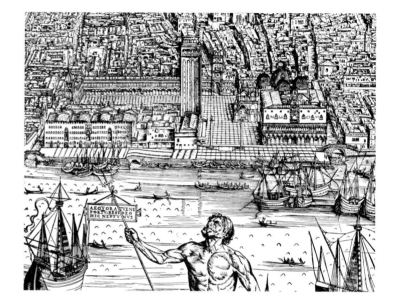

"Which age of Venetian painting was the most brilliant?"
Unquestionably it is the period between 1470 and 1590,
the zenith of six hundred years of independent and magnifi-
cent achievement from the creation of the thirteenth-
century mosaics of St. Mark's Basilica to the fall of the
Republic in 1797, the end of the epoch of Tiepolo and
Guardi. During these centuries there was one unifying
vision in Venetian art, a vision intensely bound to color.
Capable of surmounting the traditional limits of represen-
tation, it could rival nature itself or achieve picturesque
or decorative effects through beguiling and illusionary yet
expressive feats of the palette. Venetian art was thus the
legitimate cultural heir to the coloristic Roman tradition
by way of Byzantium, Aquileia, and Ravenna.

For centuries Venice enjoyed the position of a free
and powerful state. Imbued with a pragmatic outlook in
politics and finance, it stood at the center of a richly
diverse network of mercantile exchange and cultural cross-
currents that spread along the trade routes and water-
ways extending in the East from Byzantium to the Islamic
countries and the Far East, and in the North from the
medieval free cities to the courts of the refined Interna-
tional Gothic culture. Into its own late Roman tradition,
Venice assimilated Byzantine and Islamic, Romanesque
and Gothic elements to produce a distinctive culture from
Veneto-Byzantine to Venetian Flowering Gothic, epito-
mized by the juxtaposition of St. Mark's and the Doge's
Palace. The appearance of the city that resulted from
this fusion of cultures is recorded by Jacopo de' Barbari
in his bird's-eye view of Venice in 1500, at the moment
the city was about to make the Renaissance its own. This
was the time of greatest territorial expansion of the
Republic of St. Mark's, which extended its dominions in
northern Italy as far as Brescia in the west, the Dalmatian
coast and the Aegean islands in the east, Cadore in the
Alps to the north, and beyond the Po to the south. Not
only did Venice control the Adriatic, but also the sea

routes to the Orient on which the wealth of the Republic
was based, and through which filtered goods to be distrib-
uted to all of Europe, even after the Turkish conquest.

As a cultural phenomenon, the Renaissance was a
Tuscan invention that reached Venice by way of the out-
post of Padua, part of the Venetian state since 1405. The
University of Padua, the center of education for Venetian
patricians, was preeminent in science and philosophy in
the fifteenth century, sharing with Florence the revival of
ancient learning and the more individualistic conception
of man. But while Florence cultivated Neo-Platonism,
Padua developed a new humanistic and naturalistic inter-
pretation of Aristotle in keeping with its scientific orienta-
tion. In the visual arts, the lesson of Giotto in the Arena
Chapel (1305–6) was long unheeded by local artists, but begin-
ning with the presence of Filippo Lippi about 1430 the
essential elements of Florentine Early Renaissance took root
in Padua. They reached fruition during Donatello's ten-
year stay there (1443–53) when he produced the bronze
altar of the Basilica of Sant'Antonio and the equestrian
statue of Gattamelata. In this milieu an indigenous picto-
rial genius emerged: Andrea Mantegna, who created classi-
cal compositions inspired by Donatello's feeling for
volumes and space but with an added tension in their inci-
sive design and strongly expressive use of color.

Venice, too, had periodic visits from Tuscan humanists
and artists. In welcoming the great poet Petrarch as early
as the fourteenth century, Venice linked her literary cul-
ture to the humanistic tradition whose sixteenth-century
heirs were Pietro Bembo and the great printing houses—
the pride of Venice throughout Europe—headed by such
famous names as Nicolas Jenson and Aldus Manutius.
The Tuscan artists who came were no less distinguished
than those who worked in Padua, for they included two of
the greatest pioneers of Florentine painting: Paolo Uccello
who was invited to restore mosaics in St. Mark's in 1425
and Andrea del Castagno who designed a mosaic for the
Mascoli Chapel in St. Mark's and painted frescos on
the ceiling of the chapel of San Tarasio in San Zaccaria in
the early 1440s.

But these brief visits left no immediate influence. The
foundation for Venetian Renaissance painting was not laid
until Giovanni Bellini, in his early years in Padua, studied
Donatello and Mategna's principles of form and space
along with their concepts of man and nature and trans-

muted them into a Venetian idiom. Giovanni Bellini came
from an old family of painters who had, in fact, established
the link between the first appearance of the Tuscan Renais-
sance in Padua and the most typically Venetian manifes-
tations of the new style in the city of the lagoons. Giovanni
Bellini's father, Jacopo, grew up in the chivalric and pic-
turesque atmosphere of the Gothic International style, yet
his books of drawings in the Louvre and the British
Museum project the image of a new Venice of Tuscan and
Paduan inspiration: round arches, broad measured vistas,
spacious squares and solemn campaniles, majestic stair-
ways leading to airy loggias. It may indeed have been he,
as Master of Mosaics at St. Mark's, who about 1440 insisted
on the use of the new forms of Andrea del Castagno in the
Mascoli Chapel. Jacopo's other son, Gentile, in the festive
colors of his huge ceremonial canvases—so intimately
linked to the urban reality of Venice—gave new life to the
ingenuous, straight-line processions of the mosaics at
St. Mark's. But the painting of Giovanni Bellini was more
profound, announcing the approach of a new age. Even
in his early Madonnas, all the solemn, harmonious classicism
of a Roman bas-relief is reborn. At the same time, the
figures take life from a new fire of humanity. This was the
inauguration of an era, unique and grand from the very
beginning, in which the individual human being would
progressively become the center of the universe. In search
of a logical reason for everything, the age freed itself
from its anonymity and its medieval submission to the au-
thoritarian tenets of Church and State. Of equal impor-
tance to Giovanni Bellini's exploration of the humanistic
connotations of form was his discovery of color. No
longer did he use the extremely refined, decorative colors
of Gothic painting, but chose rather a palette suited to
recording the appearance of nature, one that differentiated
its subtle variations of light and shade and measured its
tonalities. The conquest of the idiom of color was a slow
process, but its achievement can be perceived in Giovanni
Bellini's paintings of the last decades of the fifteenth
century: landscapes, like the *St. Francis* in the Frick Collec-
tion; portraits in which he was impelled to equal or sur-
pass the most celebrated Flemish masters, well represented
in Venetian collections; and mythological themes inspired
by the classical Latin tradition and popularized through
the editions of Aldus Manutius and the other great Vene-
tian printing houses. In the concluding decades of the

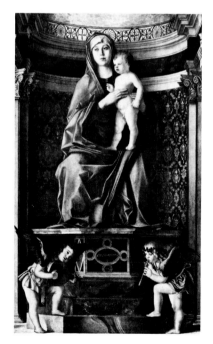

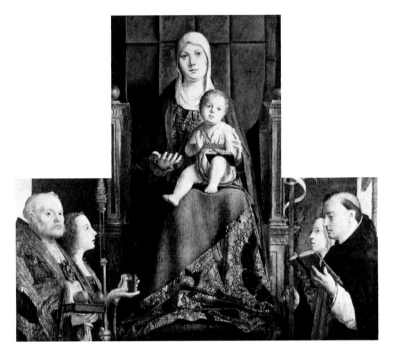

Quattrocento in Venice, the search for new forms of expression whose meaning would be synthesized in the term "Renaissance" was at its height.

Other prestigious artists joined Bellini in the task of constructing the new Venetian artistic civilization. The Sicilian Antonello da Messina, in a short visit of two years (1475–76), introduced the geometric composition that he had learned from Piero della Francesca and the enamel-like, crystalline color and oil technique of his Flemish masters. Numerous pupils followed Antonello, among whom the most important seems to have been Cima da Conegliano, the creator of composed, rustic Madonnas and of solemn Sacre Conversazioni often set in the gentle hills of the Veneto.

Vittore Carpaccio occupied a completely isolated, but for that very reason even more important, position. Starting from the ceremonial tradition of Gentile Bellini, he developed an extraordinary synthesis of strict realism in depicting objects and a magical sense of spatial proportion. His work was a faithful representation of a Venice renewed by the architectural innovations of Mauro Codussi and Pietro Lombardo, and an incisive document of contemporary social customs as well. But what surprises us most is the supremely original and free expressiveness of his color, based on his perception of Antonello and Piero della Francesca "translated into Venetian" with a sweet, resonant sumptuousness of musical rhythms and picturesque transparencies. While Carpaccio declined early, disappearing from the Venetian scene at the end of the first decade of the Cinquecento, the long-lived Bellini continued his triumphs into the second decade as the best-loved and most highly respected of masters, a patriarch of Venetian painting. In fact Albrecht Dürer, when in Venice between 1505 and 1507, characterized Bellini as "still the best in the art of painting."

Thus it was Giovanni Bellini who formed the link that united the Quattrocento to the Cinquecento in such a way that the extraordinary idiomatic continuity of Venetian painting was preserved. The next step in the exploration of color was taken by Giorgio da Castelfranco, called Giorgione. Sixteenth- and seventeenth-century literary sources agree that he was a pupil of Giovanni Bellini from the time of his arrival in Venice, probably about 1500, but little remains of Giorgione's youthful production of Madonnas and portraits, probably modeled after those of

his teacher. In any case, it was through those paintings that the nascent Venetian tradition was transmitted from the old generation to the new. Certainly Bellinian elements survive in some of the few indisputably early works of Giorgione, from the Gardner Museum, Boston *Christ Carrying the Cross* (a copy of a Bellini now in Toledo, Ohio) to the Castelfranco altarpiece of about 1504, a unique work in Giorgione's production in composition as well as color. Still, no one could seriously place Giorgione among the court of Bellini's numerous followers on the basis of these paintings. For despite the affinities between Bellini and his pupil, even in these early works substantial differences emerge that are more than sufficient to distinguish the sheer originality of the young Giorgione. Bellini's detached, hieratic classicism in the great San Giobbe and San Zaccaria altarpieces is transformed in Giorgione's Castelfranco Madonna into a more intimate, heartfelt humanity; the saints are perhaps portraits and the Virgin herself has the affectionate and modest expression of the country women whom even today one is likely to meet along the cobbled streets of the quiet little town of Castelfranco. Even more, the landscape, so important that it occupies about half the picture, clearly shows the new spirit of Giorgione's vision. So realistic that it evokes the same feelings as nature itself, this unidealized landscape closely imitates everyday reality, in accordance with the Neo-Aristotelian philosophy that had many adherents among Venetian intellectuals. Rather than turning, as Bellini did, to the models of Mantegna and Donatello with their solemn archaeological reconstructions, Giorgione turned to the realism of Dürer and perhaps even more to the careful recording of nature by the Flemish, among whom Memling and David were probably most familiar to him.

While the forward step taken by Giorgione at the dawn of the century was a large one, the aged Bellini should be credited with its first impetus. The voice of the new generation of intellectuals, men of letters, musicians, philosophers, and poets was heard in his paintings. Artistic patronage too was changing, relying increasingly on private commissions rather than the official patronage of the Church and State. The individual was becoming more and more evident in the creative life of Venice, and specifically in the works of Giorgione, whether in his serene portraits (from the *Young Man* in Berlin to the Los Angeles *Page*), in pastoral or mythological fables (from the *Adoration of the*

Shepherds in the National Gallery in Washington to the *Tempest* in the Venice Academy), or in evocative and mysterious spiritual subjects (from the *Three Philosophers* in Vienna to the Dresden *Sleeping Venus*). It has been said that modern painting really begins with Giorgione, and this is probably so in the sense that his paintings are no longer an anonymous expression of class or social status, but allow the most individual and penetrating lyric poetry to filter through: sentiments of love and pain among human beings, enchanted messages of nature from the lights of dawn and dusk, a melancholic contemplation of the cosmos practiced in the secrecy of the painter's own personality. Giorgione spread his extraordinary poetic message for only ten years, long enough to suggest the fundamental direction that Venetian painting would take, but too short a time for him to participate in it as might have been expected. When he died during the plague of 1510, Giorgione left the field open to a barely twenty-year-old genius, Titian, who had worked beside him during his brief career.

At the time of Giorgione's death at the age of only thirty-four, it is difficult to say whether Titian really appeared to the Venetians as Giorgione's follower and successor. Documentary evidence by no means indicates this, even though in source material the name of Titian is always linked during his early years with that of Giorgione, with whom he had a very rewarding affiliation after a brief association with the Bellinis. From his first appearance as an artist, Titian gives the impression of being more an antagonist than a faithful follower of Giorgione. The frescoes he painted alongside those of Giorgione in the Fondaco dei Tedeschi in 1508 immediately attracted greater attention and praise than those of the master, so much so that they created confusion as to who had painted which frescoes. This uncertainty must have been displeasing to Giorgione but not to the younger artist, who had everything to gain from being mistaken for the more established and prestigious master. Even in the documented works by Giorgione that were finished by Titian, the Dresden *Sleeping Venus* and the Vendramin *Christ Supported by an Angel,* the brushstrokes of the young artist from Cadore seem to want to submerge, with disdain and violence, the original structure of the earlier work. On other occasions Titian in his own way created earthier versions of Giorgionesque themes; thus in Titian's *Concert Champêtre* in the Louvre, one of Giorgione's favorite

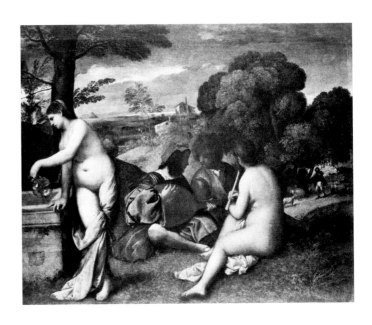

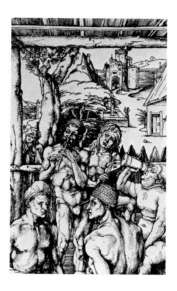

subjects—the pastorale, a poetic encounter of music, senti-
ment, and nature—is transformed into a sensual, aggressive
party of male and female figures, more in the erotic tenor
of sixteenth-century comedy from Calmo to Ruzzante than
in the refined contemplativeness of Bembo, the poet of the
Asolani and friend and companion of Giorgione. Titian's
intense vision and loaded brushwork transformed Gior-
gione's melancholy lyricism into a positive, overpowering
realism, already evident in the Paduan frescoes of 1511 that
depict dramatic episodes in the life of St. Anthony. This
style was the result not only of Titian's temperament, a
dominating one from the very beginning, but also of his
exploitation of new artistic sources, especially in assimi-
lating the experience of German engraving and painting
through his contact with Dürer. Apropos of Dürer, one
is led to suspect that his angry imprecations against certain
young Venetian painters who followed him right up to
the door of his studio to steal his ideas were also directed at
Titian, who at that time would have been about sixteen
years old. It was not by chance that Titian began his career
with a wood-engraving like the *Triumph of Christ,* in
which the Düreresque elements, beginning with the flesh-
and-blood Adam and Eve, are clearly evident. Along with
the realism of his representations, the dynamism of his
composition, and the adaptation of classical motifs from
the collections of ancient sculpture in Venice, like that of
the Grimani family, Titian soon achieved a free painterly
touch and a completely innovative palette of rich, full-
blooded hues using pure color without the aid of drawing.
The triumphs of the *Assumption* altarpiece (1518) and the
Pesaro altarpiece (1526), both in the Frari, are proof of this.

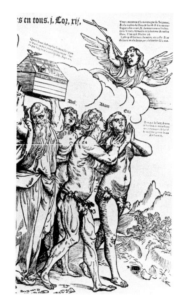

In the second decade of the Cinquecento, shortly after
the deaths of Bellini and Giorgione, Titian provided the
model for a new sixteenth-century idiom, based on the free
and sumptuous use of color. This does not mean, however,
that Venetian painting was completely dominated by
Titian's example. On the contrary, numerous other tenden-
cies survived that were originally quite distinct, even
though with the passage of time they would flow into the
Venetian mainstream. A group of artists had remained
faithful to Giorgione, above all in the external aspects of
subject matter, and to a lesser degree in the use of color. Of
this group, Sebastiano del Piombo should be remembered
rather than the mediocre Catena and Torbido, especially
for his early Venetian works in San Giovanni Crisostomo

and San Bartolomeo, painted before his departure for Rome in 1511. Another painter, Jacopo Palma il Vecchio, who was originally from Bergamo but had adopted Venice as his native city, in his youth produced arcadian pictures within the cultural orbit that was explicitly called "Giorgionism," a style which was perhaps more successful in the provinces than in Venice.

While Palma and the brilliant but superficial colorist Paris Bordon later came under the influence of Titian's radiant style, another Venetian, Lorenzo Lotto, retained a singular independence. Apparently he was not influenced by either Giorgione or Titian, even though all three matured as painters during the same years. Instead, his fastidious, patient, and introspective temperament directed him toward models of a high technical quality, such as the enameled firmness of Antonello's color, often filtered through the realism of Dürer whose prints and drawings Lotto surely studied and at times reproduced. This is especially evident in Lotto's portraits executed between 1505 and 1510, such as the Naples *Bernardo dei Rossi* or the *Young Man with a Lantern* in Vienna.

Lotto began with apparently *rétardataire* techniques, but he was destined to develop in a completely new direction. During a visit to Rome, perhaps between 1509 and 1512, he became part of Raphael's workshop in the Vatican Stanze and the Farnesina, along with Sodoma and Sebastiano del Piombo. Lotto emerged completely transformed from this experience, both in his draftsmanship, which became pliant and flowing, and in his color, which developed a refined softness with atmospheric nuances. Almost always absent from Venice, wandering between Bergamo and the Marches, this great Venetian truly provided a splendid alternative to the painting of the capital. His intimate and inspired portraits speak a delicate and allusive language and are capable of evoking the most subtle emotions, in contrast to Titian's imperious theatricality. In Lotto's Madonnas and Sacre Conversazioni the amazing vitality of the characters suggests a profoundly subjective origin. But despite his remarkable achievements, Lotto participated very little in the artistic culture of Venice, neither taking anything substantial from it nor giving anything to it. He ended his extraordinary career in the isolation of a monastery in Loreto.

If Lotto seemed to ignore Titian out of timidity, the reaction of Pordenone, who had begun his career with

works of a Giorgionesque flavor, appears all the more
lively and decisive. For Pordenone, too, a trip to Rome,
probably about 1516, was the turning point. He surely saw
Raphael's masterpieces in the Vatican Stanze, but he must
have been impressed above all by Michelangelo's powerful
ceiling of the Sistine Chapel. From these elements
Pordenone formed his personal style that can be seen in the
frescoes at Treviso and Cremona of the early 1520s. His
compositions, extremely daring in their foreshortening
and vivid coloring brightened by accents of light, served as
models for the Mannerists in Emilia and Lombardy.
Pordenone reappeared in Venice about 1537, working in
competition with Titian in the Doge's Palace on canvases
that unfortunately are lost, as well as in San Rocco and
in the cloister of Santo Stefano where a few striking frescoes
have survived. Pordenone died all too early in 1539, but
it is easy to surmise that he was Titian's only real rival in
Venice. In fact his painting, so rich in light effects and
dynamic force, had a significant influence on the painters
of the generation after Titian such as Tintoretto and
Jacopo Bassano.

At the beginning of the 1530s many artistic innova-
tions appeared in Venice. After the Sack of Rome in
1527 when Imperial troops occupied the city, numerous
artists fled, taking with them their experiences of post-
Raphaelesque and Michelangelesque culture, and dissemi-
nated the new Mannerist style. One of the artists who
fled Rome was Jacopo Sansovino, who came to Venice and
immediately became an intimate of Titian and his great
friend Pietro Aretino, the prince of writers and critics,
forming a triumvirate that was to dominate the Venetian
artistic world for many years. An architect and sculptor
trained in Rome and Tuscany, Sansovino brought a fresh
vision to Venice with his own personal experience of classi-
cal art, along with an inclination toward a refined and
modern Mannerist taste. In short, he became the creator of
the new face of the city. He replanned St. Mark's Square
and the Piazzetta, enlarging the dimensions and the per-
spectives by isolating the Campanile with its Loggetta and
building the Library and the Mint. Sansovino gave a
theatrical interpretation to the sumptuous Venetian chiar-
oscuro and a new sense of color to architecture. His genial
and grandiose buildings in the vicinity of the Doge's Palace
and the Basilica created a new sixteenth-century stage set
for the grandeur of the Doges. On the Grand Canal,

his Palazzo Corner achieved monumental forms and proportions hitherto unknown in Venice. At the same time he established an idiom rich in chromatic effects, providing a model for architects for centuries to come.

The explosion of chiaroscuro effects and the introduction of Roman elements in architecture, as well as the presence of traveling painters such as Salviati and Vasari and non-conformist Venetians such as Bonifacio dei Pitati and Andrea Schiavone, had considerable impact on the evolution of painting. We find traces of this in Titian himself, who enlarged his compositional breadth, exaggerated his foreshortenings, and magnified his figures as in *Cain and Abel, Sacrifice of Isaac,* and *David and Goliath* of 1543 in Santa Maria della Salute. But not even his direct Roman experience in 1545 could make him alter his essentially coloristic approach, and Michelangelo's assessment of Titian's *Danae,* despite its echoing his own *Dawn* in San Lorenzo in Florence, is symptomatic: "What a pity that in Venice they don't learn how to draw first." By this Michelangelo meant that the Venetian idiom was based fundamentally on the illusory effect of color, rather than on the sculptural firmness of graphic modeling. The style of the great Titian was such that it permitted him to transcend the Mannerist crisis and to pursue the course of his highly original and poetic art. As time advanced, he made increasingly greater use of heavily mixed and tormented color, drenched in vibrating light and darkened by terrible shadows, almost as if in the solitary despair of his old age, he wished to express the tragedy of all humanity. Of this late style there are unforgettable examples such as the *Christ Crowned with Thorns* in Munich or the *Pietà* in Venice, both painted on the threshold of the approaching Baroque age.

Venice approached the second half of the sixteenth century in the midst of a spiritual crisis brought about by the spread of Protestantism in Northern Europe. Of equal importance was the political and economic stress that resulted from the diversion of maritime trade to the Atlantic ports following the discovery of America and of new routes to India and the East—at the very time the Turks were making the Mediterranean unsafe for traffic. The artistic climate of Venice was equally unsettled, ready for a choice among new and contradictory alternatives at the risk of interrupting the extraordinary continuity of its artistic tradition. The flood of Mannerist motifs, which had left

Francesco Parmigianino
Seated Youth with Two Old Men

Andrea Palladio
Il Redentore, Venice

Alessandro Vittoria
Portrait of a Man, Museo Correr, Venice

Titian and the painters of the older generation unshaken, had a decisive effect on artists born between 1520 and 1530, such as Tintoretto, Bassano, and Veronese. In a sense these artists came to represent a new episode in the history of Venetian art, somewhat extraneous to the more traditional line of development still represented by Titian. In fact Tintoretto, the son of a Tuscan, revealed the strong influence of Michelangelo from the very beginning of his career; Bassano grew up in the provinces where he assimilated Parmigianino's early Mannerism; and Veronese developed as an artist quite far from Venice, among the Romanist temptations of the Palazzo del Te in Mantua and the elegance of Correggio and Parmigianino. These were the painters destined to fill the second half of the century with their masterpieces, all three at first oriented toward extra-Venetian cultures. And yet these great artists were to converge in their careers and complete the image of Venetian Renaissance painting.

During the second half of the Cinquecento, Venice continued to demonstrate an extraordinary capacity for absorbing diverse cultural strains and integrating them into her own indestructible tradition. It is enough to mention the architect Andrea Palladio and the sculptor Alessandro Vittoria in this respect. Palladio's buildings in Venice, the churches of San Giorgio and the Redentore and the cloister of the Carità, appeared to oppose Venetian tradition, presenting in contrast to Sansovino's chiaroscuro an inspiration from classical forms of antique origin. But there can be no doubt that the luminous values so evident in those churches reveal a conception of architecture in terms of scenography and color that has always been typical of Venice, as does Palladio's modern and vibrant use of forms based on an optical rather than a plastic vision. Consequently, everything about the new face of Venice in the late Cinquecento that was the product of Palladio's inventiveness became authentically Venetian, just as his picturesque villas scattered throughout the countryside from Malcontenta to Asolo, from Vicenza to Padua, remain Venetian masterpieces.

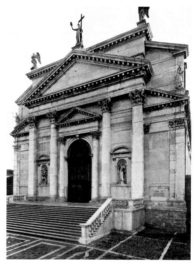

Tintoretto's art seems to be analogous to that of Palladio's, appearing to oppose the Venetian tradition in the use of Michelangelesque Mannerist motifs, as in the famous *Miracle of the Slave* of 1548 in the Academy in Venice, and then in the creation of an entirely new, fabulous, and evocative world in the Scuola di San Rocco—a world of

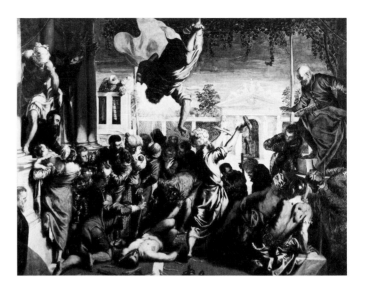

biblical tales that seem to capture the religious sense of a primitive humanity unforgettable in its choral dimensions. Tintoretto's pictorial style, purposely created to produce such a vision of the world—popular and at the same time intimately mystical, terrible yet consoling, solitary yet universal—seems to contradict the tradition of Titian's color. But perhaps this is so primarily in appearance. In contrast to Titian's vaporous color and use of impasto, Tintoretto's style is based on the clear dynamics of outline and distinctive accents of light. But in the end, Tintoretto returned to an evocative repertory of painterly effects that used the common figurative language of Venice's golden age of painting. Particularly representative of this late style are his works of the late 1580s at San Rocco such as *St. Mary of Egypt* and *St. Mary Magdalen* in the wilderness in which the unexpected colors and the eerie moonlight create phantasmal landscapes; or the very late *Last Supper* at San Giorgio in Venice, in which the atmosphere becomes almost tangible in the golden and vaporous effects of the light emanating from the torches and the halos of Christ and the Apostles. Tintoretto achieved a surreal and magical vision that found its logical fulfillment only in the exalted images of El Greco in Spain.

The painting of Jacopo Bassano, often based on the representation of rustic episodes from nature that were familiar to him, is a far cry from the visionary fantasy of Tintoretto. Here we find adorations of shepherds, rests on the journey to or from Egypt, and country scenes in hilly or mountainous landscapes—all expressed in twilight coloring. Bassano's palette, although it continuously makes use of light effects, is quite distinct from that of Tintoretto. While Tintoretto often let chiaroscuro prevail, Bassano punctuated his canvases with lively chromatic touches. According to the acute seventeenth-century critic Marco Boschini, Bassano's brushstrokes resembled precious stones: "pearls, rubies, emeralds and sapphires/diamonds, so that even the night is resplendent." Bassano availed himself of an idiom that included the most calculated effects, the most unusual settings—often nocturnal—and the most astonishing painterly refinements. He passed these qualities on to his sons, who often collaborated with him: Francesco, who had a soft, silvery touch, especially in small figures and in landscapes, and Leandro, who had a heavier, more dense style, and was particularly gifted in portraiture. Similar to the Bassanos in his paintings of

religious themes and portraits was the little-known but often surprising Jacopo Marescalchi. With Bassano and his followers it seems safe to say that the highest level of painting achieved through color was maintained by the Venetian school of the late Cinquecento.

Paolo Veronese's contribution to the history of Venetian colorism is indeed unique. His beginnings, like those of his contemporaries, were linked in some ways with Mannerism. But this connection was at the same time more direct and more indifferent: more direct because it developed during his early training in Verona, where the forms of Roman and Emilian Mannerism were familiar; more indifferent because his vision of the world had no polemic intention or sentimental pathos, but tended above all to create a free and joyous chromatic language. Arriving in Venice about 1551 after a brief experience in Verona, he established himself by painting the Giustiniani altarpiece in San Francesco della Vigna. The skill with which he used the diagonal composition of Titian's Pesaro altarpiece is notable, but he also made himself independent of Titian in his use of color. It is completely his own in its unique accord with the underlying chiaroscuro drawing upon which the chromatic surfaces lie like transparent veils. A light melody of greens, golden yellows, pinks, and pearl- and blue-grays creates the unmistakable timbre of the masterpieces Veronese painted while in his mid-twenties in the Sala dei Dieci in the Doge's Palace. With the beginning in 1555 of the decoration of the church of San Sebastiano, where he worked on different occasions over a long period of time, Veronese's style found a stable formulation from which he would not substantially depart in later years. The intent of his painting is not a dramatic or idyllic representation of reality, as it is in Titian or Bassano, nor is it a dazzling transfiguration of reality as in Tintoretto. Veronese does not belong to the category of dramatic painters, but rather to that of the contemplative ones. His figures pose in Olympian serenity and release a vital energy that invades the most tranquil recesses of our spirit, exalting it in the contemplation of so much beauty. This fullness of vitality and joy is the principal attribute of Veronese's art. He achieved it to a large degree through his technique, which went beyond Titian's fusion of colors and Tintoretto and Bassano's luminism. Anticipating the modern theory of the analysis of light into its separate color components, Veronese discovered by instinct the increased luminosity that

derives from the juxtaposition of complementary colors. His reds and blues, his yellows, greens, and violets thus create a myriad of faceted planes of light of extraordinary intensity. Local neutral colors assume the reflections of adjoining colors, black is almost abolished, and the very shadows themselves take on color, so that the luminosity of Veronese's paintings becomes greater than that of reality itself.

This idiom, which can be defined as the highest decorative poetry, finds its most triumphant application in Veronese's frescoes in villas and palaces in the Veneto. His most famous decoration is in the Villa Volpi in Maser, built by Palladio before 1559 for a family of erudite humanists, the brothers Daniele and Marcantonio Barbaro. Here Veronese interpreted the theme of the harmony of the universe with the freest creations of his figurative imagination. On the walls, painted landscapes open the space illusionistically and a calm luminosity suffuses the Palladian setting, making it gentler and more intimate. In lunettes and ceilings with architectural perspectives, translucent mythological and allegorical figures create, by their diaphanous clarity of color, visions that overcome the persistent reminder of the monumental forms of Mannerism. The same luminous texture gives a special accent to Veronese's portraiture, a genre of which he was a master. We see this in the *Lady (La Bella Nani)* in the Louvre, vibrating in a harmonious symphony of blues and pinks. Other compositions from 1560 to 1570 are inspired by the same freedom of touch which gives a coherent stylistic unity to the glowing *Family of Darius before Alexander* in London, the theatrical martyrdoms in San Sebastiano, and the two resplendent figures of the *Allegories of Navigation* in Los Angeles. In these paintings Veronese was still as alert as ever to the need for consistency of plastic form and for evocative drawing, although he abandoned himself to color in an indescribable sequence of delicate, scintillating touches with mother-of-pearl effects in the iridescence of the surface. The whole achieves a quality that in modern terms would be called "abstract"; it surpasses the subject that it represents to express itself with the most astounding freedom in tonal and compositional terms.

This formal freedom prevails in all of Veronese's paintings of profane subjects which offered him the possibility of approaching nature more closely: especially his portraits and scenes such as banquets depicting biblical

events that he could relate to contemporary life. The latter
were among Veronese's favorite subjects during the
seventh and eighth decades of the century, certainly not for
personal religious reasons but for the opportunity the pic-
turesque crowds and the theatrical settings offered him to
represent images that were increasingly rich in color and
festive as decorations. Veronese himself proved that the
banquet scenes were above all pretexts for the use of color
when, in the *Feast in the House of Levi,* which was originally
a *Last Supper,* in the Venice Academy (1573), he placed
"Germans and buffoons" among Jesus' retinue. Brought
before the tribunal of the Inquisition for taking such
liberties, Veronese justified his actions by defending his
freedom to paint as he saw fit: "We painters have the
same license as poets and madmen."

Among the greatest undertakings of Veronese's late
period is the decoration of the Sala del Collegio in the
Doge's Palace (1575–77), a mythology made up of fresh
and luminous images. These, along with the contem-
poraneous allegories painted for the Emperor Rudolph II,
seem to bring to a close the golden age in the life and art of
Venice. Three of these allegories may be identified as the
Virtue and Vice and *Wisdom and Strength* in the Frick Col-
lection and the *Mars and Venus United by Love* in the
Metropolitan Museum in New York, pictures in which the
most delicate refinement of style is blended with a mag-
nificently harmonic formal rhythm. Parallel to these re-
splendent masterpieces, during the last decade of his career
Veronese developed an inclination toward pathos, achieved
through a more subdued palette often accented by unex-
pected darks. It would almost seem that, upon contact
with the luminosity of Bassano, Veronese tended to return
to a more restrained use of color and a more naturalistic
representation of his subject matter. A twilight or noctur-
nal illumination appears, with a supple and somber touch,
as we see in the anguished sulfur-green atmosphere of the
Omaha *Venus,* while a more overt pathos manifests itself
in the *Christ Crowned with Thorns* in San Francisco and
in Veronese's last picture, the *Miracle of St. Pantalon* in
Venice, begun a year before the artist's death.

The history of criticism of Venetian painting can be traced back almost to the origins of the school itself. A precise characterization of the "Venetian school" is already evident from the time of the first edition of Vasari's *Lives* in 1550, and a sense of what we would like to call the "Venetian-ness" of Venetian painting is already present in the sixteenth-century debates about the preeminence of color over draftsmanship or vice versa (Pino, 1548; Doni, 1549; Dolce, 1557). In the literature of the seventeenth century as well, especially in the works of Ridolfi (1648) and Boschini (1660), the common idiomatic character of Venetian painting, based on color, is distinguished with the precise critical sense that later characterized Anton Maria Zanetti's *Venetian Painting* (1771), the first modern study of Venetian painting as such.

It was the good fortune of the Veneto with the advent of the nineteenth century to have produced the great Giovanni Battista Cavalcaselle, who in large portions of his works dealt with the Venetian painters, treating them in separate sections within a modern historical framework. Cavalcaselle, too, recognized color as the distinguishing element of "Venetianness." His fundamental works, published in English in collaboration with J. A. Crowe, are *A New History of Painting in Italy* (1908–09) and the even more penetrating *A History of Painting in North Italy* (1912), in which the space dedicated to Venetian painters is predominant. Bernard Berenson began his long research on the Italian Renaissance at the end of the nineteenth century, focusing on the Venetians from as early as 1893 and culminating in the publication in 1932 of his first *Index,* which served as the fundamental basis for his cataloging. This was also the period of the great comprehensive histories of art which contributed substantially to the critical definition of "Venetianness," especially with regard to its development up to the time of the Renaissance (Venturi, 1901–40; Van Marle, 1936).

In outlining the critical history of Venetian painting of the Renaissance, it is essential to consider the relevant part that exhibitions have played. The title "Venetian Art" is found for perhaps the first time in the catalogs of the exhibitions held in the New Gallery in London in 1894–95; other important shows with similar titles followed at the Burlington Fine Arts Club: *Early Venetian Pictures* in 1912 and *Venetian School* in 1914. The importance of these London exhibitions is demonstrated by the number of works that passed from their display rooms to the great collections, especially the American ones, that were being formed during the period between the two World Wars.

Naturally the importance of exhibitions, seen from the perspective of interest in Venetian art, increases apace as we approach the present day. It is worth recalling the large part dedicated to Venetian masters in memorable shows such as the exhibition of *Italian Art* at the Royal Academy of London in 1930. A broadly based exhibition of *Venetian Painting* was held in San Francisco in 1938, and *Four Centuries of Venetian Painting* in Toledo in 1940. It was only in private galleries that exhibitions, usually quite small ones, were devoted exclusively to Venetian Renaissance painting. *Venetian Painting of the Fifteenth and Sixteenth Centuries* at the Knoedler Gallery in New York in 1938 is perhaps the only exact precedent of any relevance to the present exhibition.

Recent times have produced substantial changes in the panorama of art exhibitions, which for some decades have tended to concentrate on specialized themes or single personalities. For Venetian painters, the most important center for this type of exhibition has been Venice itself, which has conducted a systematic review of her own artists with monographic exhibitions of great cultural impact and quality. In them the greatest attention has been accorded precisely to the period of the Renaissance, from Titian (1936), Tintoretto (1938), Veronese (1939), Bellini (1949), Lotto (1953), Giorgione (1955), Bassano (1957), and Crivelli (1961) to Carpaccio (1963).

Along with the catalogs of the exhibitions, we should consider in our survey of the history of criticism of Venetian painting the large production of catalogs of permanent collections in museums that in the last few decades have dedicated particular sections, and even special volumes, to this subject. Among foreign museums, the high quality of catalogs is exemplified in the volumes by Martin Davies on paintings of the Quattrocento (1961) and Cecil Gould on paintings of the Cinquecento (1959) in the National Gallery in London, as well as in Rolf Kultzen's volume on Venetian paintings of the Renaissance in the Munich Alte Pinakothek (1971). In America, it is enough to cite the magnificent volumes by Fern Rush Shapley on the Kress pictures in Washington and the brilliant catalog of the Venetian paintings in the Metropolitan by Federico Zeri and Elizabeth Gardner. At the same time, great help

has come from the *Census of Pre-Nineteenth Century Italian Paintings in North American Public Collections* by Burton Fredericksen and Federico Zeri, which lists hundreds of Venetian paintings of the Renaissance in American museums. Naturally, the Venetian school has benefitted from the most meticulous cataloging in Italy as well: Moschini Marconi's exhaustive catalogs of Venetian paintings in the Academy should be mentioned, along with the entire series published between 1957 and 1978 by the Giorgio Cini Foundation on the paintings in the museums of Venice and the Veneto (Bassano, Padua, Treviso, Venice, Vicenza).

Finally, an immediate effect on scientific research of the broadened interest of collectors and museums in the Venetian school is the recent flourishing of monographs on the major artists, most of whom are included in the present exhibition. In general, one can say that each of these artists has received particular attention from scholars in the course of the last generation, with a great prevalence of *catalogues raisonnés*. Among these we find, to cite only the most recent volumes in the field of the Renaissance and without in any way underrating the works that must be omitted for brevity's sake, Fiocco's Pordenone (1943); Pallucchini's Sebastiano del Piombo (1944); Prijatelj's Schiavone (1952); Berenson's Lotto (1955); Arslan's Bassano (1960); Paccagnini's Mantegna (1961); Lauts' Carpaccio (1962); Menegazzi's Cima (1962); Canova's Bordon (1964); Mariacher's Palma Vecchio (1968); Pallucchini's (1969), Valcanover's (1969), and Wethey's (1969–75) Titian; Pignatti's Bellini (1969); Pignatti's Giorgione (1969 and 1978); Rossi's Tintoretto (1973–78); and Pignatti's Veronese (1976).

From this brief survey of criticism and museum activity, one can legitimately conclude that interest in Venetian painting has steadily increased during our century. It has, in fact, been fully restored to that cultural and stylistic autonomy that the authors of the art historical sources recognized from the very beginning of the Venetian school. In the same way, one can see that a specific interest in the artists of the Venetian Renaissance has become more intense in recent times. This exhibition was conceived to assemble works of the highest quality from both sides of the Atlantic, and at the same time to bring to public attention some works that had temporarily disappeared from view or that have been little known to scholars. It

will surely succeed in reaffirming the pictorial validity of the Venetian school, especially since the exhibition is taking place during a critical trend that is so favorable to the better understanding of the "Venetianness" of Venetian art.

Terisio Pignatti

> University of Venice
> Director Emeritus
> of the Civic Museums
> of Venice

Giovanni Bellini

Madonna and Child (Frizzoni), early 1460s

Tempera on canvas, transferred from panel
21⅛ x 17⅝ in. (53.5 x 44.7 cm.)
Museo Civico Correr, Venice

c. 1426–1516

Giovanni Bellini was the innovator who prepared the way for Venetian Renaissance painting by assimilating Early Renaissance concepts and forms that were evolving in Florence and Central Italy and by adapting them to the particular Venetian sensibility that included a seemingly innate responsiveness to color and a singular delight in the natural and human. Born in Venice about 1426, the son of Jacopo and brother of Gentile Bellini, Giovanni was reared in the late Gothic shop tradition of his father.

He formed his personal style in the 1450s and 1460s through the study of the Paduan sculptures of Donatello, with their solid structure of harmoniously articulated three-dimensional forms, and the paintings of Mantegna, with their plastic vigor and statuesque grandeur derived by the Paduan artist from his studies of classical archaeology and the human figure in perspective. Bellini progressively modified these formal elements through his light, color, and deep concern with human feelings. A major change in style evolved by the mid-1470s when Bellini turned from tempera to oil, a medium popularized in Venice by Antonello da Messina during his stay there in 1475. Bellini also took from Antonello a greater roundness of form. At the same time in the Pesaro altar he employed Piero della Francesca's perspective system that gave a new rational order to figures, architecture, and landscape. He continued to develop this spatial and formal integration in the San Giobbe altarpiece (1487) and the Frari triptych (1488). During these same decades he produced his most

Giovanni Bellini invented a type of Madonna and Child of great formal beauty and human sentiment that has become almost synonymous with his name. In the Madonna, with her inherent sense of fulfillment and the dignity of her role, unobtrusively cherishing and protecting the Child as she holds him, the artist has captured the essence of ideal motherhood. The entire development of Bellini's style can be followed in his more than three score extant representations of this theme.

In the Frizzoni Madonna, named for its former owner, the influences of Donatello and Mantegna are clearly apparent in the simplification of natural forms to produce more solid, abstract compositional units, studiedly articulated into a harmonious whole not unlike a relief sculpture. The crispness of modeling is more specifically from Mantegna. Already here Bellini used a gentle light to unify the composition, expressing a tender lyricism in his color that seems to emerge through the transparency of Venetian glass.

The painting was transferred from panel to canvas and the sky was repainted by Cavenaghi while it was still in Bergamo in the collection of Gustavo Frizzoni, who donated it to the Museo Correr in 1919. The attribution of Giovanni Bellini was made by Morelli (1891), who placed it among the earliest

of the master's works. Both the attribution and period have been universally accepted by historians, who have not entirely agreed on precise dating. On the basis of the incisiveness of the drawing, which is still reminiscent of Mantegna, and the correspondence of its Paduan elements with the four triptychs in the Academy in Venice, painted for the church of Santa Maria della Carità in Venice between 1460 and 1464, it seems most likely that the painting was done in the early 1460s. The humanity and immediacy of the woman portrayed have led some critics to believe this is a portrait of the artist's sister, Nicolosia, who was married to Mantegna in 1453 (Berenson, 1894). A variation of this painting, extensively restored, is in the Gardner Museum in Boston.

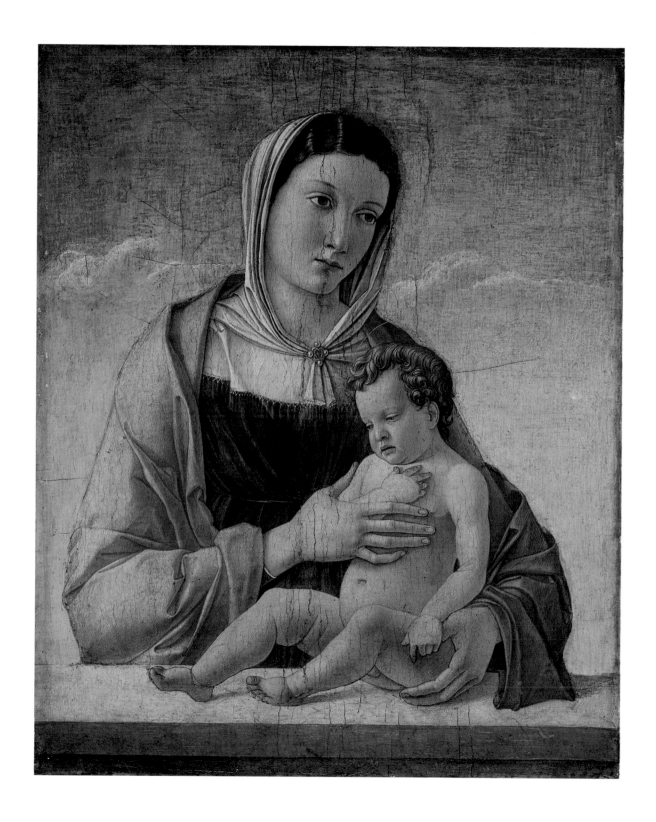

Bellini

Portrait of Joerg Fugger, 1474

Oil on panel
10¼ x 7⅞ in. (26 x 20 cm.)
Inscribed on reverse: Joerg Fugger
a di XX Zugno MCCCCLXXIIII
Norton Simon Inc Foundation,
Los Angeles

glorious landscapes such as the *St. Francis* in the Frick Collection in New York, filled with a warm, glowing light. As the Venetian Republic's most prominent painter, Bellini along with his brother and other artists decorated the Sala del Maggior Consiglio in the Doge's Palace with grandiose historical subjects. After 1500 he was the teacher of both Giorgione and Titian to whom he imparted his technique of modulating colors imperceptibly and creating a unifying atmospheric light. At the same time he took from the two emerging artists an increasingly free application of color, which he employed in his late works like the San Zaccaria altarpiece (1505) and his last great masterpiece, the altarpiece in San Giovanni Crisostomo in Venice (1513). He died in Venice in 1516.

Giovanni Bellini's *Joerg Fugger* is a cornerstone of Venetian Renaissance portraiture. It is Bellini's first firmly dated work, inscribed 1474 on the reverse of the panel, and may well be both his earliest portrait and the first portrait by any painter to emerge from the revitalized artistic climate of the late Quattrocento in Venice. Bellini's innovative approach to portraiture, which manifests itself in his penetrating depiction of the sitter's physiognomy, is clearly demonstrated in the *Joerg Fugger.* This objective realism, however, is combined with a balanced and harmonious presentation of the illustrious twenty-one-year-old banker of Augsburg in a highly dignified and solemn pose.

With this portrait Bellini departs from the stylized and precious late Gothic tradition still prevailing in Venice at the time. A comparison of this work with contemporaneous portraits by Bastiani and by Jacopo and Gentile Bellini reveals that these artists in their portraiture were still trying to create imitations of painted medallions that lack the airier, more humanized qualities of the *Joerg Fugger.* Flemish painters had even a little earlier begun to record the physical features of their subjects more objectively and to probe their personalities as well. It seems likely that Bellini may well have turned directly to portraits by van Eyck, van der Wey-

den, Petrus Christus, or Memling as inspiration for the *Joerg Fugger* or assimilated their new direction through Antonello da Messina, as many of the leading Bellini scholars believe (Gronau, 1930; Pallucchini, 1949; Bottari, 1963; Pope-Hennessy, 1966).

The *Joerg Fugger* was attributed to Bellini by Mayer (1926) and unanimously accepted as such by Gronau (1930); Düssler (1949), who had rejected the attribution in 1935; Bottari (1963); and Pope-Hennessy (1966). There are copies of it in a private collection in New York and in the collection of Prince Fugger in Kirchheim Castle.

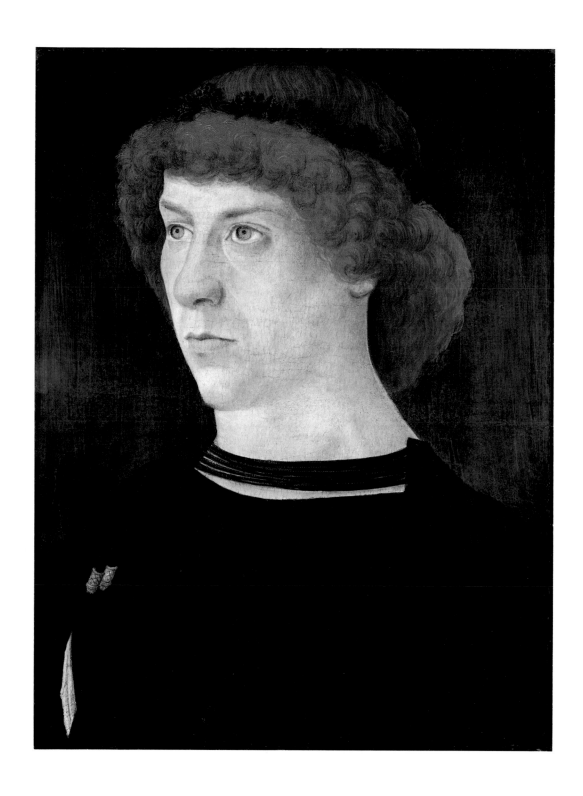

Bellini

Christ Blessing, c. 1500

Tempera and oil on panel
23¼ x 18½ in. (59.1 x 47 cm.)
Kimbell Art Museum, Fort Worth

This representation of Christ is one of the most evocative created by Bellini in the sixty-five years of his career. During that time his image of Christ passed through a number of stages of inspiration. In his early years, the artist most often depicted the dead Christ isolated in terrifying solitude; later he used the same pathetic image, supported by angels or flanked by the grief-stricken figures of his mother and St. John. During his middle years Bellini more often chose to represent the beatified or triumphant Christ in his miraculous apparitions, the Transfiguration, Resurrection, and Ascension. It was primarily in his late works, especially those of the sixteenth century, that he represented Christ, as he does in this painting, in the attitude of blessing the world, almost always in front of an open, natural landscape of extraordinary beauty. Brought close to the spectator in a telescopic manner, Christ moves rapidly forward, becoming increasingly large to the point of almost entirely covering the background. In this profoundly religious conception the serene power of Christ dominates man and nature in the meditative hour of sunset.

This work, initially ascribed to Basaiti, was attributed to Bellini by Morassi (1958), who identified it as the "effigie del Salvatore" noted by Ridolfi (1648) as having been painted by the artist for the Augus-

tinian monks of Santo Stefano in Venice. Until 1958 the painting from Santo Stefano was thought to be the *Christ Blessing* in the Louvre. Ridolfi's term "effigy," however, can be applied much more appropriately to the Kimbell *Christ Blessing.* Further, the Louvre *Christ Blessing,* close in spirit to the *Pietà* in the Brera, is an early work that can be dated about 1460, when, as is noted in the catalog of the Kimbell Art Museum (1972), it would have been unlikely that Bellini could have obtained such a commission from the monks of Santo Stefano.

The attribution proposed by Morassi is shared by most critics, with the exception of Robertson (1968), who remains unconvinced. The generally accepted date, between 1490 and 1495 (Morassi, 1958; Pallucchini, 1959; Heinemann, 1962; Bottari, 1963; catalog of the Kimbell Art Museum, 1972), was advanced to about 1500 by Pignatti (1969), because of the georgic landscape that is so similar to the landscapes in Bellini's Madonnas from the first decade of the sixteenth century.

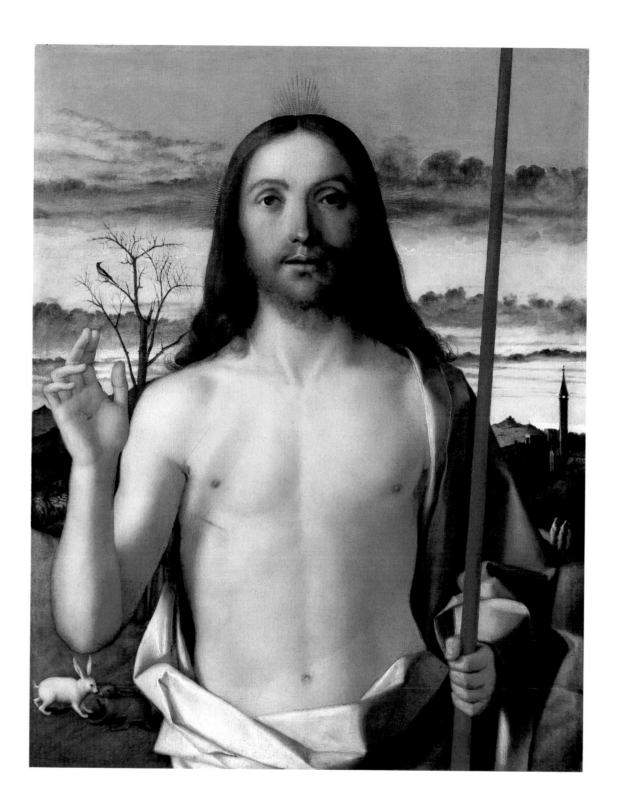

Bellini

The Drunkenness of Noah, c. 1515

Oil on canvas
40½ x 61¾ in. (103 x 157 cm.)
Musée des Beaux-Arts, Besançon

The drunken Noah derided by his sons demonstrates the extraordinary versatility of Giovanni Bellini, who continued to adapt his work to contemporary artistic culture until the last days of his life. Here his close rapport with Giorgione's late style and Titian's early works is evident in the expressive realism of the figures and setting, in the dynamically developed composition, and in the liquid colors applied with agitated brushstrokes, shading into half tones and shadows. This work of about 1515 is an exceptional document of Bellini's last period. The diarist Marin Sanudo testified to its quality when he wrote on the day of the artist's death, November 29, 1516: "as old as he was, he still painted with excellence."

The attribution to Bellini is Longhi's (1927), who considered the painting to be the pivotal point of Bellini's late "Giorgionesque" period. This attribution and dating of the work, considered by Brizio (1949) to be among Bellini's finest paintings, have been accepted by, among others, Gamba (1937); Pallucchini (1949), who noted its affinity with the altarpiece in San Giovanni Crisostomo in Venice and the *Bacchanal* in the National Gallery in Washington; Bottari (1963); Wethey (1969); and Pignatti (1969), who dates it about 1515. Nevertheless, not all critics have been in agreement with this generally accepted attribution. Berenson (1932), before accepting the attribution to Bellini (1957), believed it to be by Cariani; Arslan (1952) rejected it as an autograph Bellini; while Gilbert (1956), who based his argument on a comparison with Lorenzo Lotto's *St. Jerome* in the Louvre, assumed that the artist was Lotto; Heinemann (1962) attributed it to Titian.

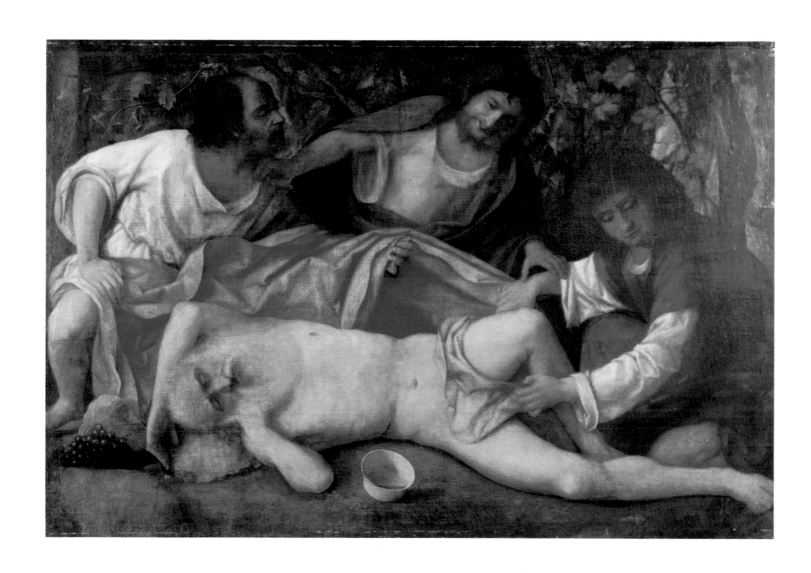

Cima da Conegliano

Madonna and Child in a Landscape

Oil on panel
28 x 24¾ in. (71 x 62.8 cm.)
North Carolina Museum of Art,
Raleigh
Original State Appropriation

Giovanni Battista Cima, c. 1459–1517

Younger than Bellini by a generation, Cima became a less-sophisticated alternative to him. In contrast to the "classicism" of a Venetian culture that fused Byzantium and Florence, he offered an instinctive, rustic culture born of the deep attachment to nature that is native to the provinces. Cima was born about 1459 in the village of Conegliano, near Treviso, of a long line of cloth shearers (*cimatori*). He produced his earliest known works in Vicenza in the circle of Montagna (*Madonna and Saints,* Museo Civico, Vicenza, 1489) before moving in 1492 to Venice, where he became associated with the school of Alvise Vivarini (*Baptism of Christ,* San Giovanni in Bragora, Venice, 1494). The melodious color of Giovanni Bellini's great altarpieces of the last decade of the fifteenth century fascinated Cima, but above all it was the limpid, crystalline style of Antonello da Messina that provided him with his most evocative models. Always linked to his native province, Cima knew how to elicit its rustic gentleness, especially in his Madonnas and his groups of sacred figures set in peaceful landscapes (*Madonna of the Orange Tree with Sts. Jerome and Louis of Toulouse,* Museo Correr, Venice; *Sts. Peter Martyr, Nicholas, and Benedict,* Brera, Milan; *Madonna and Child with Michael the Archangel and St. Andrew,* Galleria Nazionale, Parma). After a prolific career in Venice, Cima returned to Conegliano late in life and died there in 1517.

Typical of Cima's affinity for the people and landscape of his youth, this Madonna suggests the image of a peasant mother with her healthy son, set between a rustic monastery and a many-towered castle, just as they are found in the hills of Conegliano. The enamel-like colors and rhythmic draftsmanship reveal the influence of Antonello da Messina's pure light and plastic conception of the human figure, while the pervasive serenity is characteristic of Cima's work throughout his career.

The leading historians of Venetian Renaissance painting have concurred in the attribution of this painting to Cima. Coletti (1959) listed four other versions of the subject with similar Madonna and Child figures but with variations in backgrounds in the National Gallery, London; the Museo Civico, Treviso; the Louvre, Paris; and the Hermitage, Leningrad. He considered the Raleigh painting to be superior to the other versions by reason of "the vigor of its chiaroscuro and its fine landscape." Weiner (1909), Van Marle (1935), and Lazareff (1957) were of the same opinion. Van Marle added a fifth version in the O. Schuster Collection included in the exhibition of Italian painting from Dutch collections at the Stedelijk Museum in Amsterdam in 1934. Davies (1961) indicated still a sixth version in the Doria Gallery in Rome. While Van Marle (1935) dated the Raleigh picture about 1505, most other scholars considered it to be a late work of Cima. The painting is in an outstanding state of conservation.

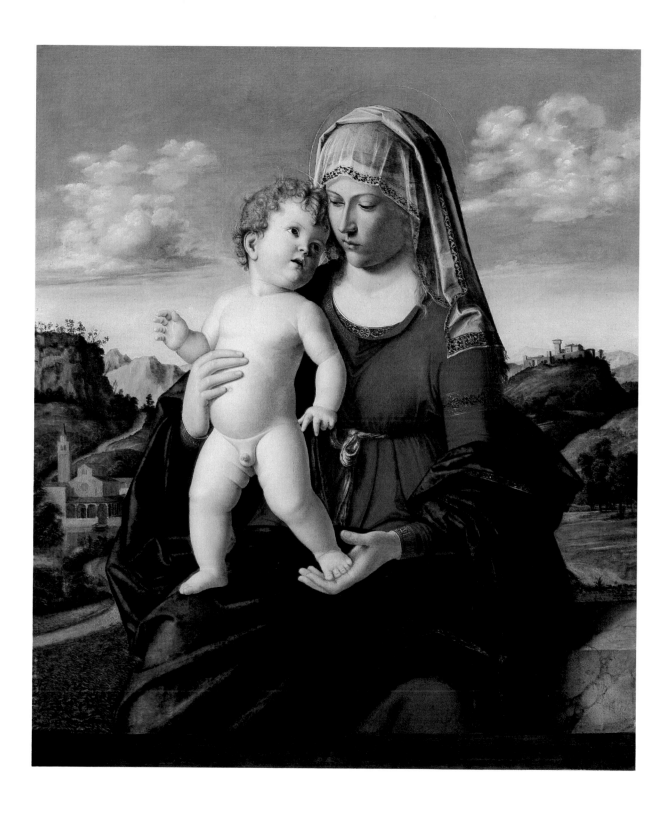

Vittore Carpaccio

Portrait of a Lady, 1490–95

Oil on panel
10½ x 8⅞ in. (26.7 x 22.5 cm.)
Nelson Gallery-Atkins Museum,
Kansas City
Nelson Fund

c. 1465–c. 1526

Berenson characterized Carpaccio as the earliest Italian master of genre painting whose episodes from sacred history and legend, replete with the minutae of the everyday world, are based not on the exploitation of the subject but on the purely pictorial qualities of the scene. Carpaccio was born in Venice about 1465 of a family of fur merchants. It is likely that he received his early training with Alvise Vivarini, in the tradition of Antonello da Messina (*Salvator Mundi,* Contini-Bonacossi Collection, Florence, before 1490). But he soon became associated with Gentile Bellini, with whom he collaborated on ceremonial and historical paintings commissioned by the Scuole (Benevolent Societies) and other confraternities (*Miracle of the Relic of the True Cross* for San Giovanni Evangelista, about 1494, now in the Academy, Venice). The rigorous perspective and strong architectural sense of Carpaccio's early *Legend of St. Ursula* series in the Academy, Venice, 1490–1500, reveal a knowledge of the frescoes of the great Ferrarese artists, while his minute realism, often employed in portraiture, links him to the Flemish painters who were already popular in Venice toward the end of the Quattrocento. Between 1500 and 1507 Carpaccio decorated the Scuola di San Giorgio degli Schiavoni with magnificent canvases in which he gave free rein to his narrative abilities. His colors, rich in atmospheric values, filled the scenes with light appropriate to the varied moods of the

Carpaccio's fame is based on his Venetian ceremonial canvases and his fable-like representations of faraway lands. At the root of his poetics, however, is a constant realistic element which he masterfully succeeded in transforming into fable, well exemplified by the numerous portraits that he boldly inserted into his pageant paintings and even into religious scenes. These and his independent portraits were recorded by contemporary sources as extraordinarily successful likenesses. In the Kansas City *Portrait of a Lady,* Carpaccio placed particular emphasis on the large, wide-open eyes, the drawn mouth, and the pulled-back hairstyle, imparting to them an abstract value, almost as if they were part of a perfect object in silver, crystal, or polished ivory that had come from the hands of a skilled artisan. In this portrait, as in most of Carpaccio's work, reality assumes a symbolic value.

The painting was first attributed to Carpaccio by L. Venturi who, in an expertise of July 6, 1940, dated it between 1500 and 1510, about the same period as the *Courtesans* in the Museo Correr, Venice. The portrait came to the Nelson Gallery-Atkins Museum in 1947 as a Carpaccio, and was confirmed as such by Vertova (1949), Arslan (1952, as an early work), and Berenson (1957). Perocco (1960) advanced doubts as to the artist and Lauts (1962) attributed the portrait to Mansueti. The painting, restored in 1948, presents a substantially integral pictorial surface. A comparison with the portraits in the *Legend of St. Ursula* series of 1490–1500 places the work in the same early period and shows it to be indubitably autograph.

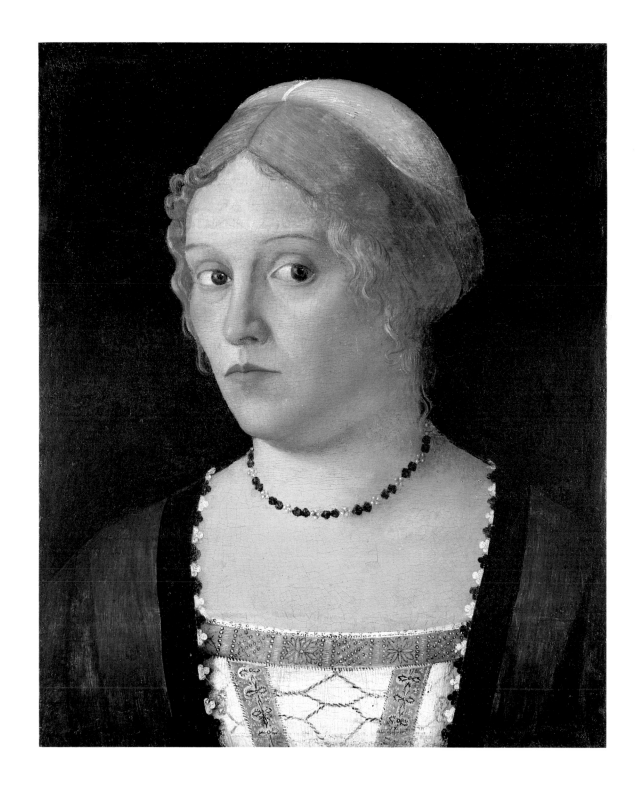

Carpaccio

Apparition of the Martyrs of Mount Ararat in Sant'Antonio di Castello, 1513–14

Oil on canvas
47⅜ x 68½ in. (121 x 174 cm.)
Gallerie dell'Accademia, Venice

action and often gave them a sense of magic and mystery. In 1507 Carpaccio was called upon to collaborate with the Bellinis on the canvases in the Sala del Maggior Consiglio in the Doge's Palace. Compared to Giorgione and Titian, Carpaccio seems to be much less innovative, and in fact, except for some individual works of special inspiration, he declined quickly (Scuola degli Albanesi, c. 1504; Scuola di Santo Stefano, 1511–20). Perhaps for that reason he sought commissions on the opposite shore of the Adriatic, where he worked in Pirano, Pola, and Capodistria. It was most likely in Capodistria that he died about 1526.

After painting the large canvases of the St. Ursula series now in the Academy, Venice, and the cycle in San Giorgio degli Schiavoni, Carpaccio often chose more modest compositional formulas and pictorial means, as in the scenes from the Life of the Virgin for the Scuola degli Albanesi and the St. Stephen cycle for the Confraternity of Santo Stefano. Rarely, however, was he able to express with such penetrating simplicity and intimate emotion the mystical sense of a religious vision as in the small canvas of the *Apparition of the Martyrs of Mount Ararat,* formerly in the church of Sant'Antonio di Castello. The painting represents the vision of Francesco Antonio Ottoboni, prior of the monastery of Sant'Antonio, kneeling before the altar at left and witnessing the appearance in his church of the ten thousand martyrs of Mount Ararat he had called upon to lift the plague that had broken out among the friars. As the saints move into the nave, they are blessed by St. Peter in pontifical robes before the central altar.

In the manner of an *ex-voto,* Carpaccio depicts in precise detail the unpretentious Gothic church of a fisherman's quarter, as Sant'Antonio was—a bare interior in which votive gifts of the faithful impart a touch of humanity. It is a vivid document of the church demolished in 1807. At the left is the wooden choir screen of a type no longer extant in

Venice; before it are lamps incorporating ostrich eggs, perhaps a symbol of the Madonna. High above the nave on the intercolumnar beams are *ex-voto* cargo ships. On the far wall are two Medieval gold-ground polyptychs, not yet identified, and the Ottoboni altar in the new Renaissance style erected by Cardinal Ettore Ottoboni in 1512 in thanksgiving for the deliverance from the plague. In 1515 Carpaccio's altarpiece, *The Martyrdom of the Ten Thousand Christians of Mount Ararat,* now in the Academy, Venice, was installed in the Ottoboni altar. Since the altarpiece shown here seems to be an earlier one representing Christ's agony in the garden, the painting of Prior Ottoboni's vision must have been done after 1512 but earlier than 1515. Carpaccio after 1510, weary of the glowing polychromy that had characterized his more formal works, is frequently undervalued. But this painting is an example of the still virgin poetry of the aged painter.

The attribution to Carpaccio dates back to Boschini (1664) and is contested only by Berenson, who does not list the picture, and by Van Marle (1936) and Lauts (1962), who consider it a school work. In our opinion it is a late autograph work of Carpaccio, characteristic in its modesty of composition and in the minute attention to detail in the drawing.

Giorgione

Page Boy, c. 1505

Oil on panel
9½ x 7¾ in. (24.1 x 19.7 cm.)
M. Knoedler & Co., New York City

Giorgio da Castelfranco, c. 1477–1510

Giorgione's importance to Venetian painting is manifold: he provided the transition in composition and color from Giovanni Bellini to Titian, he achieved a unified vision of man and nature in form, space, and mood, and he created that pastoral style called "Giorgionism" which persisted in North Italy through the early decades of the century.

Giorgione was born in Castelfranco in the province of Treviso, probably in 1477, and died in Venice during the plague of 1510. Biographical information about the artist is limited, but it is usually assumed that he moved to Venice about 1500 and quickly became part of Venetian cultural and intellectual life. Vasari (1550, 1568) reports that he was both poet and lutenist, "playing and singing divinely." An analysis of his patrons indicates further that he was part of a group of young humanists in Venice, Padua, and Treviso devoted to ancient philosophy and bucolic poetry whose best-known spokesman was Pietro Bembo, author of *Gli Asolani,* in which the nature of love is discussed in an arcadian environment. Art historical sources of the sixteenth and seventeenth centuries agreed that Giorgione was a pupil of Giovanni Bellini and later became the master of Titian. He was also aware of Carpaccio's free colorism and was profoundly influenced by the iconography and realism of Dürer and the Flemish painters who were well represented in Venetian collections. Giorgione produced only a few works, most of them for private patrons: devotional images like the *Holy Family* and the *Adoration of the Shepherds* in the National Gallery, Washington, and profane subjects often with complex allegorical

The precise meaning of many of Giorgione's subjects remains unclear. Unlike other artists of his time, he seemed to have conceived his secular works for a restricted circle of intellectuals who may have even suggested themes—expressions of an elite culture—whose meanings have been lost. A number of Giorgione's single figures hold objects whose significance, if not their very identity, is difficult to interpret, from *Laura* and the *Boy with an Arrow* in Vienna to the *Shepherd Boy with a Flute* in Hampton Court. Close to these is this enigmatic portrait of a boy whom we should like to construe as a page holding a piece of armor, perhaps a helmet or a shoulder-piece. They are all personages enveloped in a halo of mystery that Giorgione builds up through the slow accumulation of minute strokes of color until he approximates the calm vibrations of the atmosphere of an interior illuminated by a ray of sunlight.

This painting can perhaps be identified as "the boy . . . with hair like fleece" mentioned by Vasari in 1568 as being in the home of the Grimani. It does not seem to be, as Suter (1928) supposed, the "little shepherd boy holding a piece of fruit in his hand" which Michiel noted as being in the home of Giovanni Ram. The object on which the boy's hand rests, however, is clearly gilded metal. The identification with the Grimani boy

is rendered even more probable by stylistic observation, which places the work in Giorgione's early years, in agreement with Vasari.

The history of the attribution of this painting has been confused until recent times by restorations that made a valid assessment impossible. The picture was judged to be a Giorgione by Hartlaub (1925), Fiocco (1929), and later by Richter (1942) and Zampetti (1968). At first this writer had doubts about the attribution to Giorgione (1969 and 1971), but these were completely dispelled following Modestini's restoration, which in 1973 completely freed the canvas of its heavy, almost total repainting. We now decisively attribute the painting to Giorgione (1975), relating it stylistically and chronologically to the Castelfranco altarpiece and to the Berlin *Young Man,* about 1505.

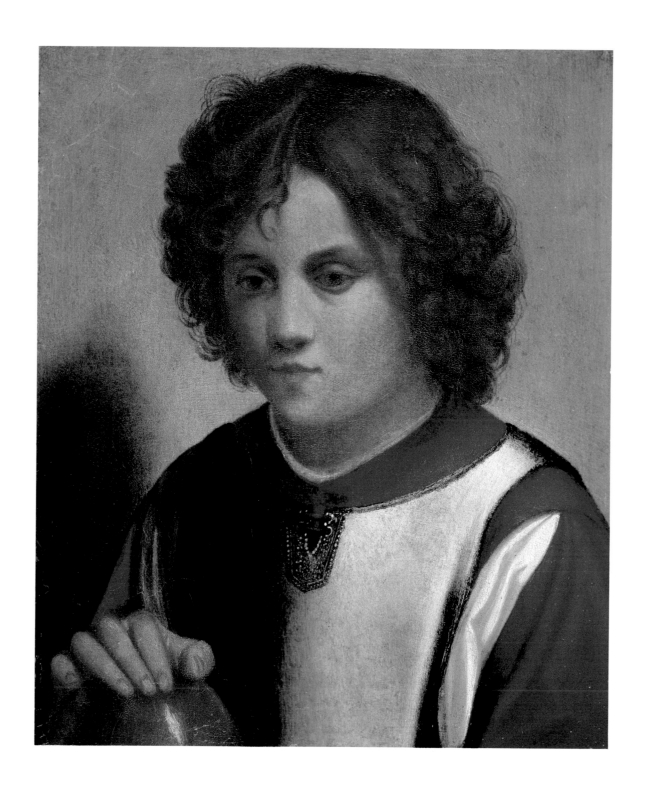

Giorgione

Portrait of a Young Man (Terris),
1510

Oil on panel
11¾ x 10½ in. (29.9 x 26.6 cm.)
Inscribed on reverse: 15 . . . di man,
de mo Zorzi da castel fr. . .
San Diego Museum of Art

meanings such as *The Tempest, The Three Philosophers,* and the *Sleeping Venus.* The catalog of his works includes just one altarpiece, that in Castelfranco of about 1504. His frescoes painted on the facades of Venetian palaces have been lost, except for a fragment of the most famous of his works in this medium—a female nude in the Venice Academy—from the Fondaco dei Tedeschi of 1508.

Giorgione's late style developed alongside that of his pupil Titian, whose competition he surely felt. The conceptions and technique of the two artists were at times so close in the last years of Giorgione's life that the Vendramin *Christ Supported by an Angel* and the Dresden *Sleeping Venus,* presumably left unfinished when Giorgione died, could be completed by Titian. The attribution to Giorgione or Titian of the *Christ Carrying the Cross* in San Rocco and the *Pastoral Concert* in the Louvre can still be vigorously debated.

This evocative portrait is related only in composition to Giorgione's earlier portraits such as the *Laura* in Vienna or the *Young Man* in Berlin. In all other respects it marks a turning point in the artist's career, which was tragically interrupted by his untimely death. The date 1510 on the back of the panel allows us to place this qualitative leap in Giorgione's painting in the last year of his life, the same period in which he painted works of the expressive power of the *Old Woman* in the Academy in Venice and the *Christ Carrying the Cross* in San Rocco. In these paintings Giorgione achieved an extraordinarily intense approach to "reality" that appeared to observers like Vasari to be "just as occurs in life, without drawing beforehand." It was this approach that distinguished his new painterly poetics founded upon astute analysis of emotional expression and tonal gradations of color. In the San Diego portrait, the black of the sitter's coat with its gray reflections vibrates against the dark green background, from which the face itself takes on some of its color, gaining thereby a disarmingly frank expression.

The attribution of this painting to Giorgione, proposed by Richter in 1937, has been universally accepted, except by Fiocco (1948) and Berenson (1957), who believed it to be the work of Palma Vecchio. The inscription, which Richter recog-

nized as authentic, was deciphered by him only as "15," while Morassi (1942) read it as "15.8"; Pignatti (1971) identified the date as "15.0": the work therefore can be placed in Giorgione's latest period (not 1505, as Della Pergola maintained in 1955). As an example of the artist's "new realism" it can be linked to Titian's early works.

Richter (1937) noted the resemblance of this painting to the engraving of *David* by Wenzel Hollar, which bears the inscription "Authentic Portrait of Giorgione da Castelfranco made by him as celebrated in Vasari's book." According to Pignatti (1971), Richter's hypothesis that this is a self-portrait, a hypothesis shared by Frankfurter (1941) and Andrews (1947), should be discarded. Garas (1972) has proposed an identification of the sitter of this portrait with Cristoph Fugger.

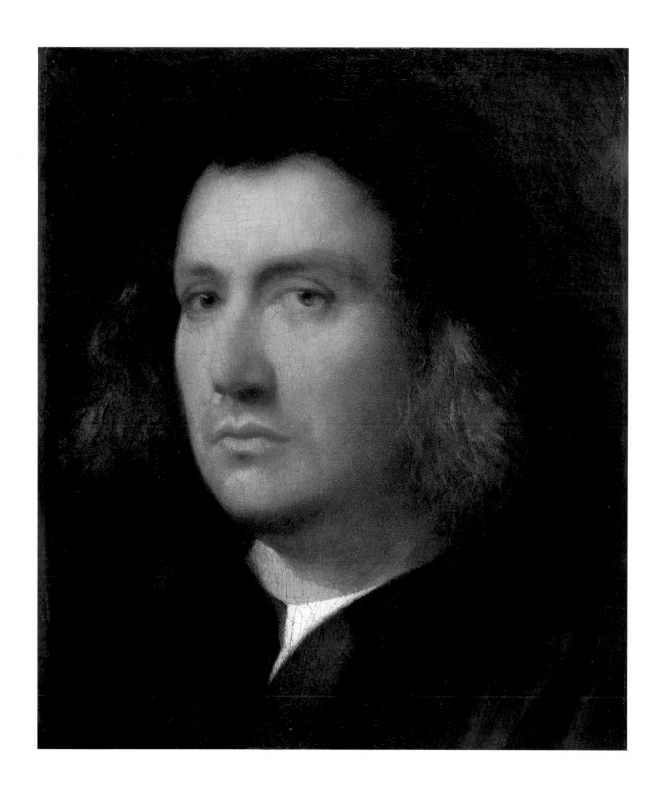

Giorgione

Dead Christ Supported by an Angel,
c. 1508–10

Oil on canvas
30 x 24⅞ in. (76.2 x 63.2 cm.)
Private Collection, New York City

One of the most difficult problems in the study of Giorgione is that of the late paintings which unknown events or the artist's sudden death prevented him from completing. That other painters, especially Titian, came to finish these works is documented by contemporary sources in at least two cases: the Dresden *Sleeping Venus* and the *Dead Christ Supported by an Angel.* Before the latter work, a profound emotion overtakes us as we try to isolate the surviving parts created by Giorgione: the delicate hands of the angel that strain to support the body of Christ and the angel's gentle face that closely recalls the classic oval of the Dresden *Venus.* The figure of Christ, which has become gigantic, is so typical of Titian that there is little doubt that it is by his hand. The colors correspond to the substantial differences in the two artists' personalities: Giorgione's yellows and blues are gentler and veiled, while Titian's browns and grays are aggressive and restless. Just under the right hand of the angel, x-rays reveal the upper part of a figure for a different composition in a manner typical of Giorgione.

Mentioned by Tietze (1950) as a work by Giorgione, and restored by Modestini in 1959, this painting was examined (1959–60) by Pallucchini, who supported its identification with the work seen by Marcantonio Michiel in Gabriele Vendramin's house in 1530: "The

dead Christ on the tomb, with the Angel supporting him, was by the hand of Zorzi da Castelfranco, retouched by Titian." Suggestions for the identification of the Vendramin *Dead Christ Supported by an Angel* have been advanced for quite some time; first it was thought to be the *Pietà* belonging to the Cassa di Risparmio of Treviso, and then the *Pietà* in the Pinacoteca Tadini in Lovere (Verga, 1929), the *Pietà* in the Bernasconi Collection in Milan (Richter, 1942), and finally the *Pietà* in a private collection (Serra, 1962). The provenance of the present painting from the Palazzo Vendramin di San Fosca, reported to Pallucchini by Count Polcenigo, the former owner, combined with the obvious completion by Titian, make it reasonable to believe that this is indeed the painting which Michiel saw. Direct observation after Modestini's restoration provided confirmation that the heavy brushstrokes and vibrant coloring of Titian's hand have almost entirely reshaped the figure of Christ, while the angel shows the delicate and gently shaded handling of Giorgione from the period of the Dresden *Sleeping Venus* (c. 1508). A comparison of the Christ in this painting with Titian's figures in the altarpiece of *St. Mark Enthroned with Four Saints* (now in Santa Maria della Salute) suggests a date not much later than 1510 for the completion.

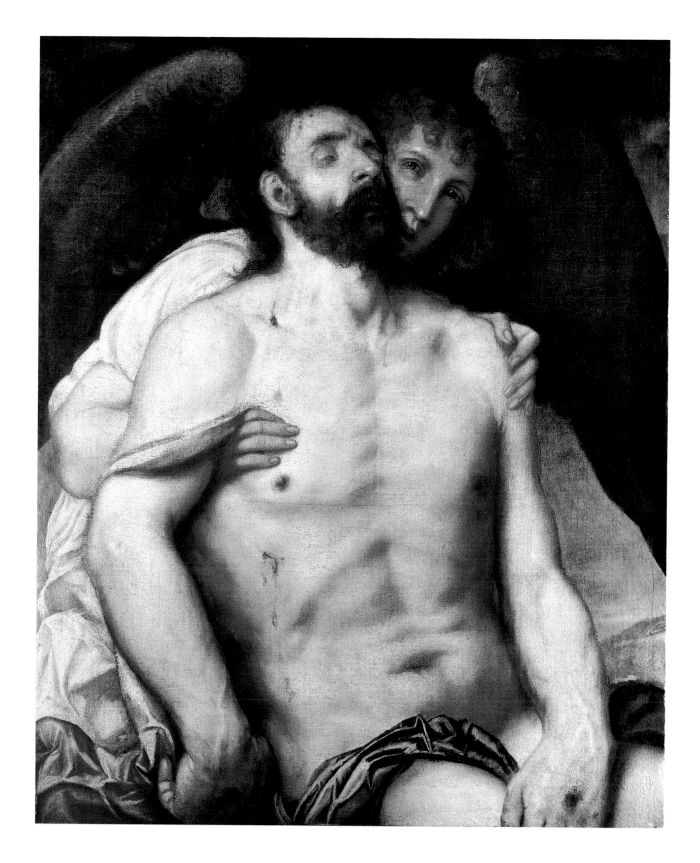

Sebastiano del Piombo

St. Louis of Toulouse, c. 1507–09

Oil on panel
115⅜ x 53⅞ in. (293 x 137 cm.)
Church of San Bartolomeo al
Rialto, Venice

Sebastiano Luciani, c. 1485–1547

Vasari wrote that Giorgione had formed Sebastiano and Titian as artists in order that his own art would be continued. If indeed this is true, he could not have known for how short a time Sebastiano would fulfill his intention. Sebastiano Luciani, who was called del Piombo only after 1531 when he became Keeper of the Papal Seal *(il Piombo),* was born in Venice about 1485. Vasari relates that Sebastiano, like Giorgione, was a singer and lutenist; consequently, after his training in the studio of Giovanni Bellini, he was drawn into the orbit of Giorgione with whom he worked very closely for several years. His most distinguished early works in Venice are clearly Giorgionesque: the organ shutters in San Bartolomeo, 1507–9, and the altarpiece of *St. John Chrysostom Surrounded by Six Saints* in San Giovanni Crisostomo, 1509–11. Yet in these and his other Venetian works there is also a growing classicism, possibly inherited from Giovanni Bellini, that disposed him favorably toward the art of Florence and Rome. In the spring of 1511, shortly after the death of Giorgione, he was called to Rome by Agostino Chigi to work with Raphael and Baldassare Peruzzi on the decoration of the Farnesina. His early work in Rome was still strongly Venetian with some influences from Raphael, especially in portraiture. By 1516 he had begun to reorient his style toward the bold formal statements of Michelangelo, who became his close personal friend and mentor and who sometimes furnished drawings for Sebastiano's paintings. His color also became increasingly subordinated to form. He did not, however, become merely an imitator of Michelangelo, but main-

The earliest documented works of Sebastiano are the four panels that comprise the organ shutters of the church of San Bartolomeo al Rialto, commissioned in late 1507 by the vicar Alvice Ricci (Nardini, 1788) and completed in 1509. On the interior panels are St. Louis of Toulouse and St. Sebald of Nürnberg, each in his niche of warm gray stone and gold mosaic. On the exterior panels, which join to form a single image when closed, are St. Bartholomew and St. Sebastian before an arch flanked by two columns. The interior panels, most likely the first executed, are of all the early work of Sebastiano the closest to Giorgione. St. Louis in his quiet reverie, bathed in golden light that falls gently and naturally from a single source beyond the picture, seems to be a self-conscious imitation of Giorgione, as does the technique that relies so heavily on the mastery of *sfumato.* Wilde (1974) has observed that the figure itself is the "twin brother" of St. Liberale in Giorgione's Castelfranco altarpiece. Wilde (1933) also suggested that the scenographic character of the compositions was influenced by Fra Bartolommeo, who was in Venice in 1508. Zampetti (1955) agreed with this hypothesis but felt it applied more to the outer panels than the inner ones, which reveal so vividly their Giorgionesque derivation. Despite these obvious influences, Sebastiano

nevertheless manifested his own artistic personality here in the tendency towards monumentality and classical feeling for form and space. This tendency was nurtured in the studio of Giovanni Bellini and already seemed to be leading him toward the styles of Raphael and Michelangelo, whose influence would soon change his idiom from Venetian to Roman.

The attribution to Sebastiano has been accepted by all critics except Crowe and Cavalcaselle (1876, who believed them to be by Rocco Marconi) and Wickhoff (1908). The organ shutters were considerably overpainted in the restoration by Giambattista Mingardi in the eighteenth century. This overpaint was removed and the paintings were properly restored by Pellicioli in 1940.

San Bartolomeo was the church of the German nation in Venice, for which Dürer in 1506 had painted the *Feast of the Rose Garlands* altarpiece, now in the National Gallery, Prague. The altarpiece was commissioned by the two German fraternities that maintained the church as well as the Fondaco dei

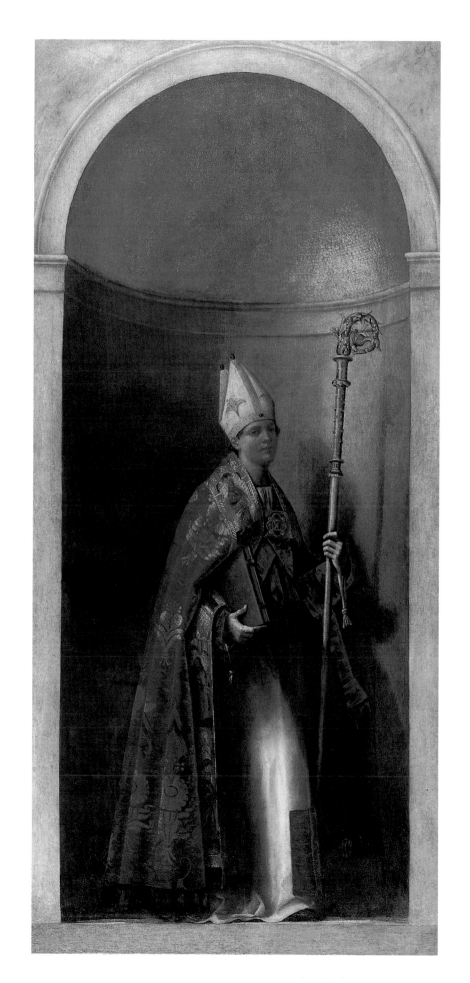

tained a strong individuality. Exemplary of this new style are the *Flagellation of Christ,* San Pietro in Montorio, 1516–24; the *Pietà,* Museo Communale, Viterbo, 1517; the *Raising of Lazarus,* National Gallery, London, 1517–19; and the portrait of Clement VII, Museo di Capodimonte, Naples, 1526. Following the Sack of Rome in 1527, Sebastiano returned to Venice bringing his Roman monumental style. By 1531 he was back in Rome where he remained until his death in 1547. Sebastiano's late work, attuned to the Catholic Reformation in Italy, became more austere and more deeply spiritual; still based on High Renaissance forms and space, it never became truly Mannerist.

Tedeschi: one composed of merchants of Nürnberg, the other of merchants from other German cities, especially Augsburg. The inclusion of St. Sebald, the patron saint of Nürnberg, on Sebastiano's organ shutters suggests that while the contract negotiations were handled by the vicar, the panels may have been financed by the fraternities. St. Louis of Toulouse (1274–1297) of the house of Anjou was the great nephew of Louis IX of France and son of Charles II of Naples. After seven years as a political hostage in Barcelona, he renounced his heritage to become a Franciscan friar minor in 1295. A year later he was appointed Bishop of Toulouse, but died in 1297 at the age of twenty-three from an illness contracted on a journey. He is therefore always represented as youthful and with fleurs-de-lys, here on his miter and crosier, to indicate his royal ancestry. He shares August 19 with St. Sebald as his day for special veneration.

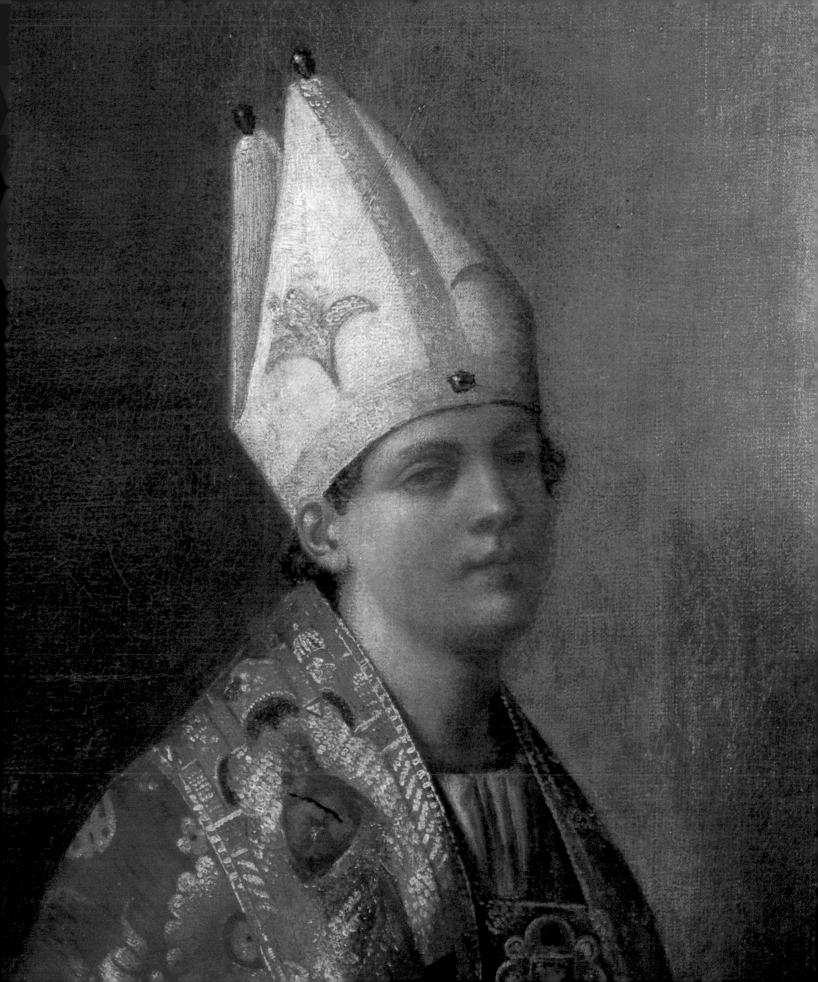

Sebastiano del Piombo

Portrait of a Man in Armor,
c. 1511–15

Oil on canvas
34½ x 26¼ in. (87.6 x 66.7 cm.)
Wadsworth Atheneum, Hartford
The Ella Gallup Sumner and
Mary Catlin Sumner Collection

The obviously Giorgionesque pose and expression of this magnificent portrait raise doubts whether the proposed date of about 1515 should not be brought closer to 1511, the time of Sebastiano's departure from Venice for Rome. Here, translated into Sebastiano's more measured and less pictorial style, is the youthful boldness of Giorgione's typical "over-the-shoulder" portraits. Traces of these portraits are left in engravings, copies, and Giorgionesque works of unknown authorship that recall lost originals of Giorgione, such as the so-called *Self-Portrait as David* in the Herzog Anton Museum, Braunschweig, the *Gattamelata* in the Uffizi, Florence, or the *Young Man,* sometimes called Fugger, in the Alte Pinakothek, Munich. The lesson of Giorgione must have been so strong for young Venetian artists that even after his death they recalled his models with extraordinary clarity.

Cunningham (1960) pointed out the stylistic analogies of this painting to the early Titian *Knight of Malta* in the Uffizi, formerly attributed to Giorgione, and to the portrait of *Raphael and his Fencing Master* in the Louvre, the latter attributed by some critics to Sebastiano.

Perhaps identifiable with the "captain in armor" by Sebastiano seen by Vasari (1568) and Borghini (1584) in the house of Giulio de Nobili in Florence, this painting was for many years believed to be by Giorgione. While Waagen (1857) had doubts about the attribution, Richter (1936) restored the work to Sebastiano with the generally accepted date of 1516–19. Pallucchini (1944) dated it about 1515. Richter identified the sitter as the Florentine general Francesco Ferrucci, but did not produce evidence to confirm his hypothesis. A copy of the picture is in the Magazzino degli Occhi in the Palazzo Pitti, Florence.

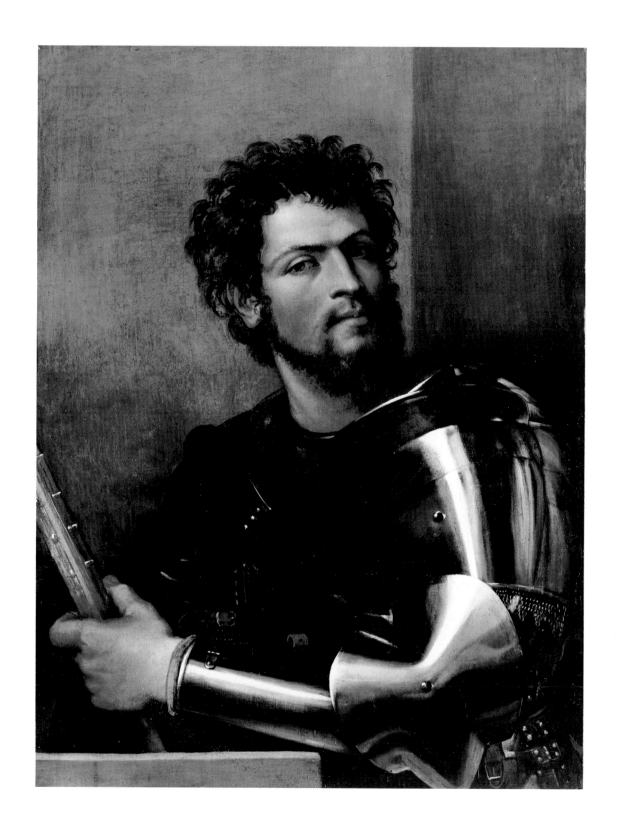

Palma Vecchio

The Appeal, c. 1520–25

Oil on canvas
33¼ x 27¼ in. (84.5 x 69.2 cm.)
Inscribed on reverse: FRA BASTIAN
DEL PIOMBO GIORZON TITIAN
Detroit Institute of Arts
City Purchase

Jacopo Negretti, c. 1480–1528

In the history of Venetian art, Palma Vecchio is most significant for his paintings of women in arcadian landscapes and for his portraits of a singular type of sumptuous and opulent Venetian beauty. He was born about 1480 in the town of Serina north of Bergamo, but little else is known about his early life or even of the time of his arrival in Venice. While there is evidence of the influences of the Bergamesque painter Previtali, and of Alvise Vivarini and Carpaccio, it is usually assumed that he received his essentially High Renaissance orientation in the studio of Giovanni Bellini. Toward the end of the first decade of the century he came so greatly under the influence of Giorgione that, even after the latter's death, he perpetuated Giorgione's style in his arcadian scenes and portraits, although on a somewhat more mundane level. Throughout his life, he retained in his works something of Giorgione's quiet contemplation. He did not, however, belong to Giorgione's aristocratic circle nor did he evince interest in humanistic studies. About 1515 he turned, as Titian did and possibly under his influence, to large paintings of a calm monumentality based not on High Renaissance formal balance but on the graceful rhythm of his now full and flowing forms. About 1524 he completed his most famous work, the Santa Barbara altarpiece for Santa Maria Formosa in Venice.

Until his early death in Venice in 1528, at the age of forty-eight, he was noted for his portraits both literal and fanciful, especially those of "fair women." From time to time he revived his earlier interest in mythological figures in an idyllic landscape.

The inscription implies either that this painting is the result of the collaboration of Sebastiano del Piombo, Giorgione, and Titian or that the figures are painted in the manner of these masters. The differences are not in technique or style, but rather in types of images; the male figure recalls in a rather academic way Giorgione's Terris portrait (c. 1510) from San Diego in this exhibition, the woman on the right the Magdalen in Sebastiano's altarpiece in San Giovanni Crisostomo, Venice (c. 1509), and the woman on the left the female figure in Titian's *Allegory of the Marchese del Vasto* in the Louvre (c. 1530). The most probable author was Palma Vecchio, a follower first of Giorgione and later of Titian, precisely for the sincere admiration it shows for the three "old masters" of Venetian painting as well as for the correspondence of the painting to the style of Palma of about 1520–25. The inscription is certainly apocryphal, since Sebastiano did not become "Frate" or "del Piombo" until he was appointed Keeper of the Papal Seal in 1531; this at least establishes the earliest date the inscription could have been added. The subject of the painting, commonly called *The Appeal* or *Jason between Medea and Creusa,* is still unexplained. Pietro Maria Bardi suggested orally to Suida that it might be *Amor, Concordia, Honor* (Love, Harmony,

Honor) on the basis of the three letters, A, C, H, intertwined on the cap of the male figure, while Suida (1956) proposed *Amor, Charitas, Humanitas* (Love, Charity, Humanity), the motto of the Scuola della Carità in Venice.

The history of the attribution of this painting is a tortuous one. While in the castle at Pommersfelden it was believed to be by Giorgione. In 1867, the year of its sale in Paris, Mündler attributed it to Cariani, a judgment accepted by Crowe and Cavalcaselle (1871), Morelli (1891), Borenius (1913), A. Venturi (1928), L. Venturi (1931), Pallucchini (1944), and Fiocco (1948). A. Venturi (1900) and Benkard (1908) had attributed it to Sebastiano del Piombo, while Berenson (1930) believed it had been done by Titian at various stages in his career. Valentiner (1926) considered it to be the collaborative work of Giorgione, Titian, and Sebastiano. This thesis was repeated by Valentiner (1927) and accepted by Schubring (1926), Suida (1933 and 1956), Zampetti (1955 and 1968), Pallucchini (1955), Berenson (1957), Braunfels (1964), and Volpe (1964). Mather (1926), on the other hand, deemed it a seventeenth-century pastiche, as did Robertson (1955) and Valcanover (1969). Morassi (1942) and Pignatti (1969) believed it to be the work of Palma Vecchio, an opinion still held by this writer.

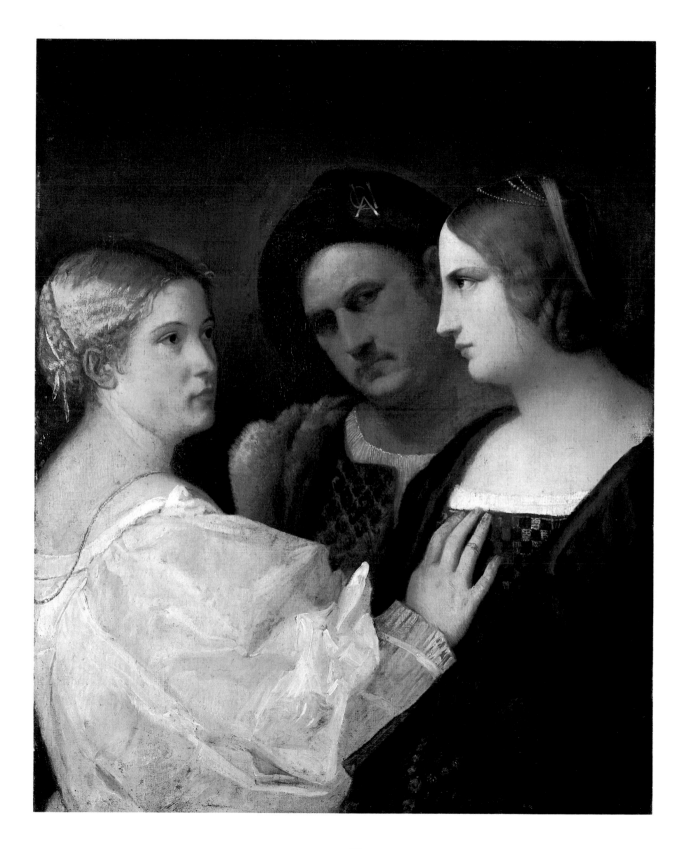

Palma Vecchio

Diana and Callisto, c. 1525

Oil on canvas
30½ x 48¾ in. (77.5 x 124 cm.)
Kunsthistorisches Museum,
Gemäldegalerie, Vienna

The subject of Diana and Callisto, like that of Diana and Acteon, is a vehicle for showing the female body in a diversity of poses. In this work, unusual in the oeuvre of Palma, the artist deviated from his painting of live models to take his inspiration from classical sculptures, the Roman High Renaissance, and his own earlier images. The reclining Diana in the foreground is related to Palma's *Venus and Cupid* in the Fitzwilliam Museum, Cambridge, and to his *Reclining Venus* in Dresden. The standing Callisto in the left foreground is dependent on the ancient Venus Kallipygos, now in Naples, while the next-to-last standing nymph on the right echoes the robust back of another ancient sculpture of the Venus de Milo type, although the sculpture in the Louvre was not discovered until 1820. The nymph combing her hair is quite literally taken from Marc Antonio Raimondi's engraving (Bartsch 325) of *Pan and Syrinx* after Giulio Romano (Wilde, 1930). In the modification of the earlier Venus type for his Diana, by changing the placement of her right hand from that of a *Venus pudica* to having it rest on her right leg and by uncrossing the legs to create an uninterrupted curve of the lower part of the body, Palma anticipated by several decades the type of Venus that Titian was to use in his *Venus with an Organ Player* in Berlin and Madrid and his *Venus with a Lute Player* in the Fitzwilliam Museum in Cambridge and the Metropolitan Museum in New York. Both individual figures and the covert eroticism of the scene with its many nude maidens in a landscape were the precursors of the mythological paintings by Hans Rottenhammer, whose debt to Venice is generally acknowledged, and by other Northern Mannerists who so delighted Rudolph II. The painting has its own fascination, being midway between the pure poetry of Giorgione's arcadian landscapes and the joyful sensuality of Titian's bacchanals.

While in the Della Nave Collection until 1636, this work was attributed to Palma Vecchio, but in Teniers' *Theatrum Pictorum* of 1660 it was erroneously called Palma Giovane. After considering it to be by Cariani in 1930, Wilde reattributed it to Palma Vecchio in 1931. This attribution was accepted by Suida in the same year, while Spahn (1932), admitting some analogies with Palma's other works, placed it in the circle of Bonifazio, about 1530. The attribution to Palma Vecchio is now generally accepted with a date about 1525.

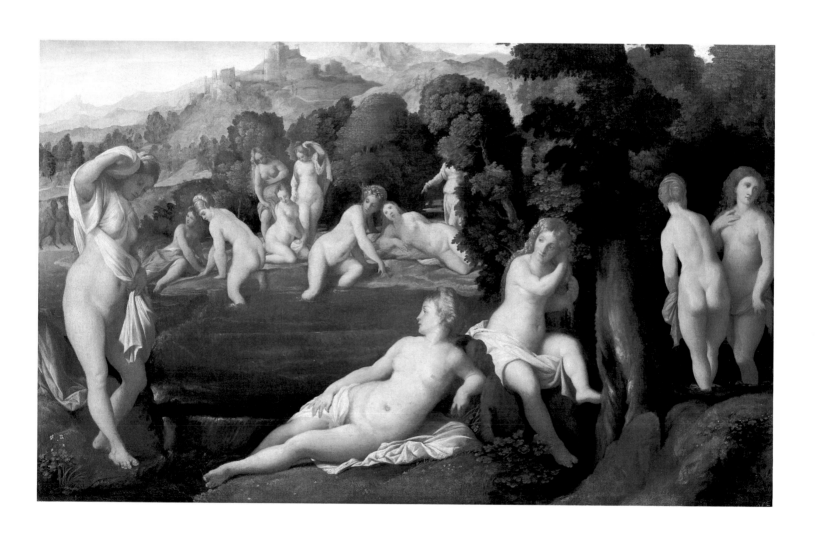

Cariani

Portrait of a Man, 1525–30

Oil on canvas
36½ x 36½ in. (92.7 x 92.7 cm.)
Signed: IO • CARIANVS • DE • BVSIS
• BGO MESIS • PIXIT
National Gallery of Canada,
Ottawa

Giovanni de'Busi, c. 1485–after 1547

Specific biographical documentation concerning Cariani is scarce. It is generally accepted that he was born about 1485 and died after 1547. On the basis of his signature in which he identifies himself as "Bergamesque," it is assumed that he was born in Bergamo. His artistic formation is nevertheless Venetian, and he can be placed in the orbit of "Giorgionism" on the basis of his early preserved works, especially softly shaded portraits and arcadian subjects like the *Sleeping Shepherd* in the Accademia Carrara in Bergamo. He also drew on the tradition of the Sacre Conversazioni of Giovanni Bellini, and came especially close to Palma Vecchio, possibly on the basis of their common Bergamesque origin. Moving to Bergamo at the end of the second decade of the century, he perfected his art of portraiture under the influence of Lorenzo Lotto. Cariani remained in Bergamo from 1518 to 1524 and was there again from 1528 to 1530, painting among other subjects portraits of the notables of the city. When away from Bergamo, it seems that he worked primarily in Venice. Unfortunately his later religious paintings became increasingly provincial, so that he never again reached the level of his Bergamesque portraits.

In the history of a painter like Cariani who was not a major master, it sometimes happens that he produces a few works of such excellence that they must be considered masterpieces. This is the case with Cariani, especially in his portraits. There is little doubt that the finest among them is this portrait of a distinguished man of letters holding a parchment with a seal that may be a papal or imperial document; behind him is a laurel tree and in front on the parapet are other documents and writing materials. In the psychological penetration of his sitter, Cariani demonstrates that he has learned well the lesson of Lotto. The colors recall the iridescent luminosity of Cariani's master, Palma Vecchio. In synthesizing these elements Cariani has recorded the dignity and strong character of his subject seen against a tempestuous sky at sunset in a cold and revealing light.

According to Troche (1932), this portrait belongs to the period of Cariani's maturity between 1525 and 1530, when he was influenced by the Bergamesque works of Lotto. It is closely related to another of Cariani's portraits in Bergamo, that of the Venetian ambassador in the Suardi Collection. Gallina (1954) observed that the coat of arms is the same as that in Cariani's portrait in the Accademia Carrara, Bergamo, of the much younger Giovanni Benedetto da Caravaggio, Philosopher and Doctor of Medicine, Rector and Professor at the University of Padua. Mariacher (1975) proposed that the subject of both portraits is the same scholar, painted fifteen to twenty years apart; to do this he has hypothesized that the Accademia Carrara portrait was completed about 1516–18, before Cariani came to Bergamo, and that the Ottawa portrait was painted between 1530 and 1535.

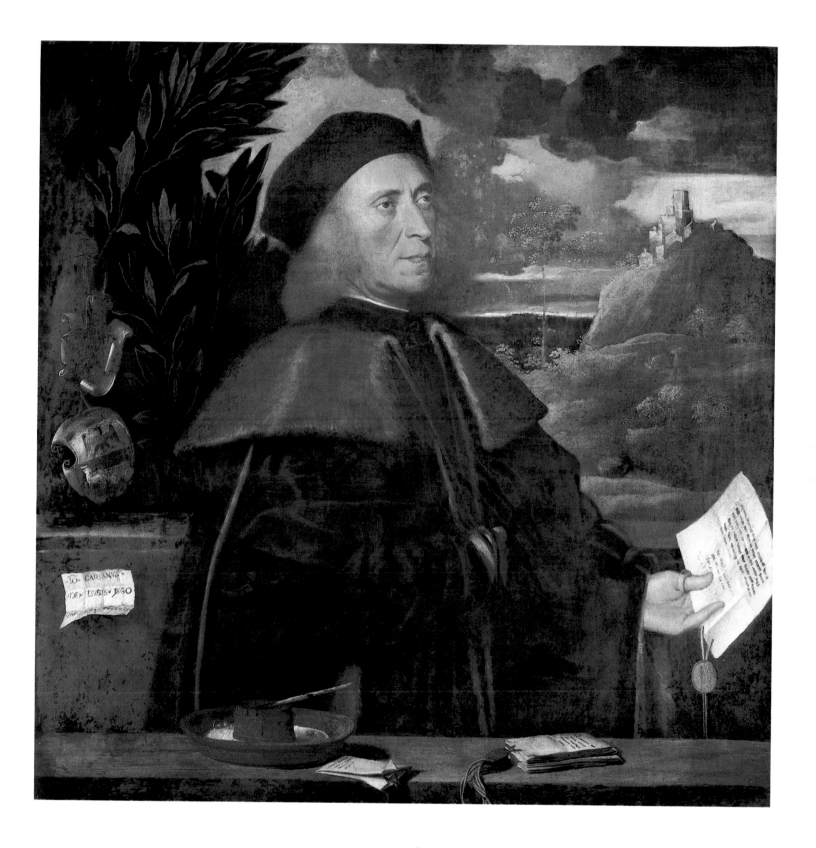

Lorenzo Lotto

Madonna and Child with Sts. Jerome and Anthony of Padua, 1521

Oil on canvas
37⅛ x 30⅝ in. (94.3 x 77.8 cm.)
Museum of Fine Arts, Boston
Charles Potter Kling Fund

c. 1480–1556

Lotto, the most independent genius among all the Venetian artists of the sixteenth century, was deeply religious and possessed an extraordinary insight into the human personality. Of a restless nature, he constantly sought in his art new means of expression rather than accepting traditional formulas. Lotto was born in Venice about 1480 and died as an oblate at the Santa Casa of Loreto in 1556. He studied initially with Giovanni Bellini and emerged as an important figure between 1505 and 1507 in the area of Treviso, producing portraits and altarpieces; in 1508 he moved to Recanati, where he left an altarpiece. A wanderer, Lotto went to Rome in 1509 to decorate the apartments of Julius II in the Vatican and later worked with Raphael in the Stanze. In 1512 he returned to the Marches to paint the Jesi *Entombment;* in 1513 he went to Bergamo, where he stayed until about 1523, painting the altarpieces in the churches of San Bartolomeo, San Bernardino, and Santo Spirito, in addition to providing the designs for the extraordinary intarsias in the Cathedral. He was in Venice for a brief period, but could not find a place among the already established masters. For almost three decades he moved back and forth from Venice and Treviso through the Marches until he finally settled in 1554 in Loreto.

A very personal artist, Lotto was attracted at the beginning of his career to German art, especially to Dürer's incisive draftsmanship and search for realism. After his experience in Rome, he abandoned his early training for the more elaborate compositions and brilliant coloring of Raphael. Subsequently, in contrast to the "classic" Venetian school headed by Titian, he developed an individual

In Lotto's highly singular artistic conceptions, the Madonna almost always retains aspects of her worldly femininity. This is one of the many seemingly disparate elements that Lotto brings into harmony in the *Madonna and Child with Sts. Jerome and Anthony of Padua.* With a renewed consciousness of the picture plane in the 1520s, Lotto delimited his space by closing the background except for the small landscape vista and providing only a shallow foreground for his figures, compressing them into an interlocking group to make a deep, continuous frieze. They form a pattern that is given vitality by the exaggerated movement of the billowing drapery and the undulating play of arms and hands. These compositional devices seem to be leading toward Mannerism, but he was too intimate an artist to accept the formal rigors of that style. Characteristic of Lotto, each reveals a carefully delineated personality: the somewhat Leonardesque Madonna with her fleeting melancholy, St. Jerome, oblivious of the others, absorbed in penance, and St. Anthony rapt in devotion to the Christ Child. It is probable that St. Anthony is a portrait of the monk for whom the picture was painted.

A copy or damaged replica of this painting in the National Gallery in London bears the inscription "Laurenti-Lotto/1521," apparently a restored version of "Laurentius Lotus" used by Lotto on other paintings (Gould, 1975). The Boston painting was itself once considered to be a copy, but now is universally recognized as autograph. The date 1521 is a logical one on stylistic grounds. A variant of these two paintings in the Palma Camozzi Collection in Bergamo is signed and dated 1522.

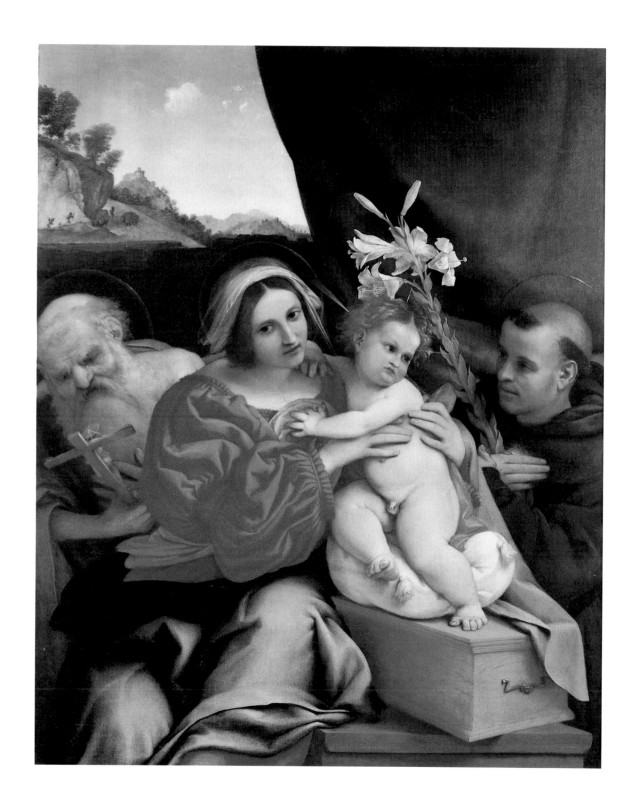

Lotto

Madonna and Child with Two Donors, c. 1523

Oil on canvas
34 x 45½ in. (86.4 x 115.6 cm.)
The J. Paul Getty Museum, Malibu

style with elements not borrowed from but often parallel to those of Florentine-Roman Mannerism: melancholy themes, sophisticated and sometimes distorted draftsmanship, and expressive use of color. Like those of the late Titian, the works of Lotto's last years are the most psychologically and spiritually profound.

Berenson (1956) characterized Lotto as "a psychological painter in an age which ended by esteeming little but force and display, a personal painter at a time when personality was getting to be of less account than conformity, evangelical at heart in a country upon which a rigid and soulless Vaticanism was daily strengthening its hold."

The *Madonna and Child with Two Donors* is one of Lotto's most classic works with its intermixture of idealism and realism. The two divine figures are idealized; that is, they are not imitated directly from human models, but are conceived in the mind of the artist as types more perfect than any found in nature. Yet they move in space in a quite natural manner. The donors—the epitome of prosperous gentry—are drawn with an incisiveness that is reminiscent of Northern realism. At the same time they are given a sense of classical permanence by being painted in profile against the parapet in a manner that recalls sculptured reliefs.

The spiritual superiority of the Madonna and Child is conveyed by their placement in the composition on a level above the donors, a device used by Titian on a grand scale in the contemporaneous Pesaro Madonna at the Frari, Venice. Typical of Lotto's religious conceptions is the uninhibited, but deeply respectful, relationship of the donors to the Madonna and Child, who in turn express their benevolence with the noble simplicity of a profoundly human act. The combination of stylistic elements in the painting recalls Lotto's youthful experience of both Dürer and Raphael. Collins Baker (1928) has in fact shown the close dependence of the Madonna and Child on a Raphael School drawing in

Chatsworth dated about 1520 and noted the change in feeling made by Lotto.

The painting has been identified by Banti-Boschetto (1953) with that seen by Boschini (1660) in the house of Paolo del Sera in Florence: "There is by Lorenzo Lotto marvelously done/a beautiful Madonna and the little Child/Our Lord Jesus, so perfect/that indeed it causes eyebrows to raise./With two portraits, truly alive/adoring, devout, and feeling/of a man and woman, so artful/that their true spirit is revealed."

Opinions of scholars concerning the date of the painting are somewhat contradictory: from 1524 for Berenson (1956) to 1529 for Coletti (1953). There are, however, compositional similarities to works of Lotto's in Bergamo after 1521, such as the opening to the landscape in the upper left quadrant, as in the *Madonna and Saints* from Boston of about 1521 in this exhibition and in the double portrait from the Hermitage, usually dated 1523–24. A more telling comparison is that between the portraits of the donors and that of Lucina Brembate in the Accademia Carrara, Bergamo, of about 1523. Finally, the abundant drapery of the Madonna, her brown hair, and the type of Child all seem especially close to the *Mystic Marriage of St. Catherine* in the Accademia Carrara, Bergamo, dated 1523.

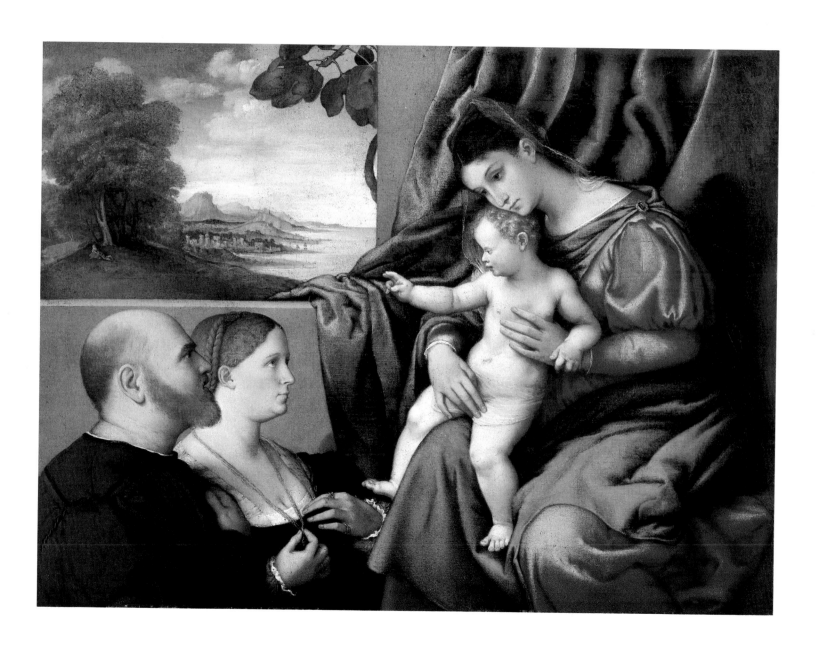

Lotto

Brother Gregorio Belo of Vicenza,
1547

Oil on canvas
34⅜ x 28 in. (87.3 x 71.1 cm.)
The Metropolitan Museum of Art,
New York City
Rogers Fund, 1965

From Lotto's account book we know the troublesome fate of his portraits, sometimes rejected, sometimes reluctantly accepted by disappointed clients. And yet if we examine Lotto's most characteristic portraits—for example, the *Young Man with an Oil Lamp* in Vienna, the *Dominican Monk* in Treviso, or the *Gentleman on a Terrace* in Cleveland—we sense that these images are the result of a long association between artist and model, of conversations and sittings of an almost confessional character. The painter's attitude is hardly ever that of "presenting" his sitter, but rather one of scrutinizing him, of looking him in the eye as if to discover his deepest secrets. In the penetrating Metropolitan portrait of Gregorio Belo, we have this sense of a quiet dialogue, rendered more intense by the handling of the light and the use of subdued natural colors.

Gronau (1924) in an unpublished statement and Berenson (1955) identified the painting with the entry in Lotto's *Libro di Spese Diverse:* "portrait from life...with a crucifixion, the Madonna, St. John, and the Magdalen" executed for "Fra Gregorio of Vicenza of the brothers of St. Sebastian in Venice," commissioned on December 9, 1546, and with final payment made on October 11, 1547. Canova (1975) calls attention to the close relation of this work to Lotto's paintings of *St. Jerome in Penance* in the Doria Pamphili Gallery in Rome and in the Prado, and Zeri-Gardner (1973) call specific attention to the allusions to St. Jerome in the rocky landscape and the gesture of Fra Gregorio's right hand beating his breast, noting as the inscription indicates that Fra Gregorio was a member of the order of poor hermits of St. Jerome, founded by Blessed Pietro de'Gambacorti of Pisa, which had its seat in Venice at San Sebastiano. Canova suggested a certain "Grünewaldian flavor" in the crucifixion at the upper left, which Zeri-Gardner relate to Lotto's small *Christ Crucified with the Symbols of the Passion* in the Berenson collection in Florence. Fra Gregorio's book bears the title, *Homelie d greg,* the sermons of Gregory the Great.

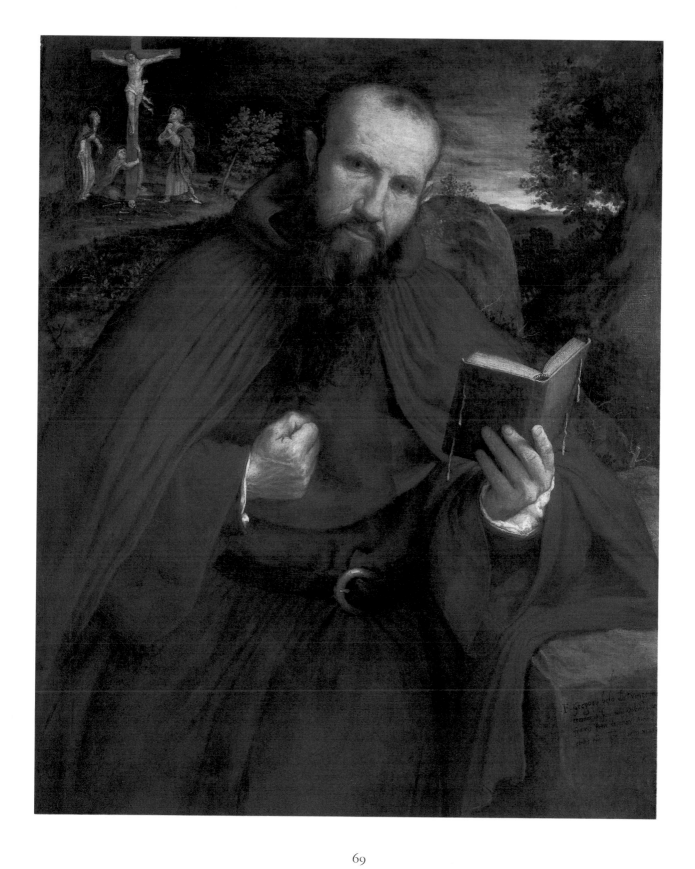

Titian

Man with the Glove, 1520–23

Oil on canvas
39⅜ x 35 in. (100 x 89 cm.)
Signed lower right: TICIANVS F.
Musée du Louvre, Paris

Tiziano Vecelli, c. 1490–1576

Titian was the only Venetian artist to be called by his contemporaries "divine," a term otherwise reserved for Michelangelo. The emperor Charles V must have agreed, for in 1533 he named Titian "Knight of the Golden Spur, Count of the Lateran Palace and of the Imperial Consistory" and appointed him his personal painter. After the abdication of Charles V in 1555, Titian retained the position of court painter to the King of Spain, Philip II. In Italy, he received the patronage of the courts of Ferrara, Mantua, and Urbino. Made official painter of the Venetian Republic in 1516, and unrivaled in Venice most of his life, he received his choice of commissions and dominated the Venetian art world for the greater part of the century. Internationally he was esteemed even by his sharpest critics as the greatest living colorist. Vasari summarized his natural abilities and his career in the phrase: "he has not received from heaven anything save favors and blessings."

Born in Pieve di Cadore about 1490, Titian was sent to Venice at the age of nine with his brother Francesco to be trained by the renowned mosaicist Sebastiano Zuccati. Titian soon transferred to the Bellini studio to study painting, working briefly with Gentile, then for some years with Giovanni. When and how he became associated with the workshop of Giorgione is not known, but by 1508 he was working side by side with the master, his senior by about thirteen years, on the frescoes at the Fondaco dei Tedeschi. There are independent works of Titian that may be earlier than this, but the dates are disputed by historians. The years between the beginning of the century and 1518 are generally thought of as Titian's formative period, during which he assimilated the stylistic ideas of Giovanni Bellini and Giorgione, and began his studies of ancient sculpture, the innovations of Leonardo, Michelangelo, and Raphael, and Dürer's approach to nature. His own artistic personality emerged with immense force in his second fresco

Even the most staid critics have used the terms "best beloved" and "irresistibly appealing" when speaking of this portrait. Its attraction springs from the aspects of personality Titian chose to emphasize: freshness of youth, wistfulness and sensitivity, and at the same time a ripening dignity and self-assurance. This combination could have been produced only in the early 1520s when Titian stood midway between his earlier Giorgionesque portraits, in which he saw his sitters as pensive, quiet, and sensitive, and those of the following two decades such as the *Young Englishman* in the Palazzo Pitti, in which he preferred to depict his subjects as having commanding presence and overt self-confidence.

From his very first years in Venice, Titian established himself as a portraitist. Contemporary writers commented not only on his manner of perceiving an individual sitter but also on his extraordinary capacity to represent secondary elements in the painting, as Vasari noted in describing a portrait of a member of the Barbarigo family with a doublet of silvered satin "in which even the stitches could be counted." Titian frequently used such casual elements to characterize a human type or to associate it with its environment, as in the marble profile of *La Schiavona* in the National Gallery, London; the handful of flowers in the *Flora* in the Uffizi;

and the red cap of the *Young Man with a Red Cap* in the Frick Collection, New York. Similarly, in the Louvre painting the gloves are remembered as its distinguishing attribute. Of even greater importance for the composition are the collar and cuffs of milk-white lace and the white shirt front that stand out against the darkness of the garment and background. From the inverted triangle of light of the shirt and the ring of the lace collar, the head emerges like a flower from its calyx to be the focal center of the picture.

Hourticq (1919) proposed that the painting be identified with the *Portrait of Girolamo Adorno* that Titian sent to Federico Gonzaga, Duke of Mantua, in 1527 (Crowe and Cavalcaselle, 1877). Wethey (1971) pointed out that Girolamo Adorno, a Genoese nobleman who was ambassador of Charles V to Venice in 1522–23, died in 1523 at the age of either thirty-three or forty, while the sitter here appears to be much younger. Mayer (1938) suggested that the subject is Giambattista Malatesta, agent of the Duke of Mantua in Venice, but no proof exists for this identification. The date generally assigned to the work is about 1523 (Mayer, 1938; Pallucchini, 1969; Valcanover, 1969); Ricketts (1910) places it between 1518 and 1521; Tietze (1950) in 1520; and Wethey (1971) between 1520 and 1522.

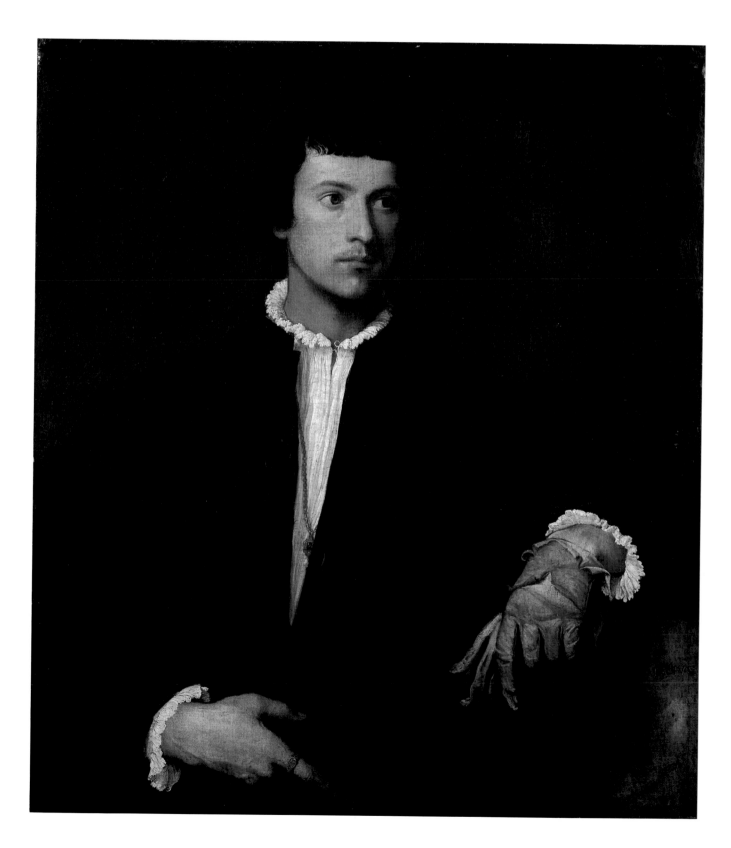

commission: three scenes from the life of St. Anthony in the Scuola di Sant'Antonio, Padua, 1511, especially in the *Jealous Husband* with its dynamic composition, sharp foreshortening of the wife about to be slain, and unification of the figures through vigorous movement. It contrasts greatly with the gentle lyricism of Giorgione; yet Giorgionism persists in varying degrees in Titian's work over the next years, not only in the more obviously Giorgionesque *Three Ages of Man* in the National Gallery of Scotland or the *Salome* in the Doria Pamphili Gallery in Rome, but also in works typically his own like the *Sacred and Profane Love* of about 1516 in the Borghese Gallery, Rome, and the *Man with the Glove* of the early 1520s in this exhibition.

The quintessential element of Titian's style already evident in these early works is his conception of color, not as something to be added to form to embellish it, but as the means by which form, space, and light are perceived. Titian's monumental style, the apex of Venetian High Renaissance, was inaugurated between 1516 and 1518 with the *Assumption of the Virgin,* a twenty-three-foot panel for the high altar of the Gothic basilica of Santa Maria Gloriosa dei Frari, Venice. The apostles below form a substantial base in continuous movement straining upward; God the Father provides a termination in the dome of heaven; between them the Virgin, a powerful woman swaddled in billowing draperies, surges upward into the golden celestial light on an arc of cherub-studded clouds. A great pyramid is formed by the red of the garments of the Virgin and two of the apostles, echoed in God the Father above. In contrast to a painting of Raphael, which can be read with complete logic in black and white, Titian's use of color for compositional structure makes it impossible to read his paintings of this period except in color.

One masterpiece followed another during the next decade, including the Pesaro altarpiece, in the Frari, Ven-

Titian *Portrait of Paul III,* 1543 Oil on canvas
 41¾ x 33½ in. (106 x 85 cm.)
 Galleria Nazionale, Capodimonte,
 Naples

ice; the polyptych with the *Resurrection, Annunciation, and Saints* in Santi Nazaro and Celso, Brescia, its resurrecting Christ inspired by the Laocoön and its St. Sebastian based on two of Michelangelo's slaves; and three mythological paintings for Alfonso d'Este's Alabaster Chamber. The latter three, the *Worship of Venus* and the *Bacchanale of the Andrians,* both in the Prado, Madrid, and the *Bacchus and Ariadne* in the National Gallery, London, are, like the *Assumption,* composed of forms in continuous movement, brilliant in color, and filled with the joy of life.

After this tremendous expenditure of energy, Titian turned in the 1530s to a quieter, more lyric painting of clear, harmonious colors and graceful forms often reminiscent of Giorgione. In the *Venus of Urbino* in the Uffizi, Florence, he paid tribute to Giorgione by repeating the pose of his sleeping Venus now in Dresden with only a change in the position of the head and right arm. Titian, however, transformed Giorgione's ideal poetic figure in a landscape into a naturalistic one in a domestic setting, filled with painterly nuances. The most imposing work of this period is the *Presentation of the Virgin* painted between 1534 and 1538 for the Scuola della Carità, now the Academy, Venice. The architectural setting and the quietly posed individual figures that compose the processional group of spectators are reminiscent of Gentile Bellini and Carpaccio. Titian, however, has given a new sublimity to the event by isolating the child Mary, self-confidently participating in the solemn ceremony, and enveloping her in divine and natural light. In the 1530s Titian also began the series of imperial and regal portraits that brought him not only a title of nobility but an unassailable reputation throughout Europe.

Like Picasso in the twentieth century, Titian exhausted one complex of pictorial elements and then turned to another often radically different one. This happened again in the early 1540s, a time often referred to as the period of Titian's "Mannerist crisis." Titian traveled

Paul III was sixty-five in 1543, the ninth year of his papacy. Cautious, choleric, and stubborn, he was a vigorous champion of papal authority, a shrewd diplomat in maintaining a balance between King Francis I of France and Emperor Charles V, and the first strong papal leader of the Catholic Reformation. A year earlier he had reestablished the Inquisition; in 1543 he promulgated the Index of Forbidden Books; and two years later, after several unsuccessful attempts, he convened the Council of Trent. It was on the occasion of the meeting of Paul III and Charles V at Busseto in 1543 to discuss the Council that Titian painted this portrait of the pope without the papal cap (*camauro*). Under the rose velvet cape, the figure of the aged warrior looms large—almost limitless—and, as if to affirm his power, the long slim fingers suggest the talons of an eagle. Titian's brush races, skipping over the surface of the canvas in nervous vibrations that transmit the most minute subtleties of feeling. He painted two later portraits of Paul III, one wearing the papal cap and another with his two grandsons; all three are in the Farnese Collection in Capodimonte. Since there are more than thirteen copies of the portrait without the cap, Wethey (1971) quite justifiably concluded that this one was considered the official portrait by the pope and his family.

In choosing Titian as his portraitist, Paul III continued a level of patronage of the arts he had established both as Cardinal Alessandro Farnese and as pontiff. He had, for example, initiated the construction of the Palazzo Farnese in Rome, commissioned Michelangelo to paint the *Last Judgment* in the Sistine Chapel, and upon its completion in 1541 the *Conversion of St. Paul* and the *Crucifixion of St. Peter* in his newly completed private chapel, the Capella Paolina, in the Vatican.

Whether the painting was executed in Busseto or Bologna is not certain. The date, however, can be established quite precisely as late April or May of 1543 by a document dated May 27, 1543, recording the payment of two gold ducats to Titian for shipment of the painting. The only doubt concerning the attribution of the portrait was raised by Tietze-Conrat (1946) who questioned whether it might be by Sebastiano del Piombo, to whom it has no demonstrable stylistic relationship. Ortolani (1948) proposed that the portrait was executed in Rome between 1545 and 1546, later than the *Portrait of Paul III with the Papal Cap,* and that the portrait painted in 1543 was instead the lost *Double Portrait of Paul III and Pier Farnese* recorded as being in Parma in 1680 (Campori, 1870). Both of these hypotheses were disputed by Pallucchini (1969) and rejected by all later scholars.

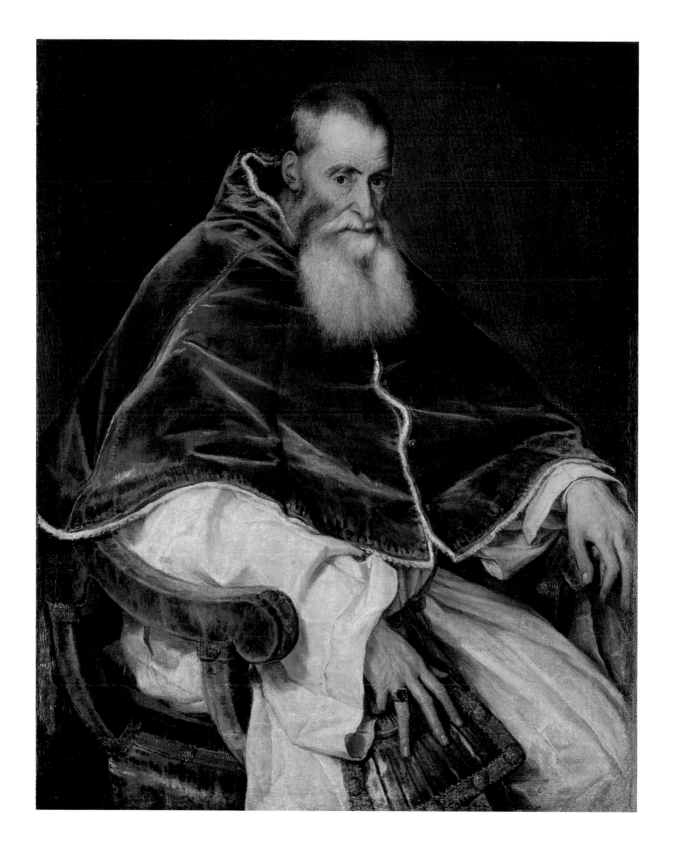

Titian

Venus with a Mirror and Two Cupids,
c. 1553

Oil on canvas
49 x 41½ in. (124.5 x 105.5 cm.)
National Gallery of Art,
Washington, D.C.
Andrew W. Mellon Collection,
1937

extensively at this time and could easily have seen Giulio Romano's late paintings in Mantua, Correggio's in Parma, and those of Pordenone, Vasari, and Salviati in Venice itself. At the same time he seemed to have renewed his interest in antique sculpture. Whatever the influences were, Titian at this time quite abruptly abandoned his earlier contraposition of calculatedly beautiful local colors for the unifying effect of heavier and darker transitional coloring with contrasts of light and dark, which gives dynamism to the composition. His figures become heavier and more massive; action again becomes bold and vigorous. The *Ecce Homo* of 1543 in the Kunsthistorisches Museum, Vienna, with its dramatic concentration and dense grouping of figures, seems decades away from the somewhat archaizing *Presentation of the Virgin,* completed only five years earlier. In *Cain Slaying Abel, The Sacrifice of Abraham,* and *David and Goliath,* painted in 1544 for Santo Spirito and now in Santa Maria della Salute, the audacious foreshortening of monumental forms intensifies the violence of these dramas of heroic conflict. The *Christ Crowned with Thorns* in the Louvre is a paradigm of human brutality with vehement movement and negation of color for chiaroscuro. This second monumental style of Titian was well formed before his visit to Rome from October 1545 to June 1546. In 1543 Titian had painted the portrait of Paul III in Ferrara; in 1545 the pope's nephew Cardinal Alessandro Farnese invited Titian to Rome as a guest of the Vatican. There for the first time he saw the great frescoes of Raphael and Michelangelo and the most famous sculptures of classical antiquity, all of which he studied assiduously. He demonstrated his artistic prowess there in the *Portrait of Paul III and His Grandsons* and the *Danae,* both in the Museo di Capodimonte, Naples. In the *Danae,* painted to compete with Michelangelo's *Leda,* the torsion and sculptural abstraction of Michelangelo gave way to a relaxed grandeur in a warm and sensuous atmosphere produced by the soft shading and myriad hues and values of

Titian was about sixty or sixty-five when he painted this *Venus,* and it is not difficult to see in her a more mature, more classical reminiscence of the youthful goddesses of thirty years earlier who attested to the delicate beauty of his wife Cecilia, his early model. In the Washington *Venus* the art of Titian achieves a consummate mastery of color; with a painterly touch he builds up tones from the darker areas, and with singular refinement produces threads of light, golden reflections, the softness of velvet, and the sensuous opulence of the figure. It is a canvas that, indeed, epitomizes the golden century of Venetian painting.

In a letter of 1574 to Philip II, Titian told the emperor of a "Venus with a Cupid that holds her mirror." He may have been referring to the lost prototype of the composition of Venus Genitrix, of which Titian made or had others make numerous copies. Titian created a variant based on the Venus Pudica type, which exists in numerous versions cataloged with great precision by Poglayen-Neuwall (1934, 1947). The Washington *Venus* with the two cupids and the mirror represents an elaboration of the Venus Pudica type. Wethey (1975) quite rightly proposed the possibility of an iconographic source in classical sculpture that Titian could have seen on his trip to Rome or in an-

cient decorative objects like engraved mirrors that he could have studied in Venetian collections.

The painting has the merit of possessing an impeccable provenance. From the estate of Titian himself, it was acquired from his son Pomponio by Cristoforo Barbarigo in 1581, passed from his heirs to the Czar of Russia in 1850, thence to Andrew Mellon in 1930–31, and with his collection to the National Gallery in 1937. For most writers, this is the only remaining original of the many Titianesque versions. However, Valcanover (1969) accepted the version in the Cà d'Oro in Venice as Titian, following its cleaning. Wethey (1975), on the other hand, accepts only the Washington painting as autograph. The date is probably not very far from 1553, the date of the *Danae* in the Prado, which shows identical treatment of the softly glazed flesh. A recent radiographic examination revealed that the Washington *Venus* is painted on a canvas that Titian had previously used in a horizontal direction for an unfinished double portrait, clearly visible in the x-rays (Shapley, 1971–72). From the braided coiffure of the woman, Wethey (1975) dated the double portrait about 1545, the date before which the *Venus* could not have been painted. He dates the *Venus* 1552–55.

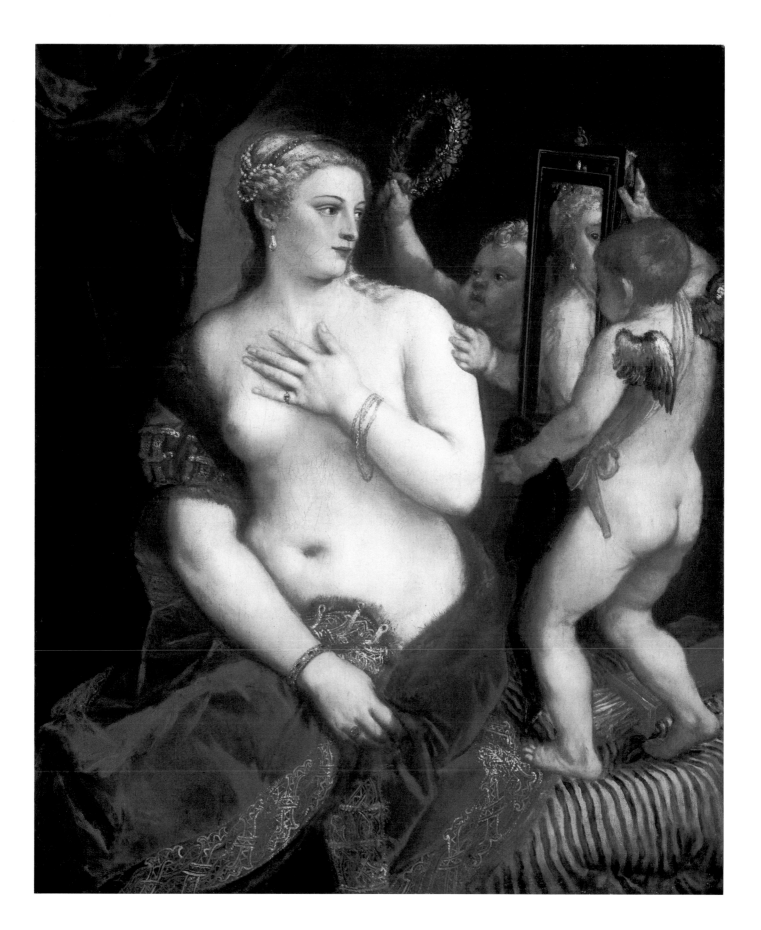

Titian

Self-Portrait, c. 1562

Oil on canvas
37¾ x 29½ in. (96 x 75 cm.)
Staatliche Museen Preussischer
Kulturbesitz, Gemäldegalerie,
Berlin (West)

reds and olives. Titian, whose personal relationship with Charles V was a very close one, was a guest of the emperor at the imperial court in Augsburg from January to October 1548. During this visit he painted the seated Charles V in the Alte Pinakothek, Munich, and the majestic equestrian portrait of Charles V in the Prado, Madrid. He was back in Augsburg in 1550–51 and painted the Prado portrait of the young Prince Philip, who was to be his greatest patron for the remainder of his life.

In the 1550s Titian, as Panofsky has expressed it, "experienced a kind of second youth" and a final blossoming of rich, modulated colors. The result was a succession of erotic subjects from mythology and ancient poetry, many of them for Philip II. Some of them—from the still quite classical *Venus with the Mirror* of about 1553 in this exhibition, the *Venus and Adonis* of 1553–54 in the Prado, and the second *Danae* of 1553–54 in the Prado, through the several paintings of Venus with musicians, to the *Rape of Europa* of 1559–62 in the Gardner Museum, Boston— continue the grandiose style of the *Danae* painted in Rome in 1548, but with an increasing freedom of paint application, broader brushstrokes, thicker impasto, and more scumbling, producing fragmented colors with a depth of reflection that writers inevitably try to describe by comparing them to jewels. Titian seems to be taking an ever-increasing delight in the joy of paint without sacrificing plastic credibility, compositional cohesion, and sensuous stimulation on a number of levels. In the *Diana and Acteon* and *Diana and Callisto* of 1556–59 in the National Gallery of Scotland, Edinburgh, Titian makes a last nod toward the Mannerism of Parmigianino in the graceful elongation and contortion of his figures and the relative condensation of composition; but the interrelation of the figures and natural forms, the play of light breaking into the shaded grove, and the suffusion of the entire scene in a unifying atmosphere look forward to the next century rather than backward.

In the entire history of art few self-portraits can equal this one in the expression of the dignity of the artistic profession and the transience of the artist himself. Titian's age was a secret about which doubts grew as the artist approached the end of his life. In fact, Titian himself contributed to the confusion, giving his age as older than he really was in order to persuade his illustrious creditors to dissolve his debts. This portrait, documented by Vasari, can be placed about 1562; according to the most reliable assumption Titian would then have been about seventy-two years old. He wears the gold chain of his knighthood awarded him by Charles V in 1533. Titian portrayed himself with the same nobility of mien with which he endowed aged popes, emperors, and doges, yet there is in the painting a profound melancholy, an almost existential anguish that seems to torment the senescent artist. The freedom of technique in much of the painting, especially the hands, sleeves, and doublet, prompts the question whether Titian considered the painting finished (Wethey, 1971). Of all the portraits of Titian, only this and the later profile portrait in the Prado are universally accepted as by Titian's own hand.

Gronau (1904) and Fischel (1904), followed by Foscari (1933), Tietze (1950), and Wethey (1971), dated the painting about 1550 be-cause of the similarity of facial features to the 1550 woodcut portrait of Titian by Giovanni Britto. Ricketts (1910) placed it between 1550 and 1560, a hypothesis taken up by Kunze (1931) and Panofsky (1969). Suida (1935) identified it as the "self-portrait...finished four years ago, very beautiful and natural" seen by Vasari in Titian's house in 1566. This identification and the date of about 1562 were accepted by the leading scholars of Venetian painting, including Foscari (1935), Dell'Acqua (1955), Valcanover (1960), and Pallucchini (1969).

There are numerous school variants and later copies of this painting, including two in the Uffizi, one of which Fischel (1904) and Berenson (1932) considered autograph. Other portraits of Titian dependent on the Berlin painting include an engraving by Agostino Carracci of 1587 and the triple portrait of *Titian, Andrea dei Franceschi, and a Friend of Titian,* in Hampton Court.

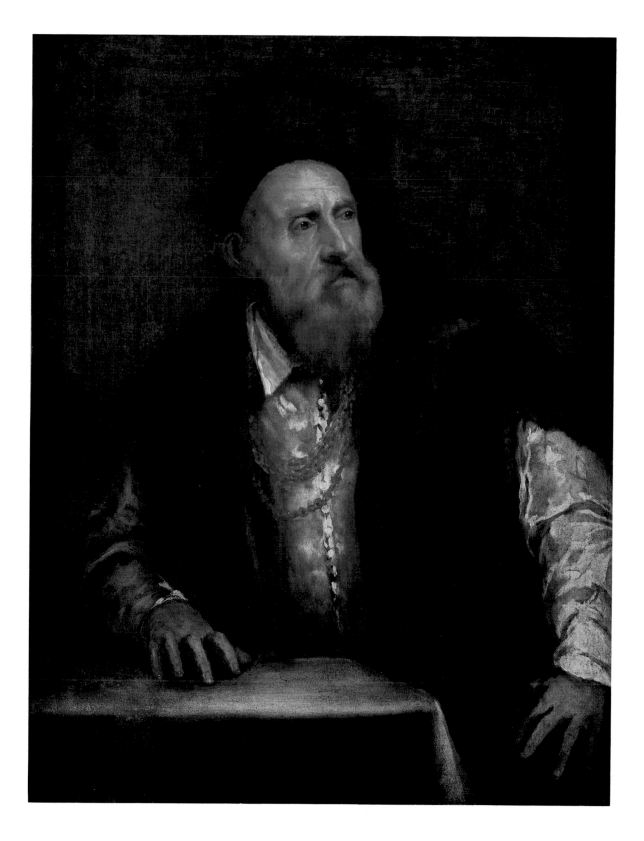

Titian

Entombment of Christ, c. 1565–70

Oil on canvas
51¼ x 66⅛ in. (130 x 168 cm.)
Signed on sarcophagus: TITIANVS F.
Museo del Prado, Madrid

In his very late style from about 1560 to his death in 1576, represented in the exhibition by the *Self-Portrait* of about 1562 and the *Entombment of Christ* of about 1565–70, Titian abandoned color in its traditional pictorial usage for a pervading monochrome that he had used increasingly since the 1540s, but now it is more laden with emotion and symbolic meaning. Chiaroscuro obliterates outlines; form is dissolved in color and space exists through color. Nocturnes are frequent, especially for tragic subjects. More and more introspective, Titian reached the depth of spiritual profundity in his very last works, the *Christ Crowned with Thorns,* c. 1570–76 in the Alte Pinakothek, Munich, and the *Pietà* in the Academy, Venice, conceived for his own tomb but completed only after his death by Palma Giovane.

It was Palma Giovane who told Boschini of Titian's method of working on these late paintings: "he blocked in his pictures with a mass of colors, that serves as the ground...upon which he would then build. I myself have seen such underpainting, vigorously applied with a loaded brush, of pure red ochre, which would serve as the middle ground; then with a stroke of white lead, with the same brush then dipped in red, black, or yellow, he created the light and dark areas that give the effect of relief. And in this way with four strokes of the brush he was able to suggest a magnificent figure." After some months of making periodic revisions "he brought the figures to the highest degree of perfection.... For the final touches he would blend the transitions from highlights to half-tones with his fingers, blending one tint with another, or with a smear of his finger he would apply a dark accent in some corner to strengthen it, or with a dab of red, like a drop of blood, he would enliven some surface—in this way bringing his animated figures to completion.... In the final stages he painted more with his fingers than with the brush." And Titian himself is quoted as saying that he worked like God when he created man.

The first version of the *Entombment* painted in 1556 by Titian for Emperor Philip II was an ill-fated work, mysteriously lost in transit. At Philip's insistence, Titian painted a second version in 1559 that did reach Madrid and is still in the Prado. The reason Titian painted this third version of the *Entombment* is not known. In 1572 it also was sent to Spain, as a gift of the Venetian state to the secretary of Philip II, Antonio Perez, from whose estate it seems to have been acquired in 1585 for the royal collection. In contrast to the more subdued, illusionistic version of 1559, this *Entombment,* a more impassioned, almost expressionistic representation, is emotionally more devastating. In both versions Titian portrayed himself as the aged Joseph of Arimathea; yet he is more grave and sorrowful in this version in which we sense the anguish typical of Titian's late works.

This painting may well be the *Entombment* by Titian recorded in the royal inventory of 1600 and called "a most beautiful work of Titian" by Cassiano dal Pozzo when he saw it in 1626 in Aranjuez. It is certainly the painting recorded as a work of Titian in 1657 by Padre de los Santos in the Escorial, where it remained until it was transferred to the Prado in 1839. De Madrazo (1873) expressed doubts about the attribution to Titian; Crowe and Cavalcaselle (1877) confused it with a copy by Juan del Mazo, who was charged by Philip IV with making copies of the Venetian paintings in the royal collection. In 1925 Longhi restored the attribution to Titian; it has rarely been contested since that time. Berenson (1957) considered the picture to be in great part but not entirely autograph, and Wethey (1969) stands alone in calling the painting a workshop production. The date of about 1570 proposed by Longhi and espoused by Wethey was advanced to 1565–66 by Ricketts (1910), Rothschild (1931), Tietze (1950), Dell'Acqua (1955), Valcanover (1960, 1969), and Pallucchini (1969). To substantiate that date Ricketts proposed that this *Entombment* is the one seen by Vasari in Titian's house in 1566. It is entirely possible that Titian could have painted the picture some years before its shipment to Madrid in 1572 and retouched or "modernized" it before its departure. Wethey noted that the canvas has been cut down a bit on all sides, especially the left, as the copy of it in the Old Cathedral in Salamanca shows.

There is a copy of this work, with some variations, in the Ambrosiana in Milan, cited in the act of donation of April 28, 1618, by Cardinal Federigo Borromeo. Wethey lists five other copies in Spain.

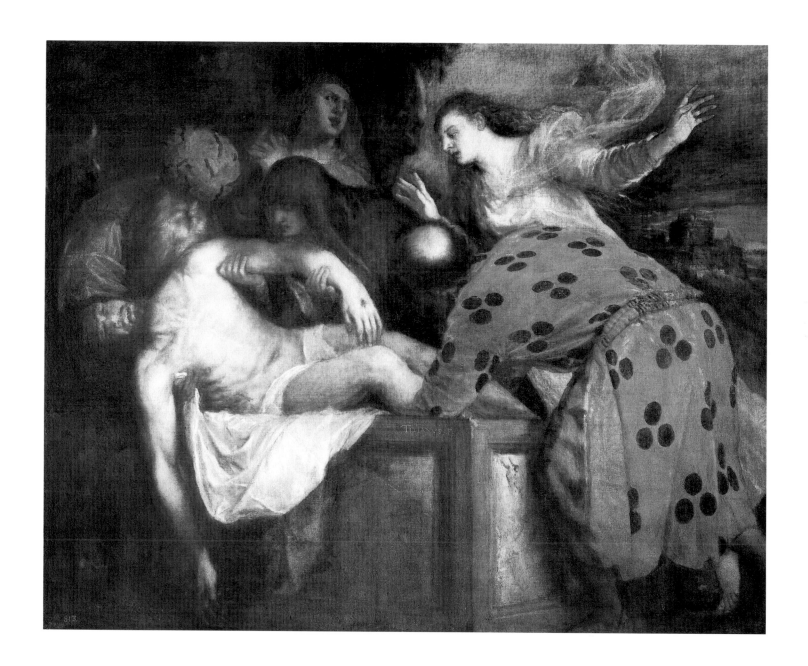

Paris Bordon

Portrait of a Knight in Armor,
1540–45

Oil on canvas
36 x 30 in. (91.4 x 76.2 cm.)
North Carolina Museum of Art,
Raleigh
Original State Appropriation

1500–1571

Paris Bordon exemplifies the level of accomplishment that a talented but not highly inventive artist could achieve in the company of genius. Born in Treviso in 1500, Bordon was brought as a boy of eight to Venice, where he spent most of his life and where he died in 1571. While he was undoubtedly trained in Venice, there is no document that identifies his master. He was, however, listed as an independent painter in 1518. Attracted in his youth to Giorgionesque motifs and sentiments, especially in his pensive male portraits and melancholy lovers, he intensified his palette under the influence of Titian's brilliant color of the 1520s. Bordon painted in the Lombard town of Crema in 1525–26, where his work assumed a somewhat Pordenonesque monumentality. While he created religious and mythological subjects throughout his life, it was his abilities as a portrait painter that brought him to the court of Francis I in France about 1538 and to the imperial court in Augsburg about 1540, where, according to Vasari, he produced many works for the Fuggers. He is noteworthy above all for the fluidity of his colors and the acute realism of his portraits in which he rarely attempted to achieve psychological profundity. A distinctive characteristic of Bordon is his gathered folds of drapery, deeply modeled like the figures and landscape forms in his early work, flattening out into rippling surfaces in his later paintings. G. Mariani Canova in her monograph on Bordon in 1964 indicated two inclinations in the mature Bordon, one toward the elegiac and melancholic, the other toward intellectual over-refinement, and concluded that "the diversity of these two streams, on occasion directly antithetical to one another, produced his singular and by turns striking output."

The attraction of Titian's painting must have been extremely strong for young artists active in Venice in the early Cinquecento, especially for those who came from the provinces and saw him as a fascinating but unattainable model. Such was the case with Palma Vecchio and Paris Bordon. Titian's portraits executed under the patronage of the Estes and the Gonzagas seem to be in the background of this fascinating portrait, in which Bordon fully exploits his fiery colorism in the red velvet and the white plumes of the helmet reflected in the shining armor.

This work was considered a masterpiece of the artist by Cook, according to Bailo and Biscaro (1900). G. Mariani Canova (1964), who dates it between 1540 and 1545, describes it as "a splendid portrait that reveals a singularly lively and fanciful vein" in the artist.

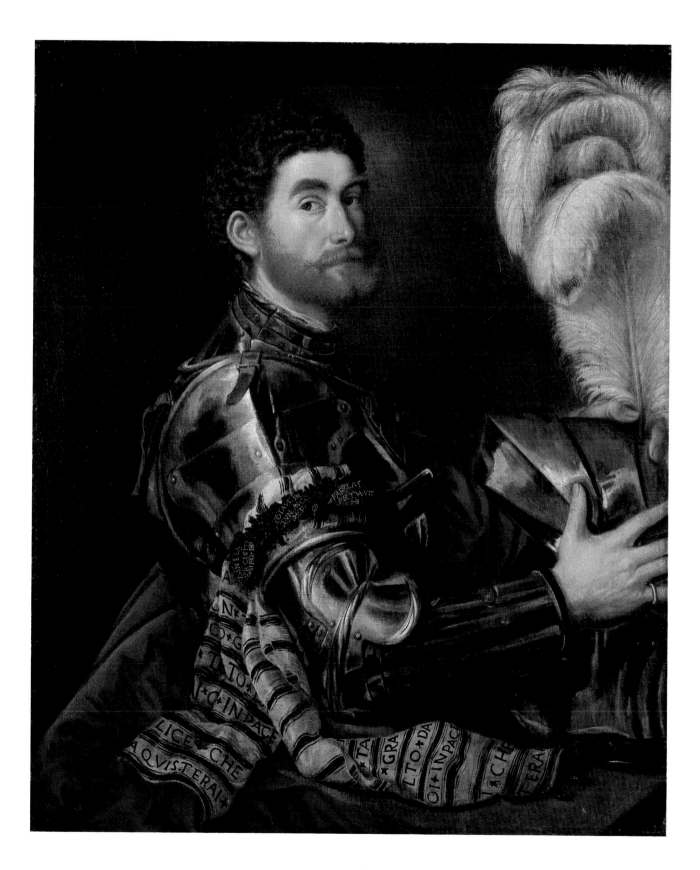

Paris Bordon

Lady in a Green Mantle, c. 1550

Oil on canvas
40⅛ x 30½ in. (102 x 77.5 cm.)
Kunsthistorisches Museum,
Gemäldegalerie, Vienna

Paris Bordon's interpretation of Titian's style is so closely related to the master's spirit as to suggest that Bordon must have studied directly under Titian. And yet in certain female figures, such as *The Lady at Her Toilet* and this *Lady in a Green Mantle,* both in Vienna, Bordon reveals his personal vision, elegant and in a certain way sophisticated. A rain of color, lavish yet well contained within an already Mannerist drawing, gives life to this sumptuous portrait that may depict one of the well-known "courtesans" like the famous Veronica Franco, who played an important part in the social and cultural history of mid-sixteenth-century Venice.

The identification of this picture with the portrait of a woman formerly in the Vendramin collection is based on a pen drawing in the British Museum manuscript *De Picturis in Museeis Domini Andreae Vendramini Positis: Anno Domini MDCXXVII* with sketches illustrating the paintings in the collection.

In the inventories of the Castle of Prague of 1718 and 1737 there is a listing of "two female figures," which has been traditionally interpreted as referring to this painting and its companion in Vienna. G. Mariani Canova (1964), however, has advanced the hypothesis that since there is a single inventory number the entry may refer to a single painting of two women. Bailo and Biscaro (1900) suggested that the sitter is the same as in the *Portrait of a Lady* in the National Gallery, London, perhaps a member of the Brignole family of Genoa. G. Mariani Canova (1964) proposed a date of about 1550, a "sophisticated and refined" period in Bordon's career.

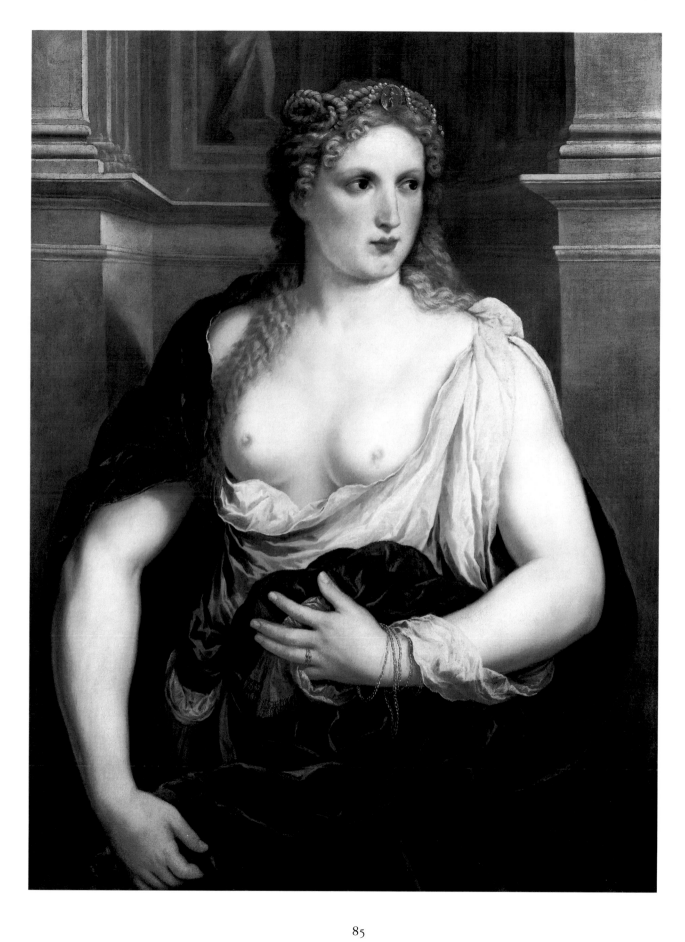

Pordenone

Sts. Sebastian, Roch, and Catherine, c. 1535

Oil on canvas
68⅛ x 45¼ in. (173 x 115 cm.)
Signed : IO¹ˢ ANT¹¹ POR.
Church of San Giovanni
Elemosinario, Venice

Giovanni Antonio de Sacchis, c. 1484–1539

Pordenone, whose powerful forms and vigorous foreshortening influenced Titian, Tintoretto, and Jacopo Bassano, was Titian's only serious rival for the great commissions of the late 1530s in Venice. Born about 1484 in Pordenone, he studied there with Pellegrino da San Daniele, an artist in the tradition of Mantegna, later influenced by Cima. He must at least have visited Venice, for his pre-Roman works, such as the *Madonna della Misericordia* in the Cathedral of Pordenone of 1514–15, clearly reveal his acquaintance with the figural types of the young Titian and the poetry of Giorgione. In 1515 and again in 1518 and 1520 he visited Rome where he absorbed Michelangelo's monumentality and Raphael and Giulio Romano's techniques of dramatic presentation of episodes from religious and secular history. North Italian and Roman elements plus Pordenone's natural boldness combine to form the early mature style of the frescoes in the Cathedral of Treviso of 1520 and the overwhelming scenes of the Passion of Christ in the Cremona Cathedral frescoes of about 1522. Pordenone executed commissions for frescoes and altarpieces across Lombardy, Emilia, and the Veneto, characterized by full, often rugged forms in dynamic movement that frequently break traditional spatial barriers. Pordenone's attraction to the work of Correggio and Parmigianino in the late 1520s, evident in his frescoes in the Franciscan Church of Cortemaggiore, before 1529, and the Sanctuary of Santa Maria in Campagna in Piacenza, 1529–36, added proto-Mannerist elements to the style that he brought to Venice in the late 1530s. Here he painted, among other works, frescoes in the cloister of Santo Stefano and the *San Lorenzo Giustiniani* altarpiece in the Academy, Venice. Late in 1538, Pordenone went to Ferrara and died there suddenly, some say by poison, in January 1539. His death interrupted a career increasingly at odds with traditional Venetian aesthetics.

In the second quarter of the sixteenth century "modern" artists like Pordenone brought to Venice anti-classical stylistic elements from Rome, Florence, and Parma which threatened the tradition of Venetian painting that had been developing from the days of Giovanni Bellini. This altarpiece, painted about 1535 for the Corrieri Chapel of San Giovanni Elemosinario, documents the new style and typifies the late work of Pordenone. In 1550 Vasari wrote that Pordenone accepted the commission to be able to compete with Titian, who a short time earlier had painted *St. John the Almsgiver Distributing Money to the Poor* for the high altar of the same church. Pordenone seems, in fact, to have conceived this work in deliberate opposition to Titian's harmonious and classical colorism. The powerful swelling forms and the rugged aspect of St. Roch are Pordenone's personal characteristics. Typically Mannerist are the centrifugal composition and the figures, psychologically unrelated to one another, pushing out from the center against the confining frame and pressing forward and backward in a shallow space to emphasize the rhythmic movement of shapes and light on which the composition is based. They contrast sharply with Titian's centrally balanced altarpiece of idealized figures in natural but decorous movement in a rationally organized space against a background of clouds and sky. The most obviously Mannerist figure in Pordenone's altarpiece is that of St. Sebastian, somewhat reminiscent of Michelangelo, whose movement is distorted to conform to the curve of the arch and the demands of the compositional pattern. The painting was highly praised by A. Venturi (1928), especially for the St. Sebastian, which "imparts to the entire composition an impulse of rotary motion"; Venturi related this figure to the *St. Sebastian* in the Harrach Collection in Vienna, by a follower of Titian (Fiocco, 1969).

It is entirely possible that Pordenone was given the commission about 1535 to provide fresco decorations for the entire Church of San Giovanni Elemosinario, newly rebuilt after the fire of 1613. Zanetti (1771) stated that Pordenone had painted the cupola, and Crowe and Cavalcaselle (1912) noted a few traces of fresco in the manner of Pordenone on the exterior of the apse, but unfortunately no vestige of Pordenone frescoes here has survived.

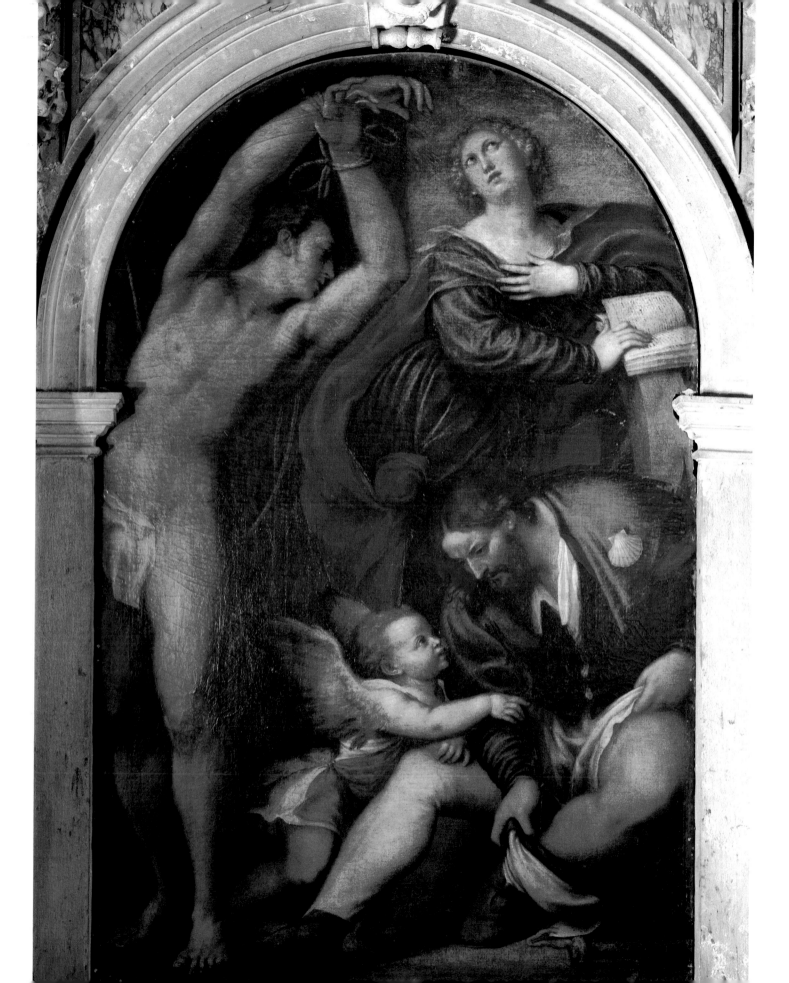

Schiavone

The Annunciation

Oil on panel
37⅜ x 89¾ in. (95 x 228 cm).
Church of the Carmini, Venice

Andrea Meldolla, c. 1503–1563

Schiavone, who maintained a considerable independence of the Venetian tradition, is credited with having introduced the fluid style of Parmigianino to the Venetians and thus to have been a major influence on Venetian art of the second half of the century. He was born Andrea Meldolla or Medulich about 1503 at Zara, or Hyadra, a small town nearby on the Dalmatian Coast, at that time part of the territory of Venice. Nothing remains of his early works executed in Zara and Sebenico before he moved to Venice about 1530. There is speculation that he might at some time have known or worked with Parmigianino in Parma.

By 1530 Mannerism had assumed two quite distinct aspects: one originated by the late Michelangelo, Pontormo, and Rosso; the other best represented in its early phase by Parmigianino. The first is deeply spiritual, with restricted space and with figures—often self-preoccupied—attenuated and contorted to express the state of the soul. The second is sophisticated and elegant, taking its delight in the delicacy and fluidity of line; space is also limited to negate the mundane, and figures are elongated to suggest a higher than usual degree of sensitivity and cultivation. If there are mysteries, they are more poetic than religious. It was this Mannerism of Parmigianino that Schiavone combined with Titian's color of the 1520s and 1530s to create works that appeared innovative and inspiring to the young artists in Venice.

While Schiavone influenced Tintoretto in the 1540s, he later borrowed from him, as he continued to do from Titian. Schiavone's only documented works are three circular ceiling pictures in Sansovino's Library in Venice executed about 1556–57 in a heroic manner that he might also have used for facade painting, quite different from his typical style for panels and canvases. On the basis of tradition, legend, and art historical study, a large body of works

The Annunciation, the first joyful mystery of the rosary, was a subject of great popularity in sixteenth-century Venice. It was conventionally used to depict the human and spiritual experience of Mary or to record the details of the Venetian domestic environment. Schiavone, however, used the subject as a vehicle for expressing pure delight in the rhythmic flow of color. Modeling and even internal structure are suppressed in favor of the play of light and rich, freely applied pigments. The color is clearly influenced by the late Titian, but even in his most improvised works Titian retains an underlying structure. Ridolfi (1648) wrote of another painting by Schiavone in the same church, almost as if he were speaking of a Monet, that it was painted in such a manner that it could best be seen from a distance, since the brushstrokes were too evident close-up. Moschini (1943) concluded in his study on this group of paintings that the highly refined use of color in which a gold glaze prevails, as well as the rapid and sure brushstrokes which create blending forms, make this one of Schiavone's masterpieces.

Ridolfi notes this *Annunciation* as being in the forepart of the choir of the Church of the Carmini, along with the *Nativity* and the *Adoration of the Magi,* all by Schiavone. When the choir was reconstructed a few years later, the paintings were transferred to the parapet of the two grandiose choir lofts, *The Annunciation* to that on the right.

Schiavone The Angel Gabriel

Oil on canvas
107⅛ x 61⅜ in. (272 x 156 cm.)
Church of San Pietro, Belluno

is now recognized as by his hand. Their dating, however, is still uncertain, except for paintings after prints of Parmigianino, which are considered to be relatively early, and those showing the influence of the old Titian which are obviously late. Ridolfi reports that since Schiavone received few major public or ecclesiastical commissions he worked primarily for private patrons, painting palace facades, panels for storage chests (*cassoni*), and both devotional images and mythological and poetic subjects for private houses. Schiavone's contemporary reputation was divergent. Pino (1548) called him a "plasterer" working without adequate study, while Pietro Aretino praised him in a letter of the same year. Vasari wrote that he painted "in dabs or lumps, left unfinished," yet in 1542, when he was in Venice, he commissioned from Schiavone a painting commemorating the victory of Charles V over the Turks. Domenico Tintoretto is quoted by Boschini (1674) as stating that his father had a painting of Schiavone that he retained as a model "to keep in mind Schiavone's great art of using color, strong and immediate." In 1563, the year of his death, he served with Titian, Tintoretto, and Veronese on a committee to judge the mosaics of the Zuccatos for St. Mark's. Schiavone was also noted for his engravings and drawings. Among his most distinguished extant paintings are *The Marriage of Cupid and Psyche* in the Metropolitan Museum, New York, of the later 1540s or early 1550s, and the late *Annunciation* panels from San Pietro, Belluno, of which the *Angel Gabriel* is in this exhibition.

The Angel Gabriel is one of two canvases that comprise the *Annunciation* in San Pietro in Belluno, later and more grandiose than that in the Carmini in Venice. It may also be the most modern painting of the Venetian sixteenth century. The entire work is a tone poem in yellow, gray-blue, and white, with the graceful balletlike movement of the angel, animated by the swirls of drapery and the waving ringlets of hair, softly echoed in the movements of clouds and brushstrokes in the Whistlerian background. Valcanover (1950) has called the landscape background one of the most stupendous of the sixteenth century. This *Angel Gabriel* must be one of the last works of Schiavone, justly compared in technique to the fluttering touch of the late Titian. But Schiavone expresses his own artistic personality in the graphic values which create the nervous dynamism, veiled but perceivable beneath the chromatic surfaces.

The painting must have been known traditionally as a work of Schiavone, for it is recorded as such by two historians of Belluno, Lucio Doglioni in 1816 and Florio Miari in 1843. It was not, however, until the removal of nineteenth-century repaint in the restoration of 1949 that the extraordinary quality of the work was revealed.

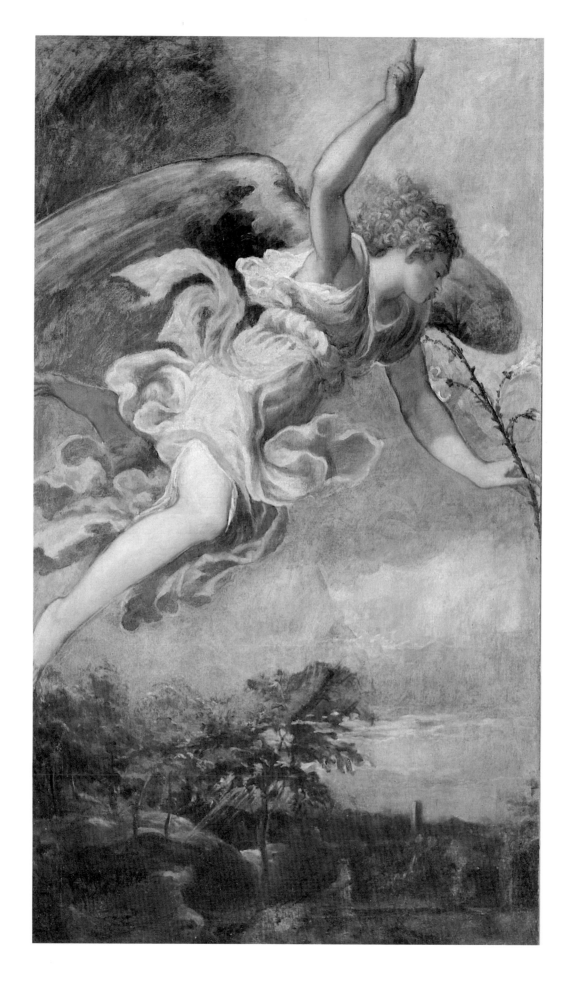

Tintoretto

Sacra Conversazione, c. 1540

Oil on canvas
67½ x 96 in. (171.5 x 243.8 cm.)
Signed and dated lower left:
Iachobus · 1540
Private Collection, New York City

Jacopo Robusti, 1518–1594

Titian used color to make the supernatural seem natural; Tintoretto used light to portray the spiritual in all its mystery and even to give an aura of the supernatural to the natural. It is this quality that makes his paintings at the Scuola di San Rocco, often referred to as the Venetian Sistine Chapel, among the most moving masterpieces in the history of art. Tintoretto was born in Venice in 1518, the son of a Tuscan clothes dyer *(tintore)*. The thirty years that separate him from Titian meant that he was born into another generation, insecure because of social and political changes but with a new religious fervor. While Titian remained a Renaissance artist throughout his lifetime, Tintoretto gave form to the uncertainties and spirituality of the middle and late sixteenth century. Titian's favorite patrons were the emperor and European nobility; his life style was aristocratic and his reputation international. Tintoretto, on the other hand, worked primarily for Venetian churches, confraternities, and officialdom; he led a quiet, middle-class life, entirely devoted to his work.

No precise documentation exists concerning Tintoretto's training. His earliest biographers relate that he was first sent to study with Titian, but after a short time the master became so jealous of the boy's natural ability that he sent him away. It may well be that he did study for a time with Titian and then moved to one of the other leading studios in Venice, that of Bonifazio de' Pitati, Schiavone, or Paris Bordon. Each of these possibilities has been justified in art historical speculation, but the answer is still uncertain. In any event, by 1539 he had become an independent painter.

Tintoretto's stylistic development is well represented in this exhibition beginning with his first signed work, the Michelangelesque *Sacra Conversazione* of 1540. The next eight years were ones of experimentation with the sensitive, elongated forms and sometimes irrational space of

By May of 1539 Tintoretto, a precocious young man of twenty-one, had already set up shop as an independent artist. Until the discovery of this *Sacra Conversazione* and its general acceptance as a work of Tintoretto, the nature of his style at this period was vigorously debated. When the painting first came to the attention of scholars in the mid-1920s, its full Michelangelesque forms were not readily associated with Tintoretto. Its identification was further delayed by von Hadeln's interpretation in 1928 of the hieroglyph that follows the inscription "Iachobus · 1540" as the wheel of a mill *(mulino)* and his conclusion that this was the signature of a painter whom he named "Jacopo Molino." Noting the relation of the *Sacra Conversazione* to Tintoretto's early works, von Hadeln solved the problem by concluding that "Jacopo Molino" must have been Tintoretto's teacher. It was Pallucchini in 1950 who proved Tintoretto's authorship of the painting by careful stylistic analysis. In essence he found Tintoretto using Michelangelesque elements by way of the Florentine Francesco Salviati, who was in Venice in 1539 painting the Cupid and Psyche cycle in the Palazzo Grimani. St. Francis, however, he felt was rather in the spirit of Pordenone. In all the other figures he perceived a pathos and psychological agitation that characterized much of Tintoretto's work

of the 1540s. The most significant personage, of course, is the Madonna, who is accompanied by Sts. Zacharias with his son the infant John the Baptist, Anna, Joseph, Catherine of Alexandria, and Francis, all of whom form a niche in which she sits. The Madonna is so close in conception and form to Michelangelo's *Medici Madonna* in the Medici Chapel, San Lorenzo, Florence, that Stubbelbein (1967) and Schulz (1968) concluded she must be derived from that sculpture. Steinberg (1971), however, proposed that the Tintoretto and Michelangelo Madonnas have a common source in a Hellenistic sculpture of a draped muse now in the Ashmolean Museum, Oxford. It is highly likely, according to Steinberg, that the sculpture was earlier in Venice where both Michelangelo and Tintoretto could have studied it. Steinberg has pointed out a major difference in the Michelangelo and Tintoretto Madonnas. Michelangelo's Child turns back to the Madonna, affirming their unity and her motherhood. Tintoretto's Child, quite independent of the Madonna—a divine Child, heaven sent—turns toward the saints who will continue his mission. No other work of such scale or grandeur is known from this period; it must therefore be considered as the *magnum opus* of Tintoretto's youth.

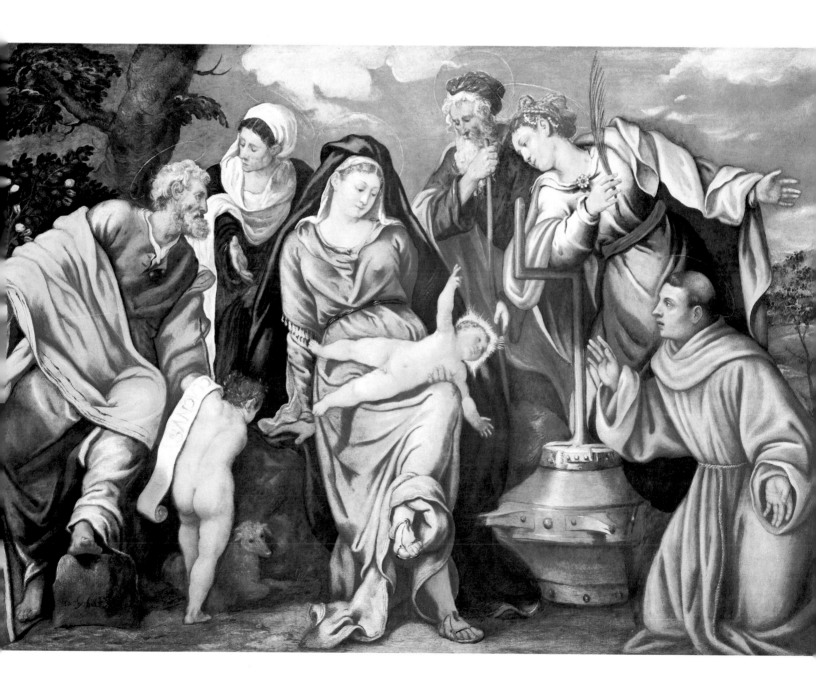

Tintoretto

Christ and the Woman Taken in
Adultery, c. 1546–47

Oil on canvas
53½ x 66⅛ in. (136 x 168 cm.)
Galleria Nazionale, Palazzo
Barberini, Rome

Parmigianino, transmitted through Schiavone. He adapted them to the Venetian tradition of thinking in color and elaborate, stagelike settings. In 1548 he astonished the Venetian art world with the *Miracle of the Slave,* a mature and accomplished work that marked a turning point in his career. The figures have a new plasticity and an integration of form and action that suggest Tintoretto had been studying engravings of works by the late Raphael and his school and by Michelangelo, and at the same time had accepted elements of Titian. The apparition of St. Mark is made credible by the startling foreshortening, and the entire scene is given a heightened dramatic excitement by the light.

The success of the *Miracle of the Slave* was followed by a decade of more tranquil, self-assured works than those of the preceding years. It began with Tintoretto's brief flirtation with classic compositions, represented in the exhibition by *The Fall of Man,* and continued with narratives from mythology, ancient and modern poetry and legend, and the Bible. In them Tintoretto's concentration is not on expression and building tension with light, but on the virtuoso use of form and space, demonstrating his command of the medium with foreshortening, inverse perspective, and an unending variety of compositional relationships. Typical of this period are the *Presentation of the Virgin,* Madonna dell'Orto, Venice; *Susanna Bathing,* Gemäldegalerie, Vienna; and *Joseph and Potiphar's Wife* in this exhibition.

The advent of Tintoretto's most characteristic style coincides with what Max Dvořák (*Geschichte der italienischen Kunst,* II, 1929) calls his "spiritual rebirth" about 1560. It appears already in the *Last Judgment* of about 1560 in the Madonna dell'Orto, Venice; individuals lose their identity in the complexity of the groups that fill the picture plane in seeming disarray, from the depths of earth to the height of heaven, with light flickering over them in a manner that enhances the impression of chaos of that last

Christ and the Woman Taken in Adultery is a notable work in Tintoretto's career since it demonstrates his early commitment to Mannerism and contains in embryo the elements that characterize his mature style of the 1560s and later. In the years following his early Michelangelesque style Tintoretto assimilated Parmigianino's graceful elongation of form and his almost surreal relation of figures to space, both directly and through Schiavone. Yet his developing style is independent and Venetian.

The luminous color and elaborate setting are Venetian; the attenuation and posturing of figures to heighten emotional expression and the use of precipitously receding but somewhat empty space to increase compositional tension are characteristically Tintoretto. Boschini (1674) relates that in planning his compositions Tintoretto used a miniature stage on which he arranged and lighted wax figures. This method of working could well have been used here since every figure and architectural element is calculated to contribute to the dramatic intensity of the scene. In a manner typical of the early Tintoretto, Christ is seated in the midst of an apse-like semicircle of apostles that makes him a principal actor in the drama; the scribes and pharisees scurry away, leaving the adulteress in quiet isolation in an empty central space as the other

protagonist. In the spirit of the earlier and more spiritual stage of Mannerism, Tintoretto has given the scene an otherworldly feeling.

This *Christ and the Woman Taken in Adultery* was recognized as a work of Tintoretto by Adolfo Venturi, who saw it in the collection of Prince Don Mario Chigi before he presented it to the Galleria in 1902. Di Carpegna (1953) reported that Corrado Ricci thought it was instead by El Greco. The attribution to Tintoretto has been accepted by the leading critics except Coletti (1940), who believed that the artist's son Domenico had collaborated on it, and Maxon (1961), who attributed it to an anonymous artist whom he named the "Master of the Corsini Adulteress" after this painting, formerly in the Corsini Gallery.

This work is thought to be an early work by most critics (Pittaluga, 1925; De'Rinaldis, 1932; Berenson, 1932; Barbantini, 1937; Tietze, 1948; A. Pallucchini, 1969) and is generally dated between 1546 and 1548 (Pallucchini, 1950) along with the Dresden *Woman Taken in Adultery.* Von der Bercken (1942) dates it between 1548 and 1550, later than the *Woman Taken in Adultery* in the Rijksmuseum, Amsterdam, while Arslan (1937) and Coletti (1940) concluded that it should be dated about 1550.

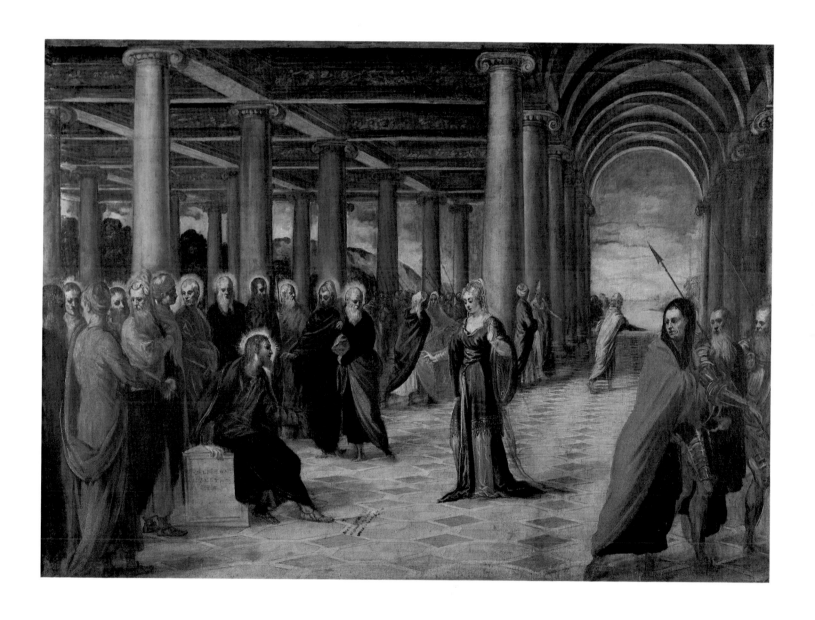

Tintoretto *Self-Portrait*, c. 1547

Oil on canvas
18 x 15 in. (45.7 x 38.1 cm.)
Private Collection, New York City

moment. This mature spiritual style is further developed in the three paintings of about 1562 for the Scuola Grande di San Marco: *St. Mark Rescuing the Saracen* in the Academy, Venice; *The Finding of the Body of St. Mark* in the Brera, Milan; and *The Removal of the Body of St. Mark* in the Academy, Venice. In the latter two, the long, off-center, rapidly receding spaces, the eerie light from torches, the divine radiance and flashes of lightning, and a diminution in the plasticity of the figures validate the mysterious reality of these terrifying events. It was in the Scuola di San Rocco that Tintoretto was to give free rein to his genius. In 1565, having won the competition for a large ceiling painting of *St. Roch in Glory* for the Sala dell' Albergo (hostel) on the upper floor, he was accepted as a member of the Benevolent Society of St. Roch and thereafter provided paintings either free or for such a modest stipend that they can be considered virtual contributions. From 1565 to 1567 he completed the decoration of the Church of San Rocco and the painting for the side walls of the Sala dell'Albergo including the grandiose panorama of the Crucifixion with its scores of figures, to which light gives a compositional unity. The dominance and strength of the figure of Christ, however, leave no doubt of the eternal significance of the divine sacrifice. In the second phase of Tintoretto's work at San Rocco, from 1576 to 1581, he decorated the Sala Grande on the upper floor with Old Testament scenes on the ceiling and New Testament parallels on the side walls. Representative are the *Brazen Serpent* and *Moses Bringing Forth Water from the Rock,* in which God and man, the heavens and the earth are part of a continuous essence in unceasing movement given cohesion by light; they are like the vision of an ancient prophet. Within these concepts he provides a wealth of compositional inventions in the thirty-three paintings in this room. Frequently here are the illusory figures, like chalk drawings of disembodied spirits, that are a leitmotif of Tintoretto. In the final phase of the work on the lower floor

Jacopo Tintoretto's portraiture, of which the first extant examples are from the early 1540s, found its individuality only when it broke away from the Titianesque models from which it sprang. This occurred about 1545 when the expressive tension of Mannerism began to sustain the natural creative impetus of the young artist. It is already evident in this *Self-Portrait* that is closely related to the heads of the apostles in the celebrated *Last Supper* of 1547 in San Marcuola in Venice. Like them it vibrates with a nervous spirituality, realized by staccato strokes of the brush that have the freshness of improvisation that is also found in Tintoretto's youthful drawings of heads from Michelangelo and the antique. A little less than thirty years of age in this portrait, Tintoretto had already revealed himself as unique and inimitable among the Venetian painters, capable of making a profound impression through his aggressive and independent pictorial personality.

The canvas appeared for the first time in the exhibition of *Four Centuries of Venetian Painting* in Toledo, Ohio, in 1940, where Tietze noted in the catalog that Suida considered it a self-portrait because of its similarity to the portrait in the Victoria and Albert Museum, which von Hadeln (1924) had identified as an early self-portrait. Successively, Pallucchini (1950) explicitly defended

it as autograph, admiring the synthetic energy, "prouder, more defiant" than the Victoria and Albert version, and proposed a date of 1545–48, accepted later by Rossi (1973). Von Hadeln (1924) dated the London version about 1548, identifying it with the Tintoretto self-portrait in the inventory of the possessions of the sculptor Alessandro Vittoria. Pallucchini (1950), on the other hand, was inclined to identify one of the two versions with the Tintoretto self-portrait cited by Ridolfi (1648, II, 56) in the house of Nicolò Crasso, "painted by his own hand in his youth." Unfortunately, there is not adequate documentary evidence to associate either portrait with the reference in Ridolfi or the Vittoria inventory.

The excellent quality of this painting and the quite different interpretation of the physiognomy suggest that it is not another version of the London portrait, but an entirely independent painting. In addition, the pictorial treatment in this canvas appears looser and more impromptu, especially in the restlessness of the design.

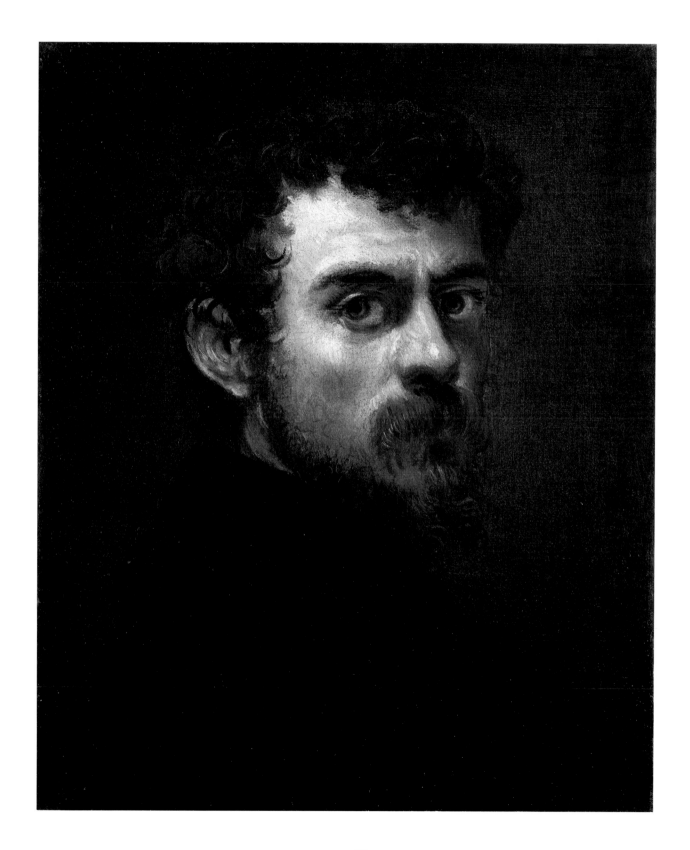

Tintoretto

The Fall of Man, c. 1550

Oil on canvas
59 x 86⅝ in. (150 x 220 cm.)
Gallerie dell'Accademia, Venice

of the Scuola di San Rocco, from 1583 to 1587, are scenes from the life of the Virgin and the two mysterious and disquieting landscapes with St. Mary Magdalen and St. Mary of Egypt.

During these same years, Tintoretto painted in a more official style in the Doge's Palace vast battle scenes and exaltations of the state that were destroyed in the fire of 1577. Their replacements were executed primarily by his son Domenico, his daughter Marietta, and other studio assistants. His own concepts, however, can be seen in the study for *Doge Alvise Mocenigo Presented to the Redeemer,* c. 1577, and the *modello* for the *Paradise,* c. 1588, both in this exhibition. Among his last works is the *Last Supper* in San Giorgio Maggiore, Venice, 1592–94, the culmination of his spiritual expressionism. The composition based on the sharply receding diagonal of the table, the ceaseless motion produced by figural relationships, the illumination by divine light and the fire of the hanging lamp, and the atmosphere filled with smoke and swirling transparent angels bring the scene to a high pitch of excitement. Unlike Leonardo, whose *Last Supper* is a moment of solemn human experience, Tintoretto has given reality to the divine mystery.

After a decade of experimentation with Mannerism, especially that of the late Michelangelo and of Parmigianino, Tintoretto turned to a classic style of solid forms and normative proportions closer to Titian and the Venetian tradition. *The Fall of Man,* with its idealized male and female figures, its gentle light that models the forms, and its harmony of figures and landscape, together with its companion piece *Cain and Abel,* are the ideal exemplars of this new direction. Tintoretto himself is quoted by Ridolfi (1648) as saying he painted "those bodies from nature with great diligence adding to the contours a certain increase in grace which he had taken from sculptured reliefs . . ." The story is told simply, without the emotional intensification of Mannerism. The fall of Adam seems inevitable in the face of Eve's slightly embarrassed offer as she tempts him with the forbidden fruit; it is an unexpected moment of serenity in the work of Tintoretto.

The Fall of Man, Cain and Abel, and *Creation of the Animals* in the Venice Academy along with *God the Father with Adam and Eve at the Tree of Knowledge* in the Uffizi and the lost *Creation of Adam and Eve* were painted by Tintoretto as part of a cycle of nine episodes from Genesis for the Scuola della Trinità in Venice. Three of the series were painted by Francesco Torbido of Verona by 1547, and a fourth shortly thereafter (Ludwig, 1905). Since a document of the Scuola dated September 24, 1550, lists five paintings, Tintoretto must have already completed one of his five, the last of which he finished on November 25, 1553. The first observations on the series were by Borghini (1584) and the first ample description was by Ridolfi (1648), who noted that among all the paintings "the most celebrated are those which depict the errors of our first parents who, persuaded by the Serpent, eat the forbidden apple and Cain killing his brother." In 1631 the Scuola della Trinità was demolished to make room for the construction of Santa Maria della Salute. The paintings were moved to the new Scuola built close by (Martinioni, 1663) and remained there until the Napoleonic decree of 1806 ordered the removal of works of art from convents and benevolent society buildings (scuole). When Pietro Edwards, restorer and curator of the Gallery of the Academy, took possession of *The Fall of Man,* he recorded its dimensions in Venetian feet as 4.5 by 7.7, about 153 by 264 cm. It must have been cut down slightly more than an inch in height and in width about 17½ inches, after 1720, when it was engraved in its original dimensions by Andrea Zucchi for Lovisa's *Gran Teatro.*

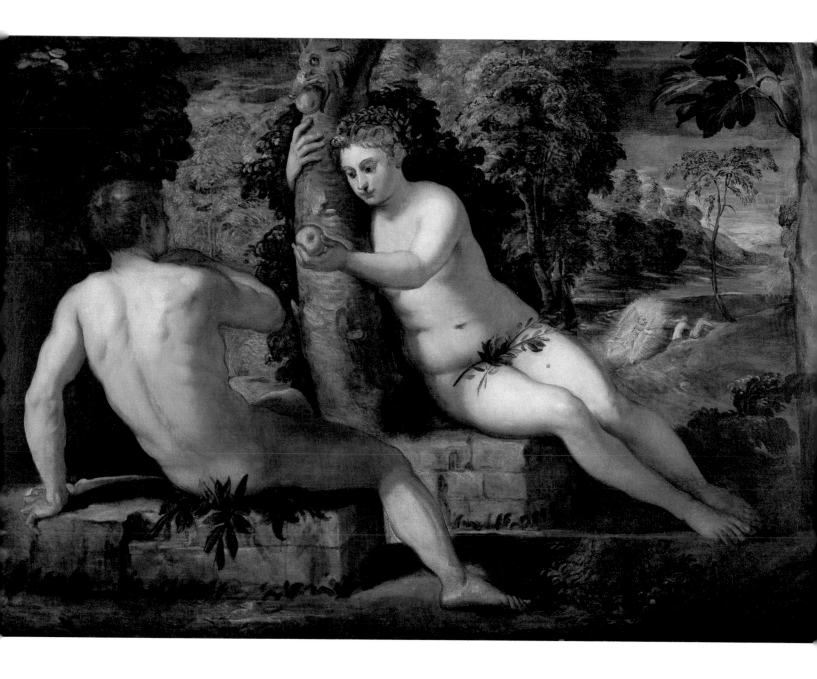

Tintoretto

Portrait of a Venetian General,
c. 1550

Oil on canvas
22½ x 19½ in. (57.2 x 49.5 cm.)
The Armand Hammer Collection,
Los Angeles

The demand for his portraits was so great that Tintoretto found it necessary to limit the number of commissions he could accept. Still he produced more than two hundred portraits, a third of his entire painting production. His sitters were all chosen from the official circles that controlled the Venetian Republic: doges, magistrates, ambassadors, attorneys, and financial and cultural personalities. It is curious that among them there are so few military and naval officers. Only seven are known: three in Vienna, one each in Madrid, Warsaw, and Richmond, Virginia, and the Los Angeles painting in this exhibition. The subject of this portrait has not yet been identified, although the four twisted gold buttons on the cloak over his armor distinguished him as Proveditor-General of the Venetian Republic. The subject was traditionally called Doge Grimani, but there was no Doge Grimani between 1523 and 1595. Suida is quoted in the Bondy catalog (1949) as observing some similarity between the features of this sitter and those of Sebastiano Veniero, the victor in the sea battle of Lepanto as represented in his portrait in the Kunsthistorisches Museum in Vienna, but Suida did not suggest a certain identification. The question may even be raised whether this general was from one of the great Venetian families. His physiognomy suggests that he might have been from the mountainous regions in the north or even from Austria or Bohemia, perhaps a leader of mercenary troops or a soldier of fortune who rose to high rank in Venice. Certainly Tintoretto felt his powerful personality and re-created it, as if he were drawing his subject out of the shadows, revealing stroke by stroke, with shimmering reflections, his inner vitality.

The painting has been shown in a number of exhibitions as a work by Tintoretto dating from 1560 to 1570. The highly graphic treatment of the face—especially the eyes, hair, and beard—produced by incisive strokes of the brush as well as the expressive chromatic density suggests a work from Tintoretto's early career, shortly after 1550. This was the time of the *Portrait of a Warrior in Armor* and the *Portrait of Lorenzo Soranzo,* both in the Kunsthistorisches Museum in Vienna (Rossi, [1974?], color plates VII and IX). This new date plus further archival research may well produce a name and a biography for the Los Angeles general.

Tintoretto

Joseph and Potiphar's Wife,
c. 1555

Oil on canvas
21¼ x 46⅛ in. (54 x 117 cm.)
Museo del Prado, Madrid

After a brief classic period at the end of the 1540s and beginning of the 1550s, Tintoretto turned for the rest of the decade to the most relaxed and unrestrained works of his career. It was during this time that he produced most of his mythological paintings, often erotic, characterized by a free play of form and space. The most joyous and decorative are *Joseph and Potiphar's Wife* and its companion pieces representing episodes in the lives of women of the Old Testament, treated as if they were mythological or at least secular scenes. In this painting the rhythmic, dancelike movement of forms is accompanied by a play of light that picks up the reflections of cloth and gold decorations to give life and movement even to the secondary elements of the composition. Rather than the gravity of the Bible, it has the spirit of the Venetian comedies of the sixteenth century. It is, indeed, the closest Tintoretto ever came to Veronese.

The series of biblical paintings in the Prado, of which *Joseph and Potiphar's Wife* is a part, includes *The Finding of Moses, Solomon and the Queen of Sheba, Judith and Holofernes, Esther and Ahasuerus,* and *Susanna and the Elders.* Borghini (1584) and Ridolfi (1648) mention "eight different subjects of Poetry" which Tintoretto executed for Philip II and with which these are sometimes identified. Sánchez-Cantón

(1942) concluded with much more justification that they were the "paintings of a ceiling of stories of the Old Testament, by the hand of Jacopo Tintoretto. The principal of them being oval in form..." reported by Palomino (1724) as having been bought for Philip IV by Velasquez on his second trip to Venice. He identified the center oval, called by Palomino *Fall of the Manna,* with the *Purification of the Captured Virgins of Midian* in the Prado. That painting, however, is considerably different in style, later and with extensive workshop participation. That the paintings were intended for a ceiling is suggested by the perspective. They were indeed installed at one time on the ceiling of the "alcove" of the first floor of the Alcazar in Madrid, according to the Inventory of 1686.

Pallucchini (1950) dated the cycle about 1544 along with the *St. Ursula* in San Lazzaro dei Mendicanti in Venice. Coletti (1940) dated it about 1555, a date that is generally agreed upon by critics and that has also been accepted by Pallucchini (de Vecchi, 1970). Only Maxon (1961) has contested the attribution to Tintoretto, believing the series to be by the anonymous "Master of the Corsini Adulteress" to whom he also attributed *Christ and the Woman Taken in Adultery* in this exhibition.

Tintoretto

Doge Alvise Mocenigo Presented to the Redeemer, c. 1577

Oil on canvas
38¼ x 78 in. (97.2 x 198.1 cm.)
The Metropolitan Museum of Art, New York City
John Stewart Kennedy Fund, 1910

A constant protagonist in the canvases of the Doge's Palace is the figure of Christ, from whom the Doges of Venice and the representatives of the Magistratures invoked protection and guidance in governing the Republic. A politico-religious union was thus represented, which tended more to guarantee stability and security to the myth of Venice and the power of the Doges than to express any particular devotional intention. In this canvas, a preliminary study for the larger painting in the Sala del Collegio in the Doge's Palace, the Prince of Venice Alvise Mocenigo (1507–77) is being presented to the Redeemer by St. Mark, roughly sketched in the air. At the right are St. John the Baptist, St. Louis of Toulouse, an unidentified saint, and St. Gregory the Great, patron of the Mocenigo family. In the left foreground is the lion of Venice and in the background the Piazzetta with the Doge's Palace to the left, the Library to the right.

Douglas in a letter of 1910 proposed that the painting commemorated the consecration of the city to Christ before the battle of Lepanto. All other writers have related the painting to the plague that devastated Venice from 1575 to 1577.

Von Hadeln (1921) proposed that the Metropolitan picture is the model which Tintoretto submitted to his patrons. He was apparently forced to abandon the model because of the radical changes required in the final version. The latter work in the Doge's Palace, executed with the collaboration of assistants, is of quite inferior quality and is heavily restored (de Vecchi, 1970).

X-rays of the Metropolitan picture have revealed that Tintoretto had drawn a gigantic sketchy figure of St. Mark between the lion and the Doge and then painted it out. A recent cleaning brought to light the two unfinished figures in the sky, most likely further ideas for the figure of St. Mark, which had been overpainted not by Tintoretto but at a later date (Zeri-Gardner, 1973).

Pallucchini (1954) observed the relationship between the figure of Doge Mocenigo in this sketch and that in reverse in Tintoretto's *Madonna of the Doge Alvise Mocenigo* of about 1573 in the National Gallery, Washington, and the woven altar frontal of about 1571 in the Museum of St. Mark's, based on a design by Tintoretto.

The sketch is dated about 1577 by von Hadeln (1921), von der Bercken (1942), Pallucchini (1954), Rossi (1973), and Zeri-Gardner (1973). Burroughs (1911), in the belief that it was not a study for the painting in the Doge's Palace, Pittaluga (1925), and Tietze (1948) placed it between 1577 and 1584, while Berenson (1957) dated it no later than 1581.

Tintoretto

Christ at the Sea of Galilee,
c. 1575–80

Oil on canvas
46 x 66¼ in. (116.8 x 168.3 cm.)
National Gallery of Art,
Washington, D.C.
Samuel H. Kress Collection, 1952

There are moments of fantasy in the work of Tintoretto in which man and nature are combined in an atmosphere of hallucination. It is this spirit in the *Christ at the Sea of Galilee* that has tempted critics to attribute it to El Greco. The painting, however, is typically Tintoretto both in conception and execution: in the concept of Christ sundering the darkness and aiding man, so small and powerless, in his struggle with nature; in the almost surreal luminosity that recalls the light in the later exalted visions of Mary of Egypt and the Magdalen in the Scuola di San Rocco; and in the irrepressible movement of sea and sky produced by flashing and broken highlights.

The subject has sometimes been interpreted as Christ walking on the water from Matthew 14:21 ff. Careful observation reveals that Christ is actually standing on the shore with the water washing up to his feet, following quite literally John 21:1–8, in which Christ after his resurrection appeared at daybreak on the shore of the sea where seven of his disciples had been fishing through the night and had caught nothing. He bade them cast their nets from the right side of the boat and they were immediately filled to bursting. Peter, seeing that it was the Lord, cast himself into the sea to swim to shore. When all arrived, they feasted on their catch.

The attribution to Tintoretto, advanced by von der Bercken and Gronau in 1925, has been accepted by most critics since that time. Tietze (1948) was the first to suggest that it might be by El Greco and later confirmed his belief in that attribution, in which he was followed by Chatzidakis in 1950 (Wethey, 1962). It is primarily the intense blues and the elongated figure of Christ that suggest El Greco, but as Shapley (1973) has observed the composition is too sophisticated and the impasto not thick enough for El Greco at such an early period in his career. Shapley does find close parallels to other works of Tintoretto, for example in the handling of highlights on the crests of waves and edges of clouds in *St. Mark Rescuing the Saracen* in the Academy, Venice, and in the figure of Christ in his *Raising of Lazarus* of 1573 formerly in Viscount Rothermere's collection.

Von der Bercken in 1925 maintained that the painting was from the early 1550s, though in 1942 he placed it in Tintoretto's last years. Borenius (1925) dated it between 1562 and 1566, while L. Venturi (1933) and De Vecchi (1970) agreed on a date between 1591 and 1594. To this writer an intermediate date in the 1570s seems more defensible, a date in which Shapley concurs, probably 1575–80.

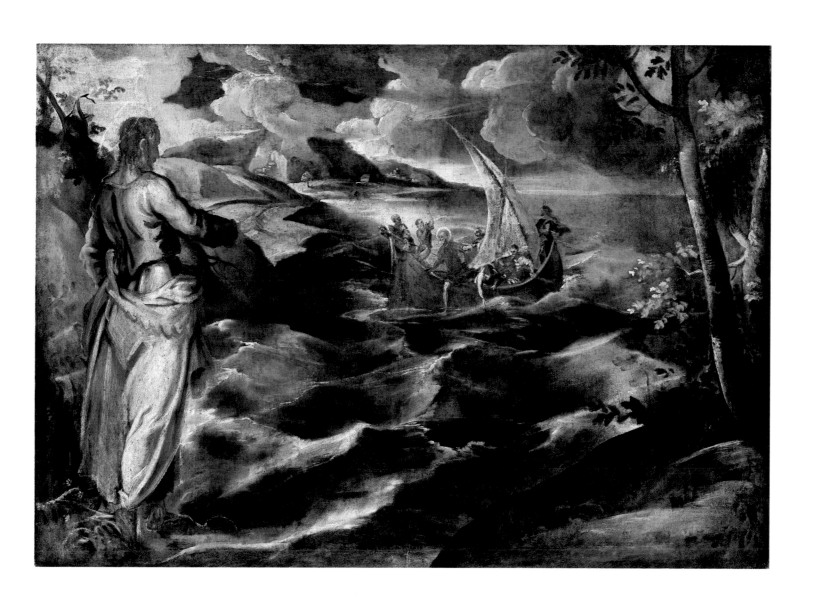

Tintoretto

Paradise, c. 1588

Oil on canvas
60 x 193 in. (152.4 x 490.2 cm.)
Private Collection, Switzerland

This majestic image, only recently rediscovered and recognized by Rodolfo Pallucchini as the *modello* for Tintoretto's *Paradise* in the Sala del Maggior Consiglio in the Doge's Palace, is being shown publicly for the first time in this exhibition. Still known to only a few scholars, it will be published by Rodolfo Pallucchini and Paola Rossi in their collaborative volume *Jacopo Tintoretto—I dipinti sacri e profani,* Alfieri Editrice, Venice, now in preparation.

On December 20, 1577, a fire in the Doge's Palace irreparably destroyed the fourteenth-century fresco by Guariento of Padua depicting the crowning of the Virgin in Paradise, which occupied the whole of the east end wall of the Sala del Maggior Consiglio. The Senate thereupon asked a number of artists to submit proposals for a modern replacement.

Four of the resulting oil sketches have been preserved, all of considerable size but smaller than the *modello* in this exhibition. Of the four smaller sketches, Veronese's is in the Musée des Beaux-arts, Lille; Francesco Bassano's in the Hermitage, Leningrad; Tintoretto's in the

Louvre, Paris; and Palma Giovane's until recently in the Contini-Bonacossi Collection, Florence. They all follow a similar concept from Dante's *Paradiso,* with the Divinity in the center of the dome of heaven surrounded by angels and saints on banks of clouds according to their rank in the heavenly hierarchy. Veronese and Bassano both show the Trinity in the empirium. Veronese's myriad figures are ordered in concentric arcs while Bassano's rise in radial groups from all corners of the canvas to converge on the Divine Presence. Tintoretto, following Guariento, substituted the Crowning of the Virgin for the Trinity. His sketch is lighter and airier than the others, closer to Dante's "heaven that is pure light" (*Paradiso,* Canto XXX, 39–40). An earlier pen-and-wash drawing formerly in the Von Stumm Collection by Federico Zuccari is based on an entirely different conception, adding arches at the ceiling line and employing fresco rather than oil.

The Senate apparently received the proposals in 1579 or 1580, but only in 1587 awarded the commission to Francesco Bassano in collaboration with Veronese, who according to Ridolfi (1648) was to

have painted the Trinity and the choirs of surrounding angels. For a reason that is not documented, although Ridolfi says it was because of the incompatibility of the styles of the two artists, the work had not begun when Veronese died in 1588. At about this time the Senate asked the seventy-year-old Tintoretto to undertake the task. The mammoth canvas, twenty-three by seventy-two feet (seven by twenty-two meters), painted in sections and elevated into place, was unveiled in 1590. The focal center is no longer the coronation of the Virgin, but her intercession with her Son for the Republic of Venice. The design is brought closer to the Veronese-Bassano proposal through the addition of innumerable figures of the blessed from the Old and New Testaments, apparently at the request of the authorities. The execution was left, substantially or entirely, to Domenico Tintoretto, Palma Giovane, and other members of the studio.

Dr. Rossi, who is preparing the catalog entries for the book cited above, has concluded that the newly discovered *modello* is a work of the late 1580s and is consequently the only document that has thus far come to light of the post-Veronese phase of the commission. It differs considerably from the earlier Louvre sketch. Emphasis has shifted to the personages, more numerous and more easily identifiable, although the beauty of the heavenly light is retained in the pastel areas. Space is no longer measured by stratified circles but has become indefinable, with clusters of figures floating like nebulae in the cosmos. The *modello* was not followed closely in the executed mural but points the way to it, as Dr. Rossi will discuss in the publication mentioned above. Since the painting in the Doge's Palace was done primarily by assistants, it is this *modello* that preserves Tintoretto's final conception of that celestial beatitude that rewards a good life.

Domenico Tintoretto

Portrait of a Lady in White

Oil on canvas
46 x 37 in. (116.8 x 94 cm.)
Dr. and Mrs. Bob Jones, Greenville

Domenico Robusti, 1562–1635

The son of Jacopo and the closest collaborator on his father's large-scale works in the Scuole and the Doge's Palace, Domenico was born in Venice in 1562 and died there in 1635. He lived so much in the shadow of his father until the latter's death in 1594 that it is difficult to establish his artistic development. Ridolfi (1648) wrote that from his youth Domenico was a gifted portraitist, and it is for his portraits, sometimes confused with those of his father, that he is best known. Many of the historical paintings in the Sala del Maggior Consiglio, painted between 1581 and 1584, are his. In 1586 he became a member of the Scuola di San Marco, one of the six leading Venetian benevolent societies, and contributed to the decoration of the society headquarters next to Santi Giovanni e Paolo. After his father's death he continued to produce works in the spirit of the Tintoretto studio, but progressively accentuated a mundane realism and a gray, metallic tone in his light effects as in his scenes of the miracles of St. John the Evangelist in the Scuola di San Giovanni Evangelista. He continued to paint portraits in the manner of his father, from whom he distinguished himself by a decorative exuberance and an elegance of pose and costume that express a courtly manner rather than an underlying human dignity.

An imposing three-quarter view, an armchair ample enough to accommodate a mountain of silk, velvet, and brocade, lace at the sleeves and shoulders, abundant jewels—these are the ingredients of a typical "Portrait of a Venetian Lady" of the mid-sixteenth century. If the artist is Jacopo Tintoretto, then one must add a dash of sorcery in the handling of light, at times a preoccupied expression, and almost always an individualization of personality. If instead the artist is Jacopo's son Domenico, the touches of lace will seem to come alive, creating a fanciful conchlike frame for the head; the hair will rise in masses of lively curls, and the total aspect will be one of vivid courtly femininity. We can easily visualize Domenico's ladies gliding through the salons of a palace by Sansovino, like stately Venetian vessels returning from a celebration.

Originally attributed to Veronese, this portrait remained practically unknown until its acquisition by the Bob Jones Collection. There it is modestly called school of Tintoretto; it is, however, quite clearly the work of Jacopo's son Domenico. This is demonstrated not only by the figural conception and technique, but specifically by Domenico's characteristic chiaroscuro in, for example, the dramatic touches of lace decorating the white damask gown. The attribution is further attested by the similarity of the conception of the figure and the handling of costume here and in Domenico's generally recognized masterpiece, the *Portrait of a Seated Lady,* formerly in the Liechtenstein Gallery in Vienna (Rossi, 1973, figure 264).

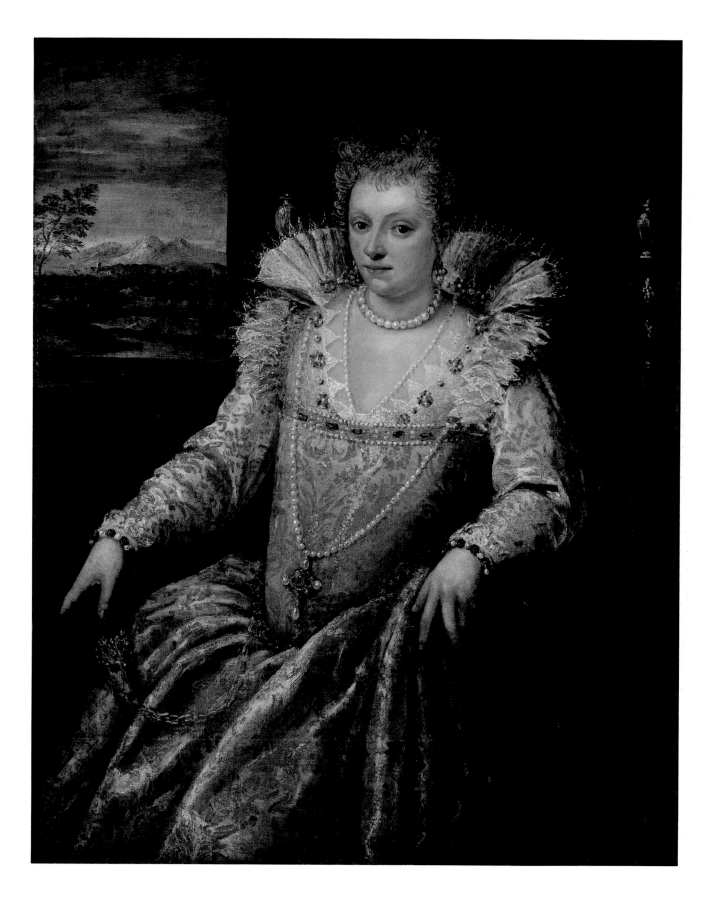

Veronese

Portrait of a Venetian General in Armor, c. 1551

Oil on canvas
78 x 47 in. (198.1 x 119.4 cm.)
Private Collection, Paris

Paolo Caliari, 1528–1588

Veronese in the sixteenth century, like Matisse in the twentieth, raised decoration to the highest level of art. He was born Paolo Caliari of a stonemason in Verona in 1528. While he received his early training in Verona under Antonio Badile, he must have traveled to Mantua and Parma where he could admire the frescoes and oils of Giulio Romano, Correggio, and Parmigianino. It is these artists who are the source of his early works, such as the Bevilacqua altarpiece of 1548 in the Museo Civico in Verona and the Giustiniani altarpiece of 1551 in the Church of San Francesco della Vigna that mark Veronese's first appearance in Venice. Since his stylistic development is discussed at some length in the introduction to this catalog, only his most important undertakings will be reported here. From 1553 to 1556 Veronese, still in his mid-twenties, was employed in the decoration of the Consiglio dei Dieci in the Doge's Palace. In 1556 and 1557 he participated in the decoration of the Libreria Vecchia finished shortly before by Sansovino, where Titian praised him as the best of the young artists engaged there. Intermittently, from 1555 until about 1570, Veronese dedicated himself to providing frescoes and altarpieces for the Church of San Sebastiano in Venice. During those same years, he painted frescoes in numerous villas of which the only remaining complete cycle—Veronese's undisputed masterpiece—is in Palladio's Villa Barbaro at Maser. In 1566 he married Elena Badile by whom he had two sons, Carletto and Gabriele, who along with his brother Benedetto collaborated with him. After the disastrous fire of 1574 in the Doge's Palace, Veronese designed a new ceiling for the Sala del Collegio with allegorical paintings exalting Venice; after the second fire

Veronese's portraits, which first appeared in Venice about 1550, clashed drastically with some of the fundamental rules of Venetian painting. The young artist, having just arrived as a twenty-year-old from the provinces, seemed to ignore Titian's theatrical grandiloquence as well as Tintoretto's symbolism. Instead, he favored the intimacy and candor of the Lombards like Moretto or Moroni. This little-known portrait of a warrior dates from the earliest years of Veronese's career; it is patiently and incisively drawn, highlighted by a play of reflections on the accurately modeled surfaces.

Between its exhibition in Hartford in 1943 and its reappearance in this exhibition, the painting disappeared from view and was known to scholars only through photographs. It had apparently been attributed to Giorgione while in the Hamilton Collection, since it appears as such in the sale of the collection in 1882 although with incorrect measurements, 78 x 47 cm. Valentiner and Suida rightly certified the painting as by Veronese, comparing it to the *Family Portrait* in The Fine Arts Museums of San Francisco now considered to be by Fasolo, with no relation to the painting under consideration. What we have here is an extraordinary example of Veronese's

early portraiture, perhaps his earliest portrait, which can be related to the *Portrait of Francesco Franceschini* in the Ringling Museum, Sarasota, Florida, and the da Porto portraits, one in the Walters Gallery, Baltimore, and the other formerly in the Contini-Bonacossi Collection, Florence. This would suggest a date of about 1551, the inscribed date of the Franceschini portrait.

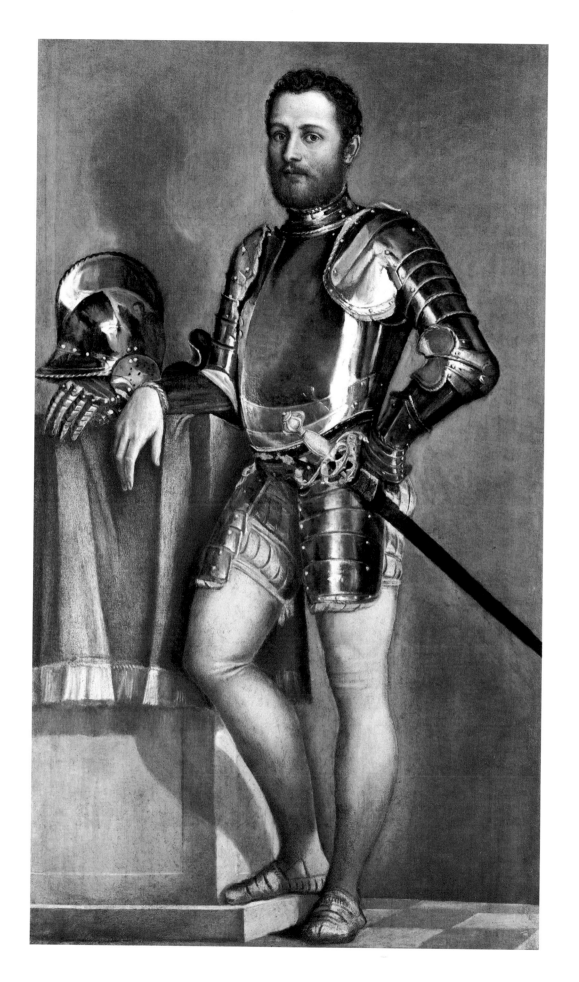

Veronese

Virgin and Child with Angels Appearing to Sts. Anthony Abbot and Paul the Hermit, 1561–62

Oil on canvas
112 x 66½ in. (284.5 x 168.9 cm.)
Chrysler Museum at Norfolk
Gift of Walter P. Chrysler, Jr.

of 1577, he collaborated on the restoration of the Sala del Maggior Consiglio. During the 1570s he painted banquet scenes of grandiose size, among which the *Feast in the House of Levi* of 1573 is famous for the charges of lack of respect for the scriptures and suspected heresy brought against Veronese by the Inquisition. About 1580 he began to paint for Emperor Rudolph II, to whom he dedicated a series of allegories, many of them erotic. These were followed, as if in reaction to their subject matter, by Veronese's late religious paintings, intense and intimate in their drama. He died in Venice in 1588, but his delight in joyful and luminous color was born again in the eighteenth century in artists from Sebastiano Ricci through Giambattista Tiepolo.

It has been said that Veronese was not a painter of religious subjects, but rather of great Venetian secular scenographic compositions. Throughout his career, however, he produced altarpieces that unite a moving if sumptuous sense of the religious with an extraordinary brilliance and sonority of color and a theatrical richness of composition. Certainly, Veronese's Church is a Church Triumphant rather than a Church Suffering. Recall, for example, the glowing draperies of his Madonnas or his angels spread across blue skies like magnificent clouds over a golden sunset. *The Virgin and Child with Angels Appearing to Sts. Anthony Abbot and Paul the Hermit* and its two companion pieces document one of the happiest moments of Veronese's colorism.

On December 27, 1561, Veronese received a commission to paint three altarpieces for the chapels dedicated to St. Nicholas, St. Anthony Abbot, and St. Jerome in the abbey church of San Benedetto Po in Mantua. On March 30, 1562, payment was made for the commission (Caliari, 1888-Doc. 21). The canvases, mentioned by Vasari (1568) and Borghini (1584) and described by Cadioli (1763), were dispersed during the Napoleonic period (Zannandreis, 1891) and were replaced by copies (*Inventario degli oggetti d'arte in Italia,* VI, Mantua, Rome,

1935, 148). Fiocco (1928) was the first to suggest that the *Consecration of St. Nicholas as Bishop of Mira* in the National Gallery, London, was part of the series, a thesis accepted by all modern critics. In 1960 L. Venturi identified the altarpiece of the Chapel of St. Anthony Abbot with *The Virgin and Child with Angels Appearing to Sts. Anthony Abbot and Paul the Hermit,* then in the Chrysler Collection in New York. The third painting for the altar of St. Jerome, representing the *Madonna and Child in Glory with St. Sebastian,* was destroyed in the nineteenth century by a fire in England where it had been taken along with the *Consecration of St. Nicholas* (Gould, 1959).

The dimensions of this painting, almost identical to those of the London altarpiece, along with stylistic similarities, confirm L. Venturi's hypothesis that this beautiful work belongs to the San Benedetto Po series.

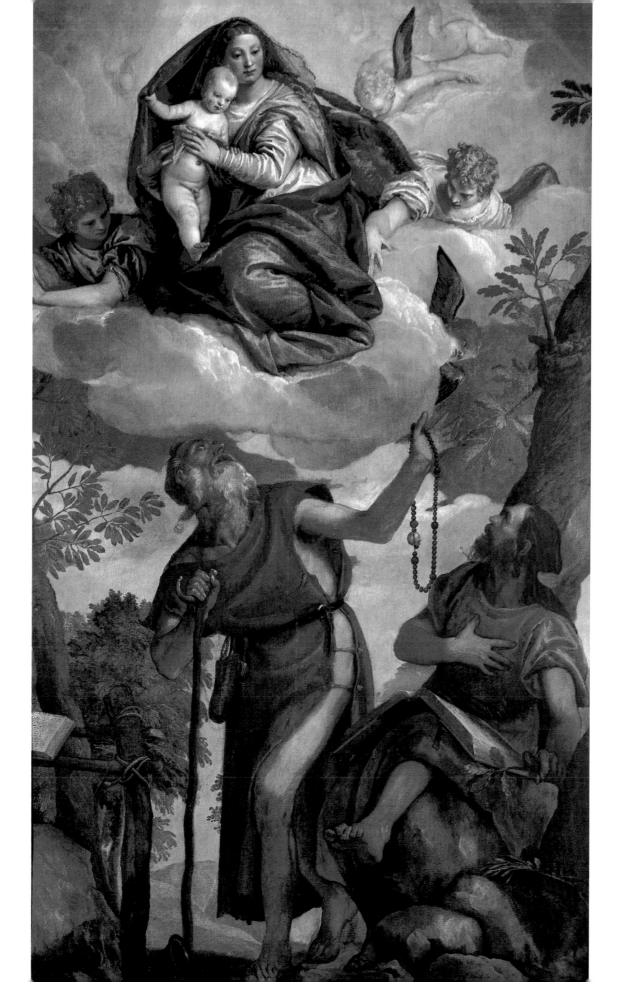

Veronese

Allegory of Navigation with Astrolabe, 1565–70

Oil on canvas
81 x 46 in. (205.7 x 116.8 cm.)
Los Angeles County
Museum of Art
Gift of The Ahmanson Foundation

There are at times individual works in the complex history of an artist that seem to synthesize his poetic values and express them in the most concentrated manner. If we were to choose works of this nature from Veronese's production, we would certainly include these two "navigators." It is easy to detect in these figures Veronese's magnificent compositional inventiveness, supported by striking architectural elements; the figures move in space with the infallible sureness of seasoned actors. They have that particular dash of curious and evocative fantasy that makes Veronese's characters unique: the young man with the cross-staff who so clearly expresses his confidence in the stars and the old man preoccupied with arcane celestial calculations on his astrolable. Finally Veronese's color triumphs—his melodious, clear, transparent color made up of juxtaposed tints like the stripes of a banner triumphantly waving in the wind. These canvases are illuminated by a marine light that is particularly suited to their theme and their destination, which could only have been a palace overlooking the waters of the Most Serene Republic.

The *Allegories* were probably acquired in Italy in the early nineteenth century by John Campbell, Marquess of Breadalbane on behalf of the Baillie-Hamilton family of Langton near Duns, Berwickshire, Scotland. In 1881 Robert Baillie-Hamilton lent them as "Geometry and Navigation" and "Astronomy" to an exhibition at the Royal Academy, London (nos. 164, 166), where they were singled out for praise by the critic of *The Athenaeum.* In 1911 they were sold to an American, Robert Goelet, whose house in Newport, Rhode Island, was donated to the Catholic Church in 1947, becoming Salve Regina College. The two pictures later passed to the London market in the Sotheby sale of December 12, 1973, and then, by way of Thomas Agnew and Sons, to the Los Angeles County Museum of Art in 1974, as a gift of The Ahmanson Foundation.

With regard to the iconographic meaning of the canvases, Clovis Whitfield, who generously communicated his opinion to me, rightly thinks that they must have

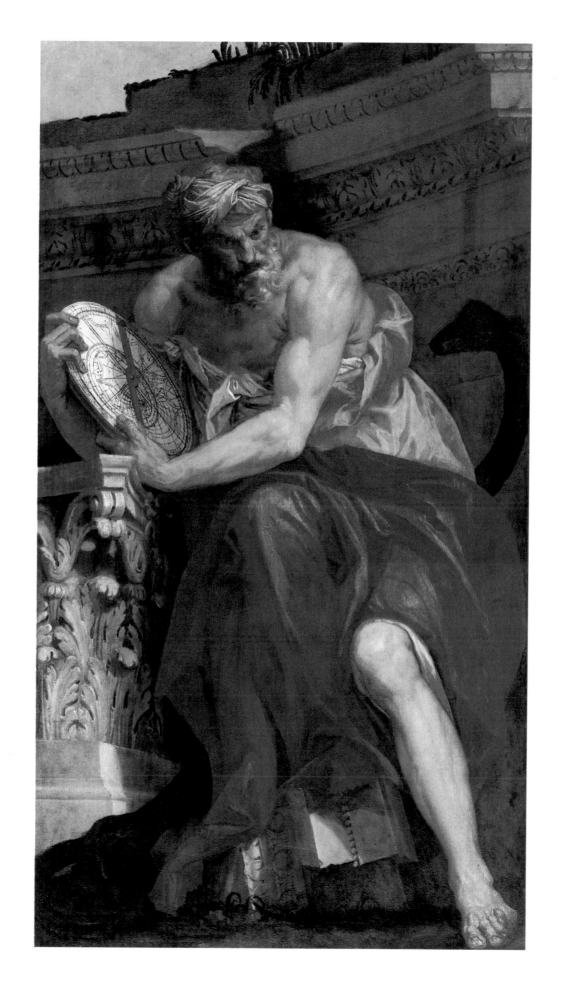

Veronese

Allegory of Navigation with Cross-Staff, 1565–70

Oil on canvas
81 x 46 in. (205.7 x 116.8 cm.)
Los Angeles County
Museum of Art
Gift of The Ahmanson Foundation

originally been part of a complex decoration, in a place somehow connected with navigation—a public magistrature or perhaps the home of a Venetian admiral. In fact, the instruments that the two "astronomers" hold in their hands are precisely identifiable: one, composed of eccentric discs, is the well-known instrument for determining the height of the stars on the horizon, called the "flat astrolabe"; the other, in the shape of a cross, is a "linear astrolabe" with sliding listels, also made to measure the angle of certain stars in relation to the surface of the sea, and used particularly for navigation until it was replaced by the sextant. Another proof that the canvases were originally part of a single decoration is the architectural background that runs from one to the other, creating a sort of scenographic niche.

The two *Allegories of Navigation* belong to Veronese's mature years and are among his most superb achievements. They have the same quality as the figures of the martyrs in the church of San Sebastiano in Venice, and they share their typical fluid colorism, with broad transparent layers of paint of an extraordinary clarity and luminosity. They should therefore be dated between 1565 and 1570. The cleaning of the paintings by Modestini in 1974 re-

vealed them to be in an exceptional state of conservation.

Two related paintings, cut off at three-quarter length (57⅛ x 42⅛ in., 145 x 107 cm.), are in the Courtauld Collection in Umtali, Rhodesia. One, except for the missing lower part, is practically identical to the Los Angeles astronomer with the cross-staff. The other represents a different figure in Near Eastern costume holding an armillary sphere—an instrument derived from the astrolabe and similar in use—another motif from the realm of navigation. They were attributed to Veronese by Marini in 1968 before the rediscovery of the Los Angeles paintings. Later copies of all three figures are in the Musée des Beaux-arts, Chartres.

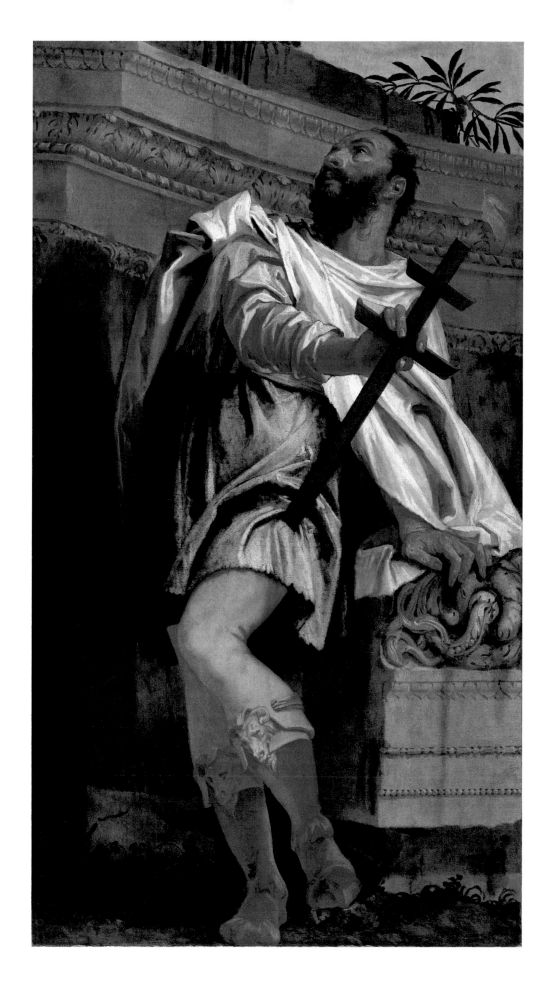

Veronese

Diana and Acteon, late 1560s

Oil on canvas
10 x 43½ in. (25.4 x 110.5 cm.)
Museum of Fine Arts, Boston
Gift of Mrs. Edward Jackson
Holmes

Could a great artist like Veronese, at the height of his fame, undertake small-scale works like those of an artisan: furniture decorations or *cassone* panels? If we consider the series of four paintings in the Boston Museum of Fine Arts, of which this *Diana and Acteon* is a part, it seems that this actually did happen. There is no doubt that the spirit of the antique in this painting corresponds to a certain aspect of Veronese's style, which

can be seen in his paintings of classical themes at Maser. The color is unmistakably Veronese's, luminous and full of chromatic joy, evoking a mythical Golden Age with the full, resonant beauty of its impasto.

This small canvas is part of a series formerly in the Holford Collection in London, sold by Christie's on July 15, 1927, to Edward J. Holmes of Boston and donated to the Museum of Fine Arts in 1959. In 1934 Fiocco, based on information given him by Morassi, published them as original works of

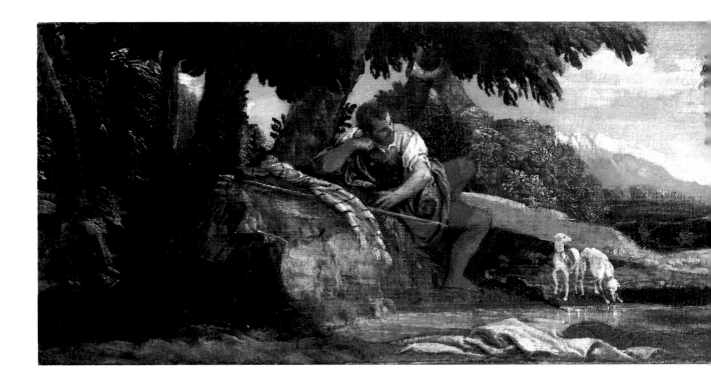

Veronese's youth belonging to a single series, most likely *cassone* panels. In 1935–36 Morassi himself dated them about 1560. Pallucchini (1939) believed that the four works could perhaps be identified with the "seatbacks" painted for Marc Antonio Barbaro, procurator of St. Mark's, which Ridolfi (1648) mentioned as being in the Nani home on the Giudecca.

Upon examination after their recent cleaning, it is evident that these little stories—even though they present a lack of continuity in execution—correspond to Veronese's works of the late 1560s. They demonstrate a classical spirit that recalls, albeit distantly, the frescoes at Maser.

Ridolfi (1648) mentioned a painting by Veronese of *Diana and Acteon* in the Curtoni Collection in Verona, but for Suida (1945) that canvas is identifiable with the painting of the same subject in the Johnson Collection in Philadelphia.

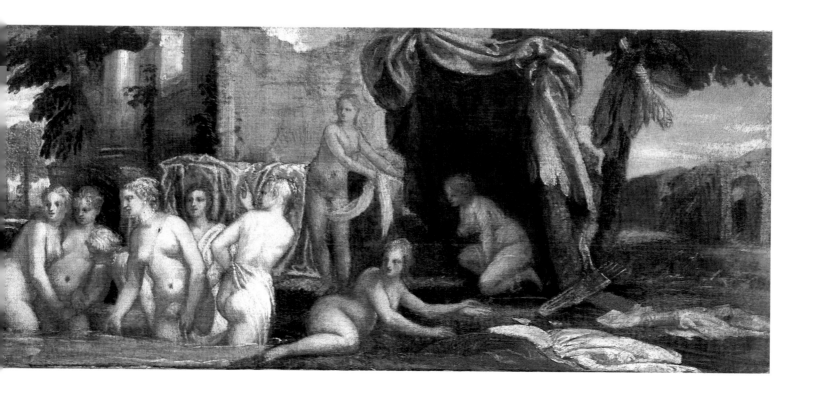

Veronese

Portrait of Agostino Barbarigo, 1571

Oil on canvas
44½ x 45¾ in. (113 x 116.2 cm.)
The Cleveland Museum of Art
Holden Collection

The Venetian admiral Agostino Barbarigo, killed at Lepanto in 1571 by a Turkish arrow, is here portrayed by Veronese in full armor, with the fatal weapon in his hand. The painting has all the calculated scenic planning of an "in memoriam" portrait. A master at balancing the internal elements of a composition, Veronese plays upon the mirrored surface of the armor in contrast to the soft curtain in the background in order to emphasize the face, which is drawn with a chiseled fineness that also distinguishes the bronze bust of Barbarigo sculpted by Tiziano Aspetti for the Doge's Palace.

This portrait was originally in the collection of the Manfrin family in Venice. When it was acquired in 1928 by the Cleveland Museum of Art, it was therefore thought to be a portrait of an Admiral Manfrin; but Gombosi (1928), on the basis of a comparison with other portraits of Agostino Barbarigo, proposed the present identification of the sitter, which has been accepted by later critics. In fact, Ridolfi (1648) mentioned a portrait of Barbarigo by Veronese. Arslan (1946–47, 1948), however, doubted that this portrait was autograph, suggesting instead Veronese's son Carletto as the author. Pallucchini (1939) related the work, which he dated about 1570, to the portrait of the same subject in the Budapest Museum of Fine Arts, as well as to the beautiful drawing of armor in the Berlin Kupferstichkabinett (no. 5120), which, however, is closer in style to the lost paintings of *St. Sebastian* and *Mars and Venus* (Tietze-Conrat, 1959–60). The date of the death of Barbarigo, 1571, is also the probable date of the portrait.

A school copy of this portrait (Fredericksen-Zeri, 1972) without the column on the left, formerly in the Lewis Einstein Collection, has been in the National Gallery in Washington since 1957 (Walker, 1965).

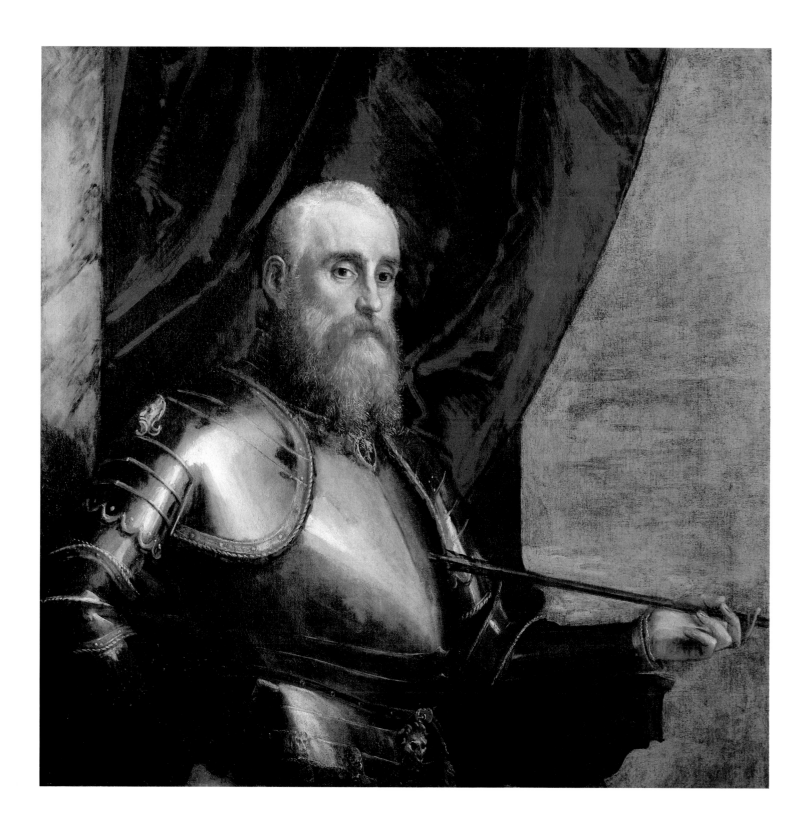

Veronese

The Annunciation, 1572–73

Oil on canvas
41¼ x 32¾ in. (104.8 x 83.2 cm.)
Suida Manning Collection
New York City

This *Annunciation,* iconographi-
cally unique among Veronese's
works, suggests that the painter in-
tentionally wanted to present the
scene as if it were happening in
Venice. In fact, the terrace to which
the angel lightly descends is quite
similar to those designed by San-
sovino for the Palazzo Corner on
the Grand Canal. In addition, the
Madonna, who leans on one of the
typically Venetian stone seats near
the columns at the sides of the bal-
cony, resembles a Venetian girl
with her little dog, surprised at her
reading. Even the light recalls that
reflected from the slightly misty
Grand Canal in the early morning,
with a brilliance of blinding
intensity.

While Berenson (1958) believed
this work to be only partially by
the hand of Veronese, the canvas
was included as autograph by
David Rosand in the exhibition
Veronese and His Studio in Birming-
ham, Alabama (1972). We also
believe it to be entirely the work of
Veronese, from about the time of
The Annunciation in Cleveland. The
color, which is faceted and rich in
light effects, is characteristic of the
master's last works.

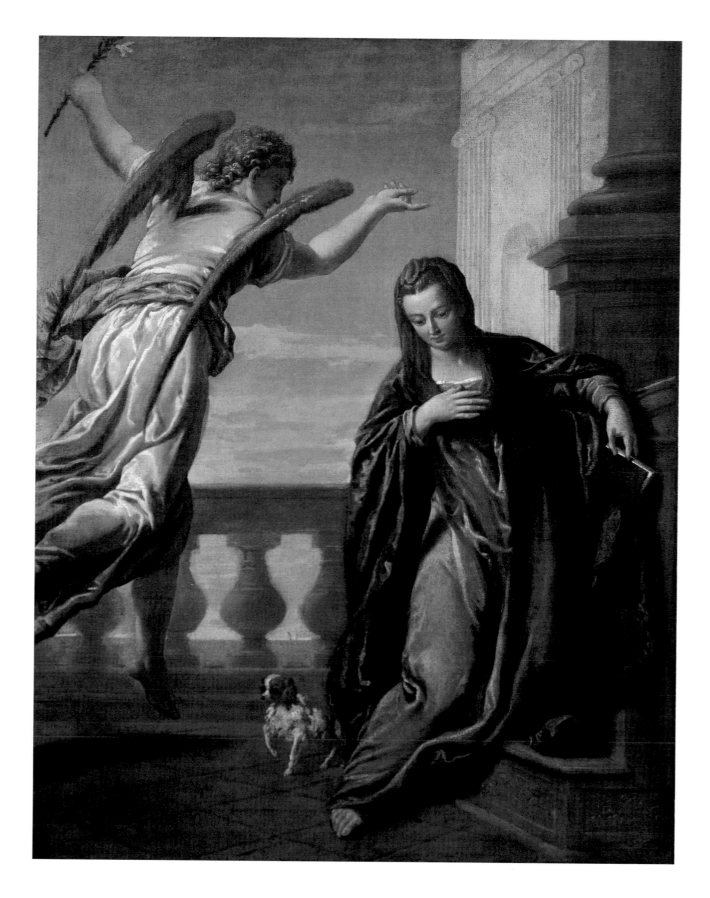

Veronese

Venus at Her Toilette, early 1580s

Oil on canvas
63½ x 47½ in.
(161.3 x 120.7 cm.)
Joslyn Art Museum, Omaha

In some of his late paintings Veronese employed a single dominant color to achieve more expressive compositional force. This he did most frequently in paintings of isolated figures, like the Vienna *Lucrezia,* the Colonna *Venus,* and the Prado *Magdalen,* in which a single tone of green or pink or gold provides, as in music, the major or minor key of the entire composition. A dark, velvety green imbued with golden reflections provides the key for this sinuous and sophisticated *Venus.* There is a sort of melancholy in the work, accentuated by the gentle touches of the Cupid and the billing doves.

Borghini (1584) mentioned that a painting of this subject was commissioned by Rudolph II along with another picture of *Mars, Venus, and a Weeping Cupid.* Ridolfi (1648) listed three paintings of *Venus at the Mirror* by Veronese: one belonging to Rudolph II and the other two to the Bevilacqua and Muselli families in Verona. The Omaha painting does not appear in the seventeenth-century inventories of the imperial collection. The Bevilacqua and Muselli pictures turn out to be one and the same, as is evident from the litigation over it between the two families who owned it jointly, at the time of an attempted sale to the Duke of Modena in the mid-seventeenth century (Campori, 1870). The painting remained in the possession of the Bevilacqua family until 1805. Its history of ownership is complete from that time until it entered the Joslyn Art Museum. Thus it is identifiable as far back as the Muselli Inventory of 1662, where it was thoroughly described (Campori, 1870), and therefore also identifiable with the painting seen by Ridolfi in the Bevilacqua Palace in Verona in 1648. The attribution to Veronese has been affirmed by von Hadeln (1929), Fiocco (1934), Poglayen-Neuwall (1934, as a derivation from Titian), Marini (1968), Franzoni (1970), Fredericksen-Zeri (1972), and, with doubts, Cocke (1974, 1975).

The highly original conception of this picture—in contrast to Titian's conventional *Toilet of Venus* seen from the front—as well as the dense colorism with the typical shimmering effects of Veronese's late style indicate the authorship of Veronese. Uncertainties in the face reflected in the mirror and in the Cupid, for example, can probably be accounted for by the state of conservation of the painting; but on the whole the hand of Veronese is unmistakable. The picture dates from a period quite close to the time of the Vienna *Lucrezia* at the beginning of the 1580s. Very little known to the public, this painting may well be considered one of the rediscoveries of modern Veronese criticism.

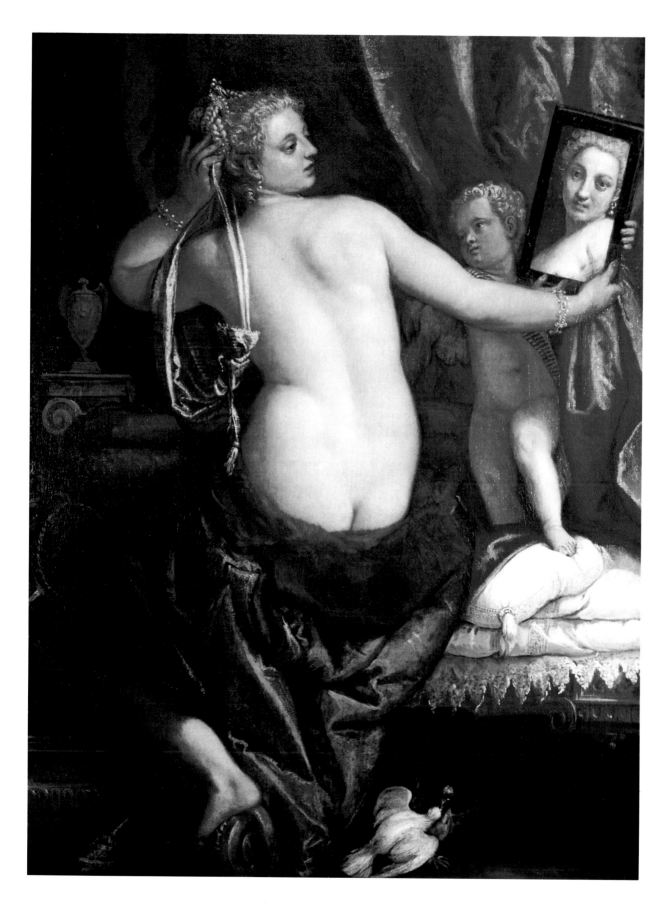

Veronese

Christ Crowned with Thorns, 1580s

Oil on canvas
55 x 43 in. (139.7 x 109.2 cm.)
Marie Stauffer Sigall Foundation,
on loan to The Fine Arts Museums
of San Francisco

The last years of Veronese's life reveal a formal direction that is difficult to interpret and that only recent criticism has begun to investigate. Putting aside his self-consciously beautiful compositions and themes of a happy Golden Age such as the allegories in the Frick Collection and Metropolitan Museum or single figures like the Colonna *Venus,* Veronese withdrew into himself and sought subjects of penetrating religious drama. The painter with the magical palette, whose clear, refined colors have been compared to precious jewels, discovered the magic of nocturnal lights, and he supported his new conception of chromatic values with shimmering effects, almost in the manner of Jacopo Bassano. This very late style is well exemplified in this *Christ Crowned with Thorns,* with His unforgettable silver and salmon pink robe, cold as a thin layer of metal. The painting is obviously related to the Titian *Christ Crowned with Thorns* in Munich, both in its overall composition and the illumination from the lamp and torch in the foreground that spread their light like rain.

The history of this *Christ Crowned with Thorns* is unknown before it appeared in the Schaeffer Gallery in New York, where it was acquired by the Marie Stauffer Sigall Foundation. It was attributed to Veronese as a "beautiful autograph work" by Suida in 1961.

Pallucchini (1963–64) also recognized its high quality, writing that in it Veronese was influenced by the luminism of Bassano's late work while maintaining his own magical sense of color. Ballarin (1965) expressed a similar opinion and proposed a date between 1580 and 1583. For Crosato Larcher (1968), who also saw the influence of Bassano and compared the painting to the *Resurrection* in Westminster Hospital in London, the work is the product of a collaboration among Veronese's sons, Carletto and Gabriele, and his brother Benedetto.

The obvious iridescence of the pictorial surfaces does bring to mind the style of Carletto, but the singularly expressive force of this painting is characteristic of Veronese in the last years of his life.

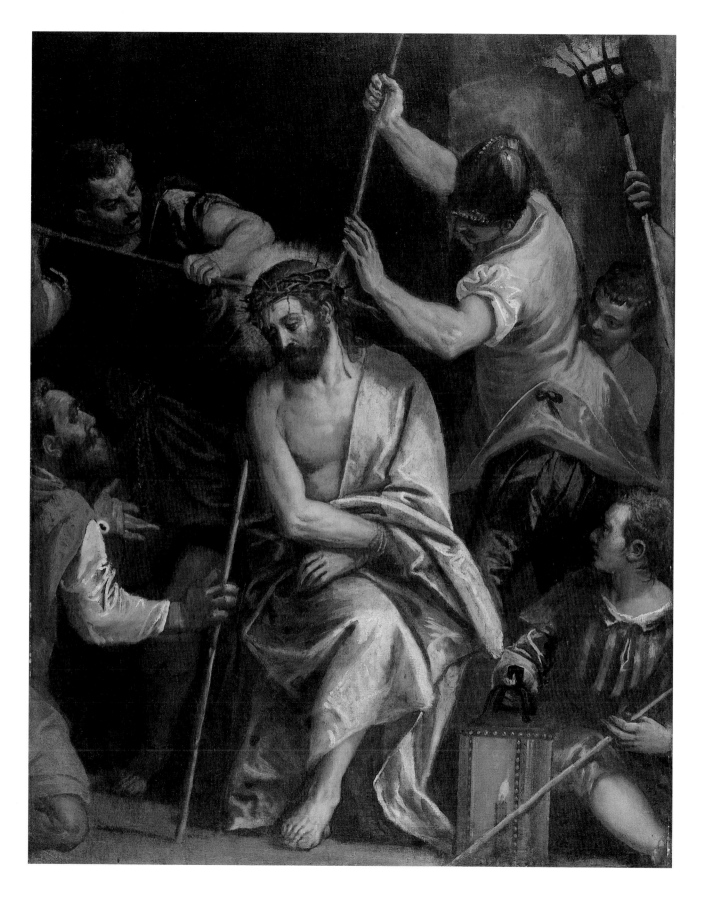

Jacopo Bassano

Flight into Egypt, c. 1540–45

Oil on canvas
47 x 78 in. (119.4 x 198.1 cm.)
Norton Simon Inc Foundation,
Los Angeles

Jacopo da Ponte, c. 1515–1592

Sixteenth-century writers mentioned Jacopo Bassano only in passing and then primarily as a painter of animals; but in the seventeenth century Ridolfi and Boschini ranked him with Titian, Tintoretto, and Veronese. They cited his mastery of color, his verisimilitude, and his invention of a new type of painting the depiction of religious events as if they were happening in the rustic environs of his native town. Jacopo's life was closely associated with the market town of Bassano at the foot of Monte Grappa, about forty miles northwest of Venice, where he was born about 1515. His father, Francesco the Elder, was a provincial painter who established the workshop in Bassano. Trained by him from childhood, Jacopo as an adolescent assisted him in painting altarpieces for village churches. In the early 1530s Jacopo was sent to Venice for further training by Bonifazio de' Pitati, a follower of Palma Vecchio. Jacopo never tried to establish himself as an artist in Venice, although he kept abreast of artistic developments there. In fact, he never received a commission from the Venetian government and only two requests for altarpieces for small churches in Venice. His clients were churches in the towns and villages of the Veneto and the new class of sixteenth-century patrons, the private collectors in Venice and the surrounding region. By 1535 Jacopo had returned to Bassano, where on the death of his father in 1541 he inherited the family workshop which he maintained until his death in 1592. His life in Bassano was uneventful except for the birth of seven sons, of whom four became painters in their father's workshop: Francesco (1549–1592), Giambattista (1553–1613), Leandro (1557–1622), and Gerolamo (1566–1621). Jacopo's artistic life, on the contrary, was filled with excitement, an unending adventure in the search for new means of expression.

In design and in expressive realization of the subject this *Flight into Egypt* is a masterpiece of Jacopo Bassano's fusion of Mannerist elements with both rich and improvised Venetian color and his own closeness to nature. Its leitmotif of flight has rarely been depicted so convincingly. The youthful angel courses forward, intent on his divinely inspired journey, with drapery, wings, and his entire being charged with energy. St. Joseph, heavier and older, follows with determined stride, his cloak billowing majestically behind him, giving emphasis to his forward movement. Even the donkey advances with a lively and willing gait. The peasant, not part of the flight, trying to recapture the frightened chickens, still lurches toward the group, creating a strong parallel diagonal from the very edge of the canvas at the lower right; the drinking soldier separates the fleeing group from the quiet village and serene landscape they are leaving so rapidly. In the midst of so much movement the Madonna and Child ride serenely along, their frontality suggesting a minimal mobility—a peaceful island in an agitated sea. The colors, revealed in their astonishing brilliance only after cleaning subsequent to the acquisition of the painting by the Norton Simon Inc Foundation, enhance the meaning of the forms. The juxtaposition of

vivid hues of blue, green, pink, orange, and mauve create an extraordinary vibrance in the picture. Only one figure, the Madonna, wears a somber dark blue cloak. So singled out, she is clearly intended as the solemn focal point in an otherwise vivacious scene. Bassano's ingenious use of color and action communicates more than narrative detail. It implies that the Madonna exists as a stable link between the mundane and spiritual worlds, and that she provides an anchor for both spheres.

The angel is one of the most scintillating in all of Venetian painting. It combines graceful elongation of forms inspired by Parmigianino, a typically Mannerist torsion that permits the radial extension of arms, legs, and wings, a freedom of color and movement of drapery that has its closest parallels in Schiavone's Venetian adaptation of Parmigianino, and an observation of natural details in, for example, the wings that is almost Flemish in its minuteness. All of these elements are brought together, however, in a completely unprecedented invention.

Gibbons (1972) pointed out that the pose of Madonna and Child is derived quite literally from Titian's now damaged fresco of *Madonna and Child with Two Angels,* 1523, in the Doge's Palace in Venice. He

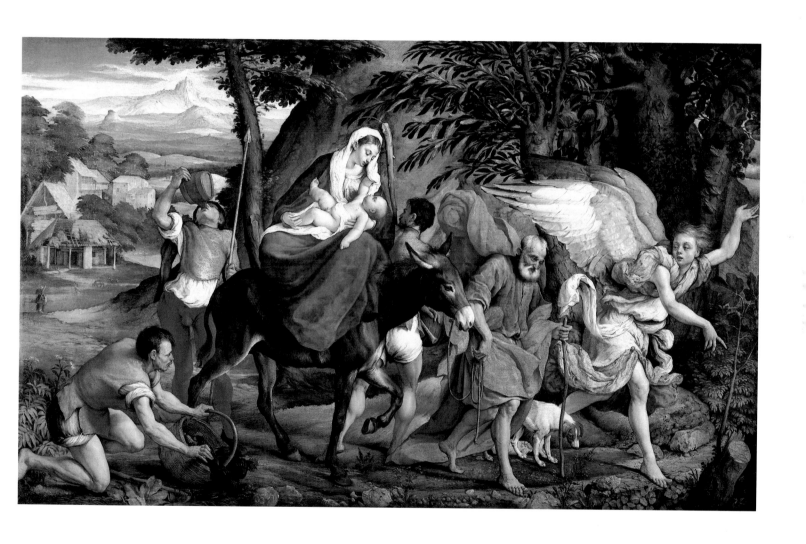

Jacopo Bassano

Jacopo's earliest works combine adaptations of Bonifazio, Lotto, and Titian with personal characteristics: an archaistic compactness of form, a studied relationship of volumes, and a nascent realistic vision. In the late 1530s a new element appears, a great Pordenone-like horse in the *Adoration of the Magi* in Burghley House. Pordenone's massive forms multiply and are set into motion with violent foreshortenings in *Samson and the Philistines* in Dresden. The *Martyrdom of St. Catherine* of about 1542 in the Museo Civico, Bassano, with its complex intertwining of muscular figures indicates that at the same time Jacopo was assiduously studying prints after Florentine-Roman Mannerist paintings. Many young Venetian artists of the 1530s and 1540s had special enthusiasm not only for Pordenone and Florentine-Roman Mannerism brought to Venice by the two Salviatis and Vasari, but also for Schiavone who brought the grace, rhythm, and fantasy of Parmigianino. Jacopo shared this interest, and reflections of the prints of Parmigianino began to appear in his works at the end of the 1530s and soon revolutionized his style. The heavy forms and violent movement of Pordenone were replaced by supple, elegantly proportioned figures in rhythmic movement. Jacopo's first pure Mannerist work, the *Beheading of John the Baptist* in the Statens Museum for Kunst, Copenhagen, is at the same time his most abstract. This was the prelude to combining aspects of Mannerism, especially from Parmigianino, with a descriptive realism to produce a new and original variation of Mannerism. In his *Trinity* in the Chiesa della Trinità in Angarano, he placed the cross of the crucifixion in a Venetian peasant village, and through the next years incorporated in his paintings the peasants and animals of that village and the landscape that surrounded it. As his mastery of Mannerist formulas grew, so did his mastery of naturalistic representation. One masterpiece followed another during the 1540s including the *Flight into Egypt* from the Norton Simon Inc Foundation, Los Angeles, and the *Adoration of the Shepherds* in the

further noted that Jacopo again used some of the peasant houses that appear in the *Trinity* of about 1540 from Angarano, now in the Museo Civico, Bassano. The London Royal Academy of Art exhibition catalog (1960) places the painting between 1540 and 1550. Herrmann (1961) limits the period to 1540 to 1545 since it has developed considerably beyond the *Flight into Egypt* in the Museo Civico, Bassano, of about 1536–37 but precedes the *Flight into Egypt* of about 1545 recently acquired by the Toledo (Ohio) Museum which repeats some of its details.

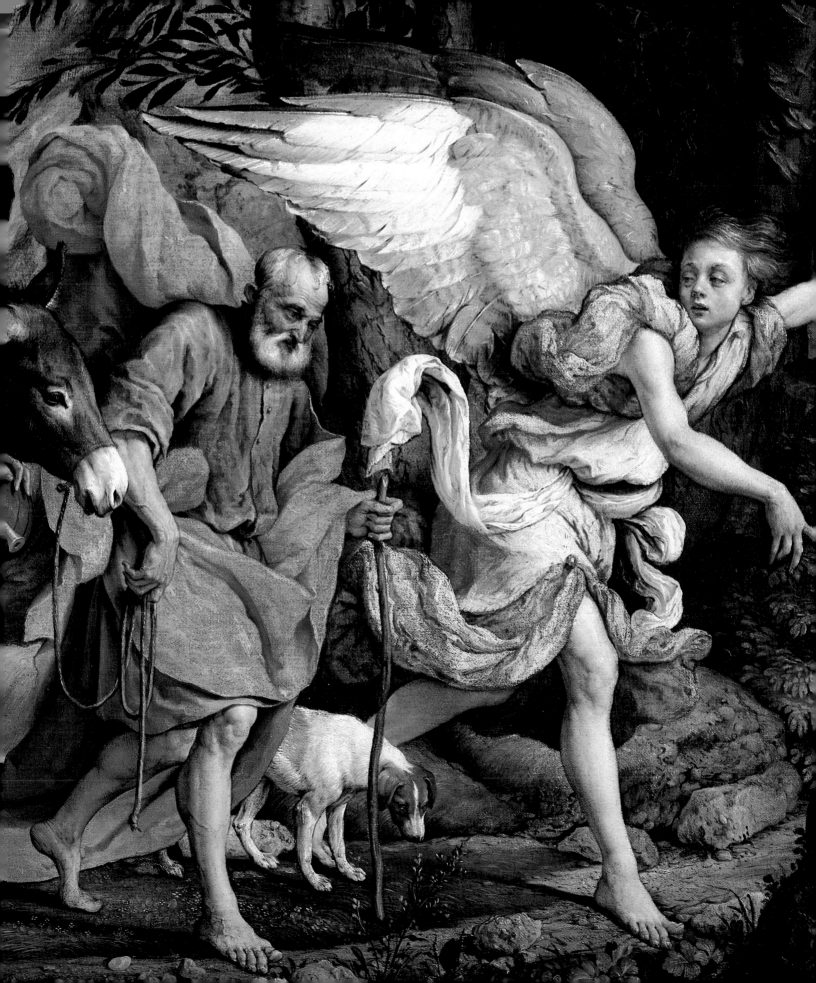

Jacopo Bassano

Adoration of the Shepherds,
c. 1542–46

Oil on canvas
38¼ x 54 in. (97 x 137 cm.)
Justo Giusti Del Giardino
Collection, Verona

Giusti Del Giardino Collection in Verona, both in this exhibition, the *Last Supper* in the Galleria Borghese, Rome, and the *Rest on the Flight into Egypt* in the Ambrosiana, Milan. From a provincial artist searching for a style, Jacopo became part of the Venetian avant-garde.

About 1550 Jacopo again revolutionized his style. He dematerialized his images by painting Mannerist figures and compositional relationships without the realism and minutely observed details that had made miraculous events part of daily life. Replacing the bright light of the sun that fully revealed nature with an arbitrary light used as an element of pattern, he created a poetic image that transcended daily experience and anticipated both the late Tintoretto and El Greco. The *Feast of Dives* in the Cleveland Museum of Art, the *Miracle of the Quail* in a private collection in Florence, and the *Adoration of the Shepherds* in the National Museum, Stockholm, all of the 1550s, are extraordinary examples of Jacopo's versatility in this style. But he was too close to nature to abandon reality for long.

At the very height of his transmundane Mannerism in the late 1550s, he began to turn from its abstract sophistication to a more traditional optical realism, associated with Titian, as in *Sts. Peter and Paul* in the Galleria Estense, Modena. The decade of the sixties is a complex one. Jacopo continued to paint some Mannerist pictures until about 1568. At the same time he produced his greatest achievement in pure landscape painting, the *Pastoral Landscape* from the Thyssen Collection in this exhibition. But the direction that had the greatest continuity and led to Jacopo's late style was his dissolution of form in light, in a Titianesque manner, in paintings such as the superb *St. Jerome* in the Venice Academy and the *Pentecost* in the Museo Civico, Bassano.

Jacopo was still a fecund artist. In the late 1560s and the 1570s he fused the magical impasto of the late Titian with the expressive chiaroscuro of Tintoretto to produce a luminism for which he has been highly esteemed over the

The almost hypnotic fascination of this picture is the result of the combination of two seemingly contradictory elements: artfully contrived elegance of design and a deep feeling for nature. This is typical of the highly original way in which Jacopo, during the Mannerist phase of his career from about 1542 to 1562, adapted sophisticated formal rules, gracefulness of line, and choreographic movement of figures learned from Parmigianino's prints to his lifelong devotion to the rural life around him. The animals and shepherds are full of authentic detail, while the intensity of expression of the shepherds, both in their faces and in the tautness of their bodies, and the animation of the animals are produced by the energizing drawing style. The rustic figures are separated from the sacred ones by the tree and the column that rises behind the Christ child who seems to unite both worlds. This difference is subtly reinforced by the concentration of shades of brown on the right and the delicate incarnation of the Madonna on the left with her soft white, carmine red, and dark blue robes. The exquisite, aristocratic Madonna uncovers the child as if she were unveiling a precious jewel with a delicacy that again suggests Parmigianino. For Jacopo, antiquity is suggested by imposing ruins; he therefore uses what seem to be the remains of an ancient temple for the stable, to which he gives reality by the addition of the modern thatched roof. This structure solidly delimits the space, creating a narrow foreground stage for the rhythmic disposition of the figures; there is only a slight suggestion of landscape beyond.

A close parallel to the formal naturalism of this painting is found in Venetian pastoral poetry that describes and eulogizes nature in a self-consciously elegant style.

Arslan (1934) compared this work with Jacopo's *Last Supper* in the Borghese Gallery in Rome, placing it at the high point of the artist's Mannerist period. In 1960, however, he implied a date at the beginning of that period in initiating his discussion of Jacopo's major Mannerist works, stating that in the Giusti Del Giardino *Adoration of the Shepherds* "for the first time, within the quite clear limits of a live intarsia, of a hallucinatory reality, the touches of color assume the density that we find in the most vital seventeenth-century artists: Feti, Borgianni; and the skin of the kneeling shepherds is almost Riberesque." An etching by Hans Sadeler reproduces this work in reverse with some variations.

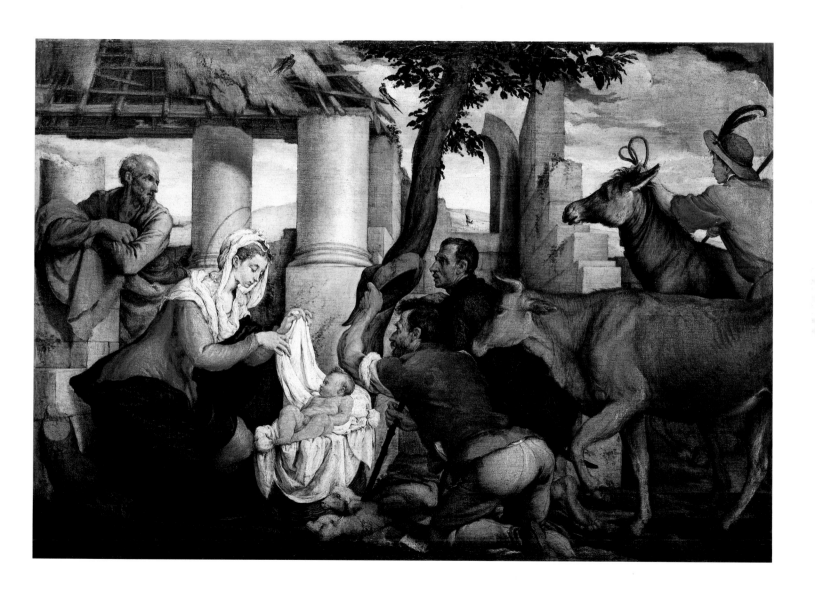

Jacopo Bassano

Pastoral Landscape, 1560s

Oil on canvas
55⅛ x 51 in. (140 x 129.5 cm.)
Thyssen-Bornemisza Collection,
Lugano

centuries. In altarpieces like the *St. Valentine Baptizing St. Lucilla* in this exhibition or the *St. Martin* in the Museo Civico, Bassano, he created poems in light and color with a strong sensuous allure that nevertheless substantiate the spiritual reality of the subject. Boschini in his *La Carta del Navigar Pitoresco,* 1660, devotes many laudatory pages to Jacopo's painting in this style. Roberto Longhi in 1946 concurred, "He was in those last years a craftsman of genius, mad for the beauty of execution: a pure artist." During the same years he created the pictorial type that was for centuries to be synonymous with the name Bassano: the event taking place in the midst of the peasants and townfolk, the animals, landscape, dwellings, and myriad objects of daily use. At times the religious subject is so minimized that the picture becomes a pure genre scene; at other times unusual episodes from the Bible, like the sons of Noah building houses after the flood, are pretexts for depicting everyday activities. Painted in Jacopo's late style, short and nervous brushstrokes dissolve form and create a pervading atmosphere, with brilliant touches of color highlighting shadowed or more often nocturnal settings. By this time Jacopo's sons were active in the studio, assisting him in many paintings and making replicas or variants of his themes. For a half-century they multiplied these Bassano genre scenes *ad infinitum* and with decreasing quality. In 1581 Francesco wrote of his father that he "does not draw any longer and cannot work much with brushes, both on account of his sight and because he is very old." He nevertheless continued to give counsel to his sons until his last moments. In his lectures on Venetian painting, Walter Friedlaender asserted that Jacopo's intimate and anecdotal treatment of his subjects made him the precursor of the Italian Caravaggists and the French and Spanish realists of the seventeenth century. Boschini summarized the esteem of that century for Jacopo in his couplet: If Tición were not Tición,

He would for sure have been Bassan.

Jacopo da Ponte's native village, Bassano, is located in a hilly region on the slopes of the southern Dolomites overlooking the Venetian plains. It is here that he found his models for landscapes, peasant huts, people, and animals. The Thyssen *Pastoral Landscape* is not only recognized as Jacopo's masterpiece of pure landscape painting, but it is the first authentic rustic scene and the oldest subject of agrarian life in sixteenth-century Italy (Zampetti, 1957).

The tensions and movement that gave such vitality to Jacopo's two Mannerist paintings in this exhibition have been replaced in the *Pastoral Landscape* by a classic calm, while the seated figure in the center has a natural sculpturesque character like an ancient goddess of the fields. There is a quiet harmony between man and beast, shaded woods and cloudy sky. The figures are illuminated by the real light of sunset in the hills. The picture is one of evening with the oxen brought to rest from the fields, the sheep being watered, and a simple meal being laid out by the woman at left.

Pallucchini (1957) and Zampetti (1958) have observed that the spirit of the painting is not idyllic but profoundly realistic, and therefore places Bassano in a position of "absolute independence" in Venetian art. In this regard Ballarin (1964) has pointed out that even the animals are drawn from life, noting the two studies of oxen that seem to be for this picture in the Royal Print Cabinet of the Statens Museum for Kunst in Copenhagen.

Since pure pastoral scenes were of such rarity in Jacopo's time, Michelangelo Muraro (1957) suggested that the subject is the Parable of the Sower, Matthew 13:3–8. Zampetti (1958) felt it might be Autumn from a series of the Four Seasons. Neither proposal has been generally accepted.

Zampetti (1957) dated the painting about 1560 on the basis of a stylistic relationship he assumed with the *Adoration of the Magi,* Kunsthistorisches Museum, Vienna, and the *Crucifix* painted for San Teonisto, Treviso, and now in the Museo Civico there. Rearick (1968) dated it, c. 1563. Arslan (1960) believed it was not painted until the late 1560s on the basis of the originality of the figures and the novelty of contrasting zones of colors that give a dominant chromatic character to the scene. A drawing of the sower from the Geiger Collection was sold in London in 1920.

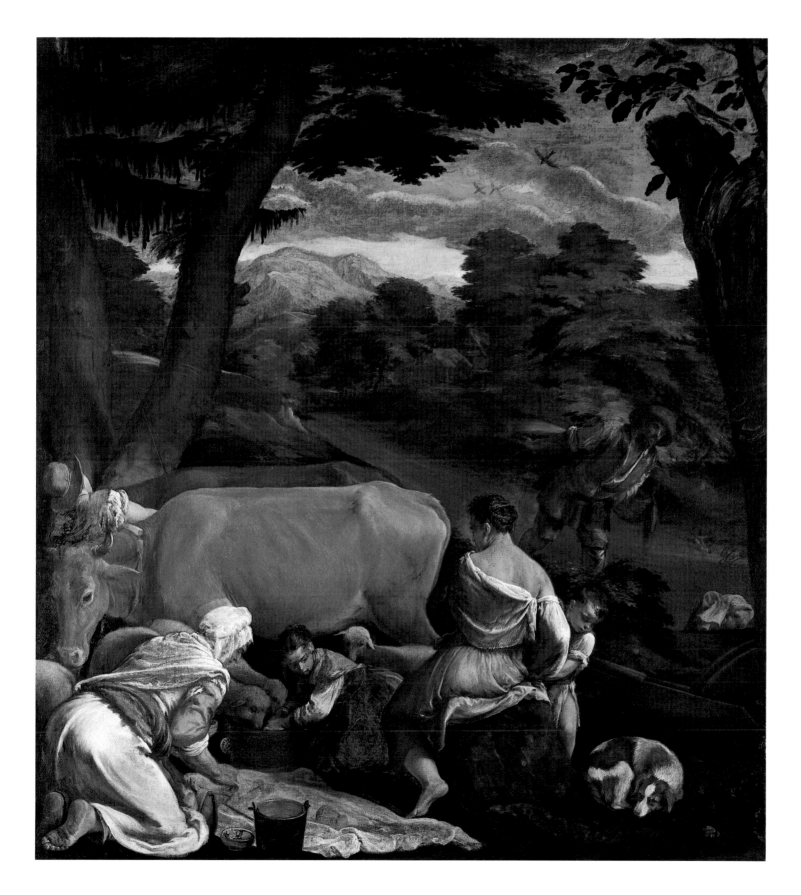

Jacopo Bassano

St. Valentine Baptizing St. Lucilla,
c. 1570—74

Oil on canvas
72½ x 51¼ in. (184 x 130 cm.)
Signed on lower step:
IAC.S A PONTE BASSANENSIS. F.
Museo Civico, Bassano del Grappa

Although seventeenth-century writers on Venetian painting consistently lauded Jacopo for his coloring, they accorded the greatest praise to his late altarpieces. Marco Boschini in his long poem *La Carta del Navigar Pitoresco,* 1660, devoted more than a hundred lines to *St. Valentine Baptizing St. Lucilla,* then in the Chiesa delle Grazie. For him Jacopo was the "arbiter of light," using it to give form to his figures, architecture, and landscape and to bring harmony into his pictorial ensemble. Boschini confessed that he knelt with reverence before this altarpiece to feel with his hand "those strokes and touches and spots of color/that I esteem as fine and precious jewels,/pearls, rubies, emeralds, turquoises,/diamonds, that glow even at night." In the following century Giambattista Tiepolo wrote to his son: "I must tell you, Domenico, that I have seen a miracle on my trip, a fine black fabric that appears to be white." Pallucchini (1946) explained that "the silk robe that St. Lucilla wears is blackish when seen close up, but, from a distance, because of the effect created by disassociated strokes of color, it becomes white and shining." Bassano's color, however, is never just a display of virtuosity or mere decoration; it remains, despite the changes over the decades, a vehicle for representing nature.

The subject of this painting is rare if not unique. St. Lucilla was a Roman convert who, with her father St. Nemesius, presumably the older man at her left, was beheaded in Rome in 254. The angels above carry her palm of martyrdom. St. Valentine met the same fate in 273. The use of extraordinary light is appropriate to both. Lucilla's name is derived from the Latin "lux," meaning light, and according to the *Legenda Aurea* Valentine taught that his "Lord Jesus is the true light." The processional cross, made by Filarete in 1449, is one of the treasures of Bassano, still preserved in the Cathedral.

According to Pallucchini (1957) the background is the work of Francesco Bassano, "opaque and static in comparison with the vibrancy of the figures." Arslan (1960), however, insists that it is entirely by the hand of Jacopo, and places it among his last works. The date of about 1580 was generally accepted in the past, because the St. Lucilla altarpiece was believed to have been executed after the *Preaching of St. Paul* formerly in the Kress Collection, New York, dated 1574 by Pallucchini (1946). Recent scholars, however, date the altarpiece earlier than the *Preaching of St. Paul,* whose composition seems to be derived from that of *St. Valentine Baptizing St. Lucilla.*

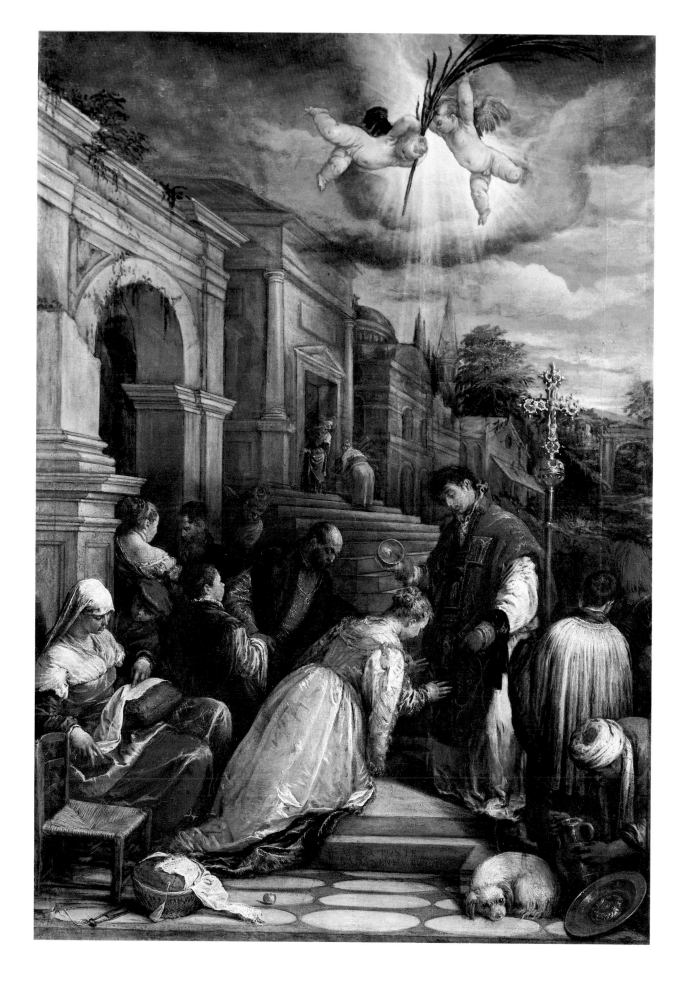

Jacopo and Francesco Bassano

Christ in the House of Mary, Martha, and Lazarus, c. 1577

Oil on canvas
38¾ x 49¾ in. (98.4 x 126.4 cm.)
Signed at left:
JAC. ET FRAC FILIVS F.
Sarah Campbell Blaffer
Foundation, Houston

Jacopo and Francesco da Ponte, 1515–1592; 1549–1592

Francesco established his individuality in two areas that anticipated the interests of the early seventeenth century: genre scenes and nocturnes. The eldest son of Jacopo, Francesco was born in Bassano in 1549 and was reared in the workshop tradition to be his father's collaborator. His earliest signed work, *The Miracle of the Quails,* 1565–70, is dependent on Jacopo's late more realistic style, but is tighter and more studied. During the 1570s he worked with his father on large altarpieces in which it is difficult to differentiate the hands of the two artists, except that Jacopo's brushwork seems freer and his figures more supple. In these years Francesco devoted himself principally to bucolic-biblical paintings, at first using compositions conceived by his father and then those of his own invention. Characteristics of these paintings are his color sprinkled with light and his tendency towards a more descriptive realism. In 1579 Francesco left Bassano for Venice. During the next years he painted nocturnal scenes illuminated by candle, torch, and flare, by moonlight and divine light—nativities, adorations of the shepherds, and passion scenes culminating in the altarpiece for Sant'Afra in Brescia. He also competed with Tintoretto, Veronese, and Palma Giovane for public commissions and was awarded several in the Sala del Scrutinio and the Sala del Maggior Consiglio of the Doge's Palace. At the height of his success, a mental illness that may have been developing for some years became more acute. Believing he was being pursued by the law, according to Ridolfi, he threw himself from an upper story window of his house and received injuries from which he died eight months later on July 3, 1592, a few months after his father.

Jacopo Bassano's bucolic-biblical scenes were in great popular demand from the mid-1570s to the end of his productive life. In them he multiplied the number of realistic details and gave increasing emphasis to genre elements, so that religious or allegorical subjects become secondary to the representation of life in the Bassano countryside. These paintings were frequently executed in collaboration with his son Francesco and sometimes with other members of the workshop. The extent to which the sixty-two-year-old Jacopo and the twenty-six-year-old Francesco each participated in the conception and execution of *Christ in the House of Mary, Martha, and Lazarus* is difficult to determine. This is especially so since the unusual indoor-outdoor setting and even a number of details of architecture and furnishings appear in other paintings signed by the two artists, such as the *Prodigal Son* in the Doria Pamphili in Rome. The traditional attribution of the figures to Jacopo and the landscape and setting to Francesco in the Blaffer Foundation painting is not convincing. It seems rather that Francesco's festive touch and sparkling light characterize the picture.

The subject is from the Gospel of St. John, 12:1–2: "Then Jesus six days before the passover, came to Bethany. . . . There they made him a supper." Jesus with two disciples is welcomed by Martha who indicates his place at the table, while Mary with long blonde hair kneels in homage. Lazarus is already seated at the table, which is set for a guest with a bowl and towel for washing hands before eating, a napkin, and a two-tined Venetian fork. The house is provisioned with a gastronomic abundance: chickens, ducks, fish, salami, vegetables, fruit, and wine as if preparations were made not to receive Jesus, a most abstemious guest, but for a lavish wedding feast in the kitchen of a country house in Bassano, amidst gleaming kettles and plates and with a crackling fire on the hearth.

Until the discovery of this painting the composition was known only through later versions and copies, the best of which are in the Kassel Gallery signed by Francesco alone (von Hadeln, 1914) and in the Palazzo Pitti in Florence, possibly by Gerolamo da Ponte (von Hadeln, 1914; Venturi, 1929). It was engraved by Hans Sadeler.

The painting was not known to Edoardo Arslan when he published his comprehensive *I Bassano,* Milan, Ceschina, 1960. He dates similar works, including the *Prodigal Son* in the Doria Pamphili, to the late 1570s.

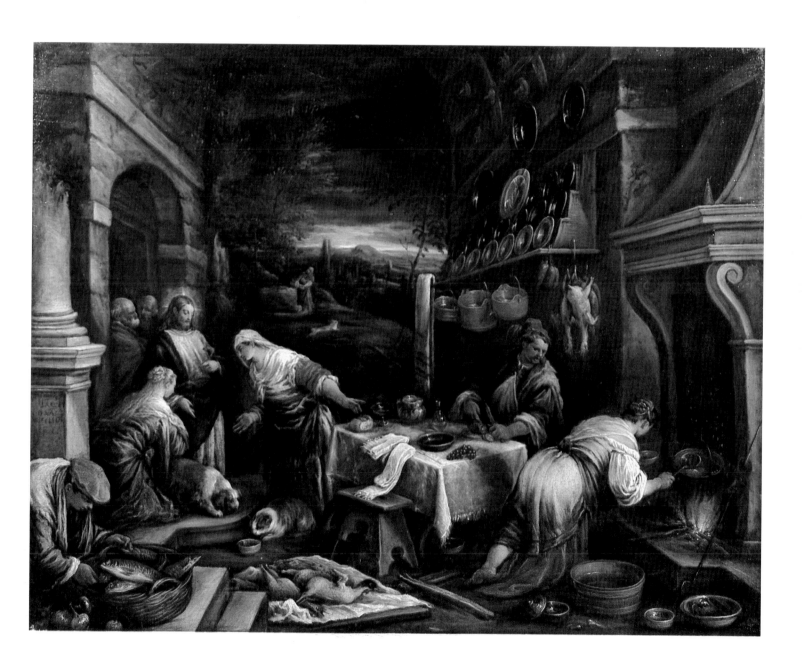

Leandro Bassano

Lute Player, c. 1580–1585

Oil on canvas
31⅜ x 26 in. (79.6 x 66.1 cm.)
Herzog Anton Ulrich-Museum,
Braunschweig

Leandro da Ponte, 1557–1622

With the death of both Jacopo and Francesco Bassano in 1592, Jacopo's third son, Leandro, born in 1557, continued the family tradition into the seventeenth century until his death in Venice in 1622. Like his brothers he was trained in his father's shop and from at least 1575 collaborated with Jacopo and Francesco on bucolic-biblical subjects for which there seems to have been an unending demand. Leandro's hand in them can be identified by its draftsman-like and literal character. Transferring to Venice in 1579 to join Francesco, who had moved there the preceding year, Leandro distinguished himself as a portraitist. His early portraits retained aspects of Jacopo's style, in the freedom of his brushwork and in revealing the sentiments of the sitter, but soon he turned to a more objective portrayal of the exterior aspects of the sitter, with harder surfaces and more precise delineation.

In the latter works, he seems to have taken inspiration not from the Venetian tradition but from Moroni in Lombardy and his contemporaries in the Netherlands. In his crayon portraits executed with painterly softness, Leandro seems to have found his most compatible medium. Into the seventeenth century Leandro continued to paint Bassanesque subjects for churches and private patrons, but his place in the history of Venetian art is not dependent on them but on his portraits. Ridolfi described Leandro at the height of his success, having been made Cavaliere by Doge Grimani, accompanied by a retinue of pupils, one carrying his gilded rapier and another his notebook, "displaying grandeur and splendor in every movement."

In the period of transition from the sixteenth to the seventeenth century, Venetian painters produced a great number of "official" portraits to memorialize administrators in the state magistratures and to glorify illustrious families in their sumptuous palaces. Rarely, however, were these portraits capable of revealing the individual personalities of the sitters. The painter who most often approached his subject as a person rather than as a symbol of governmental power was Leandro Bassano.

Leandro's early portraits, painted while he was still closely associated with Jacopo and for a short time thereafter, have much in common with the late portraits of his father: the depiction of the sitter as a person of feeling and a technique of applying paint in free, overlapping, and quite visible brushstrokes to give liveliness to the surface. The *Lute Player* has both these characteristics, with its obvious emphasis on the sensitivity of the musician and its freedom of brushwork in the face, a freedom that anticipates Frans Hals.

The *Lute Player* was first mentioned in 1697 as a Tintoretto in a manuscript description of the gallery of the Ducal Palace at Salzdahlum near Braunschweig. In 1776 in the first printed catalog of the gallery at Salzdahlum, it is again listed as Tintoretto. It was not until 1922 that Gronau recognized the work as by Leandro Bassano. In 1930 Arslan attributed the portrait to Jacopo Bassano on the basis of the relationship he found between this work and Jacopo's *Portrait of a Monk* in an unidentified private collection, published by Venturi (1930); he noted, however, that the composition was reminiscent of Francesco Bassano and the treatment of the sitter was close to Leandro. In 1960 Arslan changed his attribution to Leandro, placing the picture among his early works, about 1580–85, but reasserting that it had "touches which would seem to be by Jacopo himself," especially in the hands and face.

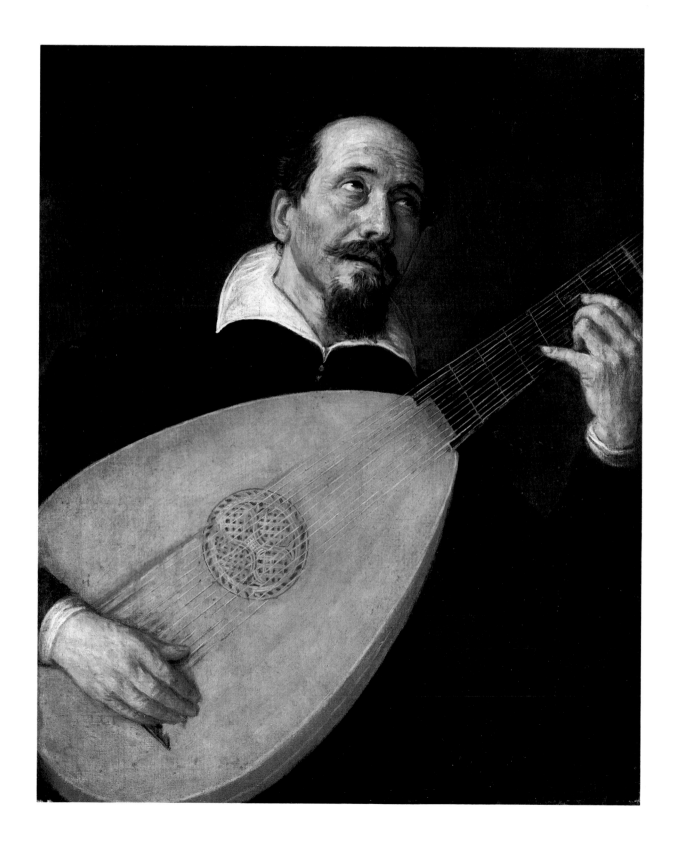

Lo Spada

Dr. Zaccaria dal Pozzo at 102 Years of Age, 1560–61

Oil on canvas
47 x 41⅜ in. (119.5 x 105 cm.)
Inscribed upper left:
ANNO ÆTATIS SVÆ CII
Museo Civico, Feltre

Pietro Marescalchi, c. 1520–1584

The Venetian painter in whom the critics find the closest parallel to El Greco's expressive transformation of Venetian Mannerism was an artist who never lived in Venice, Pietro Marescalchi. Born in Feltre in the mountainous province of Belluno about 1520, he apparently worked all or most of his life there and in the surrounding region and died there in 1584. He married Corona Minio by whom he had a son Antonio, also a painter, who died in 1576. Marescalchi's early efforts show the influence of Schiavone, whose work he must have seen in Belluno; he translated these into lively compositions in metallic colors, such as the 1547 altarpiece of the *Madonna Enthroned and Saints* in San Martino, Farra. As his work became more explicitly Mannerist, he came closer to the style of Jacopo Bassano with its tense, agitated draftsmanship, as in his altarpiece of the *Madonna of Mercy* in the Feltre Cathedral. However, the analogy to El Greco is usually made with works like his greatest altarpiece, the *Pietà and Symbols of the Passion Worshipped by Sts. Clare and Scholastica* in Santa Maria Assunta and San Bellino, in Bassanello, a suburb of Padua, of about 1580, with its mystical religious passion, tremulous movement, and tension of color, or the portrait of Dr. Zaccaria dal Pozzo in this exhibition. Fiocco (1947) feels that there is enough evidence even in the earlier work of Marescalchi to conclude that he anticipated El Greco by at least a decade.

It is strange that one of the most beautiful portraits in late sixteenth-century Venetian painting should have been the work of an artist who is still as little known as Marescalchi. This portrait of Dr. Zaccaria dal Pozzo seems to be free of the influences of Titian, Tintoretto, Veronese, and Bassano that one would expect to find in the work of a modest provincial painter. The majestic yet profoundly lifelike figure is expressed in a perfect formal synthesis of draftsmanship and color, the latter limited to an essential, penetrating, green intonation. It is difficult not to compare this work with the portraits of El Greco, who is perhaps the only other painter able to combine in one portrait so many expressionistic values with such an immediate sense of the existential.

Zaccaria dal Pozzo was a medical doctor in Feltre who died on February 15, 1561, at the age of 102 (Fiocco, 1934). The portrait, which was formerly believed to be by Bassano, was attributed to Marescalchi by Fogolari in 1929. The attribution has been accepted by critics like Fiocco (1929), who recognized the work as "a masterpiece of color and insight," and Adolfo Venturi (1934), who was particularly enthusiastic about the portrait, for the "tragic and eternal" feeling that emanates from the sitter.

Palma Giovane

The Finding of Moses, after 1570

Oil on canvas
56¾ x 108¼ in. (144 x 275 cm.)
Chrysler Museum at Norfolk
Gift of Walter P. Chrysler, Jr.

Jacopo Negretti, 1544–1628

At the end of the golden century of Venetian painting, Palma Giovane was the prototype of the versatile and prolific artists who in an academic and eclectic manner were to prolong the Venetian sixteenth-century tradition into the first quarter of the next century. Born in Venice in 1544, he became a painter by inheritance. His grand uncle was Palma Vecchio, his father Antonio a painter who taught him the graceful, fluid style of Bonifazio. After three years in Urbino, Palma spent three years in Rome studying the work of Michelangelo, Raphael, and most especially Polidoro da Caravaggio. There he must have met those artists who no longer sought to imitate the "good manner" of Michelangelo, but to combine the narrative style of the Raphael frescoes with earlier Mannerism to create that learned, facile, and impersonal style known as Maniera, the last phase of Mannerism in Rome.

Returning to Venice in 1570, he became Titian's favorite assistant, collaborating with him on his last works. To form his personal style Palma turned, however, to Tintoretto for the proportions and poses of figures, dramatic compositions, and often the brilliant play of light and shadow, but without the older master's spirituality or depth of expression. He added elements of Bonifazio, a versatility in the use of color from Titian, sometimes rich decorative surfaces from Veronese, and descriptive realism from Bassano. He thus formed a Venetian Maniera that could be adapted with varying emphasis to commissions of any size or subject and be easily imitated by a large body of assistants.

When Annibale Carracci visited Venice he is reported as having commented that "Tintoretto is sometimes better than Titian, and sometimes worse than Tintoretto." This could be paraphrased "Palma Giovane is sometimes almost as good as Tintoretto, and sometimes worse than Palma Giovane." *The Finding of Moses* was, in fact, attributed to Tintoretto when it was first brought to public attention by Suida in 1946; it retained that attribution through three exhibitions during the next decade. The influence of Tintoretto is evident in the type of movement of the figures and in the light which organizes the composition with a strong vertical to the right and left of the central group and an arc in the center to focus attention on the encounter of Pharoah's daughter with the child. The light also permits the child's mother to hover in the background in prominent obscurity. The smoothness of the paint application is, however, much closer to Bonifazio, in whose manner Palma was trained, than to Tintoretto. The moment of the story in which the maid shows the newly discovered child to Pharoah's daughter as well as the position (in reverse) of the princess and her gesture of surprise are closely related to Bonifazio's *Finding of Moses* in the Brera, Milan. Palma's *Finding of Moses,* however, has much more dramatic concentration than the

pageantlike painting of Bonifazio, through the very elements Palma has taken from Tintoretto.

Suida in attributing this work to Tintoretto quite rightly compared it with the master's youthful works such as the *Vision of St. Agnes* in the church of the Madonna dell'Orto. He also noted three versions of the subject by Tintoretto in the Metropolitan Museum, the Prado, and the St. Louis Museum. The painting was first published as a Palma Giovane by Robert Manning in the catalog of the exhibition of Venetian Baroque painters at Finch College in 1964. The date of the picture is clearly after Palma's return from Rome in 1570 and his experience in the workshop of Titian, whose inspiration can be seen in the dramatic landscape at left.

El Greco

Christ Healing the Blind, c. 1574

Oil on canvas
19¾ x 24 in. (50 x 61 cm.)
Signed: DOMÉNIKOS
THEOTOKÓPOULOS KRÈS EPOÍEI
Pinacoteca Nazionale, Parma

Domenikos Theotokopoulos, 1541–1614

Tintoretto's real heir was El Greco. Venetian artists of the late sixteenth century imitated the exterior aspects of his forms and use of light, but only El Greco continued, albeit in a very personal way, Tintoretto's deeply spiritual and expressive Mannerism. There are many speculations but few documented facts concerning El Greco's early life. He himself testified that he was born in Candia, Crete, in 1541. Crete was then a possession of Venice, and El Greco's family, prosperous enough to give him a good humanistic education, may have had associations with Venice. It is usually assumed that El Greco studied icon painting in Crete, before he came to Venice to complete his training. Scholars postulate the time of his arrival in Venice to have been as early as 1558 or as late as 1565. Of his activities in Venice all that is known is that he worked with Titian, as the book illuminator Guilio Clovio has documented in a letter of November 1570, referring to him as "a young Candiot pupil of Titian who in my judgment is exceptional in painting." El Greco most likely learned from Titian the typically Venetian use of the oil medium, composing directly on the canvas, enveloping figures in atmosphere, conceiving the painting as a unity of light and color, and at times eliciting the rich, sensuous delights of the pigments themselves. Although a pupil of Titian, El Greco seems to have been even more attracted to Tintoretto. This is not unusual, for to the young artists of the second half of the sixteenth century Titian was a traditional painter and Tintoretto the exemplary modern master. In his Italian paintings like the Dresden and Parma versions of *Christ Healing the Blind,* and the Washington National Gallery and Minneapolis Institute of Arts versions of the *Purification of the Temple,* El Greco drew on Tintoretto's early works for his approach to the subject as a stage presentation, with twisting and gesticulating figures in billowing draperies, arranged in groups

El Greco's zealous support of the principles of the Council of Trent seems to be indicated by the two subjects he painted most often during his Italian years: the *Purification of the Temple,* with its obvious Counter-Reformation meaning, and *Christ Healing the Blind* in which Christ represents the Church opening the eyes of those blind to the true faith. El Greco painted three versions of *Christ Healing the Blind,* the first in Dresden, about 1565, the next of the early 1570s in this exhibition, and the third, which Wethey (1962) believes was painted in Spain about 1577–78, in the Wrightsman Collection. All three are related to early paintings by Tintoretto. The architectural background of the Parma *Christ Healing the Blind* has a very close parallel in Tintoretto's *Christ Washing the Feet of the Apostles* in the Escorial; the figure of the white-bearded apostle with spread arms has a quite literal prototype in the St. Peter in Tintoretto's *Christ Washing the Feet of the Apostles.* There is also a precedent in the Wilton House picture, although somewhat less exaggerated, for the unusual perspective that suggests that the viewer is looking down on the scene from a balcony. It is this viewpoint that has produced the curious foreshortening of the lower parts of the bodies, which gives them the appearance of being rather squat. The use of figures seen

from behind to establish the foreground limit of figural groups is a frequent device of Tintoretto. Pallucchini (1956) dated the picture about 1574, during El Greco's second stay in Venice. Wethey concluded that it was done in Rome about 1570, shortly after El Greco's arrival there, because of its provenance from the Farnese Collection in Rome and its incorporation of Roman antiquities, unprecedented in El Greco's work. In the group at the left is the gigantic nude figure of the Farnese *Hercules* brought to life. Behind him is the anguished head of the old priest from the Laocoön group. Immediately behind Christ in the architectural vista is the Arch of Constantine and at the terminus of the vista is a section of the Baths of Diocletian. Matthew 9:27–34 relates that Christ restored sight to two blind men by touching their eyes. The youth at left pointing to the sun is the first of them manifesting his recovered vision. The young man in a white ruff is most likely a portrait of the artist. The painting has been trimmed at the right, cutting off two figures and part of the man seen from behind. The three paintings of *Christ Healing the Blind* reveal the extent to which El Greco's mature work in Toledo was dependent on his Venetian training.

unified by the movement and countermovement within the group before an off-center architectural vista that recedes sharply into space. In Tintoretto he also found the concept compatible with his Byzantine background that the biblical episode represented is no mundane experience, but a supernatural drama. Pacheco relates that El Greco even adopted Tintoretto's procedure of planning his compositions with small wax models and observing them in flickering candle or torch light. During these formative years El Greco may also have been influenced to a lesser degree by Jacopo Bassano and by the Florentine Francesco Salviati, who had worked in Venice.

In November 1570, El Greco went to Rome where he was given lodgings in the Palazzo Farnese. He seems to have been well satisfied with his Venetian orientation, for he was little influenced by either the formal emphasis of sixteenth-century painting in Rome or by classical antiquities. As Mancini reported later, El Greco became notorious for his open criticism of Michelangelo's *Last Judgment,* stating that he "would have made it with honesty and decorum suitable for good quality in painting." El Greco could not, however, deny Michelangelo's greatness nor escape the influence of his vigorous representation of the human body or his concentration of compact masses near the picture plane in his late works. In Rome, El Greco painted some splendid portraits like that of Giulio Clovio in the Museo di Capodimonte in Naples and seems to have had a market for small religious paintings, but he received no major commissions. His closest associates were Italian and Spanish intellectuals: Giulio Clovio, Fulvio Orsini, librarian for the Farnese, Pedro Chacon, canon of the Cathedral of Toledo, and Luis de Castilla, brother of the dean of the Toledo Cathedral, both friends of Orsini. How long El Greco remained in Rome is a matter of conjecture. Scholars generally agree that he returned to Venice sometime between 1672 and 1675 and remained there until he left for Spain. It is, therefore, difficult to determine

whether his later Italian works like the several versions of the *Annunciation* or the Wrightsman *Christ Healing the Blind* were done in Rome or Venice. In these paintings El Greco showed a much greater mastery of form and space than in earlier works, but all his Italian paintings must be regarded only as a prelude to his fully developed expression in Spain. El Greco himself refused to say why he went to Spain. Perhaps it was to participate in the decoration of the Escorial completed in 1575 or perhaps in the hope of commissions in Toledo through the friends he had made in Rome. In 1576, shortly after the death of Titian, El Greco left Italy. In the spring of 1577, after a brief sojourn in Madrid, he arrived in Toledo where he remained until his death in 1614. It was in Toledo that El Greco's Venetian training bore fruit. His first work there, the *Assumption* for Santo Domingo el Antiguo, now in the Art Institute of Chicago, is not imaginable without Titian's *Assumption* in the Frari, and Soria has found that motifs from nearly all of Titian's major works of the 1560s appear in El Greco's Spanish works. Tintoretto's most profound influences only now become evident in El Greco's dramatic, sometimes mystical light and his infusion of religious scenes with a sense of the supernatural. El Greco's Byzantine background, Venetian experience, and lasting recollections of Titian and Tintoretto fused into his own transcendental vision to create in isolation in Toledo a brilliant and original finale to Mannerism.

Collections,
Exhibitions,
and
Literature

Giovanni Bellini

c.1426–1516

1.

Madonna and Child (Frizzoni),
early 1460s
Tempera on canvas, transferred from
panel
21⅛ x 17⅝ in. (53.5 x 44.7 cm.)
Museo Civico Correr, Venice
1836

Collection:
Gustavo Frizzoni, Bergamo, 1919.

Exhibitions:
Exhibition of Italian Art 1200–1900,
catalog by R. Witt, A. Venturi, U. Ojetti,
London, Royal Academy of Art, Bur-
lington House, Jan. 1–Mar. 8, 1930,
no. 281, p. 169; *Exposition de l'art ital-
ien de Cimabue à Tiepolo,* catalog by U.
Ojetti, P. Jamot, Paris, Petit Palais, May
14–July 1935, no. 37, p. 19; *La mostra
dei capolavori dei musei veneti,* Venice,
Procuratie Nuove, 1946, catalog by R.
Pallucchini, no. 136, p. 76, repr.; *Tré-
sors de l'art vénitien,* catalog by R. Palluc-
chini, Lausanne, Musée Cantonal des
Beaux-Arts, Apr. 1–July 31, 1947, no.
21, p. 61; *Mostra di Giovanni Bellini,*
catalog by R. Pallucchini, Venice,
Palazzo Ducale, June 12–Oct. 5, 1949,
no. 52, p. 92, repr.; *L'Europe humaniste,*
Brussels, Palais des Beaux-Arts, Dec.
15–Feb. 28, 1955.

Literature:
G. Morelli, *Kunstkritische Studien über
italienische Malerei: die Galerien zu Mün-
chen und Dresden,* Leipzig: Brockhaus,
1891, p. 73; B. Berenson, *The Venetian
Painters of the Renaissance,* New York:
Putnam, 1894, p. 86; R. E. Fry,
Giovanni Bellini, London: Unicorn,
1900, p. 19; L. Venturi, *Le origini della
pittura veneziana 1300–1500,* Venice:
Arti Grafiche, 1907, pp. 359–61, repr.;

J. A. Crowe, G. B. Cavalcaselle, *A His-
tory of Painting in North Italy,* 3 vols.,
London: John Murray, 1912, vol. 1,
p. 141, repr. opp. p. 140; A. Venturi,
Storia dell'arte italiana, 11 vols., Milan:
Hoepli, 1901–40, vol. 7, part 3, 1914,
p. 424, repr. p. 427, fig. 330, vol. 7,
part 4, 1915, pp. 262–66, repr. p. 265,
fig. 146; B. Berenson, *Venetian Paint-
ings in America: The Fifteenth Century,*
New York: Fairchild Sherman, 1916,
pp. 76–77; R. Reinach, *Répertoire des
peintures du moyen âge et de la renaissance
(1280–1580),* 6 vols., Paris: Leroux,
1905–23, vol. 6, p. 412; G. Gronau,
"Über eine Madonnenkomposition von
Giovanni Bellini," *Jahrbuch der preus-
sischen Kunstsammlungen,* vol. 45,
1924, p. 41; G. Gronau, *Giovanni Bel-
lini, des Meisters Gemälde,* New York:
Weyhe, 1930, pp. xx, 201, note 29,
repr. p. 31; Lord Balniel, K. Clark, E.
Modigliani, *A Commemorative Catalogue
of the Exhibition of Italian Art,* London:
Oxford Univ. Press, 1931, p. 56, no.
163, repr. pl. 64; B. Berenson, *Italian
Pictures of the Renaissance,* Oxford:
Clarendon Press, 1932, p. 74; L. Düss-
ler, *Giovanni Bellini,* Frankfurt a.M.:
Prestel, 1935, p. 141; R. van Marle,
*The Development of the Italian School of
Painting,* 19 vols., The Hague: Nijhoff,
1923–38, vol. 17, 1935, p. 248; W.
Arslan, "L. Düssler, Giovanni Bellini,"
Achivio Veneto, serie 5, vol. 19, 1936, p.
384; C. Gamba, *Giovanni Bellini,* Mi-
lan: Hoepli, 1937, p. 54, repr. pl. 24;
V. Moschini, *Giambellino,* Bergamo:
Arti Grafiche, 1943, p. 18, repr. pl. 47;
P. Hendy, L. Goldscheider, *Giovanni
Bellini,* Oxford and London: Phaidon,
1945, p. 32, no. 22, repr. pl. 22; R.
Pallucchini, *I capolavori dei musei veneti,*

Venice: Arte Veneta, 1946, p. 76, no.
136; R. Pallucchini, *Giovanni Bellini,*
Venice: Alfieri, 1949, p. 92, no. 52,
repr.; L. Düssler, *Giovanni Bellini,*
Vienna: Schroll, 1949, pp. 14, 15, 87,
no. 7, repr. pl. 7; G. Mariacher, *Il
Museo Correr di Venezia: Dipinti dal XIV
al XVI secolo,* Venice: Neri Pozza, 1957,
p. 51, repr. p. 50; B. Berenson, *Italian
Pictures of the Renaissance: Venetian
School,* London: Phaidon, vol. 1, 1957,
p. 35, repr. fig. 207; F. Heinemann,
Giovanni Bellini e i Belliniani, 2 vols.,
Venice: Neri Pozza, 1962, vol. 1, p. 2,
no. 8, repr. vol. 2, p. 21, fig. 19;
R. Pallucchini, *Giovanni Bellini,* Milan:
Martello, 1959, pp. 48, 135, fig. 69,
repr.; T. Pignatti, *L'opera completa di
Giovanni Bellini,* Milan: Rizzoli, 1969,
p. 89, fig. 34, repr.; G. Robertson,
Giovanni Bellini, Oxford: Clarendon
Press, 1968, p. 60, repr. pl. 43a.

2.

Portrait of Joerg Fugger, 1474
Oil on panel
10¼ x 7⅞ in. (26 x 20 cm.)
Inscribed on reverse:
Joerg Fugger a di XX Zugno
MCCCCLXXIIII
Norton Simon Inc Foundation,
Los Angeles
M.69.13.P

Collections:
Johannes, Count of Fugger-Oberkirch-
berg, Castle Oberkirchberg, Ulm;
Walter Schnackenberg, Munich, 1926;
F. Kleinberger Galleries, New York,
1927; Conte Alessandro Contini-
Bonacossi, Florence; Lorenzo, Laura,
Caterina, and Anna Maria Papi,
Florence.

Exhibitions:
Exhibition of Italian Art 1200–1900, cat-
alog by R. Witt, A. Venturi. U. Ojetti,

London, Royal Academy of Art, Bur-
lington House, Jan. 1–Mar. 8, 1930,
no. 270, p. 164; *Mostra di Giovanni Bel-
lini,* catalog by R. Pallucchini, Venice,
Palazzo Ducale, June 12–Oct. 5, 1949,
no. 75, p. 114, repr. p. 115; Cam-
bridge, Mass., Fogg Art Museum, May
1969–Jan. 1970; Los Angeles County
Museum of Art, Jan. 1970–Aug. 1971;
*Selections from the Norton Simon Inc.
Museum of Art,* Princeton Univ. Art
Museum, 1972–74, no. 1.

Literature:
A. L. Mayer, "A Portrait of Joerg Fug-
ger Ascribed to Giovanni Bellini," *Bur-
lington Magazine,* vol. 48, May 1926,
p. 219, repr.; D. von Hadeln, "Two
Portraits by Giovanni Bellini," *Bur-
lington Magazine,* vol. 51, July 1927,
pp. 4–7; Lord Balniel, K. Clark, E.
Modigliani, *A Commemorative Catalogue
of the Exhibition of Italian Art,* London:
Oxford Univ. Press, 1931, no. 167,
p. 57; G. Gronau, *Giovanni Bellini,
des Meisters Gemälde,* New York:
Weyhe, 1930, pp. XXII, 205, note 69,
repr. p. 69; L. Düssler, *Giovanni Bel-
lini,* Frankfurt a.M.: Prestel, 1935, no.
75, pp. 44, 92, repr.; R. van Marle,
*The Development of the Italian Schools of
Painting,* 19 vols., The Hague: Nijhoff,
1923–38, vol. 17, 1935, p. 254;
C. Gamba, *Giovanni Bellini,* Milan:
Hoepli, 1937, p. 72, repr. pl. 52;
L. Schmeckebier, *A Handbook of Italian
Renaissance Painting,* New York: Put-
nam, 1938, p. 189; V. Moschini, *Giam-
bellino,* Bergamo: Arti Grafiche, 1943,
pp. 23, 40, repr. pl. 82; A. M.
Brizio, "Considerazioni su Giovanni
Bellini," *Arte Veneta,* Annata 3, 1949,

pp. 32–33, repr. p. 33, fig. 41; P. Hendy, L. Goldscheider, *Giovanni Bellini,* Oxford and London: Phaidon, 1945, pp. 27, 32, no. 40, repr. pl. 40; L. Düssler, *Giovanni Bellini,* Vienna: Schroll, 1949, pp. 44, 45, 92, no. 75, repr. pl. 75; B. Berenson, *Italian Pictures of the Renaissance: Venetian School,* 2 vols., London: Phaidon, 1957, vol. 1, p. 31, repr. pl. 211; R. Pallucchini, *Giovanni Bellini,* Milan: Martello, 1959, pp. 60–61, 138, fig. 93, repr. pl. 93; G. Fiocco, *Giovanni Bellini,* London: Oldbourne Press, 1960, p. 14, repr. pl. 19; F. Heinemann, *Giovanni Bellini e i Belliniani,* 2 vols., Venice: Neri Pozza, 1962, vol. 1, p. 75, no. 269, vol. 2, repr. p. 158, fig. 114; S. Bottari, *Tutta la pittura di Giovanni Bellini,* Milan: Rizzoli, 1963, p. 37; J. Pope-Hennessy, *The Portrait in the Renaissance,* New York: Pantheon, 1966, pp. 63, 311, note 94, repr. p. 189; T. Pignatti, *L'opera completa di Giovanni Bellini,* Milan: Rizzoli, 1969, p. 94, no. 71; M. Gendel, "Italy: Saving with One Hand, Giving with Another," *Art News,* vol. 71, no. 4, summer 1972, pp. 22, 23, repr.; F. L. Gibbons, *Selections from the Norton Simon Inc. Museum of Art,* ed. D. W. Steadman, Princeton Univ. Art Museum, 1972, pp. 15, 16, 20, repr. no. 1.

3.

Christ Blessing, c. 1500
Tempera and oil on panel
23¼ x 18½ in. (59.1 x 47 cm.)
Kimbell Art Museum, Fort Worth
A.P.67.7

Collections:
Church of Santo Stefano, Venice; Cunningham, England, prior to 1849; Richard Fisher, England; Mrs. Gunhilda Fisher, England; Sale, London, Sotheby's, 1958 (sold as Basaiti); Joseph H. Dasser, Zurich, 1967.

Exhibitions:
Konstens Venedig, Stockholm, Nationalmuseum, Oct. 20, 1962–Feb. 10, 1963, p. 62–63, no. 56; *Masterpieces of World Art from American Museums,* Tokyo, National Museum of Western

Art, Sept. 11–Oct. 17, 1976, and Kyoto National Museum, Nov. 2–Dec. 5, 1976, p. 20.

Literature:
C. Ridolfi, *Le maraviglie dell'arte, ovvero le vite degl'illustri pittori veneti e dello stato . . .* (1648), 2 vols., ed. D. von Hadeln, Berlin: Grote, 1914–24, vol. 1, p. 71; A. Morassi, "Scoperta d'un Cristo Benedicente del Giambellino," *Arte Veneta,* Annata 12, 1958, pp. 45–52, repr. in color p. 47, fig. 44; R. Pallucchini, *Giovanni Bellini,* Milan: Martello, 1959, pp. 88, 148, repr. fig. 162; F. Heinemann, *Giovanni Bellini e i Belliniani,* 2 vols., Venice: Neri Pozza, 1962, vol. 1, p. 57, no. 191 bis, vol. 2, p. 117, repr. fig. 86; S. Bottari, *Tutta la pittura di Giovanni Bellini,* 2 vols., Milan: Rizzoli, 1963, vol. 2, p. 25, pl. 51; L. Düssler, "Berichte: Schweden," *Pantheon,* vol. 21, 1963, p. 129, repr. p. 113; G. Robertson, *Giovanni Bellini,* Oxford: Clarendon Press, 1968, p. 113; T. Pignatti, *L'opera completa di Giovanni Bellini,* Milan: Rizzoli, 1969, p. 103, repr. fig. 150; Kimbell Art Museum, *Catalogue of the Collection,* Fort Worth: Kimbell Art Foundation, 1972, pp. 30–32, repr. p. 31.

4.

The Drunkenness of Noah, c. 1515
Oil on canvas
40½ x 61¾ in. (103 x 157 cm.)
Musée des Beaux-Arts, Besançon
896.1.13

Collection:
Jean Gigoux, Paris, 1896.

Exhibitions:
Mostra di Giovanni Bellini, catalog by R. Pallucchini, Venice, Palazzo Ducale, June 12–Oct. 5, 1949, p. 211, no. 126, repr. fig. 126; *500 Jahre venezianischer Malerei,* Schaffhausen, Museum zu Allerheiligen, May 2–July 19, 1953, no. 18; *De Venetiaanse meesters,* catalog by R. Pallucchini, Amsterdam, Rijksmuseum, July 26–Oct. 11, 1953, no. 17; *La peinture vénitienne,* catalog by R. Pallucchini, Brussels, Palais des Beaux-Arts, Oct. 16, 1953–Jan. 10, 1954, no. 16; *De Giotto à Bellini: Les primitifs italiens dans les musées de France,* catalog by M. Laclotte, Paris,

Orangerie des Tuileries, Musée des Arts Décoratifs, May–July 1956, no. 48; *Besançon, le plus ancien Musée de France,* Paris, Musée des Arts Décoratifs, Feb. 22–Apr. 22, 1957, no. 5; *Konstens Venedig,* Stockholm, Nationalmuseum, Oct. 1962–Feb. 10, 1963, no. 60; *Le seizième siècle européen,* Paris, Petit Palais, Oct. 1965–Jan. 1966, no. 43.

Literature:
A. Venturi, *Storia dell'arte italiana,* 11 vols., Milan: Hoepli, 1901–40, vol. 7, part 4, 1915, pp. 590–92, repr. p. 593, fig. 373; R. Longhi, "Un chiaroscuro e un disegno di Giovanni Bellini," *Vita artistica, studi di storia dell'arte,* Rome: La Voce, 1927, p. 134; A. Venturi, *Storia dell'arte italiana,* vol. 9, part 3, 1928, pp. 67–69, repr. p. 65, fig. 45; B. Berenson, *Italian Pictures of the Renaissance,* Oxford: Clarendon Press, 1932, p. 127; C. Gamba, *Giovanni Bellini,* Milan: Hoepli, 1937, pp. 177–78, repr. fig. 197; P. Hendy, L. Goldscheider, *Giovanni Bellini,* Oxford and London: Phaidon, 1945, p. 34, no. 114, repr. fig. 114; R. Longhi, *Viatico per cinque secoli di pittura veneziana,* Florence: Sansoni, 1946, p. 13; R. Pallucchini, *Giovanni Bellini,* Venice: Alfieri, 1949, p. 211, no. 126, repr.; A. M. Brizio, "Considerazioni su Giovanni Bellini," *Arte Veneta,* Annata 3, 1949, p. 37, repr. p. 39, fig. 46; L. Düssler, *Giovanni Bellini,* Vienna: Schroll, 1949, p. 63; E. Arslan, "Il polittico di San Zanipolo," *Bollettino d'Arte,* serie 4, vol. 37, no. 1, Jan.–Mar. 1952, p. 144; C. Gilbert, "Alvise e Compagni," *Scritti di storia dell'arte in onore di Lionello Venturi,* 2 vols., Rome: De Luca, 1950, vol. 1, pp. 296–97, repr. p. 296, fig. 16; B. Berenson, *Italian Pictures of the Renaissance: Venetian School,* 2 vols., London: Phaidon, 1957, vol. 1, p. 30, repr. fig. 264; S. Bottari, *Tutta la pittura di Giovanni Bellini,* 2 vols., Milan: Rizzoli, 1963, vol. 2, pp. 12, 36, repr. figs. 148–49; R. Pallucchini, *Giovanni Bellini,* Milan: Martello, 1959, pp. 112, 158, no. 228, repr. figs. 228–29; F. Heinemann, *Giovanni Bellini e i Belliniani,* 2 vols., Venice: Neri Pozza, 1962, vol. 1, pp. 271–72, no.

376, vol. 2, repr. p. 520, fig. 582; M. Bonicatti, *Aspetti dell'umanesimo nella pittura Veneta dal 1455 al 1515,* Rome: Cremonese, 1964, p. 123, note 1, pp. 125, 209–10, repr. fig. 113; T. Pignatti, *L'opera completa di Giovanni Bellini,* Milan: Rizzoli, 1969, p. 110, no. 21, repr. fig. 211; H. W. Wethey, *The Painting of Titian,* 3 vols., London: Phaidon, 1969–75, vol. 1, p. 177, no. X-29.

Giovanni Battista Cima

Cima da Conegliano, c. 1459–1517

5.

Madonna and Child in a Landscape
Oil on panel
28 x 24¾ in. (71 x 62.8 cm.)
North Carolina Museum of Art,
Raleigh
Original State Appropriation
52.9.152

Collections:
Private Collection, St. Petersburg,
Russia; Sale, Berlin, Rudolf Lepke,
Nov. 6, 1928, lot 364.

Exhibitions:
*Exhibition Number One from the Permanent
Collection*, Raleigh, North Carolina
Museum of Art, Oct. 1970.

Literature:
P. P. Weiner, *L'Arte*, vol. 12, 1909,
p. 218; A. Troubnikoff, "Art in Russia,"
Burlington Magazine, vol. 14, Oct.
1908–Mar. 1909, p. 326; *Katalog
2000: Kunstwerke aus den Beständen
leningrader Museen und Schlösser*,
Rudolph Lepke, Berlin, 1928, p. 104,
no. 364, pl. 15; P. Wescher, "Die Auk-
tion von Werken aus den ehem. Privat-
sammlungen im Besitz des Russischen
Staates," *Pantheon*, 1928, vol. 2,
pp. 523–28, repr. p. 528; "Prices Re-
ported on Lepke's Russian Sale," *Art
News*, vol. 27, Nov. 24, 1928, p. 3;
"Soviet Art Sale Marred by With-
drawals," *Art Digest*, vol. 3, Dec. 1,
1928, p. 32; R. van Marle, *The Develop-
ment of the Italian School of Painting*,
19 vols., The Hague: Nijhoff, 1923–
38, vol. 17, 1935, pp. 437–38; W. R.
Valentiner, *Catalogue of Painting*,
Raleigh: North Carolina Museum of
Art, 1956, p. 78, no. 182, repr.; V. Lasa-
reff, "Opere nuove e poco note di
Cima da Conegliano," *Arte Veneta*, An-
nata 11, 1957, pp. 48, 52; B. Berenson,
*Italian Pictures of the Renaissance: Vene-
tian School*, 2 vols., London: Phaidon,
1957, vol. 1, p. 67; L. Coletti, *Cima da
Conegliano*, Venice: Neri Pozza, 1959,
pp. 87–88; M. Davies, *The Earlier
Italian Schools*, London: National Gallery,
1961, p. 143.

Vittore Carpaccio

c. 1465–1527

6.

Portrait of a Lady, 1490–95
Oil on panel
10½ x 8⅞ in. (26.7 x 22.5 cm.)
Nelson Gallery-Atkins Museum,
Kansas City
Nelson Fund
47–39

Collections:
Quincy Adams Shaw, Boston; Schone-
man Galleries, New York.

Literature:
"Portrait of a Lady by Vittore Carpac-
cio," *Art Quarterly*, vol. 10, 1947,
p. 285, repr. p. 286; *The Art Digest*, vol.
22, Oct. 1, 1947, p. 11, repr.; "Sacred
and Profane Old Masters for Kansas
City," *Art News*, vol. 47, Sept. 1948,
p. 28, repr. in color; L. Vertova, *Carpac-
cio*, Florence: Electa editrice [1949],
p. 27, repr.; G. Perocco, *L'opera completa
del Carpaccio*, Milan: Rizzoli, 1967,
p. 115, no. 119, repr.; F. Arslan, "Due
disegni e un dipinto di Carpaccio,"
Emporium, vol. 116, 1952, p. 109; B.
Berenson, *Italian Pictures of the Renais-
sance: Venetian School*, 2 vols., London:
Phaidon, 1957, vol. 1, p. 37; G.
Perocco, *Tutta la pittura del Carpaccio*,
Milan: Rizzoli, 1960, p. 84, fig. 193;
J. Lauts, *Carpaccio: Paintings and Draw-
ings*, Greenwich: Phaidon, 1962,
p. 260; *Handbook of the Collections*, ed.
R. E. Taggart, G. L. McKenna, Kansas
City: Nelson Gallery-Atkins Museum,
vol. 1, 1973, p. 86, repr.

7.

*Apparition of the Martyrs of Mount
Ararat in Sant'Antonio di Castello*,
c. 1513–14
Oil on canvas
47⅜ x 68½ in. (121 x 174 cm.)
Gallerie dell'Accademia, Venice
91

Collection:
Church of Sant'Antonio di Castello,
Venice.

Exhibition:
Vittore Carpaccio, Venice, Palazzo
Ducale, June 15–Oct. 6, 1963, no. 61.

Literature:
M. Boschini, *Le ricche minere della pit-
tura veneziana…*, Venice: Nicolini,
1664, p. 163; F. Corner, *Notizie storiche
delle chiese e monasteri di Venezia…*,
Padua, 1758, p. 69; *Catalogo degli
oggetti d'arte contenuti nella I. R. Ac-
cademia di belle arti in Venezia*, Venice,
1852, p. 16; *Catalogo degli oggetti d'arte
esposti al pubblico nella I. R. Accademia di
belle arti in Venezia*, Venice, 1854,
p. 34; G. Ludwig, P. Molmenti, *Vittore
Carpaccio, la vie et l'oeuvre du peintre*,
Paris: Hachette, 1910, p. 286, repr. pl.
110; J. A. Crowe, G. B. Cavalcaselle,
A History of Painting in North Italy,
3 vols., London: John Murray, 1912, vol.
1, p. 215, note 13; A. Venturi, *Storia
dell'arte italiana*, 11 vols., Milan:
Hoepli, 1901–40, vol. 7, p. 758, note;
G. Fiocco, *Carpaccio*, Rome: Valori
Plastici, [19--], pp. 46, 81, fig. 171,
repr.; R. van Marle, *The Development of
the Italian School of Painting*, 19 vols.,
The Hague: Nijhoff, 1923–38, vol. 18,
1936, p. 370, repr. fig. 212; S. Moschini
Marconi, *Gallerie dell'accademia di
Venezia*, Rome: Libreria dello Stato,
1955, p. 108; T. Pignatti, *Carpaccio*,
Milan: Mondadori, 1955, p. 150;
M. Meiss, "Addendum Ovologicum,"
The Art Bulletin, vol. 36, 1954,
p. 221, repr. fig. 1; J. Lauts, *Carpaccio:
Paintings and Drawings*, Green-
wich: Phaidon, 1962, p. 263;
P. Zampetti, *Vittore Carpaccio*, Venice:
Alfieri, 1963, p. 272, fig. 61, repr.;
P. Zampetti, *Vittore Carpaccio*, Venice:
Alfieri, 1966, p. 89, no. 70, repr.;
G. Perocco, *L'opera completa del Carpaccio*,
Milan: Rizzoli, 1967, pp. 110–11,
no. 62.

Giorgione

Giorgio da Castelfranco, c. 1477–1510

8.

Page Boy, c. 1505
Oil on canvas
9½ x 7¾ in. (24.1 x 19.7 cm.)
M. Knoedler & Co., New York City
A9817

Collections:
Giuseppe Bossi, Milan, 1816;
Nathaniel Strode, London; William
Wilsey Martin, London; Mason
Jackson, London, 1882; Nicholas
Strode-Jackson, Oxford and New York.

Exhibitions:
Giorgione and His Circle, Baltimore,
Johns Hopkins Univ., Feb. 23–Mar.
21, 1942, no. 6; *West European and
American Paintings from the Museums
of the United States*, Leningrad,
Hermitage, Feb. 13–Mar. 24, 1976,
Moscow, Pushkin Museum of Fine
Art, Apr. 8–May 19, 1976, Kiev,
Museum of Ukrainian Fine Art, June
3–July 15, 1976, Minsk, Museum of
Fine Art, July 30–Sept. 12, 1976;
*Chefs-d'oeuvre de musées des Etats-Unis de
Giorgione à Picasso*, Paris, Musée Mar-
mottan, Oct. 13–Dec. 5, 1976, no. 6.

Literature:
Arundel Club, London, 1913, no. 5;
G. F. Hartlaub, *Giorgiones Geheimnis…*,
Munich: Allgemeine Verlagsanstalt,
1925, p. 49, pl. 10; G. F. Suter, "Gior-
giones 'Testa del pastorello che tiene in
man un frutto,'" *Zeitschrift für bildende
Kunst*, vol. 42, Nov. 1928, p. 169; G.
Fiocco, "Pier Maria Pennacchi," *Rivista
dell'Istituto di archeologia*, 1929, pp.
97 ff.; G. M. Richter, *Giorgio da Castel-
franco, called Giorgione*, Chicago: Univ.
of Chicago Press, 1937, p. 231, pl. 28;
G. M. Richter, "Lost and Rediscovered
Works by Giorgione," *Art in America*,
vol. 30, July 1942, p. 148, repr. in
color; G. De Batz, *Giorgione and His
Circle*, Baltimore: Johns Hopkins Univ.,
1942, p. 26, no. 6, repr.; H. Tietze,
"La mostra di Giorgione e la sua
cerchia a Baltimora," *Arte Veneta*,
Annata 1, 1947, p. 140, no. 6; T. Pig-
natti, *Giorgione*, Milano: Mondadori,
1955, p. 125; T. Pignatti, *L'opera
completa di Giovanni Bellini*, Milan: Riz-
zoli, 1969, p. 131, no. A49, repr. pl.

131; T. Pignatti, *Giorgione,* New York: Phaidon, 1971, p. 131; T. Pignatti, "Il paggio di Giorgione," *Pantheon,* vol. 33, 1975, pp. 314–18, repr. in color.

9.
Portrait of a Young Man (Terris), 1510
Oil on panel
11¾ x 10½ in. (29.9 x 26.6 cm.)
Inscribed on reverse: 15 . . . di man, de mo Zorzi da castel fr
San Diego Museum of Art
41:100

Collections:
David Curror, London; Alexander Terris, London; Lilienfeld Galleries, New York, 1941.

Literature:
G. M. Richter, *Giorgio da Castelfranco,* Chicago: Univ. of Chicago Press, 1937, pp. 95, 124, 226, no. 48, repr. pl. 50; A. M. Frankfurter, "Treasures of San Diego," *Art News,* vol. 41, Feb. 15, 1941, p. 13, repr. p. 14; A. Morassi, *Giorgione,* Milan: Hoepli, 1942, p. 99; G. M. Richter, "Giorgione's Evolution in the Light of Recent Discoveries," in *Giorgione and His Circle,* Baltimore: Johns Hopkins Univ., 1942, p. 10 (not exhibited); "San Diego Acquires Giorgione Portrait," *Art Digest,* Feb. 15, 1942, p. 7, repr.; J. G. Andrews, *A Catalogue of European Paintings 1300–1880,* San Diego, 1947, p. 53, repr. p. 51; G. Fiocco, *Giorgione,* Bergamo: Arte Grafiche, 1948, p. 30; P. della Pergola, *Giorgione,* Milan: Martello, 1955, p. 30; T. Pignatti, *Giorgione,* Milan: Mondadori, 1955, p. 139; T. Pignatti, "Giorgione pittore aristocratico," *Nuova Antologia,* 1955, p. XV; W. Suida, "Giorgione in American Museums," *Art Quarterly,* vol. 19, 1956, pp. 148–51; B. Berenson, *Italian Pictures of the Renaissance: Venetian School,* 2 vols., London: Phaidon, 1957, vol. 1, p. 29; L. Coletti, *All the Paintings of Giorgione,* trans. P. Colacicchi, New York: Hawthorne, 1961, p. 65, pls. 90–91; R. Salvini, "Giorgione: Un ritratto e molti problemi," *Pantheon,* 1961, vol. 19, p. 231; L. Baldass, G. Heinz, *Giorgione,* Vienna, Munich:

Schroll, 1964, pp. 35, 153, no. 18, repr. fig. 22; P. Zampetti, *L'opera completa di Giorgione,* New York: Abrams, 1968, p. 93, no. 24, repr.; G. Robertson, "New Giorgione Studies," *Burlington Magazine,* vol. 113, Aug. 1971, p. 477; *Master Works from the Collection of the Fine Arts Gallery of San Diego,* ed. M. E. Petersen, 1968, repr.; T. Pignatti, *Giorgione,* New York: Phaidon, 1971, pp. 69, 110–11, no. 26, pl. 109; K. Garas, "Bildnisse der Renaissance, Dürer und Giorgione," *Acta Historiae Artium,* vol. 18, pp. 125–35.

10.
Dead Christ Supported by an Angel, 1508–10
Oil on canvas
30 x 24⅞ in. (76.2 x 63.2 cm.)
Private Collection, New York City

Collections:
Gabriele Vendramin, Venice; Polcenigo Collection, Venice; Private Collection, Venice.

Literature:
M. Michiel, *Notizia d'opere de disegno . . . scritta da un anonimo di quel tempo* (1543), ed. J. Morelli, Bassano, 1800, p. 80, English trans. P. Mussi, London: Williamson, 1903, p. 123; G. Morelli, *Italian Painters: Critical Studies of Their Works,* 2 vols., London: John Murray, 1907, vol. 2, p. 220; G. Verga, *Il rinvenimento del "Cristo morto" di Giorgione,* Cremona: Cremona Nuova, 1929; G. M. Richter, "Lost and Rediscovered Works by Giorgione," *Art in America,* vol. 30, 1942, pp. 155–56; H. Tietze, *Titian: Paintings and Drawings,* London: Phaidon, 1950, p. 12; R. Pallucchini, "Contributi alla Veneta del Cinquecento, El Cristo morto Vendramin," *Arte Veneta,* Annata 13–19, 1959–60, pp. 39–44, repr. pp. 40, 41, 43, p. 45 in color; F. Valcanover, *Tutta la pittura di Tiziano,* 4 vols., Milan: Rizzoli, 1960, vol. 1, pp. 82–83; "Un Cristo Muerto de Giorgione y Tiziano," *Goya,* no. 40, 1961, p. 309, repr.; G. Robertson, "The Literature of Art: Some Recent Venetian Publications," *Burlington Magazine,* vol. 103, part 1, June 1961, p. 284; E. Serra, *Del "Cristo Morto" di Giorgione visto da Marcantonio Michiel,* Florence: Olschki, 1962, pp. 40–61; R. Pallucchini, "Due nuovi

Antonello," *Arte Veneta,* Annata 21, 1967, p. 266; P. Zampetti, *L'opera completa di Giorgione,* New York: Abrams, 1968, p. 94, no. 29, repr.; H. E. Wethey, *The Painting of Titian,* 3 vols., London: Phaidon, 1969–75, vol. 1, p. 171, no. X-29; F. Valcanover, C. Cagli, *L'opera completa di Tiziano,* Milan: Rizzoli, 1969, p. 100, no. 88, repr.; R. Pallucchini, *Tiziano,* Florence: Sansoni, 2 vols., 1969, vol. 1, pp. 25, 65, 262–63, no. 190, vol. 2, repr. pl. 190; A. Cloulas, "Travaux récents sur Titien," *Revue de l'Art,* no. 13, 1971, p. 100; T. Pignatti, *Giorgione,* New York: Phaidon, 1971, pp. 12–70, 109–10, no. 25, repr. pl. 107, fig. 27, pl. 19 in color; A. R. Turner, "Giorgione," *Art Bulletin,* vol. 55, Sept. 1973, p. 457; D. Sutton, "Alla Veneziana," *Apollo,* vol. 102, Sept. 1975, p. 231.

Sebastiano del Piombo

Sebastiano Luciani, c. 1485–1547

11.
St. Louis of Toulouse, 1507–09
Oil on panel
115⅜ x 53⅞ in. (293 x 137 cm.)
Church of San Bartolomeo al Rialto, Venice

Exhibitions:
Cinque secoli di pittura veneta, Venice, Procuratie Nuove, July 21–Oct. 31, 1945, no. 63; *Trésors de l'art vénitien,* Lausanne, Musée Cantonal des Beaux-Arts, Apr. 1–July 31, 1947, no. 39; *De Venetiaanse meesters,* Amsterdam, Rijksmuseum, July 26–Oct. 11, 1953, no. 73a; *500 Jahre venezianischer Malerei,* Schaffhausen, Museum zu Allerheiligen, May 2–July 19, 1953, no. 33; *La peinture vénitienne,* Brussels, Palais des Beaux-Arts, Oct. 16, 1953–Jan. 10, 1954, no. 71a; *Chefs-d'oeuvre vénitiens de Paolo Veneziano à Tintoret,* Paris, Musée de l'Orangerie, Jan.–Mar. 31, 1954, no. 38; *Giorgione e i Giorgioneschi,* Venice, Palazzo Ducale, June 11–Oct. 23, 1955, no. 83.

Literature:
F. Scannelli, *Il microcosmo della pittura,* Cesena: Neri, 1657, p. 235; A. M. Zanetti, *Della pittura veneziana e delle opere pubbliche de' veneziani maestri,* Venice: Albrizzi, 1771, vol. 1, p. 278; A. Nardini, *Series historico chronologica,* Venice, 1788, pp. XL–XLI; J. A. Crowe, G.B. Cavalcaselle, *Geschichte der italienischen Malerei,* 6 vols., Leipzig: Hiezel, 1876, vol. 6, p. 371; F. Propping, *Die künstlerische Laufbahn des Sebastiano del Piombo bis zum Tode Raphaels,* dissertation, Leipzig Univ., Leipzig: Reudnitz, Schmidt, 1892, pp. 16–17; E. Benkard, *Die venezianische Frühzeit des Sebastiano del Piombo, 1485–1510,* dissertation, Frankfurt, 1907, pp. 20–25; G. Bernardini, *Sebastiano del Piombo,* Bergamo: Arti Grafiche, 1908, p. 12, repr. pl. 69; P. d'Achiardi, *Sebastiano del Piombo,* Rome: L'Arte, 1908, pp. 33–36, repr. fig. 5; L. Justi, *Giorgione,* 2 vols., Berlin: Bard, 1908, vol. 1, p. 230; F. Wickhoff, "Die Sammlung Tucher," *Münchener Jahrbuch der bildenden Kunst,* 1908, p. 29; L. Justi, *Giorgione,* Berlin: Reimer, 1926, p. 74; B. Berenson,

Italian Pictures of the Renaissance, Oxford: Clarendon Press, 1932, p. 523; J. Wilde, "Die Probleme und Domenico Mancini," *Jahrbuch der kunsthistorischen Sammlungen in Wien,* 1933, p. 116; R. Pallucchini, "La formazione di Sebastiano del Piombo," *Critica d'Arte,* 1935, pp. 41–42; G. M. Richter, *Giorgio da Castelfranco, called Giorgione,* Chicago: Univ. of Chicago Press, 1937, pp. 241–42; R. Pallucchini, "Vicenda delle ante d'organo di Sebastiano del Piombo," *Le Arti,* 1941, pp. 448–56; L. Düssler, *Sebastiano del Piombo,* Basel: Holbein, 1942, pp. 23, 141; R. Pallucchini, *Sebastian Veneziano,* Milan: Mondadori, 1944, p. 154, repr. pl. 6; P. Zampetti, *Giorgione e i Giorgioneschi,* Venice, Palazzo Ducale, June 11–Oct. 23, 1955, pp. 178, 183, repr. p. 181, no. 83; J. Wilde, *Venetian Art from Bellini to Titian,* Oxford: Clarendon Press, 1974, p. 95, repr. fig. 81.

12.

Portrait of a Man in Armor, c. 1511–15
Oil on canvas
34½ x 26¼ in. (87.6 x 66.7 cm.)
Wadsworth Atheneum, Hartford, The Ella Gallup Sumner and Mary Catlin Sumner Collection
1960.119

Collections:

Giulio de'Nobili (?), Florence; James Brydges, Duke of Chandos, 1747; Sir Thomas Sebright, Beechwood Park; Sir Giles Sebright, Beechwood Park; Sale, Christie's, London, July 2, 1937, lot 118; F. Kleinberger & Co., New York.

Literature:

G. Vasari, *Le vite dei più eccellenti pittori, scultori, ed architetti* (1568), ed. G. Milanesi, 9 vols., Florence: Sansoni, 1906, p. 574, note 2; R. Borghini, *Il riposo...* Florence: Marescotti, 1584, p. 436; G. F. Waagen, *Galleries and Cabinets of Art in Great Britain,* 2 vols., London: John Murray, 1854–57, vol. 4, p. 329; G.M. Richter, "A Portrait of Ferruccio by Sebastiano Veneziano," *Burlington Magazine,* no. 69, 1936, pp. 88–91, repr. p. 89; L. Düssler, *Sebastiano del Piombo,* Basel: Holbein, 1942, pp. 41, 134–35; R. Pallucchini, *Sebastian Veneziano,* Milan: Mondadori, 1944, p. 160, repr. fig. 33; B. Berenson, *Italian Picture of the Renais-*

sance: Venetian School, 2 vols., London: Phaidon, 1957, vol. 1, p. 164; F. Rouchette, *La Renaissance que nous a léguée Vasari,* Paris: Les Belles Lettres, 1959, p. 373, no. 2; C. C. Cunningham, "Portrait of a Man in Armor by Sebastiano del Piombo," *Wadsworth Atheneum Bulletin,* Hartford, summer 1960, pp. 15–16 repr.; *Sebastiano del Piombo,* Milan: Febbri, 1966, no. 158, repr. pl. 9; A. Chastel, *The Crisis of the Renaissance, 1500–1600,* Geneva: Skira, 1968, repr. p. 29.

Palma Vecchio

Jacopo Negretti, c. 1480–1528

13.

The Appeal, c. 1520–25
Oil on canvas
33¼ x 27¼ in. (84.5 x 69.2 cm.)
Inscribed on reverse: FRA BASTIAN DEL PIOMBO GIORZON TITIAN
Detroit Institute of Art, City Purchase
26.107

Collections:

Palazzo Sanchi, Bergamo, 1777; Count Schönborn, Pommersfelden; Grand Duke of Oldenburg, 1876; Lucerne Fine Arts Company, 1923.

Exhibitions:

Giorgione e i Giorgioneschi, Venice, Palazzo Ducale, June 11–Oct. 23, 1955, no. 43; *Giorgione and His Circle,* Baltimore, Johns Hopkins Univ., Feb. 23–Mar. 21, 1942, no. 15; *The Age of Titian,* Columbus Gallery of Fine Arts, Oct. 5–Nov. 10, 1946.

Literature:

O. Mündler, *Kunstchronik,* vol. 2, 1867, p. 14; G. Morelli, *Kunstkritische Studien über italienische Malerei, die Galerie zu München und Dresden,* Leipzig: Brockhaus, 1891, p. 32; A. Venturi, *La Galleria Crespi,* Milan: 1900, p. 151; E. A. Benkard, "Recesione a P. D'Achiardi, Sebastiano del Piombo," *Repertorium für Kunstwissenschaft,* 1908, p. 573; J.A. Crowe, G.B. Cavalcaselle, *A History of Painting in North Italy,* 3 vols., London: John Murray, 1912, vol. 3, pp. 454–55; T. Borenius, "The Venetian School in Grand-Ducal Collection, Oldenburg," *Burlington Magazine,* vol. 23, 1913, pp. 26, 28, repr. pl. 3E; L. Venturi, *Giorgione e il Giorgionismo,* Milan: Hoepli, 1913, pp. 234, 235; W. R. Valentiner, "A Combined Work by Titian, Giorgione and Sebastian del Piombo," *Bulletin of the Detroit Institute of Arts,* vol. 7, Mar. 1926, no. 6, pp. 62–65; P. Schubring, "A Surmise Concerning the Subject of the Venetian Figure Painting in the Detroit Museum," *Art in America,* vol. 15, 1926, pp. 35–40, repr.; W. R. Valentiner, "Once More the Venetian Three-Figure Painting," *Art in America,* vol. 16, 1927–28, pp. 40–44; F. J. Mather, Jr., "An Enigmatic Picture at Detroit,"

Art Bulletin, vol. 9, 1926–27, pp. 70–75; A. Venturi, *Storia dell'arte italiana,* 11 vols., Milan: Hoepli, 1901–40, vol. 9, part 3, 1928, p. 462, repr. pl. 305; Detroit Institute of Arts, *Catalogue of Painting,* 1930, no. 228; B. Berenson, *Italian Pictures of the Renaissance,* Oxford: Clarendon Press, 1932, p. 10; W. Suida, *Tiziano,* Rome: Valori Plastici, 1933, p. 29; A. Morassi, *Giorgione,* Milan: Hoepli, 1942, p. 172; R. Pallucchini, *La pittura veneziana del Cinquecento,* 2 vols., Novara: Agostini, 1944, p. 37; Detroit Institute of Arts, *Catalogue of Paintings,* 2nd ed., 1944, pp. 134–35, no. 228; G. Fiocco, *Giorgione,* Bergamo: Arti Grafiche, 1948, p. 14; R. Pallucchini, *Giorgione,* Milan: Martello, 1955, p. 12; T. Pignatti, *Giorgione,* Milan: Mondadori, 1955, p. 120; G. Robertson, "The Giorgione Exhibition in Venice," *Burlington Magazine,* vol. 97, 1955, p. 276; P. Zampetti, *Giorgione e i Giorgioneschi,* Venice, Palazzo Ducale, 1955, pp. 96, 97, repr. no. 43; W. Suida, "Miscellanea Tizianesca," *Arte Veneta,* Annata 10, 1956, p. 72, repr. fig. 69; W. Suida, "Giorgione in American Museums," *Art Quarterly,* vol. 19, 1956, pp. 148–52, repr. fig. 7; B. Berenson, *Italian Pictures of the Renaissance: Venetian School,* 2 vols., London: Phaidon, 1957, p. 184; W. Braunfels, "Die 'Inventio' des Künstlers," *Studien zur toskanischen Kunst, Festschrift für Ludwig H. Heydenreich,* Munich: Prestel, 1964, pp. 25–27, repr.; C. Volpe, *Giorgione,* Milan, 1964, p. 6; P. Zampetti, *L'opera completa di Giorgione,* New York: Abrams, 1968, p. 94, no. 30; G. Mariacher, *Palma il Vecchio,* Milan: Bramante, 1968, p. 97; R. Pallucchini, *Tiziano,* 2 vols., Florence: Sansoni, 1969, vol. 1, p. 238, repr. vol. 2, figs. 52–53; T. Pignatti, *Giorgione,* Venice: Alfieri, 1969, no. A10, pl. 203; F. Valcanover, C. Cagli, *L'opera completa di Tiziano,* Milan: Rizzoli, 1969, no. 19; H. E. Wethey, *The Paintings of Titian,* 3 vols., London: Phaidon, 1969–75, vol. 2, p. 152, no. X-5 repr.

14.

Diana and Callisto, c. 1525
Oil on canvas
30½ x 48¾ in. (77.5 x 124 cm.)
Kunsthistorisches Museum,
Gemäldegalerie, Vienna
6803

Collections:
Bartolomeo della Nave, Venice, until
1636; Lord Fielding, Duke of Hamil-
ton, London, 1638–49; Archduke
Leopold Wilhelm; Hofburg, Vienna,
1930.

Literature:
D. Teniers, *Theatrum Pictorium . . .*,
Brussels, 1660; J. Wilde, "Wieder-
gefundene Gemälde aus der Sammlung
des Erzherzogs Leopold Wilhelm,"
*Jahrbuch der kunsthistorischen Sammlungen
in Wien*, N.F., vol. 4, 1930, pp.
246 ff., repr. pl. 17; W. Suida,
"Zum Werke des Palma Vecchio,"
Belvedere, vol. 4, 1931, p. 135; J. Wilde,
"Ein unbeachtetes Werk Giorgiones,"
*Jahrbuch der k. preussischen Kunstsamm-
lungen*, vol. 52, 1931, p. 100, note 2; A.
Spahn, *Palma Vecchio*, Leipzig: Hierse-
mann, 1932, pp. 197–98; W. Suida,
"Studien zu Palma," *Belvedere*, 1934–
36, pp. 91–92; G. Gombosi, *Palma
Vecchio, des Meisters Gemälde und Zeich-
nungen*, Stuttgart-Berlin: Deutsche
Verlag-Anstalt, 1937, p. 101; B. Berenson,
*Italian Pictures of the Renaissance: Vene-
tian School*, 2 vols., London: Phaidon,
1957, vol. 1, p. 127, repr. vol. 2, pl.
927; F. Klauner, G. Heinz, *Katalog
der Gemäldegalerie*, Kunsthistorisches
Museum, 2 vols., Vienna, 1963, vol. 1,
p. 85, no. 606, repr. pl. 15; A. Ballarin,
Palma il Vecchio, Milan, 1965, no. 12.
G. Mariacher, *Palma il Vecchio*, Milan:
Bramante, 1968, p. 77, no. 55, repr. p.
55; G. Mariacher, "Jacopo Negretti
detto Palma il Vecchio," *I pittori ber-
gamaschi: dal XIII al XIX secolo*, 2 vols.,
Bergamo: Poligrafiche Bolis, 1975, vol.
1, p. 217, no. 64, repr. p. 236, no. 7.

Cariani

Giovanni de'Busi, c. 1485/90–c. 1548

15.

Portrait of a Man, 1525–30
Oil on canvas
36½ x 36½ in. (92.7 x 92.7 cm.)
Signed: IO • CARIANVS • DE • BVSIS •
BGO MĒSIS • PĪXIT
National Gallery of Canada, Ottawa
3568

Collections:
Marquesa Maria Serra, S. Pier d'Arena,
Genoa; Adolf Thiem, San Remo.

Exhibitions:
New York, Union League Club, Jan.
12–19, 1926, no. 1; *Exhibition of
Italian Art*, London, Royal Academy of
Art, Burlington House, Jan.–Mar.
1930, no. 382; *Masterpieces from the Na-
tional Gallery*, Montreal Museum of
Fine Arts, Oct. 6–30, 1949.

Literature:
C. Cagnola, "A proposito di un ritratto
di Bernardino de' Conti," *Rassegna
d'Arte*, no. 4, 1905, pp. 61 ff.;
Thieme-Becker, *Allgemeines Lexikon der
bildenden Künstler . . .*, Leipzig: Seeman,
vol. 5, 1911, p. 595, notes by D. von
Hadeln; J. A. Crowe, G. B. Caval-
caselle, *A History of Painting in North
Italy*, 3 vols., London: John Murray,
1912, vol. 3, p. 466, note; A. Venturi,
Storia dell'arte italiana, 11 vols., Milan:
Hoepli, 1901–40, vol. 9, part 3, p.
466, note; W. G. Constable, "Dipinti
dei raccolte inglesi alla mostra dell'arte
italiana a Londra," *Dedalo*, vol. 10,
1929–30, p. 750, repr. p. 755; Lord
Baniel, K. Clark, *A Commemorative
Catalogue of the Exhibition of Italian Art*,
2 vols., London: Oxford Univ. Press,
1930, vol. 1, p. 136, no. 392, repr. vol.
2, pl. 153; W. G. Constable, "Quel-
ques aperçus suggérés par l'exposition
italienne de Londres," *Gazette des
Beaux-Arts*, vol. 3, Jan.–June, 1930, p.
294, repr. p. 293, fig. 19; W. Suida,
"Die Ausstellung italienischer Kunst
in London," *Belvedere*, 1930, p. 43,
repr. opp. p. 41; T. Borenius, "Die
italienische Ausstellung in London,"
Pantheon, vol. 5, 1930, p. 92; National
Gallery of Canada, *Annual Report*,
1928–29, Ottawa, 1930, pp. 8–9,
repr.; E. G. Troche, "G. Cariani als
Bildnismaler," *Pantheon*, vol. 9, 1932,

p. 4, repr. p. 2, English trans. p. 20; B.
Berenson, *Italian Pictures of the Renais-
sance*, Oxford: Clarendon Press, 1932,
p. 128; L. Venturi, *Italian Paintings in
America*, 3 vols., New York: Weyhe,
1933, vol. 3, no. 497, repr.; *National
Gallery of Canada Catalogue*, Ottawa,
1936, p. 33; H. Tietze, "Die öf-
fentlichen Gemäldesammlungen in
Kanada," *Pantheon*, vol. 17, 1936,
p. 184; L. Gallina, *Giovanni Cariani:
materiale per uno studio*, Bergamo: Do-
cumenti lombardi, 1954, p. 121, repr.
pl. 65; *Canadian Art*, vol. 10, no. 3,
1953, repr. p. 116; R. H. Hubbard,
National Gallery of Canada, Ottawa,
1956, p. 146; R. H. Hubbard, *Euro-
pean Paintings in Canadian Collections:
Older Schools*, Toronto: Univ. of Toronto
Press, 1957, p. 11, repr.; B. Berenson,
*Italian Pictures of the Renaissance: Vene-
tian School*, 2 vols., London: Phaidon,
1957, vol. 1, p. 55, repr. vol. 2, pl.
734; H. W. Groh, "Bemerkungen zu
zwei Bildern von Giovanni Cariani im
Bode-Museum zu Berlin," *Festschrift
Ulrich Middeldorf*, Berlin, 1968, vol. 1,
p. 310, vol. 2, pl. 4; J. Sutherland
Boggs, *National Gallery of Canada*,
Toronto, 1971, p. 22, repr. pl. 14; S. J.
Freedberg, *Paintings in Italy 1500 to
1600*, Baltimore: Penguin, 1971, p.
495, note 25; B. B. Fredericksen,
F. Zeri, *Census of Pre-Nineteenth Century
Italian Paintings in North American Public
Collections*, Cambridge: Harvard
Univ. Press, 1972, pp. 45, 525, 616;
G. Mariacher, *I pittori bergamaschi dal
XIII al XIX secolo*, 2 vols., Bergamo:
Poligrafiche Bolis, 1975, vol. 1, pp.
291–92, repr. p. 314, in color p. 282.

NB:
Color transparency made before recent
cleaning of the painting.

Lorenzo Lotto

c. 1480–1556

16.

*Madonna and Child with Sts. Jerome and
Anthony of Padua*, 1521
Oil on canvas
37⅛ x 30⅜ in. (94.3 x 77.8 cm.)
Museum of Fine Arts, Boston
Charles Potter Kling Fund
60.154

Collections:
R. M. Dawkins, Oxford, 1911–15;
Mr. Johnson, London; Sale, London,
Sotheby's, Nov. 2, 1955, lot 160.

Exhibition:
100 Paintings from the Boston Museum,
New York, Metropolitan Museum of
Art, May 29–July 26, 1970, no. 29.

Literature:
Illustrated Handbook, Boston: Museum
of Fine Arts, 1964, p. 222, repr. p.
223; W. M. Whitehill, *Museum of Fine
Arts, Boston: A Centennial History*, 2
vols., Cambridge: Belknap Press,
1970, vol. 2, pp. 750–51, repr.; C.
Gould, *The Sixteenth Century Italian
Schools*, London: National Gallery, 1975,
p. 137; *Illustrated Handbook*, Boston:
Museum of Fine Arts, 1976, p. 256.

17.

Madonna and Child with Two Donors,
c. 1523
Oil on canvas
34 x 45½ in. (86.4 x 115.6 cm.)
The J. Paul Getty Museum, Malibu
77.PA.110

Collections:
Paolo del Sera, Florence, c. 1660; Ros-
pigliosi Palace, Rome; Robert H.
Benson, London; William Randolph
Hearst; Paula C. de Koenigsberg,
Buenos Aires; Stoop, Zurich; Sale, Lon-
don, Christie's, Dec. 2, 1977, lot 55.

Exhibitions:
London, Burlington Fine Arts Club,
1905, no. 42; *The Venetian School: Pic-
tures by Titian and His Contemporaries*,
London, Burlington Fine Arts Club,
1915, no. 16.

Literature:
M. Boschini, *La carta del navegar pitoresco,* 1660, ed. A. Pallucchini, Venice-Rome: Istituto per la collaborazione culturale, 1966, p. 398; H. F. Cook, "L'esposizione del Burlington Fine Arts Club," *L'Arte,* vol. 9, 1906, p. 144; L. Cust, "La collection de M.R. H. Benson," *Les Arts,* Oct. 1907, p. 18; J. A. Crowe, G. B. Cavalcaselle, *A History of Painting in North Italy,* 3 vols., London: John Murray, 1912, vol. 3, p. 430, note 5; A. Graves, *A Century of Loan Exhibitions, 1813–1912,* London: A. Graves, 1913, vol. 2, p. 717; R. H. Benson, *Catalogue of Italian Pictures . . . Collected by R. and Evelyn Benson,* London, 1914, no. 96; R. H. Benson, *The Venetian School: Pictures by Titian and His Contemporaries,* London: Burlington Fine Arts Club, 1915, pp. 18, 39, repr. pl. 10; C. H. Collins Baker, "Notes on Pictures at Drayton House," *Burlington Magazine,* vol. 52, Feb. 1928, pp. 93–97, repr. pl. 1D; R. van Marle, *The Development of the Italian School of Painting,* 19 vols., The Hague: Nijhoff, 1923–38, vol. 18, 1936, p. 389; "New Yorkers View a 'Sampling' of Vast Hearst Art Collections," *Art Digest,* no. 13, Dec. 1, 1938, p. 8, repr.; *William Randolph Hearst Collection,* catalogue raisonné, New York: Bradford Press, 1941, p. 18, 51-1; L. Coletti, *Lorenzo Lotto,* Bergamo: Arti Grafiche, 1953, p. 46; A. Banti, A. Boschetto, *Lorenzo Lotto,* Florence: Sansoni, 1953 (?), p. 56, repr. pl. 143; P. Bianconi, *Tutta la pittura di Lorenzo Lotto,* Milan: Rizzoli, 1955, p. 56, repr. pl. 113; B. Berenson, *Lorenzo Lotto,* New York: Phaidon, 1956, p. 60, repr. p. 143; B. Berenson, *Italian Pictures of the Renaissance: Venetian School,* 2 vols., London: Phaidon, 1957, vol. 1, p. 104; P. Bianconi, *All the Paintings of Lorenzo Lotto,* New York: Hawthorne, 1963, vol. 1, p. 78, repr. no. 113; G. Mariani Canova, *L'opera completa del Lotto,* Milan: Rizzoli, 1975, p. 109, no. 174, repr.

18.

Brother Gregorio Belo of Vicenza, 1547
Oil on canvas
34⅜ x 28 in. (87.3 x 71.1 cm.)
Inscribed: F. Gregorii belo de Vicentia eremite in hieronimi Ordinis beati fratris Petri de pisis Anno eius. LV. M.D. XLVII
The Metropolitan Museum of Art, New York City
Rogers Fund, 1965
65.117

Exhibitions:
Masterpieces of Painting in the Metropolitan Museum of Art, Boston, Museum of Fine Arts, Sept. 17–Nov. 1, 1970; *Masterpieces of Fifty Centuries,* New York, Metropolitan Museum of Art, Nov. 14, 1970–June 1, 1971, no. 211.

Literature:
"Il Libro dei Conti di Lorenzo Lotto," *Le gallerie nazionali italiane, notizie e documenti,* ed. A. Venturi, vol. 1, 1895, pp. 126, 155; B. Berenson, *Lotto,* Milan: Electa, 1955, pp. 164–65, pl. 361; B. Berenson, *Italian Pictures of the Renaissance: Venetian School,* 2 vols., London: Phaidon, 1957, vol. 1, p. 107, repr. vol. 2, fig. 787; T. Rousseau, "European Paintings," *The Metropolitan Museum of Art Bulletin,* Oct. 1967, p. 64, repr.; L. Lotto, *Il libro di spese diverse,* ed. P. Zampetti, Venice-Rome: Istituto per la collaborazione culturale, 1969, pp. 74–75, 343; K. Clark, *Masterpieces of Fifty Centuries,* New York: Dutton, 1970, no. 211; C. Virch, E. A. Standen, T. M. Folds, *Masterpieces of Painting in the Metropolitan Museum of Art,* New York: Metropolitan Museum of Art, 1970, p. 21; F. Zeri, E. E. Gardner, *Italian Paintings . . . : Venetian School,* New York: Metropolitan Museum of Art, 1973, pp. 40–41; G. Mariani Canova, *L'opera completa del Lotto,* Milan: Rizzoli, 1975, p. 110, no. 259; B. Fredericksen, F. Zeri, *Census of Pre-Nineteenth-Century Italian Paintings in North American Public Collections,* Cambridge: Harvard Univ. Press, 1972, pp. 112, 510, 609.

Titian

Tiziano Vecelli, c. 1490–1576

19.

Man with the Glove, 1520–23
Oil on canvas
39⅜ x 35 in. (100 x 89 cm.)
Signed lower right: TICIANVS F.
Musée du Louvre, Paris
757

Collections:
Gonzaga, Dukes of Mantua; Charles I of England; E. Jabach, Paris; Louis XIV, Paris, 1671; Versailles, 1683.

Exhibitions:
Mostra di Tiziano, catalog by G. Fiocco, Venice, Apr. 25–Nov. 4, 1935, no. 7; *Homage à Titien,* Paris, Louvre, June 10–Sept. 10, 1976.

Literature:
Le Brun, *Inventory,* Paris, 1683, no. 248; Paillet, *Inventory,* Paris, 1695, p. 8; Bailly, *Inventory,* 1709–10, p. 37; *Inventory of the Hotel of the Duke d'Antin,* 1715, p. 9, 1718, p. 2; F. B. Lépicié, *Catalogue raisonné des tableaux du Roy . . . ,* 2 vols., Paris, 1752–54, no. 19; E. Jeaurat, *Inventory,* 1760, p. 29; *Inventaire des tableaux du Cabinet du Roi, placés à la Surintendance des Bâtiments de sa Majesté à Versailles fait en l'année 1784,* p. 2; F. Villot, *Notice des tableaux exposés dans les galeries du Musée imperial du Louvre,* Paris: Vinchon, 1853–55, no. 473, pp. 270–71; J. A. Crowe, G. B. Cavalcaselle, *Tiziano, la sua vita e i suoi tempi* (1877–78), 2 vols., Florence: Sansoni, 1974, vol. 2, p. 425; R. F. Heath, *Titian,* London: Low, Marston . . . , 1879, p. 87; L. Both de Tauzia, *Notice des tableaux exposés dans les galeries du Musée National du Louvre,* 3 vols., Paris: Imprimeries réunies, 1883–86, vol. 1, p. 254, no. 454; J. D. Champlin, C. C. Perkins, *Cyclopedia of Painters and Paintings,* 4 vols., New York: Empire State, 1885–1913, vol. 2, p. 286; N. Bailly, *Inventaires des tableaux du Roy, rédigé en 1709 et 1710 par N.B.,* ed. F. Engerand, Paris, 1899, p. 78; E. M. Hurll, *Titian: A Collection of Fifteen Pictures . . . ,* Boston: Houghton Mifflin, 1901, pp. 61–66, repr. p. 63; H. Knackfuss, *Tizian,* 4th ed., Bielefeld and Leipzig: Velhagen, Klassing, 1903, p. 82, repr. fig. 55, p. 63; G.

Gronau, *Titian,* New York: Scribner's, 1904, p. 285; C. Ricketts, *Titian,* London: Methuen, 1910, p. 64, repr. pl. 46; O. Fischel, *Titian, des Meisters Gemälde,* Stuttgart and Leipzig: Deutsche Verlagsanstalt, 1911, pp. XVII, 265, repr. p. 38; L. Hourticq, "Promenades au Louvre, Titien," *Revue de l'art,* July 10, 1912, pp. 23–40, 125–46; J. F. Raffaelli, *Les promenades d'un artiste au musée du Louvre,* Paris, 1913, p. 179, repr. p. 180; S. de Ricci, *Description raisonnée des peintures du Louvre,* Paris: Imprimerie de l'art, 1913, pp. 164–65, no. 1592; L. Hourticq, *La jeunesse de Titien,* Paris: Hachette, 1919, pp. 202, 206–14, 267, pl. 6; L. Hautecoeur, *Musée National du Louvre, Catalogue des peintures exposées dans les galeries,* 3 vols., Paris: Musées nationaux, 1922–26, vol. 2, no. 1592, p. 136, repr. pl. 41; B. Berenson, *Italian Pictures of the Renaissance,* Oxford: Clarendon Press, 1932, p. 574; W. Suida, *Le Titien,* Paris: Weber, 1935, pp. 34, 161, repr. pl. 66; H. Tietze, *Leben und Werk,* 2 vols., Vienna: Phaidon, 1936, vol. 1, pp. 125, 141, 162, vol. 2, p. 306, repr. pls. 48–49; A. L. Mayer, "Quelques notes sur l'oeuvre du Titien," *Gazette des Beaux-Arts,* vol. 20, Dec. 1938, pp. 289–90; L. Ozzòla, *Studi sul Tiziano,* Strasbourg: Heitz, 1939, p. 32; N.A. Gurvich, *Tizian,* Leningrad: State Hermitage, 1940, fig. 24; R. Pallucchini, *La pittura veneziana del Cinquecento,* 2 vols., Novara: Agostini, 1944, vol. 1, p. XXI, repr. pl. 33; H. Tietze, *Titian: The Paintings and Drawings,* London: Phaidon, 1950, p. 390; G. A. dell'Acqua, *Tiziano,* Milan: Martello, 1955, p. 116; B. Berenson, *Italian Pictures of the Renaissance: Venetian School,* 2 vols., London: Phaidon, 1957, vol. 1, p. 190; F. Valcanover, *Tutta la pittura di Tiziano,* 2 vols., Milan: Rizzoli, 1960, vol. 1, p. 63, repr. pls. 108–09; A. Chastel, R. Klein, *L'Age de l'humanisme, l'Europe de la renaissance,* Paris: Deux-Mondes, 1963, p. 330; N. von Holst, *Creators, Collectors and Connoisseurs,* New York: Putnam, 1967, p. 129; R. Pallucchini, *Tiziano,* 2 vols., Florence: Sansoni, 1969, pp. 258–59, repr. figs. 170–71; F. Valcanover, C. Cagli,

L'opera completa di Tiziano, Milan: Rizzoli, 1969, no. 114; H. E. Wethey, *The Paintings of Titian,* 3 vols., London: Phaidon, 1969–75, vol. 2, 1971, p. 118, no. 64, repr. pls. 29–32, vol. 3, 1975, p. 266; A. Walther, *Tizian,* Leipzig, 1978, pp. 36, 37, 45, 71, repr. fig. 19.

20.

Portrait of Pope Paul III, 1543
Oil on canvas
41¾ x 33½ in. (106 x 85 cm.)
Galleria Nazionale, Capodimonte, Naples
130

Collections:
Palazzo Farnese, Rome; Palazzo del Giardino, Parma; Naples and Palermo, 1798; Naples, 1815.

Exhibitions:
Exhibition of Italian Art, London, Royal Academy of Art, Burlington House, Jan.–Mar. 1930, no. 181; *Mostra di Tiziano,* Venice, Apr. 25–Nov. 4, 1935, no. 57; *IV Mostra di restauri,* Naples, Palazzo Reale, 1960, pp. 62–64, no. 19.

Literature:
G. Vasari, *Le vite dei più eccellenti pittori, scultori, ed architetti...* (1568), ed. G. Milanesi, 9 vols., Florence: Sansoni, 1906, vol. 7, pp. 442–43; G. Campori, *Raccolta di cataloghi ed inventari inediti, di quadri, statue...dal secolo XV al secolo XIX,* Modena, 1870, p. 233; J. A. Crowe, G. B. Cavalcaselle, *Tiziano: La sua vita e i suoi tempi* (1877–78), 2 vols., Florence: Sansoni, 1974, vol. 2, pp. 12, 14; A. Filangieri di Candida, *La Galleria Nazionale di Napoli,* Farnese inventories, Rome, 1902, p. 320, no. 7; O. Fischel, *Titian, des Meisters Gemälde...,* Stuttgart, 1904, p. XXI; G. Gronau, *Titian,* New York: Scribner's, 1904, p. 294; G. Clausse, *Les Farnèse peints par le Titien,* Paris: *Gazette des Beaux-Arts,* 1905, pp. 72–77; C. Ricketts, *Titian,* London: Metheun, 1910, pp. 107–08, repr. pl. 94; A. de Rinaldis, *Guida del Museo Nazionale di Napoli, Pinacoteca,* Naples, 1911, vol. 2, pp. 136–39, no. 71; A. Venturi, *Storia dell'arte italiana,* 11 vols., Milan: Hoepli, 1901–40, vol. 9, part 3, 1928, p. 293; E. Tietze Conrat,

"Titian's Workshop in His Late Years," *Art Bulletin,* vol. 28, 1946, pp. 73–84; S. Ortolani, "Restauro d'un Tiziano," *Bolletino d'Arte,* serie 4, vol. 33, 1948, pp. 44–53; H. Tietze, *Titian: Paintings and Drawings,* London: Phaidon, 1950, p. 386; R. Pallucchini, *Tiziano,* Bologna: Casa Editrice, 1953, pp. 211–12; G. dell'Acqua, *Tiziano,* Milan: Martello, 1955, p. 123; Soprintendenza alle Gallerie della Campania, *IV Mostra di restauri,* cat. by B. Molajoli, R. Causa, S. Augusti, Naples: Arte Tipografica, 1960, pp. 62–64, no. 19, repr. pls. 78–79; F. Valcanover, *Tutta la pittura di Tiziano,* 4 vols., Milan: Rizzoli, 1960, vol. 1, p. 46, vol. 2, pp. 93–94, repr. pls. 168–69; R. Pallucchini, *Tiziano,* 2 vols., Florence: Sansoni, 1969, vol. 1, p. 278, vol. 2, repr. pl. 272–74; F. Valcanover, C. Cagli, *L'opera completa di Tiziano,* Milan: Rizzoli, 1969, no. 236; H. E. Wethey, *The Paintings of Titian,* 3 vols., London: Phaidon, 1969–75, vol. 2, pp. 122–23, no. 72, repr. pls. 115–17.

21.

Venus with a Mirror and Two Cupids, c.1553
Oil on canvas
49 x 41½ in. (124.5 x 105.5 cm.)
National Gallery of Art, Washington, D.C.
Andrew W. Mellon Collection, 1937
34

Collections:
Pomponio Vecelli, Venice, 1581; Barbarigo family, Venice, 1663; Nicholas I of Russia, 1850; Private Collection, New York, 1931; Andrew W. Mellon, 1931.

Exhibition:
St. Petersburg, The Hermitage.

Literature:
C. Ridolfi, *Le maraviglie dell'arte ovvero le vite degli'illustri pittori veneti e dello stato...* (1648), 2 vols., ed. D. von Hadeln, Berlin: Grote, 1914–1924, vol. 1, 1914, p. 200; F. Sansovino, *Venetia, città nobilissima, et singolare* (1581), ed. D. G. Martioni, Venice: S. Curti, 1663, p. 374; G. Cadorin, *Dello amore ai veneziani di Tiziano Vecellio delle sue case in Cadore...,* Venice, 1833, pp. 77, 98 ff.; G. C. Bevilacqua, *Insigne pinacoteca*

della nobile veneta famiglia Barbarigo della Terrazza, Venice: Antonelli, 1845, pp. 65–67; J. A. Crowe, G. B. Cavalcaselle, *Tiziano, la sua vita e i suoi tempi* (1877–78), 2 vols., Florence: Sansoni, 1974, vol. 2, pp. 334 ff., p. 336 note; C. A. Levi, *Le collezioni veneziane d'arte e d'antichità...,* Venice: Fontana, 1900, pp. 281 ff.; A. I. Somof, *Ermitage Imperial, Catalogue de la galerie des tableaux,* St. Petersburg, 1899, p. 133, no. 99; D. A. Schmidt, "Venera pered zerkalom, Titiana, original i povtorenie," *Starye Gody,* vol. 2, 1907, pp. 216–23, repr. opp. p. 218; N. Wrangell, *Les chefs d'oeuvre de la galerie de tableaux de l'Ermitage Impérial à St. Pétersbourg,* Munich: Hanfstaengel, 1909, p. xxxi, repr. pl. 21; S. Poglayen-Neuwall, "Einc tizianeske Toilette der Venus," *Münchener Jahrbuch,* N.F. 6, 1929, pp. 174–75, 196; S. Poglayen-Neuwall, "Titian's Pictures of the Toilette of Venus and Their Copies," *Art Bulletin,* vol. 16, 1934, pp. 358 ff.; W. Suida, *Le Titien,* Paris: Weber, 1935, pp. 119, 176; H. Tietze, *Tizian,* 2 vols., Vienna: Phaidon, 1936, vol. 2, p. 314; B. Berenson, *Italian Pictures of the Renaissance: Venetian School,* 2 vols., London: Phaidon, 1957, vol. 1, p. 192; F. Valcanover, *All the Paintings of Titian,* 4 vols., New York: Hawthorn, 1960, vol. 3, p. 41, no. 62, repr. pl. 62; R. Pallucchini, *Tiziano,* 2 vols., Florence: Sansoni, 1969, p. 302, repr. vol. 2, figs. 396–97, in color pl. 43; F. R. Shapley, "Titian's Venus with a Mirror," *Studies in the History of Art,* Washington, D.C.: National Gallery of Art, 1971, 1972, pp. 93–105, repr.; B. B. Fredericksen, F. Zeri, *Census of Pre-Nineteenth-Century Italian Paintings in North American Public Collections,* Cambridge: Harvard Univ. Press, 1972, pp. 203, 476; H. E. Wethey, *The Paintings of Titian,* 3 vols., London: Phaidon, 1969–75, vol. 3, pp. 68–69, 200, no. 51, repr. pls. 127–29.

22.

Self-Portrait, c. 1562
Oil on canvas
37¾ x 29½ in. (96 x 75 cm.)
Staatliche Museen Preussischer Kulturbesitz, Gemäldegalerie, Berlin (West)
163

Collections:
Pomponio Vecelli, Venice, 1581; Casa Barbarigo a San Raffaele, Venice, 1814; Leopoldo Cicognara, 1814; Edward Solly, Berlin, 1821; Kaiser Friedrich-Museum, Berlin, 1823.

Literature:
G. Vasari, *Le vite di più eccellenti pittori, scultori, ed architetti* (1568), ed. G. Milanesi, 9 vols., Florence: Sansoni, 1906, vol. 7, p. 458; J. A. Crowe, G. B. Cavalcaselle, *Tiziano, la sua vita e i suoi tempi* (1877–78), 2 vols., Florence: Sansoni, 1974, vol. 2, pp. 60–62; W. Bode, *Beschreibendes Verzeichnis der Gemälde im Kaiser Friedrich-Museum,* Berlin: Reimer, 1904, p. 396, no. 163; O. Fischel, *Titian, des Meisters Gemälde...,* Stuttgart, 1904, pp. XXX, 212; G. Gronau, *Titian,* New York: Scribner's, 1904, p. 286; C. Ricketts, *Titian,* London: Methuen, 1910, p. 134, repr. pl. 137; Berlin, Staatliche Museen, *Beschreibendes Verzeichnis der Gemälde im Kaiser Friedrich-Museum...,* ed. I. Kunze, Berlin, 1931, p. 484, no. 163; L. Foscari, "Autoritratti di maestri veneziani," *Rivista di Venezia,* vol. 12, 1933, p. 248; L. Foscari, *Iconografia di Tiziano,* Venice: Sormani, 1935, pp. 16–18; W. Suida, *Le Titien,* Paris: Weber, 1935, p. 104, repr. pl. 151; H. Tietze, *Titian: Paintings and Drawings,* London: Phaidon, 1950, p. 366; G. dell'Acqua, *Tiziano,* Milan: Martello, 1955, p. 130; F. Valcanover, *Tutta la pittura di Tiziano,* 4 vols., Milan: Rizzoli, 1960, p. 45, pl. 98; R. Pallucchini, *Tiziano,* Florence: Sansoni, 2 vols., 1969, vol. 1, p. 313, vol. 2, repr. pl. 466; E. Panofsky, *Problems in Titian, Mostly Iconographic,* New York: New York Univ. Press, 1969, p. 8, repr. pl. 7; F. Valcanover, C. Cagli, *L'opera completa di Tiziano,* Milan: Rizzoli, 1969, vol. 3, p. 48, repr. pl. 98; H. E. Wethey, *The Paintings of Titian,* 3 vols., London: Phaidon, 1971–75, vol. 2, pp. 143–44, no. 104, repr. pls.

209, 213; R. Klessman, *The Berlin Museum: Paintings in the Picture Gallery,* New York: Abrams, 1971, pp. 36, 280; *Katalog der ausgestellten Gemälde des 13–18 Jahrhunderts,* Berlin: Staatliche Museen, 1975, p. 446, no. 163.

23.

Entombment of Christ, c. 1565–70
Oil on canvas
51¼ x 66⅛ in. (130 x 168 cm.)
Signed on sarcophagus: TITIANVS F.
Museo del Prado, Madrid
441

Collection:
Antonio Perez, 1572.

Literature:
G. Vasari, *Le vite dei più eccellenti pittori, scultori, ed architetti* (1568), ed. G. Milanesi, 9 vols., Florence: Sansoni, 1906, vol. 7, p. 458; P. de Madrazo, *Catalogo de los cuadros del Real Museo de pintura y escultura,* Madrid: Aoiz, 1873, p. 91; J. A. Crowe, G. B. Cavalcaselle, *Tiziano, la sua vita e i suoi tempi* (1878), 2 vols., Florence: Sansoni, 1974, vol. 2, p. 261; C. Ricketts, *Titian,* London: Methuen, 1910, p. 140; R. Longhi, "Giunte a Tiziano," *L'Arte,* vol. 28, 1925, pp. 45–48; E. von Rothschild, "Tizians Dartellungen der Laurentiusmarter," *Belvedere,* vol. 10, no. 6, 1931, p. 202; W. Suida, *Le Titien,* Paris: Weber, 1935, p. 145; P. Beroqui, *Tiziano en el Museo del Prado,* Madrid, 1946, pp. 156–57; H. Tietze, *Titian: Paintings and Drawings,* London: Phaidon, 1950, p. 330, repr. pl. 256; G. dell'Acqua, *Tiziano,* Milan: Martello, 1955, p. 131; B. Berenson, *Italian Pictures of the Renaissance: Venetian School,* 2 vols., London: Phaidon, 1957, vol. 1, p. 188; F. Valcanover, *Tutta la pittura di Tiziano,* 4 vols., Milan: Rizzoli, 1960, vol. 4, p. 64, no. 124, repr.; F. J. Sánchez Cantón, *Museo del Prado: Catalogo de las pinturas,* Madrid: Blass, 1963, p. 705, no. 441; R. Pallucchini, *Tiziano,* 2 vols., Florence: Sansoni, 1969, vol. 1, p. 319, repr. vol. 2, no. 496; F. Valcanover, C. Cagli, *L'opera completa di Tiziano,* Milan: Rizzoli, 1969, no. 467; H. E. Wethey, *The Paintings of Titian,* 3 vols., London: Phaidon, 1969–75, vol. 1, pp. 91–92, no. 38, repr. pl. 80.

Paris Bordon

1500–1571

24.

Portrait of a Knight in Armor, 1540–45
Oil on canvas
36 x 30 in. (91.4 x 76.2 cm.)
North Carolina Museum of Art, Raleigh
Original State Appropriation
52.9.148

Collections:
Archduke of Tuscany (?); Sir Abraham Hume, 1838 (as Pordenone); Viscount Alford, 1851; Earl Brownlow, Llandaff, Weybridge-on-Thames, by 1854; Arthur L. Nicholson, Llandaff, Weybridge-on-Thames; Sale, New York, Anderson Galleries, May 18, 1933, lot 22.

Exhibition:
Portland, Oregon, 1936.

Literature:
L. Bailo, G. Biscaro, *Della vita e delle opere di Paris Bordon,* Treviso, 1900, p. 131, no. 41; B. Berenson, *Venetian Painters of the Renaissance,* Oxford: Clarendon Press, 1911, p. 95; A Venturi, *Storia dell'arte italiana,* 11 vols., Milan: Hoepli, 1901–40, vol. 9, part 3, 1928, p. 1032; W. R. Valentiner, *Catalogue of Paintings,* Raleigh: North Carolina Museum of Art, 1956, p. 77, no. 178, repr.; W. R. Valentiner, "The Raleigh Museum's First 220 Paintings: Notes on the Collection," *Art News,* vol. 55, 1956, p. 40, repr.; G. Mariani Canova, *Paris Bordon,* pref. by R. Pallucchini, Venice: Alfieri, 1964, p. 110, repr. pl. 78.

25.

Lady in a Green Mantle, c. 1550
Oil on canvas
43⅛ x 32½ in. (102 x 77.5 cm.)
Kunsthistorisches Museum, Gemäldegalerie, Vienna
231

Collections:
Vendramin Collection, Venice, 1627; Kaiserliche Schatz- und Kunstkammer, Prague, 1718.

Literature:
Inventarium..., Prague, Apr. 8, 1718, p. 22, no. 359; *Inventory 1737* Prague,

1890, pp. 36–37; C. Mechel, *Verzeichnis der Gemälde der k.k. Bildergalerie in Wien,* Vienna, 1783, p. 77, no. 41; E. von Engerth, *Kunsthistorische Sammlungen des allerh. Kaiserhauses: Gemälde beschreibendes Verzeichnis,* Vienna, 1882, p. 90; K. Köpl, "Urkunden, Acten, Regesten und Inventare aus dem k.k. Statthalterei-Archiv in Prag," *Jahrbuch der kunsthistorischen Sammlungen des allerhöchsten Kaiserhauses,* vol. 10, 1889, p. CXXXVII, no. 359; B. Berenson, *The Venetian Painters of the Renaissance,* New York: Putnam, 1897, p. 89, no. 231; L. Bailo, G. Biscaro, *Della vita e delle opere di Paris Bordon,* Treviso, 1900, pp. 186–87, no. 114; *Kunsthistorische Sammlungen des allerhöchsten Kaiserhauses: Gemäldegalerie, alte Meister,* Vienna: Holzhausen, 1907, p. 57, no. 231; Thieme-Becker, *Allgemeines Lexikon der bildenden Künstler...,* Leipzig: Seemann, 1910, vol. 4, p. 349, note by E. Schaeffer; B. Berenson, *Italian Pictures of the Renaissance,* Oxford: Clarendon Press, 1932, p. 433, no. 231; V. Oberhammer, *Die Gemäldegalerie des kunsthistorischen Museum in Wien,* Vienna: Schroll, 1960, p. 23, no. 468; G. Mariani Canova, "I viaggi di Paris Bordone," *Arte Veneta,* Annata 15, 1961, p. 88, note 58; G. Mariani Canova, *Paris Bordon,* pref. by R. Pallucchini, Venice: Alfieri, 1964, pp. 49, 116, repr. fig. 90.

Pordenone

Giovanni Antonio de Sacchis, c. 1484–1539

26.

Sts. Sebastian, Roch, and Catherine, c. 1535
Oil on canvas
68⅛ x 45¼ in. (173 x 115 cm.)
Signed: IOᴵˢ ANTᴵᴵ POR.
Church of San Giovanni Elemosinario, Venice

Exhibition:
Mostra del Pordenone e della pittura friulana del Rinascimento, catalog by B. Molajoli, Udine, May 28–July 31, 1939, no. 55.

Literature:
G. Vasari, *Le vite dei più eccellenti pittori, scultori, ed architetti* (1568), ed. G. Milanesi, 9 vols., Florence: Sansoni, 1906, vol. 5, p. 116, vol. 7, p. 441; F. Sansovino, *Ventia città nobilissima e singolare,* Venice, 1581, p. 65; C. Ridolfi, *Le maraviglie dell'arte ovvero le vite degl'illustri pittori veneti e dello stato...* (1648), 2 vols., ed. D. von Hadeln, Berlin: Grote, 1914–24, vol. 1, p. 123; F. Scannelli, *Il microcosmo della pittura,* Cesena: Neri, 1657, p. 237; M. Boschini, *Le ricche minere della pittura veneziana...,* Venice: Nicolini, 1674, p. 261; A. M. Zanetti, *Della pitura veneziana e delle opere pubbliche de' veneziani maestri,* Venice: Albrizzi, 1771, p. 215; G. de'Rinaldis, *Della pittura friulana,* Udine: Pecile, 1798, p. 38; F. di Maniago, *Storia delle belle arti friulane,* Udine: Fra. Mattiuzzi, 1823, pp. 80, 207; G. B. Cavalcaselle, *Le vite ed opere dei pittori del Friuli,* Udine: MS. della Biblioteca comunale, 1876, p. 30; J. A. Crowe, G. B. Cavalcaselle, *A History of Painting in North Italy,* 3 vols., London: John Murray, 1912, vol. 3, p. 175; A. Venturi, *Storia dell'arte italiana,* 11 vols.,

Milan: Hoepli, 1901–40, vol. 9, part 3, pp. 725–28, repr. fig. 493; K. Schwarzweller, *Giovanni Antonio da Pordenone,* dissertation, Univ. of Göttingen, 1935, p. 105; G. Fiocco, *Giovanni Antonio Pordenone,* Udine: La Panarie, 1939, pp. 92, 97, repr. pl. 178; G. Fiocco, *Giovanni Antonio Pordenone,* Padua: Le Tre Venezie, 1943, p. 77; G. Fiocco, *Giovanni Antonio Pordenone,* Pordenone: Cosarini, 1969, vol. 1, pp. 92, 97, vol. 2, p. 237, repr. pl. 189.

Schiavone

Andrea Meldolla, c. 1503–1563

27.

The Annunciation
Oil on panel
37⅜ x 89¾ in. (95 x 228 cm.)
Church of the Carmini, Venice

Exhibition:
Cinque secoli di pittura veneta, Venice, Procuratie Nuove, July 21–Oct. 31, 1945, no. 91.

Literature:
C. Ridolfi, *Le maraviglie dell'arte ovvero le vite degl'illustri pittori veneti e dello stato...,* (1648), 2 vols., ed. D. von Hadeln, Berlin: Grote, 1914–24, vol. 1, p. 251; L. Frölich-Blum, "Andrea Meldolla, genannt Schiavone," *Jahrbuch der kunsthistorischen Sammlungen des allerh. Kaiserhauses,* Vienna, vol. 31, 1913–14, p. 217; A. Venturi, *Storia dell'arte italiana,* 11 vols., Milan: Hoepli, 1901–40, vol. 9, part 4, p. 743; V. Moschini, "Capolavori di Andrea Schiavone," *Emporium,* 1943, pp. 237 ff.; R. Pallucchini, *Cinque secoli di pittura veneta,* Venice: Ferrari, 1945, no. 91; G. Fiocco, "Nuovi aspetti dell'arte di Andrea Schiavone," *Arte Veneta,* Annata 4, 1950, p. 40, repr. p. 39; K. Prijatalj, *Andrija Medulić Schiavone,* Zagreb: Jugoslavenska akademija, 1952, p. 38; B. Berenson, *Italian Pictures of the Renaissance: Venetian School,* 2 vols., London: Phaidon, 1957, vol. 1, p. 161.

28.

The Angel Gabriel
Oil on canvas
107⅛ x 61⅜ in. (272 x 156 cm.)
Church of San Pietro, Belluno

Exhibition:
Mostra d'arte antica: Dipinti della provincia di Belluno dal XIV al XVI secolo, Belluno, 1950, no. 27.

Literature:
L. Doglioni, *Notizie storico e geografiche della città di Belluno e sua provincia...,* Belluno: Tissi, p. 36; F. Miari, *Dizionario storico-artistico-letterario bellunese,* Belluno, 1843, pp. 146–47; E. Valcanover, *Mostra d'arte antica: Dipinti della provincia di Belluno dal XIV al XVI*

secolo, Belluno: Sommavilla, 1950, p. 32; G. Fiocco, "Nuovi aspetti dell'arte di Andrea Schiavone," *Arte Veneta,* Annata 4, 1950, p. 42, repr. p. 40; K. Prijatalj, *Andrija Medulić Schiavone,* Zagreb: Jugoslavenska akademija, 1952, p. 44; B. Berenson, *Italian Pictures of the Renaissance: Venetian School,* 2 vols., London: Phaidon, 1957, vol. 1, p. 159, vol. 2, repr. pls. 1178–79.

Tintoretto

Jacopo Robusti, 1518–1594

29.

Sacra Conversazione, c. 1540
Oil on canvas
67½ x 96 in. (171.5 x 243.8 cm.)
Signed and dated lower left:
Iachobus • 1540
Private Collection, New York City

Collection:
Léger, London.

Exhibitions:
Old Masters of the 16th, 17th, and 18th Centuries, London, Léger Galleries, Apr. 21–May 30, 1953, no. 2; *The Italian Heritage,* New York, Wildenstein & Co., May 17–Aug. 29, 1967, no. 25, repr.; *Exhibition of Old Masters,* London, Helikon Gallery, June–Sept. 1974, repr.

Literature:
P. Aretino, *Corrispondenza,* 6 vols., Paris: Matteo il Maestro, 1608–09, p. 86; D. von Hadeln, "Jacopo Molino," *Burlington Magazine,* vol. 53, 1928, pp. 226–31, repr. p. 227; G. Lorenzetti, "Di un disperso ciclo pittorico cinquecentesco nel vestibolo della libreria di San Marco di Venezia," *Atti del Reale Istituto Veneto di Scienze, Lettere ed Arti,* 1942–43, vol. 102, part 2, p. 448; R. Pallucchini, *La giovinezza del Tintoretto,* Milan: Guarnati, 1950, pp. 74–76, 115–16, 129, 154, notes 18–20, 180, repr. figs. 63, 87; Perspex, "Current Shows and Comments," *Apollo,* vol. 54, 1951, p. 92, repr. p. 91; B. Berenson, *Italian Pictures of the Renaissance: Venetian School* 2 vols., London: Phaidon, 1957, vol. 1, p. 183, repr. vol. 2, fig. 1260; A. Bury, "Round about the Galleries," *Connoisseur,* vol. 140, 1957, p. 185, repr. in color; R. Pallucchini, "Un altra opera giovanile del Tintoretto," *Arte Veneta,* Annata 12, 1958, pp. 202–03; J. Maxon, "A Possible Tintoretto," *Minneapolis Institute of Arts Bulletin,* vol. 53, Mar. 1964, pp. 13–14; J. Maxon, "A New, Early Tintoretto," *Arte Veneta,* Annata 19, 1965, pp. 154–55; J. Stubblebine, "The Italian Heritage," *Burlington Magazine,* vol. 109, 1967, pp. 487–88, repr. p. 486, fig. 66; J. Schulz, *Venetian Painted Ceilings of the Renaissance,* Berkeley and

Los Angeles: Univ. of California Press, 1968, p. 14, repr. fig. 23; C. Bernari, P. De Vecchi, *L'opera completa del Tintoretto,* Milan: Rizzoli, 1970, p. 86, no. 8, repr. p. 86; S. J. Freedberg, *Painting in Italy 1500 to 1600,* Baltimore: Penguin, 1971, pp. 353–54; L. Steinberg, "Michelangelo's Madonna Medici and Related Works," *Burlington Magazine,* vol. 113, Mar. 1971, pp. 145–46, 149, repr. p. 144, fig. 35.

30.
Christ and the Woman Taken in Adultery, c. 1546–47
Oil on canvas
53½ x 66⅛ in. (136 x 168 cm.)
Galleria Nazionale, Palazzo Barberini, Rome
1460

Collections:
Nucci, Siena, 1666; Prince Don Mario Chigi, 1902.

Exhibitions:
Mostra del Tintoretto, Venice, Palazzo Pesaro, catalog by N. Barbantini, 1937, no. 5; *Chefs-d'oeuvre vénitiens de Paolo Veneziano à Tintoret,* Paris, Musée de l'Orangerie, Jan.–Mar. 31, 1954, no. 41; *Konstens Venedig,* Stockholm, Nationalmuseum, Oct. 1962–Feb. 10, 1963, no. 105.

Literature:
C. Ridolfi, *Le maraviglie dell'arte ovvero le vite degl'illustri pittori veneti e dello stato...* (1648), 2 vols., ed. D. von Hadeln, Berlin: Grote, 1914–24, vol. 2, p. 54; E. von der Bercken, A. L. Mayer, *Tintoretto,* 2 vols., Munich: Piper, 1923, vol. 1, p. 201; M. Pittaluga, *Tintoretto,* Bologna: Zanichelli, 1925, p. 284; A. de Rinaldis, *La Galleria Nazionale d'arte antica in Roma,* Rome: Istituto Poligrafico, 1932, p. 11, repr. p. 50; B. Berenson, *Italian Pictures of the Renaissance,* Oxford: Clarendon Press, 1932, p. 562; W. Arslan, "Argomenti per la cronologia del Tintoretto," *Critica d'Arte,* 1937, pp. XXVII–XXX; N. Barbantini, *Mostra del Tintoretto,* Venice: Ferrari, no. 5; L. Coletti, *Tintoretto,* Bergamo: Arti Grafiche, 1940, p. 18; E. von der

Bercken, *Die Gemälde des Jacopo Tintoretto,* Munich: Piper, 1942, p. 108; H. Tietze, *Tintoretto: The Paintings and Drawings,* London: Phaidon, 1948, p. 359, repr. pl. 14; R. Pallucchini, *La giovinezza del Tintoretto,* Milan: Guarnati, 1950, pp. 107–08; N. di Carpegna, *Catalogue of the National Gallery: Barberini Palace,* Rome: Turco, 1954, p. 58, no. 74, repr.; J. Maxon, "The Master of the Corsini Adulteress," *Connoisseur,* vol. 148, Nov. 1961, pp. 254–61, repr. p. 255; A. Pallucchini, *Tintoretto,* Florence: Sansoni, 1969, p. 29; P. de Vecchi, *L'opera completa del Tintoretto,* Milan: Rizzoli, 1970, no. 47.

31.
Self-Portrait, c. 1547
Oil on canvas
18 x 15 in. (45.7 x 38.1 cm.)
Private Collection, New York City

Collections:
Manfrini (?); Charles Eliot Norton, Boston, 1896; Wildenstein & Co., New York.

Exhibitions:
Exhibition of Portraits, Boston, Copley Hall, 1896, no. 289; *Paintings from Private Collections in New England,* Boston, Museum of Fine Arts, 1939, no. 131; *Four Centuries of Venetian Painting,* catalog by H. Tietze, Toledo Museum of Art, Mar. 1940, no. 57.

Literature:
C. Ridolfi, *Le maraviglie dell'arte ovvero le vite degl'illustri pittori veneti e dello stato...* (1648), 2 vols., ed. D. von Hadeln, Berlin: Grote, 1914–24, vol. 2, p. 56; D. von Hadeln, "A Self-Portrait by Tintoretto," *Burlington Magazine,* vol. 44, Feb. 1924, p. 93; W. G. Constable, "New England Collections," *Burlington Magazine,* vol. 75, Aug. 1939, p. 77; H. Tietze, *Four Centuries of Venetian Painting,* Toledo Museum of Art, 1940, no. 57, repr.; H. Tietze, *Tintoretto: The Paintings and Drawings,* London: Phaidon, 1948, p. 352; R. Pallucchini, *La giovinezza del Tintoretto,* Milan: Guarnati, 1950, p. 118; B. Berenson, *Italian Pictures of the Renaissance: Venetian School,* 2 vols., London: Phaidon, 1957, vol. 1, p. 182; P. de Vecchi, *L'opera completa del Tintoretto,* Milan:

Rizzoli, 1970, no. 629; P. Rossi, *Jacopo Tintoretto: I ritratti,* Venice: Alfieri, 1973, p. 117.

32.
The Fall of Man, c. 1550
Oil on canvas
59 x 86⅝ in. (150 x 220 cm.)
Gallerie dell'Accademia, Venice
43

Collection:
Scuola della Trinità, Venice, 1631.

Exhibitions:
Exhibition of Italian Art, London, Royal Academy of Art, Burlington House, Jan.–Mar. 1930, no. 343; *L'exposition de l'art italien, de Cimabue à Tiepolo,* Paris, Petit Palais, May 14–July 20, 1935, no. 447; *Mostra del Tintoretto,* catalog by N. Barbantini, Venice, Palazzo Pesaro, 1937, no. 16.

Literature:
R. Borghini, *Il riposo...,* Florence: Marescotti, 1584, p. 451; C. Ridolfi, *Le maraviglie dell'arte ovvero le vite degl'illustri pittori veneti e dello stato...* (1648), 2 vols., ed. D. von Hadeln, Berlin: Grote, 1914–24, vol. 2, pp. 18, 71; F. Sansovino, D. G. Martinioni, *Venetia: Città nobilissima et singulare...,* Venice: Curti, 1663, p. 277; M. Boschini, *Le minere della pittura...,* Venice: Nicolini, 1660, p. 352; D. Lovisa, *Il gran teatro di Venezia,* Venice, 1720, no. 44; A. M. Zanetti, *Della pittura veneziana e delle opere pubbliche de' veneziani maestri,* Venice: Albrizzi, 1771, pp. 146–47; B. Berenson, *The Venetian Painters of the Renaissance,* New York: Putnam, 1894, p. 120; H. Thode, *Tintoretto,* Leipzig, 1901, p. 44; G. Ludwig, "Archivalische Beiträge zur Geschichte der venezianischen Malerei," *Jahrbuch der k. preussischen Kunstsammlungen,* 1905, pp. 143–44; D. von Hadeln, "Nachrichten über venezianische Maler," *Italienische Vorschungen,* vol. 4, 1911, pp. 136 ff.; F. P. B. Osmaston, *The Art and Genius of Tintoret,* 2 vols., London: Bell, 1915, vol. 1, p. 36, vol. 2, p. 202; E. von der Bercken, A. L. Mayer, *Tintoretto,* 2

vols., Munich: Piper, 1923, vol. 1, pp. 38, 56, 93, 132, 139; M. Pittaluga, *Tintoretto,* Bologna: Zanichelli, 1925, pp. 190, 217; D. Viana, *Francesco Torbido detto il Moro...,* Verona: Tipografia Veronese, 1933, p. 64; W. Arslan, "Argomenti per la cronologia del Tintoretto," *Critica d'Arte,* 1937, p. XXVII; L. Coletti, *Tintoretto,* Bergamo: Arti Grafiche, 1940, pp. 10 ff.; E. von der Bercken, *Die Gemälde des Jacopo Tintoretto,* Munich: Piper, 1942, pp. 46, 127; R. Pallucchini, *La pittura veneziana del Cinquecento,* 2 vols., Novara: Agostini, 1944, p. 14; H. Tietze, *Tintoretto: The Paintings and Drawings,* London: Phaidon, 1948, p. 360; R. Pallucchini, *La giovinezza del Tintoretto,* Milan: Guarnati, 1950, pp. 131–32; E. Newton, *Tintoretto,* New York: Green, 1952, pp. 46 ff.; S. Moschini Marconi, *Gallerie dell'Accademia di Venezia: Opere d'arte del secolo XVI,* Rome, 1962, p. 225; P. de Vecchi, *L'opera completa del Tintoretto,* Milan: Rizzoli, 1970, no. 82c.

33.
Portrait of a Venetian General, c. 1550
Oil on canvas
22½ x 19½ in. (57.2 x 49.5 cm.)
The Armand Hammer Collection, Los Angeles

Collections:
Baron Moritz von Königswarter, Vienna; Sale, Berlin, Eduard Schulte, Nov. 20, 1906, lot 76 (as Portrait of Doge Grimani); Oscar Bondy, Vienna; Sale, New York, Kende Galleries, Mar. 3, 1949, lot 91.

Exhibitions:
Hollins College, Virginia, Nov. 30, 1954–Jan. 2, 1955; Lynchburg Art Center, Virginia, Jan. 31–Feb. 21, 1955; *West European and American Painting from the Museums of the United States,* Leningrad, Hermitage, Feb. 13–Mar. 24, 1976, Moscow, Pushkin Museum of Fine Arts, Apr. 8–May 19, 1976, Kiev, Museum of Ukrainian Fine Art, June 3–July 15, 1976, Minsk, Museum of Fine Art, July 30–Sept. 12, 1976, repr. in cat.; *Chefs-d'oeuvre de musées des Etats-Unis de Giorgione à Picasso,* Paris, Musée Marmottan, Oct. 13–Dec. 5, 1976, no. 6, repr. in color.

Literature:
Gemäldesammlung des Baron Königswarter, Vienna: Schwarz, 1906, pref. by Max J. Friedländer, p. 54, no. 76; *The Renowned Painting Collection of the Late Oscar Bondy,* foreword by Otto Benesch, New York: Kende Galleries, 1949, p. 76, no. 91; P. Rossi, *Jacopo Tintoretto, I ritratti,* Venice: Alfieri, 1973, pls. 7, 9; M. A. Bessonova, *Zapadnoevropeiskaia i amerikanskaia zhivopis iz muzeiev S. Sh. A.,* Moscow, 1976, repr.; F. Daulte, *Chefs-d'oeuvre de musées des Etats-Unis, de Giorgione à Picasso,* Paris: Musée Marmottan, 1976, no. 6, repr.

34.
Joseph and Potiphar's Wife, c. 1555
Oil on canvas
21¼ x 46⅛ in. (54 x 117 cm.)
Museo del Prado, Madrid
395

Collections:
Alcázar, Madrid, 1686; Isabella Farnese, La Granja.

Literature:
R. Borghini, *Il riposo . . . ,* Florence: Marescotti, 1584, p. 454; C. Ridolfi, *Le maraviglie dell'arte ovvero le vite degli' illustri pittori veneti e dello stato . . .* (1648), 2 vols., ed. D. von Hadeln, Berlin: Grote, 1914–24, vol. 2, p. 50; A. Palomino de Castro y Velasco, *El Parnaso Español pintoresco laureado . . .* (1724), ed. Sánchez Cantón, Fuentes literarias para la historia del arte español, 5 vols., Madrid, 1923–41, vol. 4, p. 165; E. von der Bercken, A. L. Mayer, *Tintoretto,* 2 vols., Munich: Piper, 1923, p. 175; L. Coletti, *Tintoretto,* Bergamo: Arti Grafiche, 1940, pp. 14–15; E. von der Bercken, *Die Gemälde des Jacopo Tintoretto,* Munich: Piper, 1942, p. 114; F. J. Sánchez Cantón, *Museo del Prado: Catálogo de los cuadros,* Madrid, 1942, p. 636; H. Tietze, *Tintoretto: The Paintings and Drawings,* London: Phaidon, 1948, pp. 353–54, no. 395, repr. fig. 103; R. Pallucchini, *La giovinezza del Tintoretto,* Milan: Guarnati, 1950, pp. 90 ff.; B. Berenson, *Italian Pictures of the Renaissance: Venetian School,* 2 vols., London: Phaidon, 1957, vol. 1, p. 175, repr. vol. 2, pl. 1284; J. Maxon, "The Master of the Corsini Adulteress," *Connoisseur,* vol. 148, Nov. 1961, p. 254; A. Palluc-

chini, *Tintoretto,* Florence: Sansoni, 1969, p. 32; P. de Vecchi, *L'opera completa del Tintoretto,* Milan: Rizzoli, 1970, no. 116E.

35.
Doge Alvise Mocenigo Presented to the Redeemer, c. 1577
Oil on canvas
38¼ x 78 in. (97.2 x 198.1 cm.)
The Metropolitan Museum of Art, New York City
John Stewart Kennedy Fund, 1910
10.206

Collections:
Baron Karl Friedrich von Rumohr, Dresden, 1843 (?); Friedrich Nerly, Venice, 1852; J. Ruskin, Denmark Hill and Brantwood, Coniston, England, 1900; Mrs. Arthur Severn, Brantwood, Consiston, England, 1910; R. Langton Douglas, London.

Exhibitions:
University Galleries, Oxford; *Old Masters,* Royal Academy, London, 1870, no. 140; *Old Masters,* Royal Academy, London, 1896, no. 103; *Titian, Tintoretto, Paolo Veronese . . . ,* Art Gallery of Toronto, Feb. 12–Mar. 13, 1969, no. 8; *100 Paintings from the Metropolitan Museum,* Leningrad, Hermitage, May 15–July 2, 1975, no. 5, Pushkin Museum of Fine Arts, Moscow, Aug. 28–Nov. 2, 1975, no. 5.

Literature:
J. Ruskin, *Works,* ed. E. T. Cook, A. Wedderburn, London: Allen, vol. 11, p. 375, vol. 21, pp. 170 ff. and note, vol. 33, p. 369; R. A. M. Stevenson, *Atheneum,* 1896, p. 255; J. B. S. Holborn, *Jacopo Robusti called Tintoretto,* London, 1903, p. 107; B. Burroughs, "Ruskin's Tintoretto," *The Bulletin of the Metropolitan Museum of Art,* New York, vol. 6, 1911, pp. 6–9, repr.; F. P. B. Osmaston, *The Art and Genius of Tintoretto,* 2 vols., London: Bell, 1915, vol. 2, pp. 177, 204; D. von Hadeln, "Zeichnungen des Tintoretto," *Jahrbuch der preussischen Kunstsammlungen,* vol. 42, 1921, p. 188, repr. fig. 29; E. von der Bercken, A. L. Mayer, *Tintoretto,* 2 vols., Munich: Piper,

1923, vol. 1, pp. 106, 229, vol. 2, p. 135, repr.; M. Pittaluga, *Tintoretto,* Bologna: Zanichelli, 1925, p. 281; F. Fosca, *Tintoretto,* Paris: Michel, 1929, p. 144; E. von der Bercken, *Die Gemälde des Jacopo Tintoretto,* Munich: Piper, 1942, p. 118, no. 251, repr. pp. 157, 158; H. Tietze, *Tintoretto: The Paintings and Drawings,* London: Phaidon, 1948, pp. 57, 356, repr. pl. 234; H. B. Wehle, "An Unfinished Tintoretto Explained," *The Metropolitan Museum of Art Bulletin,* vol. 7, 1949, pp. 173 ff., repr. pp. 174, 176, 177; H. Tietze, "Bozzetti di Jacopo Tintoretto," *Arte Veneta,* Annata 5, 1951, pp. 61 ff., repr. fig. 59; R. Pallucchini, "Un capolavoro del Tintoretto: la Madonna del Doge Alvise Mocenigo," *Arte Veneta,* Annata 8, 1954, p. 224, fig. 238; B. Berenson, *Italian Pictures of the Renaissance: Venetian School,* 2 vols., London: Phaidon, 1957, vol. 1, p. 176, vol. 2, repr. pl. 1318; P. de Vecchi, *L'opera completa del Tintoretto,* Milan: Rizzoli, 1970, pp. 127 ff., no. 261e; J. Dearden, "John Ruskin's Art Collection—a Centenary," *Connoisseur,* vol. 178, 1971, p. 31; P. Rossi, *Jacopo Tintoretto: I ritratti,* Venice: Alfieri, 1973, p. 125; F. Zeri, E. E. Gardner, *Italian Paintings . . . Venetian School,* New York: Metropolitan Museum of Art, 1973, pp. 69–71.

36.
Christ at the Sea of Galilee, c. 1575–80
Oil on canvas
46 x 66¼ in. (116.8 x 168.3 cm.)
National Gallery of Art, Washington, D.C.
Samuel H. Kress Collection, 1952
825

Collections:
Count Joseph Gallotti; Durlacher's, London and New York; Arthur Sachs, New York, 1925; Samuel H. Kress, 1943.

Exhibitions:
Cambridge, Mass., Fogg Art Museum, 1927; New York, Metropolitan Museum of Art, 1932–33; *Century of Progress,* Art Institute of Chicago, June 1–Nov. 1, 1933, no. 135; *Venetian Paintings of the 15th and 16th Centuries,* New York, Knoedler & Co., Apr. 11–Apr. 30, 1938, no. 16; *Venetian Painting from the 15th through the 18th Centuries,* San Francisco, California Palace of the Legion of Honor, June 25–July 24, 1938, no. 66; *Religious Art,* Baltimore Museum of Art, Dec. 4, 1938–Jan. 1, 1939, no. 35; *Paintings by Jacopo Tintoretto,* New York, Durlacher Galleries, Feb. 20–Mar. 18, 1939, no. 5; *Masterpieces of Art,* New York World's Fair, May–Oct. 1939, no. 377.

Literature:
T. Borenius, "A Seascape by Tintoretto," *Apollo,* vol. 2, Nov. 1925, p. 249; A. L. Mayer, G. Gronau, MS. opinions, 1925, as quoted by F. R. Shapley, p. 53; E. von der Bercken, "Zwei unbekannte Werke aus Tintorettos früher Zeit," *Zeitschrift für bildende Kunst,* vol. 59, 1925, p. 332; A. Venturi, *Storia dell'arte italiana,* 11 vols., Milan: Hoepli, 1901–40, vol. 9, part 4, 1929, p. 615; L. Venturi, *Italian Paintings in America,* 3 vols., New York: Weyhe, 1933, vol. 3, no. 555; T. Borenius, "A Tintoretto Exhibition," *Burlington Magazine,* vol. 74, Jan.–June 1939, p. 138; E. von der Bercken, *Die Gemälde des Jacopo Tintoretto,* Munich: Piper, 1942, pp. 88, 118; H. Tietze, *Tintoretto: The Paintings and Drawings,* London: Phaidon, 1948, p. 381; B. Berenson, *Italian Pictures of the Renaissance: Venetian School,* 2 vols., London: Phaidon, 1957, vol. 1, p. 183; National Gallery of Art, *Paintings and*

Sculpture from the Samuel H. Kress Collection, 1959, p. 203, repr. pl. 825; M. M. Salinger, *Tintoretto,* New York: Abrams, 1960, no. 8; H. Wethey, *El Greco and His School,* 2 vols., Princeton Univ. Press, 1962, p. 90, note 113; J. Walker, *National Gallery of Art, Washington, D.C.,* New York: Abrams, 1963, p. 158; P. de Vecchi, *L'opera completa del Tintoretto,* Milan: Rizzoli, 1970, p. 133, no. 290; F. R. Shapley, *Paintings from the S. H. Kress Collection: Italian Schools XVI–XVIII Century,* London: Phaidon, 1973, pp. 52–53, repr. fig. 92; J. Walker, *National Gallery of Art, Washington,* New York: Abrams, 1976, no. 293.

37.

Paradise, c. 1588
Oil on canvas
60 x 193 in. (152.4 x 490.2 cm.)
Private Collection, Switzerland

Literature:
G. Bardi, *Dichiaratione di tutte le istorie . . . nelle sale dello Scrutinio e del Gran Consiglio,* Venice: Felice Valgrisio, 1587, p. 46; M. Boschini, *La carta del navegar pitoresco* (1660), ed. A. Pallucchini, Venice–Rome: Istituto per la collaborazione culturale, 1966, pp. 78, 338, 447; C. Ridolfi, *Le maraviglie dell'arte ovvero le vite degl'illustri pittori veneti e dello stato . . .* (1648), 2 vols., ed. D. von Hadeln, Berlin: Grote, 1914–24, vol. 1, pp. 345, 409; D. von Hadeln, "Die Vorgeschichte von Tintorettos Paradies in Dogenpalast," *Jarhbuch der preussischen Kunstsammlungen,* vol. 40, 1919, pp. 119–25.

Domenico Tintoretto

Domenico Robusti, 1562–1635

38.

Portrait of a Lady in White
Oil on canvas
46 x 37 in. (116.8 x 94 cm.)
Dr. and Mrs. Bob Jones, Greenville
572

Collections:
Sir Joseph B. Robinson, Cape Town, South Africa; Sale, London, Christie, Manson & Woods, July 6, 1923, no. 47 (as Veronese).

Literature:
Catalogue of the Well-Known Collection of Pictures by Old Masters of Sir Joseph B. Robinson, Bart., London, 1923, fig. 47.

Veronese

Paolo Caliari, 1528–1588

39.

Portrait of a Venetian General in Armor, c. 1551
Oil on canvas
78 x 47 in. (198.1 x 119.4 cm.)
Private Collection, Paris

Collections:
W. A. L. S. Douglas, Duke of Hamilton, Hamilton Palace, Scotland; Sale, London, Christie's, June 24, 1882, lot 411 (as Giorgione); Davis Collection, London; The Earl of Rosebery, Mentmore; Sale, London, Christie's, May 5, 1939, lot 45 (as Giorgione); Leonard Kötser, Zurich (as Giorgione); Madame K. L . . . ; Sale, Paris, Charpentier, Nov. 30, 1954, lot 34.

Exhibitions:
Italian and Dutch Masters, Schaffer Galleries, New York, May 15–June 15, 1940, no. 5; *Venetian Masterpieces,* Tulsa, Philbrook Art Museum, Dec. 1940, no. 24, WPA Art Center, Oklahoma City, Jan. 7–Jan. 31, 1941; *Masterpieces of Art from European and American Collections,* Detroit Institute of Arts, Apr. 1–May 31, 1941, no. 65; *Men in Arms: 1450–1943,* Hartford, Wadsworth Atheneum, Feb. 2–Mar. 4, 1943, no. 74.

Literature:
The Hamilton Palace Collection, London: Remington, 1882, p. 57, no. 411 (as Giorgione); W. Roberts, *Memorials of Christie's,* 2 vols., London: Bell & Sons, 1897, vol. 2, p. 18; G. M. Richter, *Giorgio da Castelfranco, called Giorgione,* Chicago: Univ. of Chicago Press, 1937, p. 349; "Venetians in Oklahoma: Eighteen Masters of a Great School in the West," *Art News,* vol. 39, Jan. 4, 1941, p. 13, repr.; E. P. Richardson, "Augmented Return Engagement and Positive Farewell Appearance of the Masterpieces of Art from Two World's Fairs," *Art News,* vol. 40, May 1–14, 1941, p. 39; "Men in Arms: 1450–1943," *Art News,* vol. 42, Feb. 15–23, 1943, repr. p. 16; W. Suida, "Paolo Veronese and His Circle: Some Unpublished Works," *The Art Quarterly,* vol. 8, summer 1945, p. 185, repr. fig. 10; B. Berenson *Italian Pictures of*

the Renaissance: Venetian School, 2 vols., London: Phaidon, 1954, vol. 1, p. 133; R. Marini, G. Piovene, *L'opera completa del Veronese,* Milan: Rizzoli, 1968, p. 134, no. 358; T. Pignatti, *Veronese,* 2 vols., Venice: Alfieri, 1976, vol. 1, p. 106, no. 8, vol. 2, fig. 26.

40.

Virgin and Child with Angels Appearing to Sts. Anthony Abbot and Paul the Hermit, 1561–62
Oil on canvas
112 x 66½ in. (284.5 x 168.9 cm.)
Chrysler Museum at Norfolk
Gift of Walter P. Chrysler, Jr.
71.527

Collections:
Church of San Benedetto, Chapel of St. Anthony, Polirone, Mantua, 1662–1890; French Castle, 1950; Jean Neger, Paris, 1954.

Exhibitions:
Paintings from the Collection of Walter P. Chrysler, Jr., Mar. 2, 1956–Apr. 1957: Portland Art Museum; Seattle Art Museum; San Francisco, California Palace of the Legion of Honor; Los Angeles County Museum of Art; Minneapolis Institute of Arts; City Art Museum of St. Louis; Kansas City, William Rockhill Nelson Gallery of Art; Detroit Institute of Arts; Boston, Museum of Fine Arts, no. 26; *Paintings from Private Collections,* New York, Metropolitan Museum of Art, summer 1958; *Rockford College Festival of Arts,* Rockford, 1963, no. 8; *Venetian Paintings of the Sixteenth Century,* New York City, Finch College Museum of Art, Oct. 30–Dec. 15, 1963, no. 30; *Italian Renaissance and Baroque Paintings from the Collection of Walter P. Chrysler, Jr.,* Norfolk Museum of Arts and Sciences, Dec. 2, 1967–May 15, 1968, no. 16; *Veronese and His Studio in North American Collections,* Birmingham Museum of Art, Oct. 1–Nov. 15, 1972, Montgomery Museum of Fine Arts, Dec. 5–31, 1972; *Treasures from the Chrysler Museum and Walter P. Chrysler, Jr.,* Cheekwood, Tennessee Fine Arts Center, June 12–Sept. 5, 1977, no. 2; *Veronese to Franz Kline:*

Masterworks from the Chrysler Museum, New York, Wildenstein & Co., Apr. 12–May 13, 1978, no. 1.

Literature:
G. Vasari, *Le vite dei più eccellenti pittori, scultori, ed architetti* (1568), ed. G. Milanese, 9 vols., Florence: Sansoni, 1906, vol. 6, pp. 490–91; R. Borghini, *Il riposo...*, Florence: Marescotti, 1584, p. 561; G. Cadioli, *Descrizione delle pitture, sculture, ed architetture, che si osservano nella città di Mantova, e ne'suoi contorni...*, Mantua: Pazzoni, 1763, p. 128; P. Caliari, *Paolo Veronese: Sua vita a sue opere,* Rome: Forzani, 1888, pp. 51–52, 374; G. Cignaroli, "Postile all'opera di Bartolomeo del Pozzo," in G. Biadego, *Miscellanea della R. Deputazione di storia patria per la Venezia,* serie 4, vol. 9, 1890, p. 30; D. Zannandreis, *Le vite dei pittori, scultori e architetti veronesi, publicate da Giuseppe Biadego,* Verona, 1891, p. 176; D. von Hadeln, "Paolo Veronese," Thieme-Becker, *Allgemeines Künstlerlexikon der bildenden Künstler...,* vol. 5, 1911, p. 393; P. Osmond, *Paolo Veronese: His Career and Work,* London: Sheldon Press, 1927, pp. 47, 112; G. Fiocco, *Paolo Veronese, 1528–1588,* Bologna: Apollo, 1928, pp. 180, 199; A. Venturi, *Storia dell'arte italiana,* 11 vols., Milan: Hoepli, 1901–40, vol. 9, part 4, 1929, p. 950; P. V. Fiocco, *Paolo Veronese,* Rome: Valori Plastici, 1934, p. 122; R. Pallucchini, *Veronese,* Bergamo: Arte Grafiche, 1943, p. 28; L. Venturi, "Un'opera inedita di Paolo Veronese," *Commentari,* vol. 1, Jan. 1950, pp. 39–40, repr. pl. 21, 22; B. Suida Manning, *Paintings from the Collection of Walter P. Chrysler, Jr.,* Portland Art Museum, 1956, p. 27, no. 26, repr. in color on cover; B. Berenson, *Pitture italiane del Rinascimento: La scuola veneta,* Florence: Sansoni, 1958, 2 vols., pp. 136, 138; C. Gould, *The Sixteenth Century Venetian School,* London: National Gallery, 1959, pp. 139–41; B. Suida Manning, "Titian, Veronese and Tintoretto in the Collection of Walter P. Chrysler, Jr.," *Arte Veneta,* Annata 16, 1962, pp. 51–52, repr. in color fig. 60; R. L. Manning, *Venetian Paintings of the Sixteenth Century,* New York, Finch College Museum of Art, 1963, no. 30, repr. on cover; R. Pallucchini, *Paolo Veronese,* Padua, 1963–64, pp.

58–59; F. L. Richardson, "Two Exhibitions of Venetian Painting at Finch College," *Art Quarterly,* vol. 27, no. 3, 1964, p. 355; R. Pallucchini, "Paolo Veronese," *Enciclopedia universale dell'arte,* Venice–Rome, vol. 14, pp. 727–28; R. Marini, G. Piovene, *L'opera completa del Veronese,* Milan: Rizzoli, 1968, p. 104, no. 77B, repr.; E. E. Safarik, "Un capolavoro di Paolo Veronese alla Galleria Nazionale di Praga," *Saggi e memorie di storia dell'arte,* 1968, p. 94; R. Pallucchini, *Lineamenti del Manierismo Europeo,* Padua, 1969–70, p. 156; D. Rosand, *Veronese and His Studio in North American Collections,* Birmingham Museum of Art, 1972, p. 9, repr. p. 20; C. Gould, *The Sixteenth Century Italian Schools,* London: National Gallery Catalogue, 1975, p. 317; T. Pignatti, *Veronese,* 2 vols., Venice: Alfieri, 1976, vol. 1, p. 124, no. 124, repr. vol. 2, no. 366; E. Zafran, "From the Renaissance to the Grand Tour," *Apollo,* vol. 107, Apr. 1978, p. 242, repr. in color pl. 1.

41.

Allegory of Navigation with Astrolabe, 1565–70
Oil on canvas
81 x 46 in. (205.7 x 116.8 cm.)
Los Angeles County Museum of Art, Gift of The Ahmanson Foundation
M.74.99.1

42.

Allegory of Navigation with Cross-Staff, 1565–70
Oil on canvas
81 x 46 in. (205.7 x 116.8 cm.)
Los Angeles County Museum of Art, Gift of The Ahmanson Foundation
M.74.99.2

Collections:
Hon. Robert Baillie-Hamilton, Langton near Duns, Berwickshire, Scotland, before 1881; Robert Goelet, Newport, R.I.; Salve Regina College, Newport, R.I.; Sale, London, Sotheby, Dec. 12, 1973; Thomas Agnew & Sons, London, 1973–74.

Exhibition:
Old Masters, London, Royal Academy of Arts, 1881, no. 164, as *Geometry and Navigation* (with cross-staff) and no. 166 as *Astronomy* (with astrolabe).

Literature:
Athenaeum, Jan. 8, 1881, p. 61; *Important Old Master Paintings,* London, Sotheby, Dec. 12, 1973, no. 13 (pair) as *Astronomy* (with astrolabe) and *Patriarch* (with cross-staff), repr. opp. pp. 16 and 25; T. Pignatti, *Paolo Veronese,* 2 vols., Venice: Alfieri, 1976, vol. 1, pp. 75, 127, nos. 136–37, repr. in color pl. 13, vol. 2, repr. figs. 388, 391–92.

43.

Diana and Acteon, late 1560s
Oil on canvas
10 x 43½ in. (25.4 x 110.5 cm.)
Museum of Fine Arts, Boston
Gift of Mrs. Edward Jackson Holmes
59.260

Collections:
Sir George Lindsay Holford, Dorchester House, Park Lane, Westonbirt, Gloucestershire; Sale, London, Christie, Manson & Woods, July 15, 1927, lot 130; Edward J. Holmes, Boston.

Exhibitions:
Winter Exhibition, London, Burlington House, 1902, no. 114; *Pictures and Other Objects of Art Selected from the Collections of Mr. Robert Holford,* London, Burlington Fine Arts Club, 1921–22, no. 23; *Mostra di Paolo Veronese,* Venice, Ca'Giustinian, Apr. 25–Nov. 4, 1933, no. 31; *100 Paintings from Boston,* New York, Metropolitan Museum of Art, May 29–July 26, 1970, no. 19; *Veronese and His Studio,* catalog by D. Rosand, Birmingham Museum of Art, Oct. 10–Nov. 15, 1970, Montgomery Museum of Fine Arts, Dec. 5–31, 1972; *Antiquity in the Renaissance,* Northampton, Smith College Museum of Art, Apr. 6–June 6, 1978.

Literature:
C. Ridolfi, *Le maraviglie dell'arte ovvero le vite degli'illustri pittori veneti e dello stato...* (1648), 2 vols., ed. D. von Hadeln, Berlin: Grote, 1914–24, pp. 320, 341; *The Holford Collection, Dorchester House,* Oxford Univ. Press, 1927, pp. 41–42, no. 82, repr. pl. 75; G. Fiocco, *Paolo Veronese,* Rome: Valori

Plastici, 1934, p. 127; A. Morassi, "Opere ignote o inedite di Paolo Veronese," *Bollettino d'arte,* 1935–36, pp. 255–56; W. Suida, "Notes sur Paul Véronèse," *Gazette des Beaux-Arts,* serie 6, vol. 19, Mar. 1938, p. 175; E. van der Bercken, "The Paolo Veronese Exhibition at Venice," *Pantheon,* vol. 24, July–Dec. 1939, p. 30; G. Marchiori, "La mostra di Paolo Veronese," *Emporium,* 1939, p. 50; R. Pallucchini, *Mostra di Paolo Veronese,* Venice: Libreria Serenissima, 1939, pp. 85–87, no. 31, repr. p. 84; L. Coletti, *Paolo Veronese e la pittura del suo tempo,* Pisa, 1941, p. 260; W. Suida, "Paolo Veronese and His Circle: Some Unpublished Works," *Art Quarterly,* vol. 8, 1945, p. 186; L. Vertova, *Veronese,* Milan: Electa, 1952, pp. 28–31; G. Gamulin, "Il politico di Paolo Veronese a verbosca," *Arte Veneta,* Annata 9, 1955, p. 93; B. Berenson, *Italian Pictures of the Renaissance: Venetian School,* 2 vols., London: Phaidon, 1957, vol. 1, p. 130, repr. pl. 1056; R. Marini, G. Piovene, *L'opera completa del Veronese,* Milan: Rizzoli, 1968, p. 98, no. 64B, repr.; K. Sobotik, *100 Paintings from Boston,* New York, Metropolitan Museum of Art, 1970, no. 19, p. 35, repr. p. 35; B. Fredericksen, F. Zeri, *Census of Pre-Nineteenth Century Italian Paintings in North American Public Collections,* Cambridge: Harvard Univ. Press, 1972, pp. 38, 469, 565; D. Rosand, *Veronese and His Studio in North American Collections,* Birmingham Museum of Art, 1970, p. 18; T. Pignatti, *Veronese,* 2 vols., Venice: Alfieri, 1976, vol. 1, p. 129, no. 148, repr. vol. 2, no. 405.

44.

Portrait of Agostino Barbarigo, 1571
Oil on canvas
44½ x 45¾ in. (113 x 116.2 cm.)
The Cleveland Museum of Art
Holden Collection
28.16

Collections:
Manfrin Collection, Venice; Miethke Collection, Vienna, 1927; Italico Brass, Venice.

Exhibitions:
The Twentieth Anniversary Exhibition of the Cleveland Museum of Art, Cleveland Museum of Art, June 26–Oct. 4, 1936, no. 110; *Mostra di Paolo Veronese,* catalog by R. Pallucchini, Venice, Ca' Giustiniani, Apr. 25–Nov. 4, 1939, no. 52; *Venetian Tradition,* Cleveland Museum of Art, Nov. 8, 1956–Jan. 1, 1957, no. 61, repr. pl. 38.

Literature:
C. Ridolfi, *Le maraviglie dell'arte ovvero le vite degli'illustri pittori veneti e dello stato...* (1648), 2 vols., ed. D. von Hadeln, Berlin: Grote, 1914–24, vol. 2, 1924, p. 225; G. Gombosi, *Magyar Müveszeti,* vol. 4, 1928, pp. 724–28; W. M. Milliken, "The Portrait of Ammiraglio Manfrin by Paolo Veronese: A New Accession for the Holden Collection," *The Bulletin of the Cleveland Museum of Art,* 1928, vol. 15, pp. 63–65, repr. pp. 61, 62; F. Kelley, "A Problem of Identity," *Connoisseur,* vol. 87, Apr. 1931, pp. 211–12, repr. p. 212, pl. 8; L. Venturi, *Pitture italiane in America,* Milan: Hoepli, 1931, pl. 417; B. Berenson, *Italian Pictures of the Renaissance,* Oxford: Clarendon Press, 1932, p. 420; L. Venturi, *Italian Paintings in America,* 3 vols., New York: Weyhe, 1933, vol. 3, pl. 568; P. V. Fiocco, *Paolo Veronese,* Rome: Valori Plastici, 1934, pp. 32, 124, 127; E. von der Bercken, "The Paolo Veronese Exhibition at Venice," *Pantheon,* July 24–Dec. 1939, p. 30; E. von der Bercken, "Die Paolo-Veronese-Ausstellung in Venedig," *Pantheon,* vol. 24, July–Dec. 1939, p. 256; R. Pallucchini, *Mostra di Paolo Veronese,* Venice: Libreria Serenissima, 1939, p. 131, no. 52, repr. p. 130; W. Arslan, *I collaterali di Paolo Veronese,* Pavia, 1946–47, vol. 2, pp. 27–28 (as Carletto); W. Arslan, "Nota su Veronese e Zelotti," *Belle Arti,* vol. 1, 1948, no. 5–6, p. 236; A. Pigler, *A régi képtar katalógusa,* Szépmüveszeti múzeum, Budapest: Akademia, 1954, p. 609; B. Berenson, *Italian Pictures of the Renaissance: Venetian School,* 2 vols., London: Phaidon, 1957, vol. 1, p. 130; E. Tietze-Conrat, "Paolo Veronese 'Armato,'" *Arte Veneta,* Annata 13–14, 1959–60, p. 99; J. Walker, *National Gallery of Art, Washington,* London: Thames and Hudson, [1965], p. 138; K. Garas,

Italienische Renaissanceporträts, Budapest: Corvina, 1965, no. 45, repr. in color; Cleveland Museum of Art, *Handbook,* Cleveland, 1966, p. 97; R. Marini, G. Piovene, *L'opera completa del Veronese,* Milan: Rizzoli, 1968, p. 111, no. 139a, repr.; B. Fredericksen, F. Zeri, *Census of Pre-Nineteenth Century Italian Paintings in North American Public Collections,* Cambridge: Harvard Univ. Press, 1972, pp. 59, 510, 573; T. Pignatti, *Veronese,* 2 vols., Venice: Alfieri, 1976, vol. 1, p. 135, no. 172, repr. vol. 2, no. 449.

45.
The Annunciation, 1572–73
Oil on canvas
41¼ x 32¾ in. (104.8 x 83.2 cm.)
Suida Manning Collection,
New York City

Exhibitions:
Veronese and His Studio in North American Collections, Brimingham Museum of Art, Oct. 1–Nov. 15, 1972; Montgomery Museum of Fine Arts, Dec. 5–Dec. 31, 1972.

Literature:
B. Berenson, *Pitture italiane del Rinascimento: La scuola veneta,* 2 vols., Florence: Sansoni, 1958, p. 138; R. Marini, G. Piovene, *L'opera completa del Veronese,* Milan: Rizzoli, 1968, p. 134, no. 367; D. Rosand, *Veronese and His Studio in North American Collections,* Birmingham Museum of Art, 1972, p. 32; T. Pignatti, *Veronese,* 2 vols., Venice: Alfieri, 1976, vol. 1, p. 162, no. 315, repr. vol. 2, no. 678.

46.
Venus at Her Toilette, early 1580s
Oil on canvas
63½ x 47½ in. (161.3 x 120.7 cm.)
Joslyn Art Museum, Omaha
1942.4

Collections:
Count Bevilacqua, Verona, 1805; Richard Pryor; Abbot Celotti, 1807; Sir Thomas Lawrence, London; Sale, London, Christie's, May 15, 1830, lot 114; C. A. von Frey, Paris, before 1934; Jacob Hirsch, New York, 1942.

Exhibitions:
Colorado Springs Art Center, May 1938; *Venetian Painting from the Fifteenth Century through the Eighteenth Century,* San Francisco, California Palace of the Legion of Honor, June 25–July 24, 1938, no. 75; *Classics of the Nude: Pollaiuolo to Picasso,* New York, M. Knoedler & Co., Apr. 10–29, 1939, no. 11; *Masterpieces of Art: European Paintings and Sculpture 1300–1800,* New York World's Fair, May–Oct. 1939, (not listed in catalog); *Tenth Anniversary Exhibition,* Omaha, Joslyn Art Museum, Dec. 1941–Jan. 1942.

Literature:
R. Borghini, *Il riposo...,* Florence: Marescotti, 1584, p. 563; C. Ridolfi, *Le maraviglie dell'arte ovvero le vite degli'illustri pittori veneti e dello stato...* (1648), 2 vols., ed. D. von Hadeln, Berlin: Grote, 1914–24, vol. 1, 1914, pp. 320, 335; B. dal Pozzo, *Le vite de'pittori, degli scultori et architetti veronesi...,* Verona: Berno, 1718, p. 281; G. Campori, *Raccolta di cataloghi ed inventari inediti, di quadri, statue... dal sec. XV al sec. XIX,* Modena, 1870, p. 180; A. Graves, *Art Sales,* 3 vols., London: A. Graves, 1921, vol. 3, p. 302; D. von Hadeln, "Veronese's Venus at Her Toilet," *Burlington Magazine,* vol. 54, Mar. 1929, pp. 115–16, repr. pl. 2A; S. Poglayen-Neuwall, "Eine tizianeske Toilette der Venus," *Münchener Jahrbuch der bildenden Kunst,* N.F., vol. 6, part 2, 1929, p. 77; P. V. Fiocco, *Paolo Veronese,* Rome: Valori Plastici, 1934, p. 118; S. Poglayen-Neuwall, "Titian's Pictures of the Toilet of Venus and Their Copies," *Art Bulletin,* vol. 16, Dec. 1934, pp. 358, 378, 381, repr. fig. 21; T. Carr Howe, *Venetian Painting from the Fifteenth Century through the Eighteenth Century,* San Francisco: California Palace of the Legion of Honor, 1938, no. 75, repr.; A. M. Frankfurter, "The Venetians in California," *Art News,* vol. 36, part 2, July 16, 1938, p. 8, repr. p. 11; A. M. Frankfurter, *Classics of the Nude,* New York: Knoedler & Co., 1939, p. 16, no. 11; H. Comstock, "The Connoisseur in America," *Connoisseur,* no. 103, 1939, pp. 338–39, repr. p. 339; R. Marini, G. Piovene, *L'opera completa del Veronese,* Milan: Rizzoli, 1968, p. 122, no. 218c; L. Franzoni, *La galleria Bevilacqua,*

Milan, 1970, p. 1; B. Fredericksen, F. Zeri, *Census of Pre-Nineteenth Century Italian Paintings in North American Public Collections,* Cambridge: Harvard Univ. Press, 1972, pp. 39, 476, 615; R. Cocke, "New Light on Late Veronese," *Burlington Magazine,* vol. 116, Jan. 1974, p. 24, no. 5; T. Pignatti, *Veronese,* 2 vols., Venice: Alfieri, 1976, vol. 1, p. 154, no. 275, repr. fig. 619, vol. 2, no. 405, 449.

47.
Christ Crowned with Thorns, 1580s
Oil on canvas
55 x 43 in. (139.7 x 109.2 cm.)
Marie Stauffer Sigall Foundation, on loan to The Fine Arts Museums of San Francisco
L.67.13

Collection:
Schaffer Gallery, New York.

Literature:
W. Suida, "Chiarimenti ed aggiunte all'opera di Paolo Veronese," *Arte Veneta,* Annata 15, 1961, p. 103, repr. p. 101, pl. 106; R. Pallucchini, *Paolo Veronese,* Padua, 1963–64, p. 130; A. Ballarin, "Osservazioni sui dipinti veneziani del Cinquecento nella Galleria del Castello di Praga," *Arte Veneta,* Annata 19, 1965, p. 81; L. Crosato Larcher, "L'opera completa del Veronese," *Arte Veneta,* Annata 22, 1968, p. 221; R. Marini, G. Piovene, *L'opera completa del Veronese,* Milan: Rizzoli, 1968, p. 130, no. 288, repr.; T. Pignatti, *Veronese,* 2 vols., Venice: Alfieri, 1976, vol. 1, p. 165, no. 332, repr., vol. 2, fig. 705.

Jacopo Bassano

Jacopo da Ponte, c. 1515–1592

48.

Flight into Egypt, c. 1540–45
Oil on canvas
47 x 78 in. (119.4 x 198.1 cm.)
Norton Simon Inc Foundation,
Los Angeles
M.69.35.P

Collections:
General Craig; Sale, London, Christie's, April 18, 1812, lot 11; Sir Joseph Hawley, 3rd Baronet, Brighton; Sir Henry Hawley, 4th Baronet, Brighton; Miss Annie Massey; Lord Rendel of Hatchlands, by 1879; H. S. Goodhart-Rendel, C.B.E.; Prinknash Abbey, Gloucester, 1957; Sale, London, Christie's, Dec. 5, 1969, lot 112.

Exhibitions:
Exhibition of Works by the Old Masters..., Winter Exhibition, London, Royal Academy of Arts, 1879, no. 206 (as Venetian School); *Italian Art and Britain,* London, Royal Academy of Arts, Jan. 2–Mar. 6, 1960, no. 86; *Selections from the Norton Simon Inc. Museum of Art,* Princeton, The Art Museum, Princeton Univ., 1972–74, no. 2.

Literature:
Royal Academy of Arts, *Exhibition of Works by the Old Masters,* London: Clowes and Sons, 1879, p. 39, no. 206; Royal Academy of Arts, *Italian Art and Britain,* notes by E. K. Waterhouse, London: Clowes and Sons, 1960, p. 44, no. 86; B. Nicolson, "Some Little Known Pictures at the Royal Academy," *Burlington Magazine,* vol. 102, part 1, 1960, p. 76, repr. fig. 39; L. Herrmann, "A New Bassano 'Flight into Egypt,'" *Burlington Magazine,* vol. 103, Nov. 1961, p. 465–66; Christie, Manson & Woods, *Highly Important Pictures by Old Masters,* London, Dec. 5, 1969, p. 68, repr. fig. 112; F. L. Gibbons, "Italian Painting of the 15th and 16th Centuries," *Selections from the Norton Simon, Inc. Museum of Art,* ed. D. W. Steadman, Princeton Univ.: The Art Museum, pp. 16–19, 22, no. 2, repr. in color p. 23, details pp. 14, 17; D. W. Steadman, "The Norton Simon Exhibition at Princeton," *Art Journal,*

vol. 32, fall 1972, pp. 35, repr. p. 34, fig. 2; D. W. Steadman, "The Landscape in Art," *University: A Princeton Quarterly,* no. 57, summer 1973, repr. p. 7.

49.

Adoration of the Shepherds, 1542–46
Oil on canvas
38¼ x 54 in. (97 x 137 cm.)
Justo Giusti Del Giardino Collection,
Verona

Collections:
Giusti Del Giardino, Caracas, 1956; Villa Giusti Del Giardino, Onara di Tombolo, Padua, 1960.

Exhibitions:
Le triomphe du maniérisme européen de Michel-Ange au Gréco, Amsterdam, Rijksmuseum, July 1–Oct. 16, 1955, no. 19; *Works of Italian Old Masters from Private Collections in Caracas, from the 14th to the 18th Centuries,* Caracas, Museum of Fine Arts, Nov. 25–Dec. 16, 1956, no. 67; *Mostra di Jacopo Bassano,* Venice, Palazzo Ducale, June 29–Oct. 27, 1957, no. 21.

Literature:
E. Arslan, "An Unknown Painting by Jacopo Bassano," *Art in America,* vol. 22, 1934, pp. 123–24, repr. fig. 1; B. Berenson, *Italian Pictures of the Renaissance; Venetian School,* 2 vols., London: Phaidon, 1957, vol. 1, p. 20, repr. vol. 2, pl. 1193; R. Pallucchini, "Commento alla mostra de Jacopo Bassano," *Arte Veneta,* Annata 11, 1957, p. 102; P. Zampetti, *Mostra di Jacopo Bassano,* Rome: Istituto Poligrafico, 1958, p. 26, repr. in color pls. 18–20; E. Arslan, *I Bassano,* 2 vols., Milan: Ceschina, 1960, vol. 1, p. 173.

50.

Pastoral Landscape, 1560s
Oil on canvas
55⅛ x 51 in. (140 x 129.5 cm.)
Thyssen-Bornemisza Collection,
Lugano

Collections:
Sir Thomas Baring; Mr. Coningham, 1843; Earls of Northbrook, 1851; Earl of Harewood, 1919–35.

Exhibitions:
British Institution, London, 1839, no. 13; *Mostra di Jacopo Bassano,* Venice, Palazzo Ducale, June 29–Oct. 27, 1957; *Collectie Thyssen-Bornemisza,* Rotterdam, Museum Boymans van Beuningen, 1959–60, no. 26; *Sammlung Thyssen-Bornemisza,* Essen, Museum Folkwang, Jan. 27–Mar. 20, 1960, no. 26; *From Van Eyck to Tiepolo,* London, National Gallery, 1961, no. 9.

Literature:
G. F. Waagen, *Galleries and Cabinets of Art in Great Britain,* 4 vols., London: John Murray, 1854–5/7, vol. 4, p. 96; W. H. Weale, J. P. Richter, *A Descriptive Catalogue of the Collection of Pictures Belonging to the Earl of Northbrook...,* London and Sydney: Griffith, Farren..., 1889, p. 110, no. 153; A. Graves, *A Century of Loan Exhibitions 1813–1912,* London: A. Graves, 1913, vol. 1, p. 42; *Sammlung Schloss Rohoncz,* Lugano, 1937, no. 22, repr. pl. 223; B. Berenson, *The Italian Painters of the Renaissance,* London: Phaidon, 1952, pl. 92; B. Berenson, *Italian Pictures of the Renaissance: Venetian School,* 2 vols., London: Phaidon, 1957, vol. 1, p. 18; H. Honour, "Jacopo Bassano," *Connoisseur,* vol. 140, Nov. 1957, p. 165, repr. fig. 2; M. Muraro, "The Jacopo Bassano Exhibition," *Burlington Magazine,* vol. 99, 1957, p. 299, repr. fig. 10; R. Pallucchini, "Commento alla mostra di Jacopo Bassano," *Arte Veneta,* Annata 9, 1957, p. 106, no. 5, repr. p. 107; M. Weisstein, "Jacopo Bassano in Venice," *Arts,* vol. 31, Sept. 1957, p. 16, repr.; P. Zampetti, *Mostra di Jacopo Bassano,* Venice: Palazzo Ducale, 1957, p. 214; P. Zampetti, *Mostra di Jacopo Bassano,* Rome: Istituto Poligrafico, 1958, pp. 37, 39, 54, repr. pl. 47; *Sammlung Schloss Rohoncz,* Lugano, 1958, no. 22; E. Arslan, *I Bassano,* 2 vols., Milan: Ceschina, 1960, vol. 1, pp. 108–10, 170, repr. vol. 2, pls. 142–45; P. Hendy, *Some Italian Renaissance Pictures in the Thyssen-Bornemisza Collection,* Lugano: Villa Favorita, 1964, p. 167, repr. p. 165; A. Ballarin, "L'orto del Bassano," *Arte Veneta,* Annata 18,

1964, pp. 68–70, repr. fig. 73; W. R. Rearick, "Jacopo Bassano's Later Genre Paintings," *Burlington Magazine,* vol. 110, May 1968, p. 242, repr. fig. 6; *The Thyssen-Bornemisza Collection,* 2 vols., Lugano: Villa Favorita, 1969, vol. 1, p. 26–27, no. 20, repr. vol. 2, pl. 264.

51.

St. Valentine Baptizing St. Lucilla, c. 1570–74
Oil on canvas
72½ x 51¼ in. (184 x 130 cm.)
Signed on lower step IAC.S A PONTE BASSANENSIS.F.
Museo Civico, Bassano del Grappa
15

Collections:
Church of the Madonna delle Grazie, Bassano; Don Antonio Danieli, 1842.

Exhibitions:
L'Exposition de l'art italien, de Cimabue à Tiepolo, Paris, Petit Palais, May 14–July 20, 1935, no. 28; *Mostra dei capolavori dei musei veneti,* Venice, Procuratie Nuove, 1946, no. 253; *Trésors de l'art vénitien,* Musée Cantonal des Beaux-Arts, Apr. 1–July 31, 1947, no. 62; *Dipinti dei Bassano recente restaurati,* Bassano, Museo Civico, July 20–Nov. 30, 1952, no. 27; *De Venetiaanse meesters,* Amsterdam, Rijksmuseum, intro. by R. Pallucchini, July 26–Oct. 11, 1953, no. 4; *La Peinture vénitienne,* pref. by R. Pallucchini, Brussels, Palais des Beaux-Arts, Oct. 16, 1953–Jan. 10, 1954, no. 3; *Chefs-d'oeuvre vénitiens de Paolo Veneziano à Tintoret,* Paris, Musée de L'Orangerie, Jan.–Mar. 31, 1954, no. 2; *Mostra di Jacopo Bassano,* Venice, Palazzo Ducale, June 29–Oct. 27, 1957, no. 62.

Literature:
C. Ridolfi, *Le maraviglie dell'arte ovvero le vite degl'illustri pittori veneti e dello stato...* (1648), 2 vols., ed. D. von Hadeln, Berlin: Grote, 1914–24, vol. 1, p. 385; M. Boschini, *Le ricche minere della pittura veneziana,* Venice: Nicolini, 1660, pp. 269 ff.; *Il Museo di Bassano,* Bassano, 1881, pp. 197–98; G. Gerola, "Per l'elenco delle opere dei pittori da Ponte," *Atti del r. istituto veneto di scienza, lettere ed arti,* 1905–06, vol. 65, p. 952; G. Gerola, "Una croce proces-

sionale del Filarete a Bassano," *L'Arte,*
vol. 9, 1906, p. 295; L. Zottman,
Zur Kunst der Bassani, Strasbourg,
1908, pp. 26–29; G. Gerola, *Bassano,*
Bergamo, 1910, p. 97; A. Venturi,
Storia dell'arte italiana, 11 vols.,
Milan: Hoepli, 1901–40, vol. 9,
part 4, pp. 1218–19, 1257; W. Arslan,
I Bassano, Bologna: Apollo, 1931, p.
186; S. Bettini, *L'arte di Jacopo Bassano,*
Bologna: Apollo, 1933, p. 100; R.
Pallucchini, *La pittura veneziana del
Cinquecento,* 2 vols., Novara: Agostini:
1944, p. XXXVI; R. Pallucchini, *I capo-
lavori dei musei veneti,* Venice: Arte
Veneta, 1946, p. 155; M. Florisoone,
*Les grands maitres italiens, XVI–XVII
siècles,* Paris: Nathan, 1952, pp. 25–30;
L. Magagnato, *Dipinti dei Bassano recen-
temente restaurati,* Venice: Pozzo, 1952,
pp. 45–46; R. Pallucchini, "Com-
mento alla mostra di Jacopo Bassano,"
Arte Veneta, Annata 11, 1957, p. 112; P.
Zampetti, *Mostra di Jacopo Bassano,*
Rome: Istituto Poligrafico, 1958, p. 47,
repr. pl. 68; E. Arslan, *I Bassano,* 2
vols., Milan: Ceschina, 1960, vol. 1,
pp. 141–42, 162, vol. 2, repr. pl. 185.

Jacopo and Francesco Bassano

Jacopo and Francesco da Ponte,
1515–1592; 1549–1592

52.

*Christ in the House of Mary, Martha, and
Lazarus,* c. 1577
Oil on canvas
38¾ x 49¾ in. (98.4 x 126.4 cm.)
Signed at left: JAC. ET FRAC FILIVS F.
Sarah Campbell Blaffer Foundation,
Houston

Collections:
Private Collection, England; Julius
Weitzner, New York, 1959; Bob Jones
University, Greenville, 1974; Knoedler
& Co., New York, 1979.

Exhibition:
Collecting the Masters, Milwaukee Art
Center, June 3–July 31, 1977, no. 104.

Literature:
C. Ridolfi, *Le maraviglie dell'arte ovvero
le vite degli'illustri pittori veneti e dello
stato...* (1648), 2 vols., ed. D. von
Hadeln, Berlin: Grote, 1914–24, vol.
1, 1914, p. 394; A. Venturi, *Storia dell'
arte italiana,* 11 vols., Milan: Hoepli,
1901–40, vol. 9, part 4, 1929, p. 1280,
repr. fig. 872; M. Havens, "Collection
of Religious Art at Bob Jones Univer-
sity," *Art Journal,* vol. 20–21, 1960–
62, p. 112, repr. fig. 3; *The Bob Jones
University Collection of Religious Paint-
ings,* 2 vols., Greenville, 1962, vol. 1,
pp. 13, 105, repr. p. 104; B. Frederick-
sen, F. Zeri, *Census of Pre-Nineteenth Cen-
tury Italian Paintings in North American
Public Collections,* Cambridge:
Harvard Univ. Press, 1972, p. 18.

Leandro Bassano

Leandro da Ponte, 1557–1622

53.
Lute Player, c. 1580–85
Oil on canvas
31⅜ x 26 in. (79.6 x 66.1 cm.)
Herzog Anton Ulrich-Museum,
Braunschweig
462

Collection:
Ducal Gallery, Salzdahlum near
Braunschweig, 1697 (as Tintoretto).

Literature:
L. Flemming, *Description of the Gallery
of the Ducal Palace at Salzdahlum,* 1697,
MS. in the August-Bibliothek in Wolf-
enbuttel (as Tintoretto); C. N. Eber-
lein, *Verzeichnis der herzöglichen Bilder-
galerie in Saltzthalen,* Braunschweig,
1776, p. 39, no. 113 (as Tintoretto); A.
Venturi, "Pitture di Piero di Cosimo e
di Jacopo Bassano," *L'Arte,* 1930, pp.
46–51; W. Arslan, "Bassanesca," *Studi
Trentini di Scienze Storiche,* vol. 17, 1936,
pp. 100 ff.; E. Arslan, *I Bassano,* 2 vols.,
Milan: Ceschina, 1960, vol. 1, pp. 236,
259, vol. 2, repr. fig. 276; Herzog
Anton Ulrich-Museum, *Verzeichnis
der Gemälde vor 1800,* Braunschweig,
1976, p. 9.

Lo Spada

Pietro Marescalchi, c. 1520–1584

54.
*Dr. Zaccaria dal Pozzo at 102 Years of
Age,* 1560–61
Oil on canvas
47 x 41⅜ in. (119.5 x 105 cm.)
Inscribed upper left: ANNO ÆTATIS
SVÆ CII
Museo Civico, Feltre
8

Collections:
Dei Collection, Italy (as Giorgione);
Seminario Vescovile, Feltre, 1845.

Exhibitions:
I capolavori dei musei veneti, Venice, Pro-
curatie Nuove, 1946, no. 235; *Trésors de
l'art vénitien,* Lausanne, Musée Cantonal
des Beaux-Arts, Apr. 1–July 31, 1947,
no. 64.

Literature:
G. Fiocco, "Pietro Marescalchi detto lo
Spada," *Belvedere,* 1929, p. 214; G.
Fogolari, *Le tre Venezie,* 1929, p. 28;
Thieme-Becker, *Allgemeines Lexikon der
bildenden Künstler...,* Leipzig: Seeman,
vol. 24, 1930, p. 86; A. Venturi,
Storia dell'arte italiana, 11 vols., Milan:
Hoepli, 1901–40, vol. 9, part 7, 1934,
pp. 141–43, repr. p. 142, fig. 83; G.
Fiocco, "El Maestro del Greco," *Rivista
español de arte,* 1934, pp. 141–43; R.
Pallucchini, *I capolavori dei musei veneti,*
Venice: Arte Veneta, 1946, no. 235; G.
Fiocco, "Il pittore Pietro de Maresal-
chi da Feltre," *Arte Veneta,* Annata 1,
1947, p. 98; G. Fiocco, "Un Pietro de
Mariscalchi in Inghilterra e uno in
Svizzera," *Arte Veneta,* Annata 3, 1949,
p. 162; F. Valcanover, *Museo Civico di
Feltre,* Venice, 1954, no. 8; B. Berenson,
*Italian Pictures of the Renaissance: Vene-
tian School,* 2 vols., London: Phaidon,
1957, vol. 1, p. 110, repr. vol. 2, pl. 1235.

Palma Giovane

Jacopo Negretti, 1544–1628

55.

The Finding of Moses, after 1570
Oil on canvas
56¾ x 108¼ in. (144 x 275 cm.)
Chrysler Museum at Norfolk
Gift of Walter P. Chrysler, Jr.
71.683

Collections:
Private Collection, Bologna; Ronald
Collection, Newton, Connecticut, early
19th century; Lorillard Collection,
1908; Mrs. Blake; M. Knoedler & Co.,
New York; Walter P. Chrysler, Jr.

Exhibitions:
Italian Renaissance and Baroque Art,
Denver Art Museum, Dec. 17, 1947–
Jan. 10, 1948, no. 6 (as J. Tintoretto);
*Masterpieces of Painting: Treasures of Five
Centuries,* Columbus Gallery of Fine
Arts, Oct. 10–Nov. 5, 1950, (as J. Tinto-
retto); *House of Art,* Houston, Museum
of Fine Arts, Oct. 17–Nov. 28, 1954,
no. 52, repr. (as J. Tintoretto);
Venetian Baroque Painters, catalog by
R. L. Manning, New York, Finch
College Museum of Art, 1964, no. 1,
repr.; *Italian Renaissance and Baroque
Paintings from the Collection of Walter
P. Chrysler, Jr.,* Norfolk Museum of Arts
and Sciences, Dec. 2, 1967–May 15,
1968, no. 18, repr.

Literature:
W. Suida, "Clarifications and Iden-
tifications of Works by Venetian
Painters," *Art Quarterly,* vol. 9, 1946,
p. 289, repr. p. 295, fig. 12 (as J. Tin-
toretto); F. L. Richardson, "Two
Exhibitions of Venetian Painting at
Finch College," *Art Quarterly,* vol. 27,
1964, p. 352.

El Greco

Domenikos Theotokopoulos,
1541–1614

56.

Christ Healing the Blind, c. 1574
Oil on canvas
19¾ x 24 in. (50 x 61 cm.)
Signed: DOMÉNIKOS
THEOTOKÓPOULOS KRÈS EPOÍEI
Pinacoteca Nazionale, Parma

Collections:
Farnese family; Palazzo Giardino,
Parma; Mariano Inzani, Parma; Royal
Gallery, Parma, 1862.

Literature:
G. Campori, *Raccoltà di cataloghi ed
inventari inediti, di quadri, statue...dal
sec. XV al sec. XIX,* Modena, 1870, p.
214; C. Ricci, *La R. Galleria di Parma,*
Parma, 1896, pp. 55–56; A. Venturi,
"Tre quadri della raccoltà dei principi
Drago in Roma," *L'Arte,* 1904, pp.
61–64; M. B. Cossio, *El Greco,* 2 vols.,
Madrid: V. Suárez, 1908, vol. 1, no.
354, p. 61, repr. vol. 2, pl. 5; H.
Kehrer, *Die Kunst des Greco,* Munich:
Schmidt, 1914, p. 18, repr., pl. 3; A. de
Beruete y Moret, *El Greco pintor de
retratos,* Toledo, 1914, pp. 14, 23; M.
Barrès, P. Lafond, *Le Greco,* Paris, n.d.,
p. 115, repr. p. 15; A. L. Mayer, *Il
Greco,* Rome, n.d., vol. 3, p. 12; A. L.
Mayer, *Dominico Theotocopuli El Greco,*
Munich: Hanfstaengl, 1926, pp. XVIII,
XXI, 9, no. 42, repr. p. 8; C. Ricci, *La
Galleria di Parma e de la Camera di S.
Paolo,* Milan: Treves, [1927], pl. 35; J.
F. Willumsen, *La Jeunesse du peintre El
Greco,* 2 vols., Paris: Grès, 1927, vol. 1,
p. 434; K. Waterhouse, "El Greco's
Italian Period," *Art Studies,* 8, 1930,
no. 15; J. Camón Aznar, *Dominico
Greco,* 2 vols., Madrid: Espasa-Calpe,
1950, vol. 1, pp. 72–73, repr. fig. 45,
vol. 2, p. 1361, no. 80; R. Pallucchini,
El Greco, Milan: Martello, 1956, p. 49;

E. du Trapier, "El Greco in the Palazzo
Farnese, Rome," *Gazette des Beaux-Arts,*
serie 6, vol. 51, 1958, pp. 78–80, repr.
p. 78, fig. 4; H. E. Wethey, *El Greco
and His School,* 2 vols., Princeton Univ.
Press, 1962, vol. 1, pp. 22–24, repr. fig.
5, vol. 2, pp. 42–44, no. 62; J. Gudiol,
El Greco 1541–1614, Barcelona: Pol-
igrafa, 1971, pp. 33, 340, no. 16, repr.
p. 31, fig. 21, 22; M. B. Cossio, *El Greco,*
Barcelona: Editorial R. M., 1972,
pp. 314, 359, no. 41.

Los Angeles County Museum of Art